Design and Cultural Politics in Post-war Britain

The *Britain Can Make It* Exhibition of 1946

Edited by
Patrick J. Maguire
and
Jonathan M. Woodham

Leicester University Press
London and Washington

Leicester University Press
A Cassell Imprint
Wellington House, 125 Strand, London WC2R 0BB, England
PO Box 605, Herndon, Virginia 20172, USA

First published 1997

British Library Cataloguing in Publication Data
A catalogue record for this book is available from the British Library.
ISBN 0 7185 0073 3 Hardback
0 7185 0141 1 Paperback

Library of Congress Cataloging-in-Publication Data
Popular politics and design in post-war Britain : the 'Britain can make it' exhibition of 1946 / edited by Jonathan M. Woodham & Patrick J. Maguire.
 p. cm.
 Includes bibliographical references and index.
 ISBN 0-7185-0073-3 (hc).—ISBN 0-7185-0141-1 (pbk).
 1. Design, Industrial—Great Britain—Exhibitions. 2. Design, Industrial—Great Britain—History. I. Woodham, Jonathan M. II. Maguire, Patrick J. (Patrick Joseph), 1950-
T183.G72P66 1997
745.2'0941—dc21
96-51465
CIP

Typeset by BookEns Ltd, Royston, Herts.

Contents

List of Illustrations vii
List of Contributors x
List of Abbreviations xi
Preface xiii

PART 1: LOCATING *BRITAIN CAN MAKE IT*

1. Introduction: Politics and Design in Post-war Britain 3
 Patrick J. Maguire
2. *Britain Can Make It* and the History of Design 17
 Jonathan M. Woodham

PART 2: CULTURAL PROPAGANDA AND INDUSTRIAL
REALISM

3. Patriotism, Politics and Production 29
 Patrick J. Maguire
4. The Politics of Persuasion: State, Industry and Good Design
 at the *Britain Can Make It* Exhibition 45
 Jonathan M. Woodham

PART 3: THE OUTLOOK OF MANUFACTURING INDUSTRY

5. 'Fabrics for Everyman and for the Elite' 67
 Mary Schoeser
6. Moving Forwards but Looking Backwards: The Dynamics of
 Design Change in the Early Post-war Pottery Industry 85
 Graham M. McLaren
7. Good Design by Law: Adapting Utility Furniture to
 Peacetime Production: Domestic Furniture in the
 Reconstruction Period 1946–56. 99
 Judy Attfield

8. Industrial Design: Aesthetic Idealism and Economic Reality 111
Patrick J. Maguire
9. Putting the Industrial Into Design: Early Problems Facing the
Council of Industrial Design 123
Jonathan M. Woodham

PART 4: DOCUMENTATION AND COMMENTARY

10. Introduction to the Documents 137
Patrick J. Maguire and Jonathan M. Woodham
11. Documents and Commentary 139
12. Outline Biographies 198
Thomas Barlow, Misha Black, Kenneth Clark, Stafford Cripps,
Hugh Dalton, James Gardner, Milner Gray, Alan Jarvis,
Alix Kilroy, S.C. ('Clem') Leslie, Francis Meynell,
Gordon Russell, Basil Spence, Charles Tennyson, Allan Walton,
Josiah Wedgwood, Cecil Weir.
13. BCMI 1946: Photographs 210
14. Further Sources for Researching the *Britain Can Make It*
Exhibition 1946 224
 A. Notes on the Material Contained in the Victoria &
Albert Museum Archives
Doreen Leach
 B. Notes on the Mass Observation Archive at the
University of Sussex
Dorothy Sheridan
 C. Public Record Office, Kew
15. 1940s British Design: A Select Bibliography 234
 A. *Britain Can Make It* 1946
 B. Design in 1940s Britain

Index 243

List of Illustrations

1. *Frontispiece*: King George and Queen Elizabeth at the Opening
 Ceremony of the *Britain Can Make It* Exhibition, Victoria &
 Albert Museum, September 1946. ii
2. Catalogue of the *Britain Can Make It* exhibition, COID, 1946. xvi
3. General view, 'The Designer Looks Ahead' Section. 11
4. 'The Bed of the Future' in the 'Designer Looks Ahead' Section. 12
5. Council of Industrial Design stand at BCMI. 20
6. Paper sculptures for the Council of Industrial Design stand at
 BCMI. 21
7. James Gardner touching up models for the BCMI exhibition. 22
8. General view of Shopwindow Street at the BCMI. 22
9. Map of the BCMI exhibition. 45
10. Philip Whalley, COID member and Director of Lewis's Ltd,
 1946. 48
11. Cleveland Belle, of the COID Colour, Design and Style Centre,
 Manchester, 1946. 50
12. Furniture Selection Committee for BCMI. 53
13. Textiles manufactured by Logan Muckelt & Co. Ltd for export
 to Africa on show in the Utility and other Furniture Section. 68
14. Dress Fabrics Section, designed by Basil Spence and Ralph
 Schorr. 72
15. Display of Textiles arranged by Jacques Groag. 77
16. Display of furnishing fabrics from Furnished Rooms Section. 78
17. Drawing for the Living Room in a Large Town House for one
 of the specially furnished rooms at BCMI, by R.D. Russell
 for an imaginary family. 80
18. Finished result for the Living Room in a Large Town House
 by R.D. Russell for one of the specially furnished rooms at
 BCMI. 80
19. Cottage Kitchen in a Modern Mining Village by Edna
 Moseley, Furnished Rooms Section. 82

20. Pottery Selection Committee for BCMI. 85
21. Pottery display arranged by Harry Trethowan of Heals in Shopwindow Street. 87
22. Pottery display in Shopwindow Street. 87
23. Decorated post-war ceramic designs at BCMI. 90
24. Room designed by Jacques Groag, Furniture and Textiles Section. 99
25. Display of kitchen equipment by J. Bainbridge showing developments from the laborious Victorian kitchen to 1946. 110
26. 'Design Man', designed by James Gardner, a motif introduced throughout BCMI to illustrate the seeing eye of the designer. 123
27. One of the displays relating to the design of an egg cup in the 'What Industrial Design Means' display. 129
28. 'What Industrial Design Means' display by Misha Black, Bronek Katz and R. Vaughan of the Design Research Unit. 130
29. 'What Industrial Design Means' display at BCMI by Misha Black, Bronek Katz and R. Vaughan of the Design Research Unit. 130
30. Mass Observation Survey. 173
31. Sir Thomas Barlow, Chairman COID, 1946. 198
32. Kenneth Clark (right) at the first meeting of the COID, January 1945, with E.L. Mercier and Mr. Tresfon. 200
33. James Gardner, 1946. 201
34. Alix Kilroy (left) with Mr Caruthers and Mr Newman at the first meeting of the COID, January 1945. 203
35. S.C. ('Clem') Leslie, Director of the COID, 1946. 204
36. Sir Francis Meynell (left) and William Haigh, COID members at the first meeting of the COID, January 1945. 205
37. Basil Spence, Chief Architect, BCMI, 1946. 206
38. Charles Tennyson (right), Chair of the Industrial Art Designers National Register, and S.C. Leslie at the first meeting of the COID, January 1945. 207
39. Allan Walton, COID member, 1946. 208
40. Cecil Weir at the Board of Trade offices, Portland House, 1946. 209
41. Introduction to *Britain Can Make It*, designed by James Gardner and Basil Spence. 210
42. Inflatable rubber chair, R.F.D. Co. Ltd, Guildford, from the War to Peace Section. 211
43. Display of glass in Shopwindow Street. 212
44. Sport and Leisure Section. 213

45. General display of Furnished Rooms Section. 214
46. Living Room with Kitchen Recess in Small House, designed by
 Mrs Darcy Braddell. 214
47. Kitchen with Dining Recess for an architect and his family,
 designed by F. MacManus. 215
48. One of imaginary families envisaged by John Betjeman for
 Furnished Rooms designs at BCMI. 216
49. One of imaginary families envisaged by John Betjeman for
 Furnished Rooms designs at BCMI. 217
50. A corner of the Toys Section. 218
51. Nursery School designed by Ralph Tubbs. 218
52. Bathroom and Kitchen Equipment. 219
53. 'Goldwyn Girls' in the Fashion Hall. 219
54. Fashion Section, Hyde Park Set, designed by James Bailey. 220
55. Menswear Section, designed by Ashley Havinden. 220
56. Staff Office for the BCMI exhibition. 221
57. Trade Enquiry Office at BCMI. 221
58. Enquiries and Publications Stall at BCMI. 222
59. Exhibition Bookshop at BCMI. 222
60. Books and Publications Stall at BCMI. 223

Note

All photographs are located in the Design Council Archive at the University of Brighton. The copyright is held by the Design Council/Design Council Archive at the Design History Research Centre, University of Brighton.

List of contributors

Judy Attfield is course leader of the MA in Design History and Material Culture at Winchester School of Art. She has published widely in the area of design history and co-edited with Pat Kirkham the recently reissued *A View From The Interior*.

Doreen Leach was formerly an assistant museum archivist at the Victoria & Albert Museum.

Graham McClaren teaches at the University of Staffordshire. He has researched and published material in the field of ceramic history.

Patrick J. Maguire teaches history at Brighton University. He is chair of the History Workshop Trust and has published widely in the fields of industrial relations and labour history as well as in the field of design history.

Mary Schoeser is a consultant curator and archivist, specializing in the history of textiles. She has published a number of works and curated exhibitions in a variety of historical fields.

Dorothy Sheridan is the archivist of Mass Observation at the University of Sussex and has published extensively in areas relating to Mass Observation's work.

Jonathan M. Woodham is professor in the history of design and director of the Design History Research Centre at the University of Brighton. He serves on the editorial boards of the *Journal Of Design History* and *Design Issues*; his *Twentieth Century Design* is published by Oxford University Press.

List of Abbreviations

AAD	Archive of Art and Design
BCMI	*Britain Can Make It* exhibition
BIF	British Industries Fair
BT	Board of Trade
Cab	Cabinet Papers
CAI	Council for Art and Industry
CEMA	Council for the Encouragement of Music and the Arts
CIAD	Central Institute of Art and Design
COID	Council of Industrial Design
DIA	Design and Industries Association
DRU	Design Research Unit
MO	Mass Observation
Reco	Reconstruction Committee
SIA	Society of Industrial Artists
T	Treasury
V & A	Victoria & Albert Museum

Preface

This collection of chapters and documents is intended as a working tool for students of the post 1945 period in general and for students of the history of design within that period in particular. As such it is primarily focused on the role of the design process within individual industries and the cultural and political constructions both put upon and absorbed, and occasionally changed, by that process.

Individual industries – textiles, pottery and furniture – are discussed in detailed studies of the changing location and meaning(s) of design in the transition from highly controlled wartime production, with the state determining price and product specifications, to the more liberalized, and eventually essentially market-based, structure that would become characteristic after the immediate reconstruction period. The wider industrial and commercial constraints and the pre-war inheritance, in terms as much of aesthetic debates as of industrial ethos and practice, are the subject of other chapters in this volume and seek to introduce students to a number of key historical problems in the analysis of the trajectory of British design in particular and British industry in general. One of the arguments, which will become apparent from even a brief perusal of the text, is that design can be read neither in isolation nor solely from the 'object' in a quasi-anthropological fashion. Still less can it be read from the stated or assumed intentions of the designer(s) and a focus for a number of the chapters is provided by the politics of design in the post-war period. Whether narrowly conceived as the politics, and political positioning, of design organizations and their propagandists and protagonists, or broadly conceived as the structure, values and discourse of political society, the ramifications and resonances of post-war politics provide an inescapable concern for a number of chapters in this volume.

Given that the overarching consideration has been to open up new perspectives and specifically not to provide the unprovideable, a definitive history, a key component of this work is provided by the historiographical chapters which are intended both to identify specific historical

problems and debates, and to provide students and scholars with the wherewithal to investigate them further. As part of this process it has been considered useful to readdress some of the existing concerns of historians in addition to the identification of further concerns for future exploration.

The second section of this work is even more explicit. The brief biographical notes should identify some of the leading figures concerned and provide material for analysing what might best be viewed as the sociology of particular interest groups and of their class and gender construction. The documents section is intended to indicate to students and scholars the range of material available in relation to what might at first appear to be a relatively small-scale historical event, the *Britain Can Make It* exhibition, together with the complexities of construction and interpretation which necessarily accompany any historical phenomenon. At the same time, the documents are intended to provide some of the historical raw material which may challenge some of the authors' own assumptions. The documents section overwhelmingly comprises material from the Council of Industrial Design (COID) partly because, as the organizing body, it contains considerable material relating to the exhibition and the frequently tortuous debates about the role and location of design in 1940s Britain, but also because such material has hitherto been unavailable to scholars. Historians have been more familiar with state papers, particularly given their centralized and relatively easily accessible nature, such as those of the Board of Trade or the Treasury; with industrial records, particularly those of trade or industrial associations; with individual company records and with the plethora of local records, from newspapers and magazines to the deliberations of Chambers of Commerce or miscellaneous voluntary associations which exist in any locality and can be found in either the local reference library or the local records office. However, the workings of state-sponsored bodies have largely remained opaque, or the subject of largely hagiographical official histories.

The generous decision of the Design Council in 1994 to locate its voluminous archive, both visual and textual, at the Design History Research Centre at the University of Brighton and to allow scholarly access has provided historians with a resource which the editors of this volume believe will allow historians to analyse many aspects of design, politics and popular consumption hitherto largely untouched or confined to studies predicated on almost exclusively theoretical constructs divorced from empirical study. It should be clear that this volume is intended to address, and readdress, a

number of historical problems and to provide a contribution to historical debate. As such it has a particular location and it is intended that future volumes will continue the work of historical reassessment by addressing other historical moments and other historical issues.

Patrick J. Maguire and Jonathan M. Woodham
Design History Research Centre, University of Brighton
May 1997

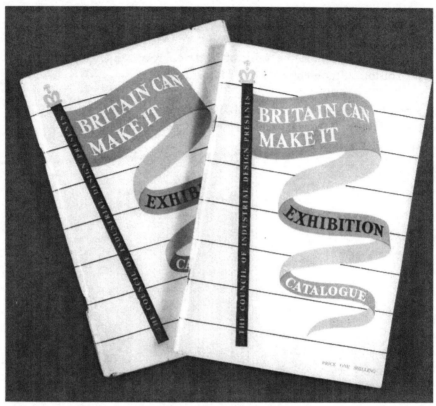

Figure 2 Catalogue of the *Britain Can Make It* exhibition, COID, 1946.

Part 1

LOCATING *BRITAIN CAN MAKE IT*

1 Introduction: Politics and Design in Post-war Britain

Patrick J. Maguire

The chapters in this volume centre around a particular moment in British history, the *Britain Can Make It* exhibition, held shortly after the cessation of hostilities in a climate in which it could well be asked whether or not Britain could indeed make it. The autumn of 1946, while not quite as bleak as the winter of 1947 (the impact of which upon British reconstruction has been well chronicled in Alex Robertson's *The Bleak Midwinter*) was scarcely a moment for untrammelled optimism. While the necessities of domestic politics and the exigencies of peacetime propaganda shielded the public from the full realities of Britain's post-war weakness, a number of the problems which would beset successive administrations were already becoming apparent. In the very moment of victory, the British government had been humiliatingly forced to negotiate a loan from the United States to finance essential purchases. The successive financial crises, detailed in Alex Cairncross's *Years of Recovery*, which would soon produce the even greater political humiliation of enforced devaluation, could not be disguised completely. If problems of industrial performance had long been evident, and an excellent concise introduction to the contentious area is provided by Michael Dintenfass's *The Decline of Industrial Britain 1870–1980*, they had a particular political edge in the immediate aftermath of the war. The desperate search for increased production to pay for the import of essential foodstuffs and raw materials was itself beginning to be subject to the kind of endemic industrial conflicts which were facilitated, but not caused, by the rupturing of wartime labour discipline associated both with the peace itself and with the growing intensity of the Cold War. As labour disputes of the kind enumerated in Robert Taylor's *The Trade Union Question in British Politics* broadened into the more overtly politically-charged conflicts explored in the recent collection of essays edited by Jim Fyrth, *Labour's High Noon*, government found itself more and more enmeshed in a web of propaganda initiatives. Towards the end of Labour's post-war administration the government

increasingly reinforced itself by open and putative resorts to legislative sanction to promote and protect its industrial policies.

If forebodings about the future added to concerns about the present were evident within the public arena they were even more evident within the more private world of policy-makers and politicians. The recent publication of the diaries and memoirs of many of the participants, some well known like Ben Pimlott's magisterially edited *The Second World War Diary of Hugh Dalton* and *The Political Diary of Hugh Dalton* (which present a substantially different picture to the one presented in Dalton's autobiographical *The Fateful Years*); some less well known like the equally magisterially edited work produced by Marguerite Dupree, *Lancashire and Whitehall: The Diary of Sir Raymond Streat*; some largely unknown but influential civil servants like Alex Meynell's *Public Servant, Private Woman*; and some, like Edwin Plowden's *An Industrialist at the Treasury,* by influential individuals almost completely hidden from public scrutiny – all have cast a new light on contemporary perceptions of the immediate post-war period. While considerations of public morale were of considerable import for government, and the wartime state had considerably developed the apparatus for monitoring – and attempting covertly to influence – public opinion(s), much of the initial concerns within government in relation to industrial affairs focused upon questions of industrial relations in general and the impact of the socialization of industry in particular. With Labour's most populist politician, Herbert Morrison, whose career is meticulously explored in Bernard Donoughue and G.W. Jones's *Herbert Morrison: Portrait of a Politician*, deeply involved in developing strategies for popularizing the 'new social order' through his position as Lord President of the Council, with his office, and in particular his secretary E.M. Nicholson, acting as something of an unofficial clearing house for initiatives in this area, Labour sought to address developing criticisms of one of its most prized policies – nationalization. Despite his role as leader of the London County Council and, more specifically, his key contribution to the creation of the London Passenger Transport Authority during his brief tenure as Minister of Transport in MacDonald's second administration, Morrison was well versed less in the intricacies of public ownership than in the complex, and often covert, world of propaganda and press manipulation. This was a field with which he had become intimately familiar through his wartime role as Churchill's Minister of Home Security (and, indeed, it was Morrison who would introduce the system of unattributable weekly lobby briefings). He would also play a formative role in the propaganda extravaganza that would come to be called the Festival of Britain in 1951.

The intricate web of interlocking committees, and the structure of decision-making within the Attlee government is meticulously detailed in Peter Hennessy and Andrew Arends' *Mr Attlee's Engine Room: Cabinet Committee Structure and the Labour Government 1945–1951*, a text which ought to be required reading for all those who seek to equate government policy with ministerial initiative (or personality) in a simple linear fashion. In similar vein, but with a broader historical perspective, Hennessy's *Whitehall* supplies a detailed study of the state apparatus essential to any understanding of the structure of the state apparatus including the function and operation of quangos such as the Council of Industrial Design (COID), upon whose governing body sat representatives of the Ministry of Education, Ministry of Health, Ministry of Supply and the Export Promotions Department, as well as the Board of Trade. Less scholarly, but no less perceptive, studies are provided by the earlier work of Peter Kellner and Lord Crowther-Hunt, *The Civil Servants: An Inquiry into Britain's Ruling Class* and Brian Sedgemore's, *The Secret Constitution: An Analysis of the Political Establishment*.

Irrespective of other considerations, Labour's policies of public ownership ensured that industrial performance would necessarily have a political edge which, largely, had not been the case before 1939. State control of industry, however partial and often ineffective that control might be, ensured state responsibility for industrial success or failure, as would be amply demonstrated in the bitter disputes detonated by the coal crisis of the following spring. While Labour's approach to nationalization is thoroughly examined in D.N. Chester's seminal study, *The Nationalisation of British Industry*, and a somewhat different perspective is provided by William Ashworth's more recent *The State in Business*, of more immediate concern here is the perception, rather than the reality, of industrial performance and industrial development. Successive crises, in particular recurrent crises related to the dollar shortage and American imposed restructuring of the international position of sterling, dogged the government. Nor was government particularly well equipped to engage in the formidably complex world of economic management demanded by its policies. As Alec Cairncross and Nita Watts's *The Economic Section 1939–1961* reveals, even at the macro level economic planning remained at best peripheral and seriously understaffed. Nor were such perceptions confined to later historians as Lionel Robbins's *The Economic Problem in Peace and War*, published in 1947, makes clear. The air of unremitting crisis is well captured in Philip Williams's *The Diary of Hugh Gaitskell 1945–1956* and his biographical study of one of the younger generation of Labour politicians, *Hugh Gaitskell*. A

similarly well-positioned observer was Douglas Jay. While Gaitskell's position at the Ministry of Fuel And Power, and subsequently at the eye of the storm as Minister of State for Economic Affairs at the Treasury, Jay's role as Attlee's secretary and then as Economic Secretary to the Treasury, and his own memoirs, *Change and Fortune*, together provide a considerably drier account of successive internal and external crises.

Not that all crises were of an economic nature, though economic problems and priorities coloured contemporary perceptions to a considerable degree. Labour's vast majority masked, and even facilitated, considerable political tensions within the party (as well as developing tensions and conflicts within the broader labour movement). Most of the personal accounts cited above are concerned with internal politicking almost as much as with external politics. If that was true of those in office and, as Kenneth Harris's biography, *Attlee*, makes clear, issues of leadership were rarely absent from the preoccupations of a number of ministers, it could scarcely be expected that they should be absent from those not burdened with the responsibilities of office. In the later stages of the administration, and after its fall from office, the series of conflicts which would come to be clustered under the heading 'Bevanism' would dominate much of the internal debate of the party although, as John Campbell's *Nye Bevan and the Mirage of British Socialism* amply demonstrates to collapse all internal disputes into a simple and singular category is to do grave disservice to the complexities of the issues involved. Albeit for a period when electoral defeat had both intensified divisions and the freedom to pursue them, the tenor, bitterness and peculiar intensity of many of the conflicts can be sampled, in a highly readable way in Janet Morgan's *The Backbench Diaries of Richard Crossman*. To many politicians, it would seem, the world revolved around Westminster, or at best their own version of metropolitan society. Later historians have often followed the same pattern with even the most complete history of Labour's administration(s), Kenneth Morgan's excellent study, *Labour in Power*, largely organized around parliamentary politics and concerns. Even the more journalistic, but no less rewarding, recent work by Peter Hennessy, *Never Again*, tends to be distinctly metropolitan in orientation. Even where historians have attempted to look less at high politics and more at their background, as with many of the contributors to Nick Tiratsoo's wide-ranging collection of essays, *The Attlee Years*, it proves difficult to escape the preoccupations of policy makers. Studies such as Steven Fielding, Peter Thompson and Nick Tiratsoo's *England Arise: The Labour Party and Popular Politics in 1940s Britain* have concentrated more on putative party initiatives and party policy aspirations rather than on popular politics or popular culture itself. Indeed it would

not be overly stretching the point to say that many historians have uncon-
sciously followed Morrison's dictum, 'Socialism is what the Labour Govern-
ment does.'

Socialism, and the politics of change was not, however, confined to
Westminster or Whitehall. It suffused the period and dominated local as
much as national agendas. Nowhere was that more evident than in the arena
of welfare, which can all too easily be dismissed, as can much of the
reforming zeal of individuals and organizations, as some kind of unworldly
idealism. As three recent histories of the welfare state, Nicholas Timmins's
detailed study *The Five Giants*, Douglas Ashford's *The Emergence of the Welfare
State* and Frank Honigsbaum's *Health, Happiness and Security: The Creation of the
National Health Service*, demonstrate, developing social policies were as much
about economic realism and social pragmatism as they were about ideo-
logical constructs. In part, as has often been pointed out, that is because the
political shift which is so easily, but occasionally misleadingly, equated with
the seismic electoral shock of 1945, had its roots in the 1930s and 1940s. The
economic, as much as the social, irrationality of mass unemployment and a
devout attachment to deflation which had so characterized the 1930s had left
the country not just semi-destitute but ill-prepared for war. As studies like
Kate Nicholas's *The Social Effects of Unemployment in Teesside* have shown, the
impact of mass unemployment deeply affected local politics as well as social
conditions. The removal of productive capacity, machines as much as men
(and, largely, in the context of the 1930s it was men) in industries as diverse
as shipbuilding and coal mining almost achieved terminal significance in
1940. As government would soon discover the impact of industrial derelic-
tion and destruction far outlived the 1930s as workers, of almost any age and
gender, proved remarkably reluctant to enter (or re-enter) industries like coal
mining or cotton textiles which enjoyed a newfound national importance.
In addition they offered, as Barbara Castle soon discovered in her brief foray
into the world of working women at Horrockses mill in Preston, and
recounted in her autobiography, *Fighting All the Way*, some very old-founded
working conditions and dubious prospects of long-term employment secur-
ity. Honed by the experience of war and the enforced collectivism of the
wartime state, the politics of social change proved irresistible. As Paul
Addison recounted in his influential study *The Road to 1945*, it was not just
electoral and party politics which were significantly altered by the experi-
ence of war. If Angus Calder's *The People's War* perhaps over-stresses the
radicalizing impact of what for the British civil population was not quite
the version of total war experienced in Germany or Japan in the latter part
of the war, or the Soviet Union after June 1941, there can be little doubt of

the substantial impact of war-enforced social and economic change. As the collection of essays in H.L. Smith's *War and Social Change: British Society in the Second World War*, clearly demonstrates that impact was broadly felt. In particular areas, as shown by David Thoms's study of the Midlands *War, Industry and Society*, the impact could be all embracing.

Nowhere was wartime collectivism more evident than in the organization of industry. The role of the state had never been greater and the increasingly complex structure of controls and regulatory agencies is well detailed in the official history, W.K. Hancock and M. Gowing's *The British War Economy*, published within four years of the cessation of hostilities. Margaret Gowing's study of industrial change was also significant in the later work, jointly authored with E.L. Hargreaves, *Civil Industry and Trade*, which analysed the impact of war, and war-induced schemes like utility, upon such industries as textiles and furniture. However, it should be remembered that, irrespective of Labour's nationalization policies, most industries after the war would revert to private ownership and it was, therefore, the performance of private industry which most concerned the Labour government in terms of economic performance in general and export performance in particular. As recent studies of various industries such as *Labour Governments and Private Industry: The Experience of 1945–1951* edited by H. Mercer, N. Rollings and J. Tomlinson have shown, the task of effectively directing private industry was a formidable one. Labour output and productivity were particular problems, the latter of which is the subject of Nick Tiratsoo and Jim Tomlinson's study of managerial initiatives in *Industrial Efficiency and State Intervention*. Nor was it solely with export of performance that government was concerned. By 1950, having abandoned many of the controls over private industry derived from the war, the then President of the Board of Trade, Harold Wilson, was seeking ways to politicize questions of consumer protection in the domestic market where suppliers were increasingly taking advantage of their position to peddle inferior goods. Equally, by 1950, questions of consumption and consumer aspirations were beginning, as Morrison would recognize in the aftermath of electoral defeat, to play an influential part in domestic politics. Nonetheless, although it might be somewhat overemphatic to suggest, as Angela Partington does in her challenging essay on 'The Days of the New Look' in another collection edited by Jim Fyrth, *Labour's Promised Land?*, that the late 1940s witnessed a shift from conventional political struggle to cultural struggle for many working class consumers, particularly women. In 1946, however, the state remained central to almost all forms of economic activity and

questions of consumption tended to be dominated not by abundance or affluence but by scarcity and restraint.

It was the industrial future that *Britain Can Make It* was intended to address (and influence) and to address in an optimistic fashion. While subsequent developments might make that optimism seem misplaced, it would be historically illiterate simply to consign such manifestations to the patronizing category of 'misplaced idealism' or 'social reformism' in a fashion reminiscent of Correlli Barnett's attempts to do so for industrial policy by ignoring political realities in his challenging study *The Audit of War* and the much less rigorous *The Lost Victory*.

While subsequent developments may have made the industrial and economic aspirations of 1945 appear ill-founded, they appeared considerably less so at the time. With Germany and Japan defeated and occupied, the Soviet Union and central Europe devastated and increasingly politically and economically isolated, as well as most of Western Europe severely affected by successive invasions, whether by friend or foe, it seemed British manufacturers had only their North American rivals to fear. With the exception of those states which had been neutral the main problem, from the British perspective, was not one of competing with western Europe but one of sustaining it. As Alan Milward's excellent study *The Reconstruction of Western Europe 1945–1951* shows, Western Europe tethered on the brink of total economic collapse in the immediate aftermath of the war and the kind of political tensions explored in Anthony Carew's *Labour under the Marshall Plan* would significantly inform developing reconstruction strategies. There could be no doubt of the American threat. As David Dimbleby and David Reynolds's *Oceans Apart: The Relationship between Britain and America in the Twentieth Century* shows, there had been long-standing tensions in the economic and commercial sphere. John Charmley's *Churchill's Grand Alliance: The Anglo-America Special Relationship 1940–1957* explores in considerable detail American ambitions to dismantle British imperial hegemony, particularly in India, by enforcing the Atlantic Charter's stipulations and Britain's inability to resist such assaults.

In the economic arena, however, there was less immediate cause for concern, and the political machinations of American policy makers were largely hidden behind grandiose rhetoric and official secrecy. Before the war outside a relatively narrow range of industries British and American manufacturers had rarely competed directly.

Indeed, the depression had witnessed a considerable repatriation of American capital and American producers, strenuously protected, concentrated on their domestic market and its neo-colonial hinterland.

Where direct competition occurred, particularly in the burgeoning consumer goods sector, it tended to be masked to a degree by the increasing trans-national structure of American corporate capitalism. Moreover, the initial indications appeared to be that the American government would again retreat into isolationism, if not necessarily to the extent which characterized American politics after Wilson, and American business would be fully absorbed by the kind of re-stocking boom which had followed the First World War. At the same time, while Britain's political classes were largely resigned to Indian independence, British imperial interests, if damaged by war, appeared to offer a degree of economic and political security denied to most competitors. The Second World War had, after all, been even more of an imperial war than the First and, between May 1940 and December 1941, the only forces engaged in action outside the Soviet Union were imperial ones. If the collapse of Empire, through a succession of wars of national liberation, would be spectacular it was largely unforeseen and, as late as 1950, Attlee, himself the product of Edwardian empire, was pondering the possibilities of replacing the Indian Army with an African Army. If the celebrations of victory in 1945 lacked some of the overt jingoism of 1918 and an exhibition like *Britain Can Make It* lacked the overt imperial didactisim of the *British Empire Exhibition* at Wembley, which Harold Wilson vividly recalled visiting in his autobiography *Memoirs: The Making of a Prime Minister 1916–1964*, that was partly the result of official sensitivity to American desires to undermine British imperial economic structures rather than to any assumptions about the inevitability of decolonization.

Although innumerable, and secret, studies had successively and cogently analysed the structural weaknesses of various British industries, analyses which were largely responsible for facilitating the development of interest-group based quangos like the COID, there were also grounds for considerable optimism. Despite the enforced confiscation of a number of technologies, most notably nuclear and jet propulsion, by the United States, a number of technologically-based British industries appeared to possess considerable comparative advantage over their potential competitors. Again, subsequent developments would invalidate original perceptions, but as studies such as David Egerton's *England and the Aeroplane* and Stephen Lavington's *Early British Computers* demonstrate, in 1945 a number of potentially key industries appeared to be well positioned to serve as foci for rapid industrial, economic and technical development. In particular, to contemporaries, it seemed that both that inventiveness and industrial change held the key to future prosperity

and that the rapidity and sophistication of war-induced inventiveness, particularly in fields like electronics properly directed by a benevolent state apparatus, could be equally, and more beneficially, applied to peacetime purposes. To contemporary eyes, therefore, some of what may now appear naive assumptions, or even some of the more outlandish, would-be futuristic exhibits at *Britain Can Make It* (Figures 3 and 4) would have had a potential relevance and resonance which it is all too easy to miss and dismiss.

Not that the climate of the immediate post-war period was one of unalloyed optimism. It is easy to mistake the politics of optimism, and the optimism of politics at particular junctures, for an all pervasive intellectual climate. Just as it would be an error to dismiss contemporary concerns, assumptions and aspirations as somehow invalidated by subsequent developments so it would be erroneous to assume that social (or political, or economic) optimism was equally shared, still less that optimism in one area of endeavour or practice was equally true of all areas. Optimism (or any other construct) is as much a matter of uneven development as any other historical phenomena. All-embracing terms like 'the spirit of the age' conceal much more than they reveal. As an almost contemporary text, Peter Drucker's, *The Future of Industrial Man: A Conservative Approach*, albeit in this

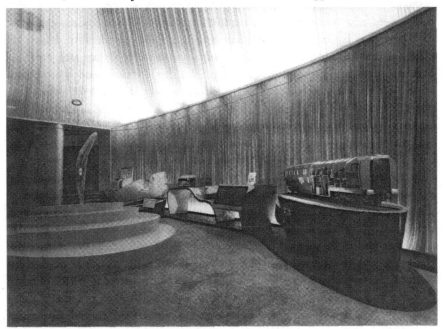

Figure 3 General view, 'The Designer Looks Ahead' Section, BCMI, 1946.

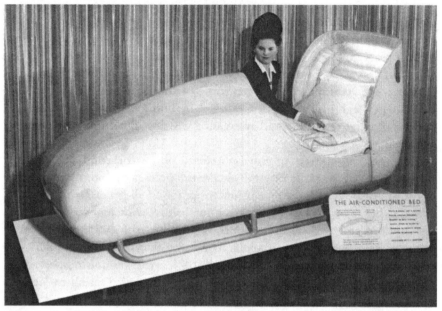

Figure 4 'The Bed of the Future', thermostatically temperature-controlled, designed by F. Ashford, in the 'Designer Looks Ahead' Section, BCMI, 1946.

instance in terms of alleged national characteristics, warned cogently of the dangers of advancing from such generic categories. If domestic political discourse was dominated by matters of reform and regeneration much of elite cultural discourse revolved around questions of decay and decline. Political optimism could all too easily mask deep divisions and intellectuals of the left were as much a prey to disillusion as any. It would be within five years of victory that Richard Crossman's *The God that Failed* charted the personal odysseys of a number of leading literary figures disillusioned with Stalinist Communism, while Robert Hewison's *In Anger: British Culture in the Cold War 1945–60* contains much illuminating material on the developing cultural pessimism of leading British intellectuals. Perhaps most famously, certainly in contemporary elite circles, T.S. Eliot's *Notes Toward a Definition of Culture*, published in 1948, set out the kind of cultural agenda, the alleged debasement of culture, which would dominate much subsequent debate. Concerns about the alleged corrosive effects of commerce upon culture (in the particular sense used in the 1940s and 1950s) were confined neither by political persuasion nor by geographical location or origin as with Theodor Adorno and Max Horkheimer's *The Dialectics of Enlightenment*, originally published in 1947. It offered a rather tortured Marxist (and central European emigré) perspective on the debasement of elite culture by mass (commercial)

culture. In a somewhat different guise, such debates were reflected in the concerns about aesthetic standards and production practices and the deep distrust of commercial imperatives so evident within contemporary design circles.

That alleged conflict between commerce and culture would have particular significance in Britain, where ruling elites, at least from the late nineteenth century onwards, appeared to have distanced themselves in public, if not financial terms, from the world of commerce. A constant tension evident throughout *Britain Can Make It* and other COID ventures would be the allegedly different functions of cultural and commercial undertakings, a conflict not confined to the COID as Frances Donaldson's institutional history *The British Council: The First Fifty Years* indicates. While Martin Wiener's *English Culture and the Decline of the Industrial Spirit, 1850–1980* has been seriously criticized for glaring methodological and empirical deficiencies, the debate which it detonated continues unabated. Recent works, such as W.D. Rubenstein's *Capitalism, Culture, and Decline in Britain*, have added substantially to earlier critiques like the collection of essays edited by Bruce Collins and Keith Robbins under the title *British Culture and Economic Decline* without resolving the argument. While the debate is a complex one, organizations like the COID which blossomed in the restructured post-war state, opaque, to all intents and purposes, to public scrutiny, virtually self-appointing and claiming a public monopoly of cultural production, or at least approbation. It was such organizations which contributed substantially to the rather egregious 1950s concept of 'the establishment' (particularly endorsed by those feeling themselves momentarily excluded from the full fruits of public patronage through state commissioning) so popularized by authors like Noel Annan and Edward Shils. That, however, is to advance somewhat further than is intended in this volume.

The current volume is intended largely as a working tool for those concerned with British society in general, and the changing location and signification of design within that society in particular. As will be evident both from the chapters and the various documents which comprise this volume, it is not a linear story. There is no single text and no single meaning. Historians always need to exercise caution lest they read history backwards and nowhere is this truer than in attempting to deal with the diffuse, and often contradictory, aspirations of ordinary people in moments of transition, and there are few more transitional moments than that following a global holocaust. The structures, histories, aspirations, prejudices, failures and successes of the period cannot simply be interpreted in terms of priorities derived from the mid-1990s. If historians

always tend to ask questions of the past in terms of the preoccupations of the present they should at least remain aware that the past is, indeed, 'a foreign country' and that not only do they do things differently there but that they often do it in a different language according to different moral, political, social and, even, economic priorities and perceptions. If historians in general need to exercise care in examining the immediate post-war period, historians of cultural and social change in particular need to do so. There are some very evident comments which should be registered at this juncture. Just as promoters of particular policies in the economic or industrial performance would need to couch their pleas in the language of economic improvement, enhanced productivity and industrial regeneration, so promoters of social policies would need to couch their proposals in the language of social improvement. Thus, there are conventions of address which are commonly pursued and historians need to take care lest they assume them to be immutable categories. An individual like Gordon Russell, long acquainted with the worlds of designer and mandarin, would slip easily from the apparent 'idealism' of public espousal of state promotion to private disavowal of some of the mechanisms of such promotion as born of socialist excess when the political moment occurred. What is true of individuals is also true of organizations. They can be quirky and contradictory, complex and confused and have very different private and public faces. To some extent, this volume offers a particular set of approaches to one such organization at a very particular and formative moment. To date, much of the history of this particular organization has been a kind of family history, constructed by intellectual relatives from hand-me-down family folklore and highly constructed public addresses. Furthermore, this volume should enable the student to explore a number of other approaches. The same is true of the 'moment', with the significance, or otherwise, explored from a number of different perspectives rather than being presented as an unproblematical and definitive history. Nor is it simply a question of approach. The *Britain Can Make It* exhibition provides the organizational focus of this volume for a number of reasons, not least the 'unpolitical' context within which the politics of design was viewed by contemporaries. Politics and design might appear to make uneasy bedfellows but, like sport and politics, they usually make inescapable ones. However much contemporaries, or subsequent chroniclers, might have wished otherwise, the two were inextricably linked.

References

Addison, P. (1975) *The Road to 1945*, Cape.
Adorno, T. & Horkheimer, M. (1975 reprinted edition) *The Dialectics of Enlightenment*, Verso.
Ashford, D. (1986) *The Emergence of the Welfare State*, Blackwell.
Ashworth, W. (1991) *The State in Business*, Macmillan.
Barnett, C. (1986) *The Audit of War: The Illusion and Reality of Britain as a Great Nation*, Macmillan.
Barnett, C. (1995) *The Lost Victory: British Dreams, British Realities 1945–1950*, Macmillan.
Cairncross, A. (1987) *Years of Recovery*, Methuen.
Cairncross, A. (ed.) (1989) *The Robert Hall Diaries, 1947–1953*, Unwin.
Cairncross, A. & Watts, N. (1989) *The Economic Section 1939–1961: A Study in Economic Advising*, Routledge.
Calder, A. (1969) *The People's War, Britain 1939–1945*, Cape.
Campbell, J. (1987) *Nye Bevan and the Mirage of British Socialism*, Weidenfeld and Nicolson.
Carew, A. (1987) *Labour under the Marshall Plan*, Manchester University Press.
Castle, B. (1993) *Fighting All the Way*, Macmillan.
Charmley, J. (1995) *Churchill's Grand Alliance: The Anglo-American Special Relationship 1940–1957*, Hodder.
Chester, D.N. (1975) *The Nationalisation of British Industry 1945–51*, HMSO.
Collins, B. & Robbins, K. (eds) (1990) *British Culture and Economic Decline*, Weidenfeld and Nicolson.
Crossman, R.H.S. (ed.) (1950) *The God that Failed*, Harper & Row.
Dalton, H. (1957) *The Fateful Years: Memoirs 1931–1945*, Muller.
Dimbleby, D. & Reynolds, D. (1989) *Oceans Apart: The Relationship between Great Britain and America in the Twentieth Century*, Viking Books.
Dintenfass, M. (1992) *The Decline of Industrial Britain 1870–1980*, Routledge.
Donaldson, F. (1984) *The British Council: The First Fifty Years*, Cape.
Donoghue, B. & Jones, G.W. (1973) *Herbert Morrison: Portrait of a Politician*, Weidenfeld and Nicolson.
Dupree, M. (ed.) (1987) *Lancashire and Whitehall: The Diary of Sir Raymond Streat*, Manchester University Press.
Drucker, P. (1943) *The Future of Industrial Man: A Conservative Approach*, Heinemann.
Egerton, D. (1991) *England and the Aeroplane*, Macmillan.
Eliot, T.S. (1948) *Notes Towards a Definition of Culture*, Faber and Faber.
Fielding, S., Thompson, P. & Tiratsoo, N. (1995) *England Arise: The Labour Party and Popular Politics in 1940s Britain*, Manchester University Press.
Fyrth, J. (ed.) (1983) *Labour's High Noon: The Government and the Economy 1945–1951*, Lawrence & Wishart.
Fyrth, J. (ed.) (1995) *Labour's Promised Land: Culture and Society in Labour Britain*, Lawrence & Wishart.
Hancock, W.K. & Gowing, M.M. (1949) *The British War Economy*, HMSO.
Hargreaves, E.L. & Gowing, M.M. (1952) *Civil Industry and Trade*, Longman.
Harris, K. (1982) *Attlee*, Weidenfeld and Nicolson.
Hennessy, P. (1990) *Whitehall*, Fontana.
Hennessy, P. (1992) *Never Again*, Cape.
Hennessy, P. & Arends, A. (1983) *Mr Attlee's Engine Room: Cabinet Committee Structure and the Labour Governments 1945–1951*, Strathclyde University Press.
Hewison, R. (1981) *In Anger: British Culture in the Cold War 1945–1960*, Weidenfeld and Nicolson.
Honigsbaum, F. (1989) *Health, Happiness and Security: The Creation of the National Health Service*, Routledge.
Jay, D.P.T. (1980) *Change and Fortune*, Hutchinson.

Kellner, P. & Crowther Hunt, Lord (1980) *The Civil Servants: An Inquiry into Britain's Ruling Class*, Macdonald.

Lavington, S. (1980) *Early English Computers*, Manchester University Press.

Mercer, H., Rollings, N. & Tomlinson, J. (1992) *Labour Governments and Private Industry: The Experience of 1945–1951*, Edinburgh University Press.

Meynell, A. (1988) *Public Servant, Private Woman*, Gollancz.

Milward, A.S. (1984) *The Reconstruction of Western Europe 1945–1951*, Methuen.

Morgan, J. (ed.) (1981) *The Backbench Diaries of Richard Crossman*, Cape.

Morgan, K.O. (1984) *Labour in Power*, Oxford University Press.

Nicholas, K. (1986) *The Social Effects of Unemployment in Teesside*, Manchester University Press.

Pimlott, B. (1985) *Hugh Dalton*, Cape.

Pimlott, B. (1986) *The Political Diary of Hugh Dalton*, Cape.

Pimlott, B. (1987) *The Second World War Diary of Hugh Dalton*, Cape.

Plowden, E. (1989) *An Industrialist at the Treasury: The Post-war Years*, Andre Deutsch.

Robbins, L. (1947) *The Economic Problem in Peace And War*, Macmillan.

Robertson, A.J. (1987) *The Bleak Midwinter 1947*, Manchester University Press.

Rubenstein, W.D. (1993) *Capitalism, Culture and Decline in Britain 1750–1990*, Routledge.

Sedgemore, B. (1980) *The Secret Constitution: An Analysis of the Political Establishment*, Hodder.

Smith, H.L. (ed.) (1986) *War and Social Change: British Society in the Second World War*, Manchester University Press.

Taylor, R. (1993) *The Trade Union Question in British Politics: Government and Unions Since 1945*, Blackwell.

Thoms, D. (1989) *War, Industry and Society: The Midlands 1939–1945*, Routledge.

Timmins, N. (1995) *The Five Giants: A Biography of the Welfare State*, Collins.

Tiratsoo, N. (ed.) (1991) *The Attlee Years*, Pinter.

Tiratsoo, N. & Tomlinson, J. (1993) *Industrial Efficiency and State Intervention*, Routledge.

Wiener, M. (1981) *English Culture and the Decline of the Industrial Spirit 1850–1980*, Cambridge University Press.

Williams, P.M. (1979) *Hugh Gaitskell*, Cape.

Williams, P.M. (1983) *The Diary of Hugh Gaitskell 1945–1956*, Cape.

Wilson, H. (1986) *Memoirs: The Making of a Prime Minister 1916–1964*, Weidenfeld and Nicolson.

2 *Britain Can Make It* and the History of Design

Jonathan M. Woodham

The history of British design in the twentieth century was for many years predicated on the work of celebrated designers and groupings, together with accounts of the propagandist manoeuvring of design reforming and improving agencies. The latter included the Design and Industries Association (DIA), established in 1915, a privately-funded voluntary organization of aesthetically-minded industrialists, designers, educators and writers modelled on the lines of the much more influential Deutscher Werkbund which had been founded in Germany eight years earlier.[1] British State-funded bodies such as the Council for Art and Industry (CAI), established under the Board of Trade in late 1933, and the more widely-known Council of Industrial Design (COID), founded in 1944 (reformulated as the Design Council in 1972), again under the aegis of the Board of Trade, also tended to dominate early historical accounts of design activity in Britain. Perhaps inevitably, many of the earlier histories of British design tended to follow (and update, with a particular British inflection) the model of Nikolaus Pevsner's *Pioneers of the Modern Movement* (1936).[2] This traced the origins of modernism from the morally didactic standpoint of nineteenth century design reform propagandists, such as A.W.N. Pugin, John Ruskin and William Morris, to the supposed reconciliation of the Arts and Crafts philosophy of truth to materials and honesty and propriety of construction with the social, economic and industrial realities of mass-production as exemplified by the more progressive forces of the German Werkbund. Texts such as Noel Carrington's *Industrial Design in Britain* (1976)[3] are thinly disguised histories of design organizations; in the particular instance of Carrington's text, deeply coloured not only by the author's deep involvement with the DIA, including a spell as editor of its magazine *DIA Quarterly* and chronicler of an early chapter in its history.[4] Similarly, Fiona MacCarthy's *All Things Bright and Beautiful: Design in Britain 1830 to Today* (1972)[5] followed a similar narrative of design reform, drawing on the history of the DIA, the CAI, the wartime Utility programme and the 'design-improving' values for which it

stood, the 'Good Design' ethos of the COID and the modernizing outlook of many figures of the British design establishment. As was remarked of histories of British design by Anthony Coulson in his pioneering *Bibliography of Design in Britain 1851–1970* [6], 'studies ranging over the whole period are still very patchy as so much research is needed to create a firm basis for an authoritative study'.[7] He also went on to suggest that 'prolonged study of some of the longer-established journals is still the best general introduction to the general history of the period'. While such advice was perhaps appropriate at a time when there were few authoritative published studies in the field, its take-up almost inevitably resulted in a portrayal of British design which reinforced the apparent dominance of reforming organizations and the design process at the expense of an understanding of the sociology of design consumption, underlying economic and industrial implications. Periodicals such as the *Architectural Review* (1897–), the *Studio* (1893–1964),[8] *Design for Today* (1933–36), *Art and Industry* (1936–58)[9] and *Design* (1949–94)[10] generally provided the material out of which a modernist outlook was examined. Other later texts such as Richard Stewart's *Design and British Industry* (1987)[11] related a similar organizationally-dominant standpoint, while Woodham's brief study *The Industrial Designer and the Public* (1983)[12] attempted to open up a number of broader issues, drawing upon a wider range of historical sources and interests, but ultimately tended to emphasize organizations at the expense of a thorough analysis of public attitudes and behaviour.

Such publications, which were specifically aimed at (the establishment of) a mainstream design historical audience, should not be seen as fully reflective of the sharper edge of design historical research which was, by the 1980s, broaching wider issues of the social, economic, political and technological location of design alongside other methodological and ideological concerns such as studies in consumption, gender and changing approaches to museology. Nonetheless, there has been an implicit assumption among many working in the field that the historical intricacies and significance of design organizations have already been explored in sufficient depth, given the tendency of what might be termed 'first generation' historians of design to focus on their outward workings and supposed import. Unsurprisingly, the greatest attention has been paid to those organizations which devoted considerable energies to publicly document and propagandize their achievements and arguments in easily retrievable forms. However, a number of more recent conferences[13] and publications[14] have suggested that the picture which such restricted, often secondary, sources portrays is in fact far more complex and revealing under the surface; also that the historical agenda remains firmly open as an increasing range of archival[15] and

prime documentary sources are brought into play which allow for a (re)-appraisal of the ways in which the state, manufacturing industry, retailers and consumers have impacted upon design, and vice versa. This volume is intended to open up afresh a number of these debates with particular relation to the *Britain Can Make It* exhibition.

The historiography of the *Britain Can Make It* exhibition, 1946

One of the most common views put across in accounts of the 1946 *Britain Can Make It* exhibition is that it was 'successful', a fact supposedly demonstrated by the vast numbers of the general public who visited it.[16] The COID itself was at pains to stress such a view in its *Annual Report 1946/47*, no doubt to remind its paymasters at the Board of Trade and the Treasury of its potentially significant role in the difficult economic climate of the immediate post-war years. (The actual position was rather more complex than this as is discussed later in this volume, see Chapters 3 and 8.) The COID in its official report claimed that the total attendance of 1,432,546 at BCMI was about three to four times higher than had been originally intended, with the pressure of visitors in the first five to six weeks being about 60 per cent higher, thus necessitating an extension of the show's duration from the end of October to the end of November, and again to the end of the year. This equation of number of visitors with 'success' was followed by Farr,[17] MacCarthy,[18] Carrington,[19] Woodham,[20] Stewart[21] and others. In fact, the attendance was very much in line with what the COID had anticipated in its 22 August 1945 proposal to the President of the Board of Trade on *The British Exhibition of 1946*. There it was suggested that the show might 'draw in three months anything from three quarters of a million to a million and a half – conceivably more'.[22] Many of the historical accounts, in line with the COID's *Annual Report*, fall in line with the simplistic view that notions of 'good design' and economic potency are inextricably linked, by laying stress on the number of trade visitors (estimated at 43,000) and trade buyers (7,000 from more than 67 countries) who, according to unofficial estimates, generated orders which were put between £25 million and £50 million.[23] In fact, the reception for trade buyers was highly unsatisfactory in the early stages of the exhibition's life, due to the fact that, in the opinion of the COID's Director, S.C. Leslie, trade buyers from home and overseas 'refused to accept the idea of the exhibition as something different from a trade fair and to adopt the intended procedure of using the catalogue to get

in touch with firms in whose products they were interested'.[24] Clearly, the COID had placed greater stress on its propagandist message than any immediate hope of realizing its economic impact, although it swiftly made *ad hoc* provision to ameliorate arrangements for trade visitors. The position was not helped by the fact that the production of the catalogue was delayed by a dispute in the printing trade and initially could only be produced in limited quantities by a Salvation Army press in St. Albans.

None of the mainstream historical accounts of BCMI really exude the full flavour of the intensely hurried manner in which the exhibition was actually put together, the constant reshaping of plans, adjustment of finan-cial projections, even the design of the COID's own stand by Milner Gray (Figures 5 and 6). For example, only eight days before the opening Leslie wrote to Gray about Eric Fraser's sketch for the stand portraying 'The Public', suggesting that:

> If it is not too late, I wish Fraser could think again about the sketches of the public. We are all agreed that such a very stylised and, if I may say so, rather unappetising treatment of the very group at whom the whole exhibition is directed may strike an unfortunate note. Would the twin causes of design and display really suffer if we kept a little nearer to John and Mrs Citizen as they like to think of themselves?[25]

Figure 5 Council of Industrial Design stand at BCMI, designed by Milner Gray of the Design Research Unit, in collaboration with Bronek Katz, with paper sculptures to the original design of Milner Gray and Eric Fraser by T. Lipski.

Figure 6 Paper sculptures for the Council of Industrial Design stand at BCMI to the original design of Milner Gray and Eric Fraser by T. Lipski.

Autobiographical accounts are not especially renowned for accurate versions of events which have taken place some decades earlier, particularly in the case of the colourful account of his own early life by James Gardner, BCMI's Chief Designer (Figure 7). Nonetheless, in his 1983 autobiography *Elephants in the Attic* [26] something of the flavour of the at times idiosyncratic organization of the exhibition comes through, even if elements are apocryphal. He spoke of meeting Stafford Cripps, President of the Board of Trade: 'Articulating with the conciseness one would expect from a KC, Cripps told me I must design a setting which would give the public a lift even if we got no goods at all ...' [27] He went on to say:

> How to design a show which will look complete in every detail even if we don't get exhibits? I concocted a new kind of layout plan. Instead of presenting the goods to the eye as one would in an open market – and that is what exhibitions have evolved from – I tucked them round corners, behind screens, and in little enclaves, so at first the visitor would see lots of 'decor' but no goods at all – wouldn't even notice if there were no goods at all. [28] (Figure 8)

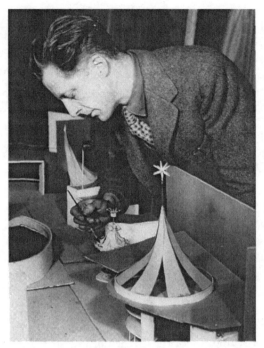

Figure 7 James Gardner touching up models for the BCMI exhibition, 1946.

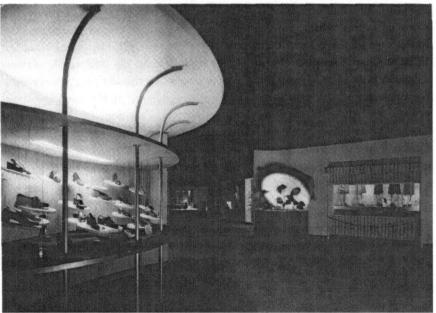

Figure 8 General view of Shopwindow Street at the BCMI.

Gordon Russell, in his rather more measured autobiography *A Designer's Trade*, (1968) acknowledged far more openly the realities of staging an exhibition in a hurry. As he wrote:

> A major snag was that the exhibition had to be got together at short notice and as most firms were then turning over from war to peacetime production and materials were in short supply no one had a clear idea of what well-designed articles might be available in a year's time. Under these conditions it was decided that the wisest thing to do would be to stress light-hearted, gay décor and display so that, if the worst came to the worst and in some sections should prove impossible to find more than a handful of exhibits, the show would not be a flop.[29]

Perhaps the most significant text relating to BCMI in recent years was *Did Britain Make It? British Design in Context* edited by Penny Sparke[30] to commemorate the fortieth anniversary of the original show. However, the aim of Sparke's collection of essays was not concerned merely with an historical account of the 1946 exhibition; it examined the changes that had taken place in British design over the succeeding 40 years, as well as a number of wider social, economic and cultural developments. The essays dealt with a number of themes including exhibition design (including an interview of James Gardner, the principal designer at BCMI), design promotion (with an interview with Paul Reilly, later Director of the COID from 1960–72), the role of the professional designer, and an historical overview of design in British industry (with contributions by historians and designers), retailers, and the public. Penny Sparke concluded the book with the following observation:

> The naivety of the ideals expressed in 1946 was both its strength and its weakness. What must be tackled now is a re-assertion of those aims, this time presented within a more sophisticated understanding of the structures upon which they depend. 1986 might well be the year to repeat the claim that Britain *Can* Make It.[31]

While the first sentence of Sparke's conclusion was certainly true, in hindsight it is rather less clear that the underpinning social idealism of those concerned with the mounting of BCMI was realistically able to be translated in the 'design for profit' ethos of Mrs Thatcher's Britain. What does remain clear from the 1986 reassessment of the exhibition was that there still remained a great deal of untapped information which had not yet been brought into a thorough analysis of design in Britain in the post-war years, whether in papers lodged at the Public Record Office at Kew, the Archive of Art & Design at Olympia, the Mass Observation Archive at the University of Sussex or the Design Council Archive at the University of Brighton. All contain rich veins of historically significant material which inform the

climate of design in British industry, its marketing and consumption. Fifty years on from BCMI, is perhaps an appropriate moment at which to begin to reconsider design promotion from a point of view other than that largely coloured by mutually reinforcing sources of propagandist reports, articles and texts.

Notes

1. The Deutscher Werkbund, along with the modernist outlook, effective propaganda and leftist politics of the Bauhaus, played a significant role in the shaping of early histories of twentieth century design in Germany.
2. Pevsner, N. (1936) *Pioneers of the Modern Movement*, Faber and Faber, later revised and expanded as *Pioneers of Modern Design* in various editions from 1949 onwards.
3. Carrington, N. (1976) *Industrial Design in Britain*, Allen & Unwin.
4. Carrington, N. (1975) 'The Last 10 Years 1925–1935' in *Design Action – DIA Yearbook 1975*, Diamond Jubilee of the Design and Industries Association.
5. This was subsequently revised in 1979 as *A History of British Design 1830–Today*, Allen & Unwin.
6. Coulson, A.J. (1979) *Bibliography of Design in Britain 1851–1970*, Design Council.
7. Ibid., p. 59.
8. It became *Studio International* from 1965.
9. Originally entitled *Commercial Art and Industry* (1927–35) and later *Design for Industry* (1959) when it ceased publication.
10. The mouthpiece of the Council of Industrial Design, later Design Council.
11. Stewart, R. (1987) *Design and British Industry*, John Murray.
12. Woodham, J. (1983) *The Industrial Designer and the Public*, Pembridge.
13. Such events have included *Design and Reconstruction* at the Victoria & Albert Museum, November, 1994, *Utility Reassessed–Design Utopia or Strategy?*, at Winchester School of Art, July, 1994, and *Design, Industry and Government Initiatives – Past, Present and Future*, November, 1995, at the University of Brighton.
14. These include recent essays in the *Journal of Design History*: Maguire, P.J. (1993) 'Craft Capitalism and the Projection of British Industry in the 1950s and 1960s', vol. 6, no. 1, pp. 97–113 and 'Designs on Reconstruction: British Business, Market Structures and the Role of Design in Post-War Recovery', vol. 4, no. 1, pp. 15–30, Woodham, J.M. (1997) 'Managing British Design Reform I: Fresh Perspectives on the Early Years of the Council of Industrial Design', vol. 9, no. 1, pp. 55–65 and 'Managing British Design Reform II: the Film *Deadly Lampshade* – An Ill-Fated Episode in the Politics of 'Good Taste', vol. 9, no. 2, pp. 101–15.
15. These include the Modern Records Centre at the University of Warwick, the Public Record Office, Kew, the National Art Library's Archive of Art & Design at Olympia, and the Design Council Archive at the Design History Research Centre, University of Brighton.
16. A more complex picture in relation to the Mass Observation analysis of visitors to the 1946 exhibition is discussed in Chapter 4 of this volume, 'The Politics of Persuasion: State, Industry and Good Design at the *Britain Can Make It* Exhibition'.
17. Farr, M. (1963) *Gran Premio Internazionale: La Rinascente Compasso d'Oro 1959, Council of Industrial Design 1959*, Milan, p. 24.

18. MacCarthy, F. (1972) *All Things Bright and Beautiful: Design in Britain*, Allen & Unwin, p. 145.
19. Carrington, N. (1976) p. 172.
20. Woodham, J. 'Design Promotion 1946 and After' in Sparke, P. (ed.) (1986) *Did Britain Make It? British Design in Context 1946–86*, Design Council, p. 25.
21. Sparke, P. (ed.) (1986) p. 88.
22. Paragraph 20, Document 20 in *Summer Exhibition 1946*, ID/312, DHRC Archive, University of Brighton.
23. *Journal of the Royal Society of Artists* (1947), 'Britain Can Make It', 17 January, pp. 148–9.
24. Report by the Director to the Meeting of the Council [of Industrial Design] on 11 October, 1946, BT/60/23/4 at the PRO, Kew, London.
25. Note by C.R. Leslie to Milner Gray on 16 September, 1946, *The Council's Display*, C729/14/A.
26. Gardner, J. (1983) *Elephants in the Attic*, Orbis.
27. Ibid., p. 47.
28. Ibid., p. 49.
29. Russell, G. (1968) *Designer's Trade: Autobiography of Gordon Russell*, Allen & Unwin, pp. 231–32.
30. Sparke, P. (ed.) (1986).
31. Ibid., p. 167.

Part 2

CULTURAL PROPAGANDA AND INDUSTRIAL REALISM

3 Patriotism, Politics and Production

Patrick J. Maguire

In October 1942, shortly before the battle of El Alamein, German armies were at the zenith of their territorial control in the Soviet Union, not long before their bloody defeat at Stalingrad, and Japanese forces, despite the reverse of Midway, were entrenched in Asia and the Pacific. At this particular moment a sub-committee of the British Cabinet, the Post War Export Trade Committee, decided to recommend that an exhibition be held as soon as possible after the war to demonstrate to the world 'goods which this country was in a position to export'. The Minister responsible, Harcourt Johnstone, who owed his position less to any particular claim to competence than to Churchill's patronage and shared sybaritic indulgences, considered that Britain 'should show the world the extent to which British industry had recovered from the war and was in a position to supply the goods needed abroad'. In part the perceived urgency of the task was fuelled by the belief, not wholly unsubstantiated, that the United States government was utilizing the exigencies of war in general and the legalities of lend-lease in particular to promote its own export trade; it was also encouraging its exporters, particularly in rapidly developing markets like Latin America, 'to stay tuned up'. In the briefing paper supplied to the committee, the same committee which would be responsible for instigating the Council of Industrial Design (COID), it was stressed that the putative exhibition would be 'almost wholly designed to attract to this country overseas buyers and tourists'.[1] The result of these deliberations was the establishment of a further committee to examine the matter in some detail and a succession of papers promoting the desirability of instituting a post-war national showcase. By April of the following year the sub-committee on exhibitions and fairs had reported in favour of an exhibition, to be staged in London, which would be 'mainly cultural and social in character'.[2] In the course of time this would be transmuted into the *Britain Can Make It* (BCMI) exhibition, although in the hands, or rather the heads, of the COID much of its original commercial purpose and would-be purchasing clientele was denied in favour of a more domestically didactic venture. Those particular tensions are properly

the subject of other considerations. Of more immediate relevance is the manner in which such economic and commercial considerations had penetrated government deliberations even during some of the bleakest moments of the war.

To some extent, the reasons for such thinking are buried in the history of the war itself and in what was taken to be the history of the previous conflict. The early stages of the war, particularly but not exclusively after the fall of France, had demonstrated British industrial and financial weakness. Without American assistance not only could the war not be won, it could not even be fought. British dependence on American credit, in all senses of the term, was starkly demonstrated to those in office, even if it was largely hidden behind a veil of patriotic and imperial propaganda from a public sustained by belief in British virtues and British doggedness dependent, largely, on an officially endorsed construction of history. Moreover, if the experience of war did not entirely demonstrate industrial decrepitude in the manner almost caricatured by Correlli Barnett's *The Audit of War* and the substantially more strident *The Lost Victory*, it scarcely gave any grounds for industrial complacency.[3] The kind of structural weaknesses apparent in much of British industry in the inter-war period – the chronic lack of investment, the plethora of small-scale producers, the almost total absence of marketing skills and strategies, the outdated technology and distrust of formal education, the myriad market structures and stress on marginal product differentiation – were even more dangerously displayed in the opening stages of the conflict, when sustaining British exports was a *sine qua non* of government financial calculations. As American involvement in financing the war effort deepened and finally dominated Allied strategies, attention necessarily turned to the likely post-war situation. To the generation of policy-makers in power during the war the experience of the First World War and its immediate aftermath was inescapable and deeply informed much of their thinking. As a result of any victory, to that generation it seemed clear both that little hope could be held of the defeated being made to pay for the war and even less hope that the United States would not exploit its position to further its own commercial and financial interests, concerns which had often directly clashed with British ones in the inter-war period. Indeed it was soon evident that a vociferous lobby within the United States was seeking to press home the advantages bestowed by American power to dismantle Britain's global structure of commercial interests, hitherto promoted through the mechanisms of imperial tariff structures.[4]

As the war progressed the various investigations of individual industries

launched by government agencies gave scant grounds for optimism. The perceived key to British industrial regeneration lay in the recapturing and development of export markets. Without dynamic growth in this sector all other aspects of government policy, of whatever political persuasion, were doomed to failure as the war itself ensured an increased dependency on imports, particularly from North America. As an internal memorandum warned in March 1942:

> If United Kingdom industry can face satisfactorily its export problems and produce more cheaply and efficiently, then our other problems can be solved. If, however, United Kingdom industry drops out as a world competitor then our other problems are insoluble.[5]

Such warnings were repeated with considerable force throughout the rest of the war. The war itself exacerbated the relative weakness of British producers since, although it could be expected that the cessation of hostilities would be followed by a re-stocking boom similar to that which had dominated industrial activity in 1919 and 1920, and while key competitors like Germany and Japan, who had posed a growing threat to British exporters in the inter-war period, could be expected to be temporarily absent from the world stage, manufacturers in the United States could be expected to have benefited from their wartime position in a way which did not apply elsewhere. The resources poured into the American war economy, partly paid for by British purchases, allowed American manufacturers considerable opportunity for investment in new plant, new technology and new production strategies. As a report on the prospects for the British motor industry warned: 'unless vigorous action is taken we can scarcely hope for more than a return to our pre-war share of world trade. Even this may be difficult.'[6]

The reasons for such pessimism included the number of small-scale units of production producing a multiplicity of models which resulted in higher unit costs. Furthermore, despite lower wage rates in the United Kingdom, the virtual absence of standardization resulted in substantially higher material costs, and there was a poor standard of sales and service organizations. Observations of a similar kind were recorded for almost every industry examined but whereas an industry like pottery or cotton textiles might be deemed to be suffering from the legacy of nineteenth-century industrialization, motor vehicle manufacture was not just a 'new' industry but one widely considered to have been a successful exponent of 'modern' production techniques in the 1930s. If the prospects for a 'new' industry were considered poor, then those for the 'old' industries which had been economically battered in the inter-war period could scarcely be considered to hold out

any prospect for national revival. Moreover, the longer the war progressed the greater the problem became. As the demands of the Alliance dictated greater and greater British concentration on war production, to the extent that a higher percentage of the population was engaged in war-related activities by April 1941 than had been the case at any stage during the First World War, by 1945 it was officially calculated that some nine million individuals were either in the armed services or directly producing for them – against a 1939 total of about one and a half million. So British manufacturers' experience of the demands of peacetime production lagged further and further behind that of their American counterparts.[7] Again, the case of the motor industry would be instructive with the government being warned as early as September 1943 that British designs were lagging behind American ones and even colonial markets:

> will be reluctant to accept commercial vehicles. Only the best and latest of designs will be able to compete in these markets against home-produced products and against American designs which are already at least two years ahead of current British development.[8]

It would be the late 1940s before any new models specifically designed for volume production became available.[9] Nor was it solely a question of design. By April 1945 it appeared that:

> American producers had reached a high degree of standardisation – especially of components – and this feature was almost wholly lacking in the British industry. Without it, it would be very difficult to complete with the Americans in the world market.[10]

Nor could it be expected that the situation resolve itself, that manufacturers would respond to the competitive pressure of the international market place and seize, or be compelled to seize the opportunity to adopt new techniques and new strategies. On the contrary, the analysis of the motor industry indicated that manufacturers would be more than content to look to state assistance in protecting their domestic and imperial markets. To an extent, the motor industry offered an almost ironic commentary on the impact of war upon manufacturing industry; it had been the First World War which had witnessed the introduction of the motor vehicle taxation structure which so inclined British manufacturers to the production of low horse-power vehicles, largely unsuitable for world markets – even colonial ones – and so discriminated against American manufacturers in particular. That form of fiscal protectionism had been increased in the 1930s to the extent

that between 1927–37 the proportion of vehicles with a capacity lower than ten horse power had increased from 27 to 60 per cent and by 1937 only around 20 per cent of production was exported, and that overwhelmingly to the Empire.[11] A similar story could be told of most British industries with the effect that, as a briefing paper on the motor industry noted, 'the whole outlook of the trade must be re-orientated towards exports. There is no evidence that the industry will do this of its own free will.'[12] It seemed that even the prospect of markets more or less assured in the immediate post-war period by, at least the global dollar shortage and the pent-up demand in the American economy, was insufficient incentive since:

> Manufacturers at present show little sign that they intend, after the war, to produce one or two models on a large scale, in the expectation that a demand will mature great enough to absorb them; nor does it seem that they propose to treat the export market as more than an accessory to their assured home market.[13]

As the prospect of victory increased so too did concerns about the shape of the post-war world in economic as well as political terms. American desires to structure post-war international financial and commercial relations through such mechanisms as the Bretton Woods Agreement, the General Agreement on Tariffs and Trade, the International Monetary Fund and the World Bank may well have been motivated by a desire to avoid the kind of financial and commercial anarchy which had so bedevilled international political and trading relations in the inter-war period, particularly in the 1930s. Many contemporary observers believed this to have been one of the principle ingredients in the rise of fascism, but it also rubbed up against perceived British self-interest. At the Board of Trade, Hugh Dalton, soon to be Labour's Chancellor, fought a bitter rearguard action against what he, and his officials, regarded as American efforts to undermine British fiscal sovereignty, warning that 'we must be free to defend our balance of pay-ments . . . to any extent necessary'.[14] In the immediate post-war period such concerns would rapidly surface in the negotiations surrounding the terms attached to the American loan, particularly that applying to the interna-tional status of sterling, which the sudden cessation of lend-lease necessi-tated. Nor were such concerns confined to the overtly political classes. To the Birmingham Chamber of Commerce, whose members had been experi-encing the realities of international competition since at least the last third of the nineteenth century, imperial preference was not just a product of the type of popular imperialism espoused by Joseph Chamberlain but 'a tangible asset' which could not easily be disregarded.[15] Nor should the strain of anti-Americanism, which was not merely confined to the British intelligentsia,

be discounted, particularly when it could be attached to the kind of imperial sentiments which had been so carefully cultivated during the preceding half century or so, and which had been reinforced by the war which itself had featured imperial forces to a considerably greater extent than the First World War. To a member of the Gosforth Co-operative Party, a political configuration not normally associated with rabid imperialism, it clearly seemed that American power had gone too far in the immediate post-war world and that the key question was 'why should we deal with the USA when we have our own Colonies'.[16] The speaker to whom the question was addressed believed that the government would be only too pleased to do so but the real answer is starkly revealed in the minute books with members increasingly beseeched to supply items like sugar for meetings and social events.

By that stage Britain's economic weakness had become domestically evident in the extension of rationing to a level even greater than had occurred during the war. In order to protect the supply of essential imports constant effort was required to sustain, and expand, the level of exports. Dollar-earning markets for exports were particularly needed but, unlike the position which existed within the sterling area and much of Europe, these markets would be in direct competition with American manufactures. To British policy-makers this was not an appealing prospect as they believed, partly from their enforced wartime collaboration with the United States, partly from American propaganda and partly from the reports beginning to be disseminated from the various missions dispatched on highly controlled visits of American production facilities, that the United States had now entered a new, and scarcely challengeable, stage of industrial development. The tenor of contemporary reports is indicated by the third report of the Anglo-American Council on Productivity, produced in 1944:

> We were greatly impressed by the enthusiasm for high productivity and low cost displayed at every level in American industry. . . . No saving in cost or improvement in productivity is too small to be considered. . . . In most of the plants we visited the layout was excellent and every detail of the process had been studied to secure maximum output of the plant and labour force with minimum human effort. The careful planning of operations to secure flow and balance in the way in which components from outside were fed into the production line bore frequent testimony to excellent production control.[17]

American management theory, American production methods, American marketing skills, American productivity and the alleged *élan* of the American industrial system dominated contemporary thinking in forms which

would soon be institutionalized through bodies like the Anglo-American productivity council. From this perspective it seemed that the only hope for national survival lay in the fastest possible adoption of much of the American system. Thus it could be argued that:

> Unless we can get ahead of the other fellows in the efficiency (and if possible the novelty) of our designs for machine-made goods, we shall be competing on a price base pure and simple; and there we may well be at a disadvantage and are most unlikely to be at an advantage ... something like an industrial revolution has taken place in the United States in the last 15 years – a revolution in industrial design. It has made our exports old-fashioned and less acceptable. It is not by accident but by prevision and provision, that there – and in Sweden, Czechoslovakia and Germany before the war – the design of machine-made goods has achieved a wholly new importance.[18]

That message would be repeated by successive reports, both public and private, as the reality of relative industrial impoverishment began to be felt. As another Board of Trade memorandum put it in 1944: 'If we achieve the American standard of efficiency we can, on British wages, look to the future with some confidence. But if we fail we cannot.'[19] Nor were such deliberations confined to official circles. *The Economist* publicly musing in June 1943 on the prospects for British industry considered that: 'If, in the struggle to pay for imports, wages and living standards in the export industries are not to be dragged down to the Continental level, then efficiency must be raised to the American level.'[20]

As the future became the present, the problems intensified. The scale of the problems may be indicated by the position of the British pottery industry which by 1947 was facing a situation in which American output per worker was twice that of the British. This enabled American manufacturers, despite considerably higher wage rates, to price their wares some 25 per cent lower than their British equivalents, and this for an industry which had recorded its highest level of exports since 1925 in 1941.[21] Such crippling gaps in performance were not confined to the older industries alone. In the production of radio sets, for example, it was estimated that American productivity, as measured in output per worker per hour, was four times greater; in motor vehicles it was estimated as three times greater; in cotton textiles almost twice as great; in woollen textiles and in iron and steel production at one and a half times the British level. Only in the cement industry did productivity levels appear roughly equal.[22]

The division of wartime labour between the allies disguised such imbalances. Indeed, the exigencies of war demanded that British productive

efforts be eulogized and newsreels and newspapers were full of reports of the heroic deeds of the factory front which, if they did not quite match their Stakhanovite Soviet equivalent, presented a picture of continuously rising output married to alleged inherent inventiveness and innovation. Nor did the dictates of war permit any public discussion of post-war competition with wartime allies or any suggestion of divergent national interests. Peace would bring with it different priorities and different prospects. Indeed the immediate problems would be exacerbated by the relative unpreparedness of the British government either for the suddenness of the Japanese surrender which, as late as January 1945, had officially not been expected to occur before 1946, and possibly not until 1947, if German resistance continued until late in 1945 or for the complete termination of lend-lease which immediately followed that surrender.[23] The British government, now a Labour administration committed to widespread domestic reform, found itself in immediate financial difficulties. It also found itself faced with substantial political difficulties. On the one hand the price of renewed American assistance was the relatively speedy dismantlement of much of the apparatus of protection which had so cushioned British manufacturers before the war. On the other, the dismantlement of protection, and the erosion of empire, would expose British manufacturers to the full force of American competition which they were so ill-equipped to meet. At the same time the emerging American commitment to a particular version of (Western) European economic recovery would also erode the degree of informal protection provided to British manufacturers by the dollar shortage. In real terms the government had little choice but to accept American assistance with all that it implied, particularly the commitment to making sterling convertible, while resisting as far as possible American desires, such as European integration, which had not been formally agreed. Moreover, the political position was exacerbated by the difficulty in explaining how victory could so rapidly be followed by dependence and by the extent to which manifest economic weaknesses would be attributed by the administration's opponents, at home and overseas, to its ambitious programme of domestic renewal and industrial direction.

The Labour government found itself in a predicament and had little alternative but to make a virtue out of its distance from both Soviet communism and American capitalism. Even here, however, there were potential and actual difficulties. Whatever the reality, the new social order of Labour placed considerable stress on the role of the state in planning and directing the economy to deliver social, as well as economic, benefits. In stressing the role of the state, however underdeveloped planning may have been and

however ineffective many of the peacetime controls inherited by govern-
ment may have been, Labour necessarily placed government at the centre of
popular perceptions of economic responsibility. As *Picture Post*, the mass
circulation magazine which consistently pursued a populist radical editorial
line, saw it in May 1946:

> The character of industry is changing, 'shareholders' replace 'owners', manufacturers
> combine instead of competing, and the State intervenes to ensure full employment.
> And Britain has decided – that was the meaning of the General Election last year –
> to provide for those changes by imaginative planning and bold action, rather than
> by returning to the conditions of 1939 and hoping for the best.[24]

Whatever the intention, therefore, the incoming Labour administration
politicized economic performance in a manner which would come to haunt
successive governments in the next three decades. Moreover, it did so in a
fashion which, through its commitment to full employment and its parti-
cular relationship with the trade union movement allegedly removed many
of the incentives to economic efficiency which had, it was claimed, moti-
vated both workers and employers in the past. And it did so without
replacing those incentives with the kind of labour discipline and motivation
characteristic of the soviet regime but with a mixed economy of large scale
nationalized industries, largely confined to public utilities and public ser-
vices and private industry debilitated by six years of war. To that extent,
Labour's most obvious economic commitment, public ownership, was not
dictated by the immediate post-war crisis and could, therefore, be repre-
sented as at best irrelevant and at worst counter-productive. The *Economist*,
which throughout the war had championed the modernization of industry,
in comparing unfavourably the approach of British workers to that of their
American and Soviet counterparts, viewed it thus in July 1946:

> The British worker tends to be betwixt and between. The old reliance on free private
> enterprise and pride in the achievements of British industry have been largely talked
> out of him, while the planners have not yet offered him any convincing alternative.[25]

Indeed, in reality there were very few planners to offer alternatives, whether
convincing or not. In the absence of a fully centralized economic structure,
or even a central planning staff, the government relied on a rough and
ready cocktail of controls, often acting in profound ignorance, in an attempt
to prioritize particular areas of production and particular markets for that
production. With economic problems, verging on perennial crises, domi-
nating government thinking, the sheer volume of exports, particularly to

dollar earning areas, took precedence over all other considerations in the field of economic policy making.

The extent of Britain's dependence on foreign support is difficult to underestimate. By July, in the midst of the convertibility crisis, the Ministry of Food, the Board of Trade and other departments under Treasury auspices were drawing up secret contingency plans to be enacted in the absence of continued American support under the putative Marshall Aid programme. The plans envisaged, among other measures such as the direction of labour, was the institution of a 'famine food programme, cutting the lowest wartime ration by almost one third'. [26] In this situation individual markets could be crucial to survival. By March 1948, for example, Canadian supplies accounted for two thirds of the bread ration (bread had not been rationed until May 1946), half the bacon ration (which itself had been halved in October 1947), one quarter of the egg ration and one fifth of the cheese ration, with total food imports from Canada expected to exceed £100,000,000 per year. Not surprisingly, the government was eager to stress the importance of the export drive with leading politicians like George Isaacs (Minister of Labour), Harold Wilson (President of the Board of Trade) and George Tomlinson (Minister of Education) dispatched to Manchester to reinforce appeals for greater output. [27] The base of British exports was also a narrow one, both geographically and in terms of product range, making even marginal fluctuations crucial to the strategy for survival. In 1946 textiles and apparel accounted for one fifth of all British exports, with the largest single market provided by South Africa with the Dominions providing the major markets (South Africa, New Zealand and Australia alone accounting for one third of all exports in this sector). Key markets like Argentina took only one-eighth of the volume that they had imported in 1938. The difference between survival and collapse could be very narrow, with output crucial to performance. In November 1946, for example, a 'Buy British' week in New Zealand had to be cancelled for lack of goods to exhibit. [28] Nor were British manufacturers granted a lengthy period of exemption from foreign competition, not least because American interests, particularly with the onset of the Cold War, dictated as rapid a recovery for the vanquished as much as for the victors. The sense of bitterness which could be engendered by resurgent Japanese competition in particular is well illustrated by a report, in October 1948, from the Huddersfield Chamber of Commerce on renewed Japanese competition in the key South African market:

you will probably scratch your heads as usefully as we are doing and wonder whether all the world's efforts in the recent war have been designed merely to rehabilitate Japan as the world's worst price-cutter and danger to countries maintaining a Western standard of civilisation.[29]

Although the full force of Japanese, and other low cost producers' competition would not be felt until the 1950s, the tenuous hold of British manufacturers on export markets could not be easily disguised.

In this scenario constantly increasing production for exports was crucial. As in the immediate aftermath of the First World War this was, largely, not a problem of discovering markets but one of supplying them. The global commodity shortage ensured that a sellers' market prevailed at home and abroad. In the case of British exports this was further facilitated by the initial absence of German and Japanese competition which would begin to re-emerge at the end of the decade. The problem from the perspective of the government was, therefore, twofold: it needed to increase the supply of goods for export and to direct, as far as possible, those goods to the most financially strategic markets. The first problem was administratively straightforward but politically fraught as it entailed utilizing controls, and in particular the supply of raw materials, to impose export quotas on individual companies while restraining domestic demand through rationing and the various fiscal devices developed immediately before and during the war. The political problem lay in that strongly suppressed domestic demand, already built up by six years of wartime shortages and controls, as it could, and as much of the initial coverage surrounding the *Britain Can Make It* exhibition demonstrated would, be used by sectors of the press hostile to the government to attack its economic competence. The second problem was even more intractable, as the 1950s and 1960s would confirm, with British companies showing a marked reluctance to attempt to penetrate new or difficult markets, and almost all dollar markets came within the latter category. To some extent this was a product of the trading system, and trading mentality, developed during the inter-war years. To some extent also it was the product of a particular species of economic rationality as margins tended to be higher in the sterling area and the infrastructure of sales and service agencies was already in place without the necessity of developing the linguistic skills and packaging demanded in many non-British markets. The Belgian Chamber of Commerce, for example, complained in 1946 that very few British manufacturers produced any of their trade literature in French or provided metric measurements and specifications.[30] To some extent it was the product of ingrained production strategies: as an internal report warned in 1944 'British manufacturers tried to

sell *against the fashion* by producing "what their machines would make" rather than what the public required.'[31] In part, too, it was the product of manufacturers' perceptions of their own self-interest in terms of market development. The Cycle and Motor Cycle Manufacturers viewed the position in July 1946 thus: 'As a matter of good policy, preference has to be given to customers in various parts of the world who were on the books before the war.'[32]

In similar fashion in the preceding June, the British Pottery Manufacturers' Federation had urged that 'as far as possible present Empire quotas should be maintained ... the Empire has always been one of our best markets.'[33] In part, too, many companies feared that any sacrificing of home markets in order to develop exports would leave them vulnerable once international competition was fully restored. As the Machine Tool Advisory Committee was warned in the summer of 1946:

> smaller firms who exported to a very limited degree pre-war were now increasing their exports through the merchant houses, but they had no representation abroad and when it became a competitive market again they would be forced out of business.[34]

At the same time Labour faced mounting domestic difficulties with growing industrial disquiet exacerbated by the impact of the fuel shortages and factory closures which accompanied the winter of 1946–47. In the midst of that crisis, with convertibility fast approaching, government had to address the issue of impending national bankruptcy.

In this instance patriotism would be the first resort of the impecunious as government relied on a continuation of wartime techniques for the production and dissemination of propaganda designed to boost production and control unit costs through wage restraint. But this was not the war where, as successive reports from the Home Office's special intelligence unit and the Ministry of Labour's equivalent had repeatedly reiterated in 1944 and 1945, the prospect of victory was eroding the sense of national solidarity and sacrifice, and appeals to the national interest could not simply be couched in wartime language nor rely on wartime imagery. As Herbert Morrison, perhaps the closest approximation to a populist politician in Labour's Cabinet, warned Clement Attlee in February 1946, having taken the precaution of briefing the opposition on the economic situation, the production campaign demanded a particular approach: 'We want something that would appeal more to the masses. "Production" might make them feel that the capitalist would be the chief beneficiaries of the campaign.'[35]

Morrison's use of the term 'the masses' betrays some of Labour's own political didactisim. Although he was increasingly worried that the socia-

lization of industry, which figured so prominently both in Labour's own version of economic management and in its relationships with the trades union movement and employers' organizations, was having little impact on industrial relations or industrial expectations. As early as July 1946 he was warning his Cabinet colleagues that they should be careful lest they 'slip into a position in which the miners or railway workers felt that they were simply working for a fresh set of employers' and expressed his concerns that 'there was a danger that the incentives which socialisation, properly, could apply would be lost'.[36] Outside governing circles the prospects looked even bleaker. A writer in *Picture Post*, which had been so optimistic in the preceding summer, summed up the position as winter finally began to recede at the end of March 1947. Bemoaning the rapidity with which the American loan was being exhausted as it was 'puffed away in smoke, gaped at in films, eaten in scrambled-eggs, and even chewed in gum', the anonymous author felt the national situation to be teetering on the brink of an unprecedented crisis:

> How could a government see so short a distance that on Thursday it could be a man's patriotic duty to work all out, and on Monday his patriotic duty not to go to work? . . . Government, employers and workers have now to find a line on which they can pull together as they have never pulled to before. Our industries have got to be modernised – and modernised while working at top speed. The days in front will in some respects be tougher than the days behind. The alternative? A few more months of smoke-puffing and gum-chewing – followed by 'austerity' on a scale unknown here for a hundred years.[37]

To many at the centre of the Party, however, bolstered both by their massive Parliamentary majority and by their belief in planning (however loosely defined) and the power of experts' knowledge properly applied, the explanation for comparative failure was substantially different. Party politics and popular politics were indistinguishable and any divergence must be the result of communist-inspired subversion. It was a scenario that occasionally could get close to Brecht's electoral aphorism. Even Nye Bevan, who prided himself on his proletarian roots, could adopt a tone which implied that the only real problem was the inability of the people to match the party's expectations. As he informed the 1949 Labour Party Conference, the government was entitled to expect from the workers 'a sense of public responsibility and service . . . [as then] they will have proved that they can safely be entrusted with the safeguarding of the nation's interests'.[38] From government's perspective in 1946 and 1947 the responsibility of the workers clearly left a lot to be desired as they considered various measures to combat

absenteeism, ranging from increasing the supply of consumer goods to banning such plebeian entertainments as association football and greyhound racing during the week, while leaving the more respectable sports of cricket and tennis untouched.[39] The tone of much of the government's approach can be gauged from an address by Cripps, delivered in Manchester in September 1947:

> We must, too, continue with our efforts to persuade men and women and young persons that textile manufacture is today as much as matter of primary national importance as was munitions manufacture during the war. In the Battle for the Balance of Payments, in which we are now heavily engaged, cotton is the front line and we must convince people of this fact until they look upon it as they did upon aircraft manufacture during the war.[40]

In the same month the Ministry of Labour, which in July had wanted powers of industrial compulsion, sought special powers to 'comb out' (in the terminology originally developed during the First World War for securing reluctant recruits for the army) persons employed in 'undesirable street trading, out of the football pools and other branches of the gambling industry ... and also for putting to work those who for no good reason are not doing any work at all'.[41]

The public rhetoric often rang hollow. Whatever the view from Whitehall, the balance of payments was not the Battle of Britain and a politician like Cripps, with austerity buried deep in his soul, was not the best chosen person to present the message. Labour's exhortations with respect to wage restraint had some effect when channelled through, and supported by, the trade union bureaucracy but its broader appeals to a perceived national interest in production had considerably less effect. Morrison, for one, believed that trade union leaders had 'shown a considerable sense of responsibility, but a great deal remained to be done in educating the rank and file'.[42] If that was true for trade unionists it was even truer for the general public. As the Party's National Executive Committee had warned in September 1945 it was imperative, in protecting the party's gains, that 'the public fully understands what the Government is doing and why it is doing it'.[43] By 1950 even many party activists were unclear as to the government's policy. As a letter from the Dorset Federation of Divisional Labour Parties warned, the failure of the government's industrial strategy could mean that 'the Labour Movement ... may receive a blow from which it would be slow to recover, and all our socialist ideals would be lost for years to come'.[44]

Those not of a socialist persuasion could be considerably more scathing. To Raymond Streat, whose position at the heart of the textile industry had

long exposed him to the ploys of politicians and industrialists, it seemed that the constant stream of exhortation was:

> so terribly similar to the Goebbels technique in Nazi Germany... what is put across to the masses must necessarily be elementary and must omit all proper philosophic doubts ... this impregnation of the masses with over-simplified interpretations of the facts of life is at any rate better than leaving them without any interpretations and therefore without any sense of personal responsibility.[45]

To others it seemed that the comparative failure of industrial performance lay in the very ethos of industry itself, with the failure to modernize attributable to the ideologically constructed frames of reference of managers and workers alike. As *The Times* viewed it in October 1948, 'before modernisation can take place British labour and British management must change their traditional thinking and become modern in outlook'.[46] Government's failure to 'modernize' industry would be a long-running complaint in the post-war period and its initial attempts to try to do so through a mixture of proselytization and propaganda clearly had little immediate impact. That failure to link production and patriotism would cost Labour dear in 1950 and 1951 and continue to haunt successive administrations in the succeeding decades as moments of economic crisis almost invariably brought forth appeals to the national interest and almost equally invariably failed to resolve the failings of British industry.

Notes

1. T 230/130 Post War Export Trade Committee (PWETC) (10), 14 October 1942 and Paper number 32, 10 October 1942. Unless otherwise stated all document references relate to papers held at the Public Record Office, Kew.
2. T 230/131 PWETC Paper No. 46, 1 April 1943.
3. Barnett, C. (1987) *The Audit of War*, Macmillan; Barnett, C. (1995) *The Lost Victory*, Macmillan. A very different account of the relative strengths of the rival wartime economies is provided by Overy, R. (1996) *Why the Allies Won*, Pimlico.
4. Kent, J. (1993) *British Imperial Strategy and the Origins of the Cold War*, Pinter; Rooth, T. (1993) *British Protectionism and the International Economy*, Cambridge University Press; Dimbleby, D. and Reynolds, D. (1989) *Oceans Apart: The Relationship between Britain and American in the Twentieth Century*, Viking Books; Pressnell, L. (1989), *External Economic Policy Since the War*, HMSO; Clarke, R. (1982) *Anglo-American Collaboration in War and Peace 1942–1949*, Oxford University Press; Thorne, C. (1978) *Allies of a Kind*, Oxford University Press; Charmley, J. (1995) *Churchill's Grand Alliance: The Anglo-American Special Relationship 1940–1957*, Hodder.
5. Cab 117/65, Memorandum, 12 March 1942.
6. Cab 87/18, Reco R (IO) (45) 9, *Report on the Motor Industry*, 19 February 1945.
7. Cab 66/28, WP (42) 416, 17 September 1942; Cab 124/905 IH (O) (46) 3, 13 May 1946.
8. Cab 124/626, Memorandum, 30 September 1943.

9. T 229/346, BTDS (CA) (48) 11.
10. Cab 87/15, R (I) (45), 5 April 1945.
11. Cab 87/15, R (I) (45) (9), 21 March 1945.
12. Cab 124/626, Briefing Paper, 30 March 1945.
13. Cab 87/15, R (I) (45) (9), 21 March 1945.
14. Cab 68/48, WP (44) 20 June 1944.
15. Birmingham Chamber of Commerce (1946), *Journal*, October, Birmingham Central Reference Library.
16. Gosforth Co-operative Party, *Minute Books*, 11/10/48, Tyne & Wear Archive, Newcastle upon Tyne.
17. BT 195/1, Third Report of the Anglo-American Productivity Council, 1944.
18. Cab 87/14, Reco (1) (44), 20 June 1944.
19. Cab 87/14, Board of Trade Paper, *Long Term Prospects of British Industry*, June 1944.
20. *The Economist* (1943), 19 June.
21. BT 64/3760, *Competitive Position of the Pottery Industry*, August 1947 and *The Economist* (1944), 30 September.
22. BT 195/21, 27 October 1949.
23. Cab 87/18, Reco R (IO) (45), 30 January 1945.
24. *Picture Post* (1946) 25 May.
25. *The Economist* (1946) 13 July.
26. T 229/139, July, 1947.
27. Cotton and Rayon Manufacturers Association (1948) *Members' Bulletin*, vol. 3, no. 5, March, Manchester Central Reference Library.
28. Cotton and Rayon Manufacturers Association (1946) *Members' Bulletin*, vol. 2, no. 2, November.
29. Huddersfield Chamber of Commerce (1948) *Journal*, October, Huddersfield Reference Library.
30. Birmingham Chamber of Commerce (1947) *Journal*, February.
31. BT 64/3565, emphasis in the original.
32. Birmingham Chamber of Commerce (1946) *Journal*, July.
33. BT 11/2555.
34. BT 258/1514, Machine Tools Advisory Committee, 27 June 1946.
35. Cab 124/904.
36. Cab 124/929, SI (M) 46, 8 July 1946.
37. *Picture Post* (1947) 22 March.
38. Labour Party (1949) *Annual Report*.
39. Cab 124/1060, CP (48) 218, August 1946; CP (47) 861, March 1947 and *Minutes* of 12/3/47; Cab 124/693, May 1946.
40. Cotton and Rayon Manufacturers Association (1947), *Members' Bulletin*, vol. 3, no. 2, September.
41. Cab 129/20, CP (47 248) 5 September 1947.
42. PREM 8/1586.
43. Labour Party, National Executive Committee, Organisation Sub-Committee, *Minutes*, 26 September, 1945, Labour Party Archive, Mechanics Institute, Manchester.
44. Cab 130/65, GEN 349/11, July 1951.
45. M. Dupree (ed.), (1987) *Lancashire and Whitehall: The Diaries of Sir Raymond Streat*, Manchester University Press, vol. 2, p. 477, entry dated 7 January 1949.
46. *The Times*, 18 October 1948.

4 The Politics of Persuasion: State, Industry and Good Design at the *Britain Can Make It* Exhibition

Jonathan M. Woodham

The *Britain Can Make It* (BCMI) exhibition of 1946 at the Victoria & Albert Museum, London (Figure 9), marked the Council of Industrial Design's (COID) major debut on the public stage, exposing it to the rigorous critical examination of politicians, the media, manufacturers, retailers, designers and the general public. In embryo it was very much the concept of Sir Stafford Cripps, President of the Board of Trade in Clement Attlee's Labour Government which had swept to power in late July, 1945. The fact that a major public exhibition of industrial design for the post-war era was able to be put together in little over a year marked not only a triumph of organization but also revealed something of the spirit of optimism and idealism shared by many early members of the COID and its administrative staff.

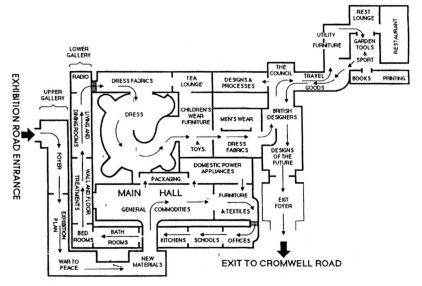

Figure 9 Map of the BCMI exhibition.

BCMI: origins and early plans

Almost immediately following the election of 1945 Cripps had summoned the COID's Chairman, Sir Thomas Barlow, and Director, S.C. ('Clem') Leslie to the Board of Trade offices in Millbank, London, where he requested that the COID should consider holding a large-scale public exhibition of British design in the Spring of 1946. That Cripps' ideas were firmly rooted in the belief that industrial design was a significant factor in the future of British manufacturing industry is clear from a handwritten note to Leslie of 10 August, following their initial meeting. It was extremely brief and to the point: 'There is one thing I forgot to say about the Exhibition. No "precious" stuff. All *manufactured* goods – not hand made.'[1]

Leslie was eager to expedite matters swiftly, holding an Emergency Meeting of the Council on 20 August in order to ascertain its feelings about involvement in such a major project. He focused its attention on his draft *Proposal to the President of the Board of Trade*[2] which was presented to the meeting as the basis for discussion. Even before this hurriedly-called meeting Leslie had been quick to canvass informed 'design opinion', as can be seen from a flurry of letters and notes on the subject to Leslie from a number of Council members including Gordon Russell, Kenneth Clark and Philip Whalley. A hastily-penned, but quite lengthy, handwritten note to Leslie from Gordon Russell (a member of the COID since its outset and Chair of the Board of Trade Design Panel since 1943) was logged in the Council's files before 17 August 1945.[3] It is interesting to consider a number of Russell's views contained in this document, entitled 'Cripps' Exhibition: Let's Go On Being Pioneers' for, although he felt that it was 'most important' to stage the proposed exhibition, he declared that:

> It would be impossible to have a good exhibition of post-war design for 1946. Many industrial designers are still in the services, labour and materials are very scarce and large sections of industry don't know what are good designs or how to set about producing them.[4]

He was also keen that the exhibition, when staged, should make clear the 'very splendid historical tradition of good design' in Britain, in many ways recasting Nikolaus Pevsner's *Pioneers of the Modern Movement* (1936) with a much stronger British (rather than European) inflection in the twentieth century.

Although suggesting a look backwards as far as tenth century manuscripts, Russell's projected focus was largely from the Industrial Revolution onwards, celebrating the output of entrepreneurs such as Josiah Wedgwood, the achievements of the early engineers and the contrasting outlook of the

Arts and Crafts Movement, *en route* to the twentieth century manifestations of British excellence in design, such as Rolls-Royce, Rover and radios. He literally underlined the point when he declared that:

> *We have always been pioneers, sometimes without noticing it.* Let's show that age-old spirit is still lusty. After all, the British Commonwealth of Nations is a pretty interesting example of pioneer design isn't it?[5]

Kenneth Clark (Director of the National Gallery, London), in a letter of 18 August, expressed reservations about the size of the proposed exhibition, advocating that it:

> should not be too large because there simply will not be enough stuff to show, and it is better to tell the President [of the Board of Trade] so now than to find ourselves letting in second rate things of which we shall all be secretly ashamed when the time comes when we have to get enough first rate material to fill our rooms. This all the more important if, as I learn to my horror, the BIF [British Industries Fair], is to be revived.[6]

A fellow member of the Council, Philip Whalley (Director of Lewis's Ltd) (Figure 10), was similarly concerned about the ambitious nature of the potential undertaking. Also writing on 18 August he expressed the:

> hope that we shall be able to carry it out properly, because it will be a ghastly thing if we were to put on something for our first real show that was not an absolute 'winner'.[7]

Even at the COID offices it had become clear before the full Council meeting of 20 August that Cripps' original proposal for a spring exhibition was quite unrealistic owing to a number of factors, including the existing commitments of manufacturers, the shortages of labour and materials, debates about precisely at whom the exhibition was to be aimed, and the securing of a suitable venue.[8] Nonetheless, at the full Council Meeting there was generally widespread support for Leslie's proposals which were put to the members on a 'round the table' basis by the Chairman, Sir Thomas Barlow. With a number of minor reservations, the only firm objection of those present[9] was voiced by Leslie Gamage (Vice-Chairman and Joint Managing Director, General Electric Company, Ltd) who felt that it was 'hopeless to aim for 1946 for any exhibition' and that it was 'impossible for many industries to even produce prototypes', including his own.[10] Francis Meynell (Advisor to the Board of Trade on Consumer Needs, founder of the Nonesuch Press and Director of Mather and Crowther) was supportive of the proposal, but suggested that it be held later than Spring 1945.

Figure 10 Philip Whalley, COID member and Director of Lewis's Ltd, 1946.

Accordingly, Leslie forwarded a modified proposal to Stafford Cripps at the Board of Trade on 22 August 1945.

Putting the 'Britain' into BCMI

As ideas about the nature of the exhibition began to coalesce, certain feelings about the importance of emphasizing the tradition of industrial design in Britain surfaced in a number of quarters. Gordon Russell in his mid-August note to Leslie[11] had raised the spectre of post-war American competition in his recommendation that the exhibition should 'stress the extreme value' of 'the very splendid historical tradition of good design' since *'here we have something which could be used most effectively against American propaganda'*. Thomas Fennemore (designer and founder of the Central Institute of Art and Design) took up a similar line in a letter to Leslie of 27 September[12] expressing the CIAD's support for the 1946 exhibition, but was anxious that his organization be informed if Council was not to proceed as it would wish to put on its own show, 'largely because we do not wish to leave the

door open for American penetration into the field of industrial design in this country'. Echoing the concerns of Kenneth Clark and others, he was also worried that the Council should not be over-ambitious in terms of the scale of the proposed exhibition as it might encourage British industrialists to feel that indigenous design thinking was out of date if too many examples of pre-war design were shown as exemplars of Good Design. He suggested it was quite obvious that:

> if any of the large American Industrial Design organisations were to take advantage of an Exhibition of that kind – by sending out propaganda to British manufacturers – this would severely jeopardise the prospects of exploiting the design talent available in this country.[13]

In October 1945 considerable progress about the nature and scope of the exhibition was made following a full press statement about Cripps' 'National Exhibition of Design' in which he declared that this propagandist, rather than sales-oriented and commercial, show would:

> represent the best and only the best that modern British industry can produce, largely the new post-war designs ... [and that] it will demonstrate the vigour, freshness, originality and skill with which our manufacturers are setting about their task of serving the home consumer and capturing a great share of the export trade.[14]

Reference was also made to the envisaged title of the exhibition: *Swords into Ploughshares: British Goods for the New Age.*

Of seminal importance in articulating the exhibition proposal more cogently was an 'Informal Conference' held at the Council's offices at Petty France, London, on 10 October, 1945. In addition to the members of the COID's Exhibition Committee, Sir Charles Tennyson,[15] Jack Beddington,[16] and Leigh Ashton,[17] there was a wide representation from other parties interested in design matters including Sir Cecil Weir,[18] Herbert Read,[19] Milner Gray,[20] F.A. Mercer,[21] Thomas Fennemore, Harry Trethowan,[22] John Gloag,[23] Noel Carrington,[24] Nikolaus Pevsner,[25] Cleveland Belle (Figure 11),[26] and Alison Settle,[27] the only woman among the 21 present apart from Lady Macgregor, who represented the COID's Scottish Committee. The Draft Plan for the proposed Exhibition,[28] which had been circulated previously, formed the basis for discussion. A wide variety of comments were made, the most out of line with the general tenor perhaps being those of Settle who felt that Britain was 'far behind other countries in Design' and that the exhibition should be concerned with foreign design, selected by the

Figure 11 Cleveland Belle, of the COID Colour, Design and Style Centre, Manchester, 1946.

COID. Pevsner argued[29] that the crafts should not be excluded altogether since in a number of industries such as pottery and weaving there were close connections with industrial design; he also felt that there should be some examples of seventeenth and eighteenth century designs of 'undated quality which still appeal today'. On the other hand, John Gloag was adamant that there should be a clean break with the past, suggesting that it was 'useless to base this Exhibition on what manufacturers had prepared for post-war markets, or what they did before the War'. Gloag enjoyed support for his proposal that teams of industrial designers should work in key industries to produce prototypes for new markets and a new public, convincing industry that design was a worthwhile longer-term investment.[30] Cleveland Belle picked up what was subsequently to become a highly controversial issue, the selection process.[31] This was seen as particularly significant in that many manufacturers equated their best designs with their best-selling lines, rather than 'their best designs', thus necessitating 'a very strong Selection Committee'. He also suggested, with considerable support from others, that fashion should be an important facet of the show, with its own selection committee.

The exhibition begins to take shape

Two days after the 'Informal Conference' on 12 October, a full Council Meeting approved a brief paper by Sir Charles Tennyson on *The Scope of the Exhibition*[32] as well as agreeing that the 1946 Exhibition be organized through three major committees (Policy Committee, Executive or Management Committee[33] and Finance Committee) on all of which the Director was to serve as an ex-officio member, with R. Dudley Ryder acting as Secretary to all three. The meeting also formally approved the appointment of James Gardner[34] as Chief Display Designer, who was described thus by Leslie:

> a comparatively young man, just released from the Army where he had done brilliant work in camouflage; his pre-war achievements in display, publicity and exhibition design were also outstanding, and those who had used his services were enthusiastic about their quality.[35]

Other important matters were also settled: Sir Cecil Weir had agreed to chair a small Sub-Committee to liaise with industry during the 'pre-Exhibition campaign'; and Lord Woolton was also to be invited to work with the Council in relation to the various Selection Committees.

The first meeting of the Exhibition Policy Committee almost two weeks later progressed things further, approving the appointment of Basil Spence as Exhibition Architect on the recommendation of Ryder.[36] The terms of contracts for Spence and Gardner were fixed with personal fees of 1000 guineas each, plus a sum for working expenses, as well as travel expenses and a subsistence allowance on the Government rate of 23s 6d per day.[37] The eventual title of the exhibition, which had been the subject of considerable debate, was finally adopted after Leslie proposed the slogan 'Britain Can Make It'.[38] Earlier suggestions had included such epithets as the late-imperial notions of 'The Lion's Share' or 'The Lion on the Label', post-war reconstruction notions of 'Arms for Peace', 'Passport to Peace' and 'Industry on Parade', as well as ideas more in line with the concepts of Good Design on which the COID was to place so much of its propagandist message in the late 1940s and early 1950s – the rather clumsy 'Good British Goods' and 'The Best in Britain'.[39]

By the beginning of 1946 many of the more fanciful ideas for the *Britain Can Make It* venue, such as 'a waterborne exhibition on barges or boats on the Thames' or 'a temporary structure in Hyde Park',[40] had been discarded in favour of the Victoria & Albert Museum which itself replaced the front-running Earls Court site originally favoured by the President of

the Board of Trade. The date of the exhibition opening was also put back to 24 September, 1946[41] and Gardner's exhibition plan was approved.[42]

The COID: selection policies, metropolitan–regional tensions and Good Design

Many of the most problematic issues at BCMI related to the selection of goods and the conflict between, on the one hand, the perceived élitist cultural values of a 'metropolitan' State-funded body and, on the other, the aesthetic 'ignorance' of provincial manufacturers who were preoccupied with short-term commercial gain.[43] A year before the exhibition opened Dudley Ryder and Sir Thomas Barlow had been reminded by Alix Kilroy of the Board of Trade of the potential controversy that could ensue from selection, drawing their attention to a Council for Art and Industry (CAI) Memorandum on the Paris Exhibition of 1937. In the 1937 British Pavilion the CAI had dispensed with the customary practice whereby manufacturers could buy exhibition space, introducing instead a rather cumbersome centralized selection process which aroused the wrath of many manufacturers. The COID inherited this aura of antipathy to intervention from the outset, the whole subject of State control also being bound up in continuing debates about the future of utility design. Sir Raymond Streat, of the Colour, Design and Style Centre in Manchester and a leading figure in Lancashire textile manufacturing circles, had advised the newly-formed Council that 'it was sometimes necessary to include goods of relatively inferior design in exhibitions held at the Centre, in order to retain the goodwill and support of manufacturers'.[44] He sought at the Manchester Centre to keep:

> clear of the eternal controversy of what is good in design. We have not sought to lecture our people, or declare roundly what was good. We have sought to bring all manner of good things to their notice, and my ambition would not be to lay down the law. . . . No centre should set off in its early stages as a place where the law is laid down as to what is good design and what not. I think you would have a lot of highbrow controversies which would not be a good start for harmony.[45]

As the urgent need to select goods for BCMI became a reality, concerns about selection came increasingly to the fore. In May 1946, Leslie alerted Council members to the 'problem' of the furniture industry: only 91 firms had responded to the call for furniture design submissions which totalled 1,170. In fact, the Furniture Selection Committee (Figure 12) selected only

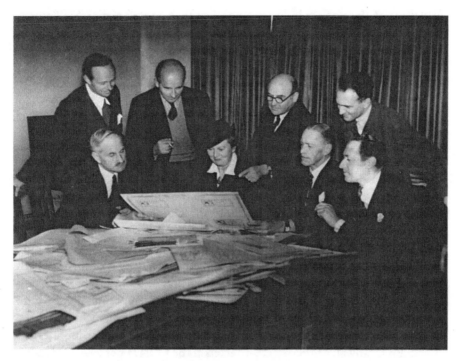

Figure 12 Furniture Selection Committee for BCMI, 1946.

about 14 per cent of this total from 23 firms since it was felt that 'the standard of design was extremely low and that if the Selection Committee, in making its final choice, restricts itself to items of real merit in design there will not be enough to meet the Exhibition requirements – i.e. to furnish the rooms'[46] (other than with utility products). The display of Furnished Rooms was intended to be a central part of the display as it was felt to be an effective means of communicating the attraction of well-designed products to the public, manufacturers and trade buyers from home and abroad. Accordingly, urgent action was proposed to overcome this stumbling block, linking the room designers more closely with the furniture industry, allowing for the possibility of including suitable designs which had been produced immediately before the war, and putting into place a strategy to fill the gaps. However, four months later, a fortnight before the exhibition opening, the Council was reassured by Leslie that selection troubles 'had been few, especially considering that twice as many firms and twice as many goods have been rejected as accepted,' although it was conceded that 'there was a great deal of criticism of the Pottery selection in the Five Towns'.[47] However, Leslie was only too well aware of the

criticisms of the pottery industry since, less than a week earlier, Sir Thomas Barlow had forwarded to him correspondence with A.E. Hewitt of Copeland & Sons Ltd in which Hewitt had declared:

> As industrialists [in the pottery industry], our ideas and the ideas of the theorists in London, who seem to be dominating the Government, are apparently poles apart, and I do not really see how the Board of Trade can make a success of the Council unless a different attitude is adopted.[48]

Since its founding in 1915 the independent Design and Industries Association (DIA) had sought to improve standards of design in British manufacturing industry and was broadly sympathetic to the mission of the state-funded COID. Nonetheless, in 1947 the Birmingham Region branch of the DIA sent a memorandum to the COID which expressed concern about the centralization of the BCMI selection policy and the geographic location of future exhibitions since it was 'felt by some that there was a danger of metropolitan bias and it was important to remove any suspicion of design standards being influenced by cliques'.[49] In a lively postscript to the memorandum there were a number of categorizations of various approaches to design, including those of 'the administrator', 'the legal or judicial mind' and the 'assumptionist'. Although clearly all of these were directed at the COID's perceived attitudes, the latter was particularly so: 'because in certain countries there is a high standard of design and also a degree of State intervention he *assumes* that – (a) the one is the result of the other, and (b) that State influence is always beneficial, however it is imposed and whoever is behind it'.[50]

Even more obviously linked was the attitude of the 'Metropolitan':

> London, he assures us, is the great retail market of the country and the centre of fashion and taste, 'provincialism' must not be encouraged and some of the provisional cities, being aesthetically starved, decentralised selection must also not be encouraged.[51]

Perceptive, as opposed to merely antipathetic, reviewers of BCMI also expressed criticisms of the selection process. Herbert Read, writing in the *Listener* felt that, due to shortage of time, the 'selectors have had to accept many articles of inferior, even of outrageously bad, design'.[52] Furthermore, although he found exemplars of Good Design in traditional industries like textiles and pottery, he wrote that 'one also finds, paradoxically, the worst designs, bastard descendants of Victorian eclecticism; and in the related glass industry the general standard of design is deplorably low.' Raymond Mortimer, another comparative veteran of design criticism, in the *New*

Statesman and Nation also considered that silversmithing, jewellery, plate and clocks were all weak categories.[53] On the other hand, the *Picture Post*'s reviewer, although fairly supportive of the aims of the exhibition as a whole, expressed a certain weariness with the adherence of the selection committees to a modernizing aesthetic, declaring that:

> In the welter of stripes and spots and white wood and homespun it would have been almost a relief to see a vast chintzy armchair, or an iron bedstead with brass knobs ... design has yet to fit itself comfortably into the British living pattern.[54]

In praise of Good Design at BCMI

There were many letters of congratulation to Leslie, praising him on the level of achievement attained at the BCMI. Unsurprisingly a considerable proportion of these emanated from COID members and others who had been drawn into the planning of the show, as well as from officials at the Board of Trade and sympathetic manufacturers and retailers: Harry Trethowan of Heal's thought it a 'Triumph of Presentation',[55] while Josiah Wedgwood was even more fulsome in his praise:

> Your gate-money and the fainting queues of the colour-starved millions are more than proof of the success of your own organisation, timing, and publicity and of your colleagues' excellent showmanship.[56]

John Gloag too was extravagant in his belief in the efficacy of the design propaganda implicit in the exhibition displays, declaring publicly in a letter to *The Times*[57] and privately in a letter to Leslie that 'with this we finally get rid of the Victorian hangover in design'.[58] There were also commendations from foreign quarters, including the Brussels Chamber of Commerce, the Belgian and US Embassies and the Svenska Slödföreningen, the last of which had been campaigning for better standards of design in Swedish industry for over 100 years. Its Managing Director, Sven Skawonius, wrote that:

> I have already expressed my great admiration for the exhibition 'Britain Can Make It', but I want to say once more to what extent it will always remain in my memory as the most generous, the most brilliant and stimulating achievement in the line in which we are working ourselves. In the long run I am sure that it will make a lot not only to promote the British arts and crafts, but also to act as a well of inspiration for everybody having had the opportunity of studying it closely.[59]

Another eminent Swedish campaigner for better standards of industrial design, Professor Ake Stavenow, the Head of the School of Arts and Crafts in Stockholm, former director of the Svenska Slödföreningen and a leading critic, also strongly expressed his admiration for the exhibition in a speech at a DIA lunch, revealing an international commonality of purpose among organizations campaigning in the cause of Good Design, whether in Scandinavia, Britain or even the United States, as at the Museum of Modern Art in New York.

Among the categories afforded most praise in the British design press were men's clothes and shoes, women's tailored clothes and shoes, domestic equipment, furnishing and dress fabrics and wallpaper. Also admired were goods on display in the sections devoted to sports, travel, garden tools and toys.

More cautious and critical evaluations

While there was a fair level of support for BCMI in the media, there was a politically-orchestrated campaign relating to the idea that *Britain Can't Have It*, and there were those who felt that the settings devised under the aegis of James Gardner were more impressive than the exhibits themselves. R.A. Bevan of S.H. Benson's Ltd, a leading advertising agency, felt that 'in many industries the exhibits do not really come up to the setting in which they are shown',[60] and Hugh Weeks of Cadbury Brothers, although admiring the exhibition layout, felt that 'somehow the exhibits failed to be exciting'.[61] Such views seemed to support the idea that there was still much to be done to persuade industry of the importance of design in the development of the post-war economy. The *Architectural Review*, an informed voice in British design propagandist debates for several decades, clearly articulated the problem:

> In a world which is the vast sellers' market, the Council of Industrial Design has had the unenviable task of selling *design* to manufacturers who must know only too well that *output*, however shoddy, cannot possibly overtake demand for several years to come.[62]

Nor had the general status of the designer in industry improved significantly since the Council for Art and Industry's report, *Design and the Designer in Industry* (1937). As Josiah Wedgwood remarked at a conference on industrial design held under the joint auspices of the COID and the Federation of British Industry a few days after the opening of BCMI, 'it is no exaggeration to say that at the present time in many businesses the designer is just used as a tame draughtsman for sales staff'.[63]

However, other representatives of industry were often quite uncomplimentary about a number of the settings in which their goods were displayed. For example, the sales manager of GEC complained about a number of the displays, including electrical appliances which were 'rather absurdly set out' as 'the majority of them are hanging from strings from the ceiling so that they neither look natural, nor can they be said to be at all functional'.[64] His comments have much in common with many more recent debates about showing design as 'art', entirely divorced from the world of the users for whom it was originally intended. Raymond Mortimer also criticized the commitment to flamboyant settings at BCMI as undermining the goods on show, drawing attention to 'the large revolving affair in the fashion section [which] looks as if it had escaped from a Hollywood "musical": not only is it clumsy in its effort to be rococo, but it stifles the clothes it is supposed to display'.[65] Far more damning were the views of Stafford Bourne, Chairman and Governing Director of the retailing firm Bourne & Hollingsworth Ltd, who declared in *Display* magazine:

> Yet I think that shop-keepers and display people are drifting in an entirely wrong course. The "Bloomsbury corduroy school" is in power and they don't know their job. The 'Britain Can Make It' Exhibition was an example of bad display when it should have been superb Foreign buyers don't want to see surrealist grotesque models and display stands in arty settings – they want to see the merchandise.[66]

The general public's response to notions of Good Design at BCMI

Many of the letters of complaint to the organizers about BCMI related to matters of catering, cloakroom facilities and public comfort. However, it is possible to gain considerable insight into the responses of the general public to the exhibition through the thorough analysis of visitors to it executed for the COID by Mass Observation. Mass Observation, established in 1937 by the anthropologists Tom Harrison and Charles Madge, employed 15 field investigators at BCMI for 'an approximate time of 244 man days', comprising 2,523 'valid interviews', noting about 1,000 overheard comments, and making factual reports based on number counts and a variety of observations.[67] Not only did this reveal such statistics as the fact that 65 per cent of visitors either lived in London, or within 25 miles of it, but also that 15 per cent more women came to the exhibition than men, and that nearly three-quarters of all the (1,432,369) visitors were married and of those who were still single, one in seven was engaged. Eighty per cent enjoyed the

exhibition, while only 2 per cent felt that it was bad. The report compiled by Mass Observation also revealed that 90 per cent of visitors spent between one and four hours there and concluded that the 'most widely represented class was very definitely artisan working class'.

According to visitors leaving the exhibition they were most interested in the Furnished Rooms (24 per cent), Women's Dress (12 per cent), Furniture (11 per cent), Furnishings and Fabrics (11 per cent) and Future Design. Analysis of the survey gives considerable detail about specific subsections of the display areas, showing, for example, that there was considerable interest in the pottery section in Shopwindow Street which was 'continually blocked by crowds' and was 'one of the most popular sections of the Exhibition'. Reactions to individual items were also studied, making it possible to appraise in detail some of the ways in which surveyed members of the public responded to the items chosen by the COID's Selection Committees as exemplars of Good Design.[68] However, the Mass Observation analysis also revealed that a majority of visitors to the exhibition to BCMI did not feel that their taste had been changed by what they had seen: 29 per cent believed that their tastes had altered; 15 per cent that they had 'perhaps a bit'; but 51 per cent thought the experience had exerted no change and 2 per cent very little. Quite apart from the exhibits themselves the COID sought to engage the critical faculties of the general public through the installation of a series of Quiz Banks[69] throughout the exhibition. Designed by the Design Research Unit, these consisted of 12 slot machines, with photographs of three different designs of various product types, placed throughout the exhibition. Visitors could register a vote for their preferred design by placing in the appropriate slot plastic coins, which had been issued to them as they entered the main part of the show – no doubt prompted in their choice by the criteria suggested in the COID pamphlets on sale. A linked *Design Quiz* book was also issued, following the same format of three alternative photographs grouped under a variety of product headings with guidance on 'How to Choose', and visitors could compare their preferences with those of a panel of experts whose choices were revealed at the end. Responses to this were considered by Mass Observation and, given the COID's clear prompts on appropriate criteria, it was not surprising that in most cases the experts and the public were fairly comparable in their expressed preferences, with the most pronounced difference being in the chair category: 56 per cent of the sample preferred choice (a), 38 per cent (b), with only 6 per cent electing for (c), the expert's favourite. Although the experts and the public disagreed on the top ranking in eight of the 12 categories – Glass, Cup and Saucer, Saucepan, Teapot, Wireless,

Clock, Chair and Wall Lamp – in three of them the variation between first and second choice was only 3 per cent; both public and experts concurred on Armchair, Lampshade, Gas Fire and Electric Fire categories.

Perhaps of greater concern to the COID would have been the relative indifference of the public to a central focus of its propaganda at the Exhibition: the 'What Industrial Design Means' section, designed by Misha Black (see also Chapter 9). As the Mass Observation Report recounted:

> Very few were really impressed by this section. Almost no one referred to it spontaneously, when asked what they thought about the Exhibition, and as few as one in fifty mentioned this, *together with* all the five other sections on Design, as that part of the Exhibition in which they had been most interested.[70]

Conclusion

BCMI has been seen by a number of writers on British twentieth-century design[71] as an undoubted success, evidenced particularly by the fact that 1,432,546 people visited it in just 14 weeks. However, such factors need to be balanced by the consideration that it is far more difficult to quantify the effectiveness of the exhibition, whether in terms of changing the receptivity of British industrialists, retailers and the general public to a modernizing design aesthetic in line with the COID's founding charter or in terms of the post-war economic aspirations of the Board of Trade. Many nuances of public perception were revealed by the Mass Observation Reports public as providing a complex, often articulate, and generally non-Pavlovian response to the design exemplars they had seen; their interest in queuing patiently for the exhibition may be explained simply by the *Punch* reviewer who felt that it stemmed principally from the fact that 'our eyes have become so accustomed to drab colour and austere cuts that we just haven't been able to resist this post-War opportunity to gaze into a brilliant shop window'.[72] Furthermore, in many instances where the goods on show had made a particular impression, the public were frustrated in their desire to purchase them since they were not yet available in the shops owing to shortages of material, labour or prioritization for exports. As has been discussed earlier, many manufacturers did not respond favourably to the aesthetic outlook of what was often seen as a state-imposed, culturally élitist body. Furthermore, the tensions between the south-eastern tastemakers and the industrialists from the provinces were increased by the whole selection process for the exhibition, which was in the hands of 20 small Selection Committees. Over 15,000 products were submitted for inclusion by

3,385 firms, but only just over 5,000 were accepted from 1,297 firms. This 67 per cent rejection rate did little to win over the manufacturing industry which felt that it knew the markets better; at a time when demand outstripped supply it was also in a strong position to remain unresponsive to the didacticism of the COID. One further problem for the COID at this early stage of its existence stemmed from the fact that its aesthetic beliefs were largely centred on conviction, rather than a profoundly-worked investigation into, or understanding of, the sociology of design and the economic realities of everyday manufacture. This was a difficulty with which it was to grapple for many years following BCMI, a large-scale exhibition which had been put on almost before the new Council had time to draw breath or reflect on how best it might achieve its original aims of promoting Good Design in industry, disseminating design advice and information to manufacturers, mounting exhibitions, advising on design education and educating the public in the importance of Good Design. A leading article in *The Economist*, published three days before BCMI opened painted a clear picture of the difficulties the COID faced:

> Industrial design has suffered from a long-haired reputation in this country; to the working man it has been something almost effeminate; to the businessman another unwelcome intervention of the idealist in his affairs. Good industrial design, *pace* Sir Stafford Cripps, is not necessarily good business, and the idea of it still has to be 'sold' to the British manufacturer and trader and the British public.[73]

This was the battleground upon which the COID continued to fight for many years, long after the *Britain Can Make It* exhibition had been relegated to its place in history.

Notes

1. ID/312 *Summer Exhibition 1946*, note from Cripps to Leslie, 10 August 1945. All documents cited in this essay with references commencing ID are located in the Design Council Archive which is housed in the Design History Research Centre at the University of Brighton, England.
2. *The British Exhibition of 1946: Draft Proposal to the President of the Board of Trade*, C(45)31, in ID/312, document 3.
3. ID/312, document 2. It is clearly noted as in circulation on 17 August and, since it cites one or two points made by Francis Meynell at the meeting of 20 August, indicates that there was some earlier discussion 'off the record'.
4. Ibid.
5. Ibid.

6. ID/312, document 14. As indicated in Chapter 8 on 'Industrial Design' in this volume, the large scale BIF, an important sales arena for buyers at home and abroad, had often been the scapegoat of the Good Design lobby of the inter-war years, being seen as an aesthetic 'free for all' dominated by the extremes of encyclopaedic historicism in ornament on the one hand and the modishness of 'Jazz-Moderne' styling on the other. Above all, the Good Design lobby saw the BIF as evidence of the prevalent lack of understanding of the precepts of modern industrial design in manufacturing circles.
7. Ibid., document 16.
8. ID/312, document 13, *Proposed Summer Exhibition 1946*, 17 August 1945. Among the early suggested venues were Earls Court, the Royal Albert Hall, Dorland Hall, Stafford House and the Victoria & Albert Museum.
9. These included J.H. Tresfon, Leslie Gamage, Francis Meynell, Allan Walton, Gordon Russell, Ernest Goodale, R.S. Edwards and Margaret Allen, with Sir Thomas Barlow in the Chair. From the COID staff Leslie, R. Dudley Ryder and Ms Monck were present, as were a number of official representatives from various bodies of State.
10. ID/1945 *Council Meetings 1944/45*, minutes of meeting of 20 August 1945.
11. See note 3.
12. ID/312 *Summer Exhibition 1946*, letter from Fennemore to Leslie, 27 September 1945.
13. Ibid.
14. ID/312, document 58, *Press Notice: National Exhibition of Design*, 3 October 1945.
15. Chairman of the National Register of Industrial Designers and member of the Federation of British Industries' Industrial Art Committee.
16. Well known for his management of publicity for Shell-Mex BP Ltd in the 1930s.
17. Director of the Victoria & Albert Museum.
18. Chair of the Board of Trade's *Industrial Design and Art in Industry Report* (1943) (unpublished).
19. Director, Design Research Unit (DRU) design critic, academic, museologist and poet.
20. Founding partner, DRU.
21. Editor of the periodical *Art & Industry*.
22. Design critic from Heal & Son, the London furniture retailer.
23. Director of the advertising agency Pritchard, Wood & Partners and tireless campaigner for Good Design in the inter-war years.
24. Stalwart design and Industries Association campaigner and author of *Industrial Design in Britain* (1947), Pilot Press.
25. Architectural and design historian, critic and writer, then working at the *Architectural Review*.
26. A key figure at the Colour, Design & Style Centre, Manchester.
27. Design consultant and fashion editor of the *Observer*. The Alison Settle Archive is held at the Design History Research Centre at the University of Brighton.
28. ID/312, document 93, *Draft Plan: Suggested Title: Swords into Ploughshares: British Goods for the New Age*.
29. Along lines more fully developed in an earlier letter from Pevsner to Leslie, 4 October 1945, in ID/312, document 66.
30. Gloag's ideas were discussed subsequently by a number of leading British industrialists at a later meeting at the COID offices. Among those present were Wells Coates, R.D. Russell, A.B. Read, Misha Black, Keith Murray, Grey Wornum, Norbert Dutton and Christian Barman.
31. As it had been at the Council for Art & Industry's selection process for the official British display at the 1937 Paris international exhibition.
32. ID/312, document 66.
33. This was to absorb the previously constituted Exhibitions Committee which met three times, on 27 July, 13 September and 11 October 1945.

34. His appointment was first approved by the Exhibitions Committee. Gardner himself suggests in his autobiography *James Gardner: the ARTful Designer* (1993) Lavis, that 'a prod from my pre-war trigger man Jack Beddington [a member of the Exhibitions Committee] got me in on the act'.
35. ID/1945 *Council Meetings 1944/45*, minutes of 12 October 1945 p. 3.
36. Ryder had approached the RIBA for their views regarding the suitability of Spence, Joseph Emberton, Herbert Rowse, Howard Robertson, Brian O'Rorke and Maxwell Ayrton. It was thought that Robertson would be too busy.
37. £1.17½p at 1997 value.
38. Credited by Leslie to the COID Librarian, Ms Goodwin.
39. ID/312, document 93, contains a list of 30 *Suggested Names for the Exhibition* sent by C.A. Mesling to Leslie on 17 October 1945.
40. ID/E1, *First Meeting of Exhibitions Committee*, 27 July 1945.
41. Discussed at the Council Meeting of 11 January 1945, ID/1946 *Council Meetings 1946*.
42. By the Exhibition Policy Committee on 7 February 1946.
43. A number of these ideas are developed in Woodham, J.M. (1996) 'Managing British Design Reform I: Fresh Perspectives on the Early Years of the Council of Industrial Design' and 'Managing British Design Reform II: The Film *Deadly Lampshade* – An Ill-fated Episode in the Politics of 'Good Taste', *Journal of Design History*, vol. 9, no. 1, pp. 55–65 and no. 2, pp. 101–15.
44. ID/1945 *Council Meetings 1944/45*, minutes of 9 March 1945.
45. As above, 'Text of Speech Addressed by Sir Raymond Streat to the Council of Industrial Design at their Meeting of 9 March 1945'.
46. ID/1945 *Council Meetings 1946*, 'Note by the Director: "Britain Can Make It" Furniture', a report presented at the meeting of 10 May 1946.
47. As above, Director's Report presented at the meeting of 13 September 1945. The 'Five Towns' were the pottery towns of Stoke-on-Trent.
48. ID/516/14A.
49. ID/E/1 Exhibitions Committee (Director's Files) E(47)5 *Design Selection for Exhibitions*, Memorandum to the Council of Industrial Design from the Birmingham Region of the DIA.
50. Ibid.
51. Ibid.
52. Read, H. (1946) 'Britain Can Make It', *Listener*, 3 October, pp. 429–30.
53. Mortimer, R. (1946) 'Britain Can Make It!', *New Statesman & Nation*, 28 September, p. 220.
54. *Picture Post* (1946), 'Britain Can Make It', 19 October, p. 22.
55. ID/910 *'Britain Can Make It': Letters of Appreciation*, letter to Leslie, 25 September 1946.
56. As above, letter to Leslie of same date.
57. 28 September 1946.
58. ID/910, letter to Leslie, 24 September 1946.
59. As above, letter of 1 November 1946.
60. As above, letter of 24 September 1946.
61. ID/911, *'Britain Can Make It': Letters Containing Criticism, Complaints and Suggestions*, letter to Leslie, 1 November 1946.
62. *Architectural Review* (1946), Special Issue on Industrial Design, October.
63. (1946) *The Conference on Industrial Design*, COID/FBI, p. 15.
64. ID/911, the sales manager's comments were passed on to Leslie by Gamage of GEC in a letter of 30 September 1946.
65. Mortimer (1946).
66. Bourne, S. (1947), 'In Defence of Mass Display', *Display*, April, p. 22.
67. ID/903 *Report by Mass Observation on Britain Can Make It: Notes*, 'A Note on the Methods Employed by Mass Observation During Their Survey of 'Britain Can Make It'.

68. This has been broached by Lucy Bullivant, ' "Design for Better Living" and the Public Response to Britain Can Make It' in Sparke, P. (ed.) (1986), *Did Britain Make It? British Design in Context 1946–86*, Design Council, pp. 145–55.

69. The COID had been committed to the idea of Design Quizzes from its earliest days: it had mounted one at the *Daily Herald* Post-War Homes Exhibition in March 1946. It also produced a wall-card Design Quiz as a teaching aid for schools in the late 1940s.

70. ID/903 *Report by Mass Observation on Britain Can Make It: Section C – Specific Preferences and Selection Problems*, p. 47.

71. Such as MacCarthy, F. (1979), *Design in Britain 1830–1979*, Allen & Unwin.

72. *Punch* (1946), 'The Great Exhibition', 16 October, p. 306.

73. *The Economist* (1946), 'Industrial Design', 21 September, p. 445.

THE OUTLOOK OF MANUFACTURING INDUSTRY

5 'Fabrics for Everyman and for the Elite'

Mary Schoeser

Reflecting the egalitarian mood of the immediate post-war years, Morton Sundour ran an advertisement from 1945 until at least 1949 that read 'Morton Sundour Fabrics Ltd and their branch Edinburgh Weavers make fine furnishing fabrics for everyman and for the elite'.[1] Neatly encapsulated in this statement were distorted truths as well as overt optimism. The real truth was that only Sundour's products were sold over the counter to 'everyman'; Edinburgh Weavers, however, founded in 1928, was created to 'design and make fabrics for individual jobs, collaborating with the architect or decorator in each case',[2] and when produced in larger amounts were aimed largely at the export market. Nevertheless, the advertisement suggested that both ranges contained something for everyone. Such ambitions paralleled those of the *Britain Can Make It* (BCMI) exhibition, which also concocted a persuasive blend of truth and optimism. Examination of the exhibition's presentation of facts and assumptions – of which there were many – allows us not only to chronicle which textile companies and designers participated, but also to understand more fully the intentions of the organizers and contributors, the position of textile manufacturers with regard to 'Good Design', the significance of the room sets and their class-based rationale, and the role of the exhibition in subsequent developments.

It seems likely that the exhibition was viewed by the majority of textile firms as an export trade fair, and there is little doubt that at the end of the Second World War the textile industry needed urgently to re-establish its export markets. Apart from the effects of the war itself, exports had already been slashed in the previous 40 years: of every 100 metres sold in 1900 approximately 75 to 80 had been exported, but by 1939 both home trade and exports accounted for the equivalent of only 20 metres each, with the 'missing' 60 metres representing lost export trade. Much of this decline had occurred within recent memory, and its most significant impact was felt by cotton spinners, weavers and bleachers (the largest branches of the industry), followed by cotton dyers and printers. In 1944 the volume of exports of bleached, printed and dyed cottons was 15 per cent that of 1929.

Clearly, promoting exports was particularly important for those firms with specialist markets. Logan Muckelt & Co. of Manchester, for example, produced handblock and machine-printed indigo wax resists (Figure 13), and their entries in the BCMI catalogue for these cotton cloths (display numbers 381–403) indicated availability for export as 'later', but nothing at all for the home trade; F. W. Grafton simply designated their cotton displays numbered 291–2 as 'African prints' (without any availability code) to make their market known. Furthermore, with no immediate end to rationing in sight, firms trading both overseas and at home recognized that exports provided the most evident chance for growth. This was indicated by the availability codes of a wide range of products, from the men's silk accessories shown by Holliday & Brown, London (display numbers 30–34)[3] and available 'soon' for export but 'later' at home, to the cotton satin dining recess curtain printed by Sanderson Fabrics (display number 173), which could be obtained immediately for export, but 'soon' for the home trade. Asked to discuss her choice of fabrics, Gaby Schrieber commented, 'The subject ought to be "The fabrics I should *like* to choose". London interior decorators are still limited in their choice of materials, since the best of these go abroad.'[4]

The keynote of the BCMI – the excellence of British design and designers – was not a new means of promoting textiles, but was particularly apt under the circumstances. Suppliers to the home trade, protected for

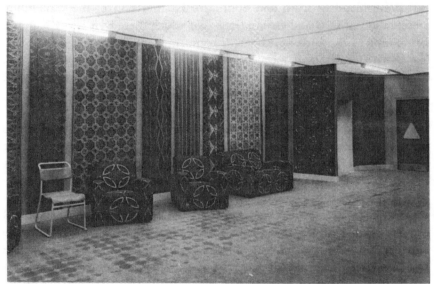

Figure 13 Textiles manufactured by Logan Muckelt & Co. Ltd for export to Africa on show in the Utility and Other Furniture Section of BCMI, 1946.

the moment from competition by import restrictions, had few incentives to invest in either design or technology. Their complacency was further reinforced by a variant of the 'make do and mend' thinking also voiced by Gaby Schrieber, who suggested that a lack of choice was 'a challenge to ingenuity and the arts of improvisation' and noted her firm's use of fabrics made originally for war purposes:

> These materials, such as duck, hessian and canvas types, we have dyed to our own shades. For softer, suitable, material we have developed our own printing service which works hand-block designs and, thank goodness, there is nylon to help us when we look for glace surfaces. It is expensive, but unrationed. As for the rest, we choose from what we can get of plain cottons, satins, moires, occasionally brocades and – for country houses – small French type chintzes.[5]

Schrieber's comment highlighted the ambiguity behind who was really responsible for design choices. It also contradicted the basic premise of the BCMI, which promoted the concept of a designer with far more cohesive control of the end result.[6]

The BCMI's focus on design and designers, combined with catalogue entries listed by manufacturer, was a construct suggesting that manufacturers played a central role in providing design innovation. It can be argued, however, that the exhibition's promotion of 'Good Design', in suggesting that designs were *instigated* by textile manufacturers, was as much a campaign to force change among certain producers as it was an attempt to educate the visitors, for this concept addressed a fundamental dilemma apparent to all who knew the textile industry. The complexities of textile production meant that before the product reached the consumer it had been handled by more than one firm. For an extreme example, a dress fabric might be made from yarn spun by one company, and then woven, bleached, printed and made up by four others. In between manufacture and making-up there was often also another firm, this happened particularly in the cotton industry, which for over a century had provided relatively inexpensive but well-made cloths to middlemen in successive markets, but they were pushed out of the markets as each country developed its own industry or, more typically in the twentieth century, by competing exporters from other manufacturing nations. Simplistically put, most manufacturers were reactive rather than pro-active; as far as possible they produced on demand, not for speculation. (This was also reflected in the BCMI availability codes; only those who warehoused stock – or who had enough yarn or cloth on hand for printing – could offer goods 'now'.)

By 1946 the industry was under pressure to reorganize, and to change not

only their working methods and machines, but their attitudes too. In urging modernism of employment practices and technology, particularly in the cotton sector (which – despite its decline – was still a substantial British industry), both the Board of Trade and the British Ministry of Production took the United States as their model. But this tack was not appropriate. The American 'styling revolution' had great relevance for finished consumer goods but not for unfinished goods such as fashion and furnishing textiles (household linens and carpets were another matter), and American manufacturers were less dependent on exporting. Far more relevant was the cooperation between textile manufacturers and fashion designers in France, since clothing textiles on average accounted for about two-thirds of British production and were, therefore, in Western markets, dependent on a healthy British fashion industry.[7] This point – if missed by the government officials – was noted in 1945 by the observant British fashion journalist, Alison Settle.[8] Praising the Board of Trade's role in proposing in 1942 that Utility garments be designed by members of the Incorporated Society of London Fashion Designers, she noted, nevertheless, that:

> Success cannot come to English fashions so long as the men of the country treat fashion as being essentially frivolous and even laughable ... to take the trends of fashion seriously, to discuss clothes seems unthinkable. Only when fashion trends, colours and the whole philosophy of clothes is talked about – as films, pictures and music are discussed – can the textile trades of Britain regain their merited superiority in the eyes of the world.[9]

This blind spot was underpinned by the fact that the success of men's and children's wear relied, not on fashionability, but on the fact that 'Britain's reputation for quality fabrics is a big gun for her when she is competing ... in world markets. Good makers-up, particularly those selling abroad, use the best fabrics they can get.'[10]

Despite the fact that garments, dress fabrics and related fashion items were given one-quarter of the floor space at the BCMI, the lack of co-ordination between clothing manufacturers and their fabric suppliers was evident. Among the children's cloths only William Hollin's 'Viyella' represented an integrated weaving and garment-making concern. An examination of the catalogue entries for the women's garments underlines the major barrier, namely the extent to which fashion houses were loath to reveal their fabric sources. Among the couturiers, the majority gave no such information; these included Victor Stiebel, Digby Morton, Bianca Mosca, Worth, Charles Creed, Jacqueline Vienne and Lachasse. Out of a total of 28 couture garments, only five descriptions included reference to the cloth manufac-

turer: Peter Russell's dinner gown was of 'satin enmeshed with gold thread woven by Silkellal, a Hardy Amies dinner dress was 'in purple crepe by John Knox', Molyneux's morning dress was in 'cloth by Dobroyd', and Angele Delanghe's debutante dress was in 'muslin and net material designed by students of Bromley School of Art'.[11] In none of these descriptions is the fibre mentioned, and other garments by the same designers gave no cloth information at all. Only Norman Hartnell's white satin evening dress, 'patterned in "White Rose of York" design printed by Grafton Fabrics of Manchester' could be determined to be of handscreen printed rayon, by use of both the official catalogue and *Design '46*, in which the cloth was illustrated.[12] The wholesale dressmaking houses revealed no fabric sources. Among the entries for Utility garments (for which cloth specifications were crucial) there were also no references to cloth manufacturers; these entries ranged from Louis Reed's suit and topcoat, helpfully described as green and brown herringbone tweed and orange and blue check tweed, respectively, to Jaeger's blunt 'Utility suit'.[13] Whether as a result of the desire for secrecy or the dislocation of labour and disruption of supply links caused by the war, no garments were available to be illustrated in *Design '46*; those shown were from the *Vogue Book of British Exports* and were not necessarily selected for the BCMI.

While the women's garments numbered only 127 (a further 22 examples were knitwear), fashion fabrics themselves were well represented. The wool and worsted fabrics were not itemized, but those of cotton, linen, nylon, rayon, silk and mixtures numbered 445 – nearly 9 per cent of the total number of itemized exhibits. The abundance of fashion fabrics can be accounted for by a number of factors, such as the inclusion of cloths designed for India, Africa and Eastern Pacific nations, and the contribution of home and professional-seamstress dressmaking to cloth sales, the latter emphasized by the inclusion of over fifty buttons in the Dress Accessories section. Some attempt was made to show the draping qualities of the cloths by use of the 'tree figure' designed by Ralph Schorr and Basil Spence (see Figure 14); aside from its striking appearance, it seems also to be aimed at helping the amateur dressmaker envision the cloth 'in action'.[14]

In contrast, the wool and worsted fabrics were clearly not for everyone, and details could only be obtained on the presentation of a trade card. This stressed the closed world from which emanated the high-quality garments, since these were mainly made from woollen and worsted cloths, a fact substantiated by *Vogue* editor Audrey Withers in her essay in *Design '46*. Devoting over half of the discussion on dress fabrics to these cloths, she commented on the increased demand for good fashion, 'enjoyed formerly by the few' and continued:

Figure 14 Dress Fabrics Section, BCMI, designed by Basil Spence and Ralph Schorr.

the woollen trade – one of Britain's great traditional manufacturers – has, rather slowly but finally with complete success, adapted itself to the new conditions and has thereby set a fine example to other trades faced with the same changes of demand. And it has become highly sensitive to fashion developments. The attitude,

"This is good stuff, I'm telling you; it will last a life-time," has given place to a realisation that today's public want lighter weights, varied weaves, and colours and patterns that change from season to season. In response, manufacturers are at pains to evolve new cloths and new finishes; such as two new superfine velours de laine from Yorkshire, one with a suede and the other with a cashmere finish; such as the exquisitely soft Bermuda doeskins; such as a superfine wool crepon, weighing $1\frac{3}{4}$ ounces a yard; and such as the new gossamer woollens, produced with the aid of an alginate carrier yarn,[15] which can weigh as little as 1 ounce, and which open up a whole vista of possibilities for wool.[16]

High praise also went to other woven fabrics made from rayon and to weaves generally. This was echoed also in the BCMI selection with roughly half of the itemized dress cloths being plain, that is, dependent for their character upon textures or stripes. Cotton, its 'endless series of variations on the classic themes of shirtings and ginghams' aside, was found exciting only so far as it could imitate other fibres. Poplins with a silky handle, for example, deserved 'good designs and careful printing as is accorded to real silk'. As for prints, 'all too many . . . are sadly lacking both in design and fashion qualities'.[17] Thus the BCMI and its literature highlighted the high status accorded to woven fabrics over prints, and to all other fibres over cotton, Britain's economic power base only 50 years before.

To a large extent, it was their low status that seemed to undermine any faith in the ability of cotton printers to put forward examples of 'Good Design'. Certainly, they seemed the most obvious subject of the 'Notes for Guidance for Selection Committees', which stated that:

> The Council has no intention of organising an exhibition of "best sellers"; the purpose of the Exhibition is to give a lead to manufacturers, retailers and the public alike, and the judgement of the market is itself something which is capable of education and development. At the same time no practical purpose is served by showing objects completely divorced from the tastes and requirements of the particular section of the market which would be reached by an article at a given price.[18]

Judging from the final selection 'Good Design' was allowed three meanings, two of which certainly suited the cotton industry. Interpreted as meaning 'appropriate', it supported the inclusions of plain cloths – shirtings, corduroys, velvets and some prints, such as those for children and exports. Those for non-Western markets had designs devised to appeal to large markets with, often, strongly 'tribal' consumers, that is, for those that required an understanding of the complex ways in which colours and motifs expressed social ties and economic status. (This was the skill for which the many Manchester design studios had been known in the past.) In contrast,

interpreted as 'fashionability', it moved British cotton goods into the middle market, in theory increasing the likelihood that they could compete in Western countries. Conflicting in themselves, these definitions of design 'types' were also at odds with the official stance promoted by the BCMI, which, as Wally Olins recalled, was based on the premise that: 'it was almost axiomatic that Good Design could not be popular; it could only be forced on a reluctant mass audience which, given the slightest opportunity, would choose meretricious rubbish instead'.[19]

In the complex relationship between fashion, status and volume sales, cost was an important factor. Silk, for example, was by definition a luxury fibre and, therefore, already up-market and capable of sustaining a high level of design investment. Its high price also removed it from the mass-market conundrum, which demanded both affordable and fashionable cloths. At the other end of the price scale, the cotton and rayon industry (to a large extent an interchangeable one at weaving and finishing stages) had become vast by being populist. Any attempt to make it move beyond the merely fashionable to embrace Good Design seemed a threat to its survival. Some steps had already been taken by the Cotton Board's opening of the Colour, Design and Style Centre in Manchester late in 1940, when the first exhibition, organized by Gerald Holtom, exhibited designs by British artists such as Eric Ravillious, Graham Sutherland, John Piper, Edward Bawden and Vanessa Bell, with a view to encouraging printers to buy them. Many were sold but few were produced, although the Centre itself developed a reputation for creative displays and became an important promoter of cotton fabrics for couture. In doing so, it tackled a barrier of some 150 years duration; in this light the BCMI Hartnell gown using a Grafton print was a great victory.

The Style Centre also used its exhibitions to subvert the presumption that high investment in printed fabric designs was traditionally the business of middlemen or garment makers. The extent to which this was also the intention of the BCMI is clear from the selection of dress fabrics and scarves, which totalled just over 500. Forty-five firms exhibited about 225 printed items, of which approximately 38 per cent were by three firms, Cresta Silks, Ascher (London) Ltd, J.A. Duke.[20] Cresta showed eight fabrics (five designs) and four scarves. Ascher was given the largest slice of all, with 20 dress fabrics (Figure 14) and 31 scarves. Neither firm used cotton for their dress prints (although Ascher used it for ten scarves), emphasizing the extent to which design leadership was identified with silk or, in its high-quality form, rayon. But of equal significance was the prominence given to three firms that were so small (in terms of production) but pro-active:

Cresta had its own chain of shops and purchased a printworks in 1946; Ascher, already well known for commissioning artists' designs, worked closely with couturiers and also purchased a printworks in 1946. J.A. Duke was the designer-owner of his Manchester firm and had selected 22 examples, each with a different design, while the giant firm Tootal Broadhurst Lee showed only six designs in various colourways (18 in all).

Promoting integrated and innovative design and manufacturing in prints was obviously on the agenda, but promoting cotton was not. The selection was fairly balanced between prints and weaves but, when divided by fibre, 148 can be identified as man-made or synthetic fibres, the majority of rayon, and there are a further 121 for which the fibre content is not stated, but descriptions such as crepe and georgette suggest that they are also of rayon, giving a total of 269. Fifty-four are of silk; 12 are linen and one is wool; there were also ten examples of 'Viyella', the Hollins cloth composed equally of wool and cotton. Only 99 are all cotton, of which 43 are 'African prints', indicating the selectors' awareness of the need to serve the full range of trade visitors. The dominant contributor of these, with 36 examples, was Logan Muckelt. The need to build up both raw cotton stocks and exports contributed to the relatively small number of cottons and the dominance of African-bound cloths, but the selectors were also playing it safe; among the remaining 66 were 35 woven cottons, of which 16 were plain velvets, velveteens or corduroys, five were cotton piqués, and seven were spots, stripes or checks. Of the remaining 31 prints, 22 were by Duke, who was thus promoted as the exemplary fashion-cotton printer. There are no cotton prints by those who had once clothed the masses – Grafton's, Heathcote's or Hoyle's (theirs are on rayon and together total ten) – instead the remaining nine cotton prints included two spotted cambrics and only four from other acknowledged designers: Betty Tanner, Lana MacKinnon, Ashley and Graham Sutherland.

The ambivalence towards patterned dress cottons echoed Audrey Withers' comments. It is also revealing given that cotton, and involvement with the Style Centre, was so integral to the judgements made by two key members of the BCMI's committee structure: Sir Thomas Barlow and Jimmy Cleveland Belle. Barlow was the 'cotton man' of his generation and owner of the large and prosperous cotton spinning and weaving firm, Barlow & Jones. During the war he had been Director General of Civilian Clothing, controlling, among other things, the distribution of all cotton yarns. It was on his suggestion that Holtom was requested to create the first Style Centre exhibition, where the director was Cleveland Belle. Despite the existence of a selection process for the BCMI, these two men had the final

word in a number of cases.[21] With strong views on cotton (and by association, rayon) and design, the selection of dress fabrics can be taken as an indication of their ambitions for their industry, if not their personal tastes. They can be summarized as promoting rayon (Barlow & Jones showed three), and the design-led firms, particularly those who used the 'right' designers. Just over 100 prints were catalogued with the names of the designers. Judged solely from the entries, the most successful freelance designer was Graham Sutherland, whose work was shown by six firms, followed by Henry Moore, with five designs for Ascher. Sutherland's success was a fillip for the Style Centre, for his 'Rose', printed on cotton poplin for Helios (owned by Barlow), had been purchased from the Holtom 1940 show.[22]

If only demonstrated obliquely by the dress fabrics, it would be wrong to suggest that the integration of cloth design and end use was not represented at the BCMI, for it was well illustrated in the furnished rooms and in the furniture section itself, where, except for the ubiquitous yellow- and cherry coloured tapestry upholstery used by at least ten different firms, the manufacturer of almost every upholstery fabric is given. Such efforts may have resulted from the foreknowledge that millions of homes awaited rebuilding or redecorating. But a number of precedents suggest that there were other factors at work, at least for those involved with the organization of the BCMI who can also be shown to have taken a stance on 'good design' for textiles in the 1930s. Sir Thomas Barlow, Gordon Russell and Sir Ernest Goodale were in different ways involved in supporting projects intended to bring well-designed cloths to a wider market: Goodale in 1932 by appointing Alec Hunter as designer at Warners and supporting that company's introduction of much more cotton, linen, wool and rayon to their formerly silk-dominated range (and thus providing a much less expensive cloth); Russell in the mid-1930s by promoting Welsh tweeds as an upholstery fabric; and Barlow in 1938 by creating a subsidiary, Helios, to specialize in providing well-designed furnishing directly to shops.[23] Barlow's role as Chairman of the COID and Russell's role in the Utility scheme are well known; Goodale joined the Council of Art & Industry in 1934 and transferred to the COID board, serving from 1944–49. All three companies actively promoted their modern ranges, as did Morton Sundour (which did the original Utility trials) and Edinburgh Weavers, run by Hunter for its first four years.

These companies were concerned with furnishings rather than fashions and had built their success on woven fabrics rather than prints, which they also supplied. Thus they were well placed to encourage collaboration between furniture manufacturers and weaving companies (which in 1946

were still supplying almost all upholstery fabrics). Indeed, Russell – as a furniture manufacturer – was a customer of Barlow, Goodale and Morton.[24] Their impact on the furniture section of the BCMI was clear: of the 12 firms supplying upholstery, most were connected with these men. Aside from their own firms – Helios, Warners, Morton Sundour, Edinburgh Weavers – there were weaves supplied by Holywell Mills (which produced the tweeds favoured by Russell), by Heal Fabrics Ltd (to which they all supplied), and R. Greg & Co (known for its cotton innovative yarns, some developed in concert with Marianne Straub, the designer for Helios). Despite 51 firms contributing lengths to the furnishing fabric display, it too showed a similar complexion: Barlow & Jones and Helios had 36 entries, Warners had 27, the two Morton firms had 35, Holywell had four and Heal's five. Greg's had 44, 16 under their own name and the remainder as suppliers of patterns to Grafton's, Morton Sundour, William Ewart had Ashton Bros (Figure 15). In total, these firms represented 48 per cent of the 314 lengths on display. The only other firms with more than 12 lengths were Donald Brothers (13, plus cloth for furniture), Turnbull & Stockdale (16, including seven on plastic) and Cavendish Textiles (24).[25]

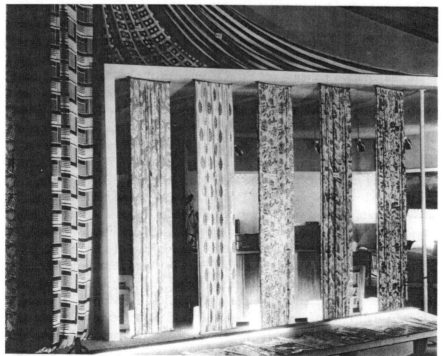

Figure 15 Display of Textiles arranged by Jacques Groag, BCMI.

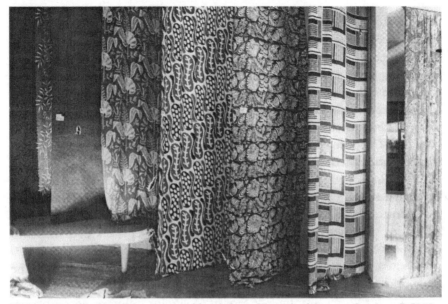

Figure 16 Display of furnishing fabrics from Furnished Rooms Section, BCMI.

Naturally, the designers linked to these firms also received the greatest recognition. Among the Greg patterns, all but the Grafton examples gave design credit to Margaret Leichner, the Bauhaus-trained weaver who developed hand-woven samples to display the Greg yarns; undoubtedly also hers were the Grafton patterns and at least some of the six lengths and other upholstery provided by Team Valley Weavers, where Leichner had been designer from 1938–42. One Warner example was also by Leichner, giving her a maximum total of 51 designs, or 16 per cent of all the furnishing fabric lengths. Next came Marianne Straub, with the Holywell tweeds to her credit as well as 23 Helios weaves, and Alistair Morton with 19 (Figure 16). Warner's display was more equitable, showing four lengths by Alec Hunter, two lengths each by staff designers Herbert Woodman and Albert Swindells, and examples by four other freelance designers besides Leichner. Helios, too, showed two lengths by Straub's assistant, Kathleen Fleetwood, and the work of seven others.[26] Hunter and Straub's use of certain freelance designers also reveals a consensus among the favoured firms: printed fabrics were commissioned from Barbara Pile (Helios and Donald Brothers), Jane Edgar (Helios and Heal's), John Farleigh (Helios and Morton Sundour),[27] Hans Tisdall (Helios and Warners) and A.H. Williamson (Warners and Donald Brothers); weaves were commissioned from Margaret Simeon and Olga Forbat (Warners and Cavendish Textiles). Margaret Simeon also provided a number of prints for Cavendish Textiles, as did Jacqueline Groag

and Lucienne Day. Other favourites already encountered through the dress fabrics were also represented, such as Gerald Holtom, Lana MacKinnon and Ascher (including one design for a Wareite table top). Nevertheless, the overriding styles were those created or endorsed by Leichner, Straub, Morton and Hunter. So while sharing with dress fabrics the emphasis on design-led firms, the focus for furnishings was on weaves, not prints.

Furthermore, although nylon and rayon are present, the focus was on cotton, linen and wool. Cotton received particular emphasis; Tootal's, having declined to state the fibre in their dress cloths, described their 11 lengths as 'Curtain fabric, screen printed, all cotton.'[28] The same fibres dominated in the furnished rooms, with all cotton (23) and cotton mixtures (10) accounting for 55 per cent of the upholstery and curtain cloths, and also represented in the many examples of household linens. Here one senses Barlow's impact as yarn controller and may assume he believed in a future when dress fabrics would be of man-made and synthetic fibres, with furnishings using natural fibres. To a large extent he was correct, although furnishings are more often printed cotton than woven wool, except for high-quality and contract uses. The ambivalence regarding fashion fabrics and confidence in furnishing fabrics also proved prescient; by 1950 India and Japan were the leading exporters of basic yarns and cloths (primarily used for clothing) and the Lancashire cotton industry was decimated during the 1950s. Screen printing of furnishings was the only flat textile sector not to decline in production until the 1980s. The woollen/worsted fashion fabric weavers who fared best were, as Wither's had predicted, those innovating cloth types and colourings; what all but a commentator on children's wear had missed was knitted outerwear, the biggest growth area, expanding by three times between 1931 and 1981 based on its lead in colour and design.[29]

The furnished rooms themselves were also a foresighted element on which Barlow, Russell and Goodale had influence and, in many cases, in which the textiles were a dominant feature (Figures 17 and 18). As active members of the DIA (Design and Industries Association), each had experienced the potency of such 'sets', both as a marketing device for products and as a way of encouraging the retail trade to promote Good Design. As the DIA's report of 1936 (alluding to the creation of the Council for Art and Industries in 1933) noted:

the Government has become a partner in the DIA's work. The latest important disciples are those engaged in large scale retail trade: men who, since they are able to dictate to manufacturers about the making of simple, everyday goods for the 1,000,000s, strategically count for a very great deal. How much these people can do for good design is shown by the success of the series of novel Store Exhibitions, started in 1934 under the direction of ML Anderson, chairman of the DIA.[30]

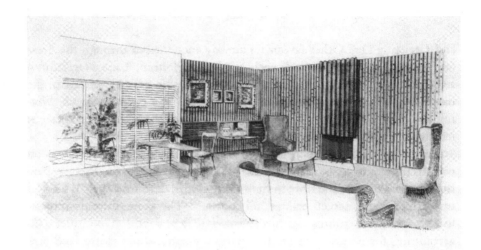

Figure 17 Drawing for the Living Room in a Large Town House, one of the specially furnished rooms at BCMI, by R.D. Russell for the imaginary family of a Barrister at Law who collects books, and his wife, a former actress, who gives musical parties.

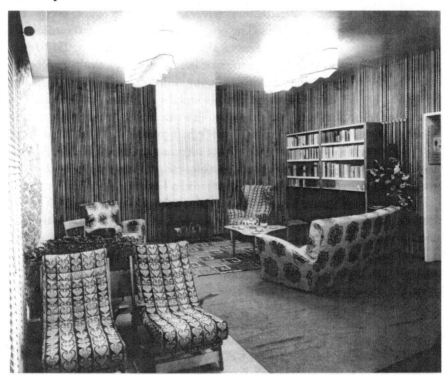

Figure 18 Finished result for the Living Room in a Large Town House by R.D. Russell for one of the specially furnished rooms at BCMI (see Figure 17).

These room sets differed from the suites of matching furniture long made available by large-scale furniture firms. While all the items were drawn from the shop's stock, they were presented as a room designed not by the manufacturer, but by an interior decorator or designer.

The BCMI's furnished rooms can be seen as an extension of the DIA's pre-war work and were evidently regarded as a key aspect of the exhibition. Nearly 20 per cent of the catalogue was given over to their description and they were one of the eight points selected as stops for the visit by the Royal party on 10 September 1946. For more than a year before, extended discussions considered their designers, hypothetical occupants, and the illustrations to accompany each room. The titles given to each room were also changed at the last minute, from, for example, 'a working-class Utility bedroom' designed by D.L. Medd, to 'A bedroom in a farm cottage.' The middle-class bedroom with twin beds, designed by A. Neville Ward, became 'A bedroom in a detached house' and the luxury bedroom with dressing-room by John Hill, became 'A bedroom with man's dressing-room and bathroom, in a large house.'[31] The original categories of working class, middle class, luxury and Scottish give an insight into the lives of those on the committees and represent one of the last occasions on which the paternalism and class concepts of the COID were so clearly revealed.

It should be no surprise by now that 68 per cent of the fabrics in the furnished rooms were supplied by Edinburgh Weavers, Morton Sundour, Warners, Helios and Holywell Mills, with Barlow & Jones represented by its sheets and towels. What is interesting is the positioning of a handful of fabrics. The architect's kitchen chairs and the railway worker's bedroom pelmets were both of 'Faulkland' wool by Helios,[32] but the slightly more expensive Holywell tweed was tightly targeted as upholstery for the curate's dining room, the broadcaster's bed-sitting room and the bank manager's living room (all sensible characters, one assumes, with an appreciation of quality). As befitted its reputation, Warner fabrics (cotton percale curtains printed with a Tisdall design, and mohair upholstery) were featured in the luxury bedroom, although their Utility weave, 'Chain', appeared in the woman journalist's bed-sit.

Two other 'working class' rooms had fabrics by Turnbull & Stockdale, Storey's and Wardle's, the latter supplying the printed cotton curtains for the miner's kitchen, the most popular room with the visitors (Figure 19), three-quarters of whom were from the 'artisan class'.[33]

Whether many of these 'artisan' visitors could have afforded – or would have liked – Helios, Turnbull or Wardle products, is not recorded. As if to reinforce this point, a printed cotton designed by Edinburgh Weavers

Figure 19 Cottage Kitchen in a Modern Mining Village by Edna Moseley, Furnished Rooms Section, BCMI.

appeared in four rooms: as curtains in the luxury bathroom, the curate's dining room and the broadcaster's bed-sit, and as a quilted bedspread and curtains in the farm cottage. Here was the promised 'fabrics for everyman and for the elite', but reality prevailed: in 1957 a *Sunday Times* correspondent noted that 'the treasures of Edinburgh Weavers are usually limited, for the general public, to what can be seen through their great glass doors.'[34] In setting out to promote Good Design – which it achieved by giving some half of the displays of fashion and furnishing fabrics to some dozen design firms – nowhere did the textile selectors really represent an understanding that:

> the fact remains that the products resulting from [a reluctance to accept compromise of any kind as a design policy] do not, as a rule, succeed in meeting public demand on a worth-while commercial scale, any more that the handmade articles of William Morris did in England during the Mid-Victorian era.[35]

Notes

1. *DIA Yearbook & Membership List*, 1945–46, 1947–48 and 1948–49, unpaginated.
2. Correspondence from Donald Tomlinson, 17 June 1983, quoting an interview with Alistair Morton in 1946.
3. Holliday & Brown had many of their silks printed by Brocklehurst Whiston Amalgamated, Macclesfield. These can be seen in the BWA guard books, Macclesfield Museums Trust.
4. 'Modern Designers of Furniture Choose their Fabrics', *Interior Textiles* c. 1946, p. 59; G. Schreiber Archive, V&A Archive of Art & Design, AAD/1991/11.
5. Ibid.
6. This was most clearly demonstrated in the display by Misha Black, which set out to explain what industrial design was.
7. Credibility in non-Western markets was also to some extent dependent on the perceived fashionability of British designers.
8. The Alison Settle Archive is held in the Design History Research Centre at the University of Brighton.
9. Settle, A., (1946) 'London: Can it Become a World Fashion Centre?' *Picture Post*, 6 January, cited in Gardener, A., 'Fashion Retailing 1946–86' in Sparke, P. (ed.) (1986) *Did Britain Make It?: British Design in Context 1946–86*, The Design Council, pp. 119–20.
10. Neale, M., (1946) 'Children's Wear', in Council of Industrial Design (1946a), *Design '46*, HMSO, p. 63; a very similar comment was made by Ashley Havinden regarding men's wear in the same volume, p. 74.
11. Council of Industrial Design (1946b), *BCMI Catalogue*, HMSO, 1946, pp. 182–3.
12. Ibid., and Council of Industrial Design (1946a), p. 55.
13. *BCMI Catalogue*, (1946) HMSO p. 186, nos 102–03 and 112.
14. Some of the draping by D. Stuart-Bell bore an intriguing relationship to the 'New Look', which was launched by Dior in the following year.
15. Withers, Audrey, (1946) 'Fashion, Dress Fabrics and Accessories', *Design '46*, HMSO.
16. Withers, Audrey, (1946), 'Fashion, Dress Fabrics and Accessories' in Council of Industrial Design (1946a) p. 46.

17. Ibid.
18. 'Notes of Guidance for Selection Committees, Summer Exhibition 1946', *Policy Commission Papers other than Minutes*, p. 50.
19. Wally Olins, 'The Industrial Designer in Britain 1946–82' in Sparke, P. (ed.) (1986), *Did Britain Make It?*, Design Council, p. 59.
20. The designers for Cresta were Mary Duncan, Patrick Heron, and Lana MacKinnon (who also designed for S. W. Whaley & Sons Ltd in Bradford and John Hall Ltd, Manchester); for Ascher the designers were his wife Lida (three examples), Henry Moore (five cloths and four scarves), Gerald Wilde (one), Sir Francis Rose (one), Elizabeth Forbes (one) and Graham Sutherland (two scarves). Catalogue entries 26–61 and 396 (Cresta); 309–27, 398–403, 414–15 (Ascher); and 346–67 (Duke).
21. For example, ID 361/14A: *Summer Exhibition 1946 – Design and Policy Progress Meetings*, 3rd meeting, 4 June 1946, at which the main textile section's design by Jacques Groag was approved 'as long as J. Cleveland-Belle is satisfied'; 10th meeting (19 June 1946), on materials section, textiles: 'Approved, but could not be passed until Sir Thomas Barlow has seen it'.
22. Sutherland's other designs were produced by Courtaulds, Heathcote's, Langworthy, Whaley and Ascher. The rose design became a good seller as a furnishing fabric and was continued in production by Warners after it purchased the Helios range in 1950.
23. Tomlinson (as above) shrewdly commented that 'it was hard for an outsider not to see Helios as a chairman's concession to a principle publicly endorsed'.
24. For further discussion of the links between these companies, see Schoeser, M. (1984) *Marianne Straub*, Design Council, pp. 71–80.
25. Donald Brothers were linen and jute weavers in Dundee, long known from their commitment to Good Design, having built their reputation by supplying Gustave Stickley's 'Craftsman Canvas'. Turnbull & Stockdale were (and are) Lancashire printers with a similar reputation, their first design director having been Lewis F. Day. Cavendish Textiles is the John Lewis Partnership brand.
26. Including Marion Parkinson, Dora Batty and Graham Sutherland.
27. And probably is the Edinburgh Weavers' designer referred to as James Farleigh.
28. *BCMI Catalogue*, 1946, p. 188; the designs were by A. Glasson and L. Dorriey.
29. Neale, M., (1946), p. 63, noting 'Children's knitgoods is another field in which British manufacturers excel . . . Design is mostly a question of clever knitting in quality yarns'.
30. *DIA Report* (1936) p. 4.
31. ID 361/14A, Minutes of *Summer Exhibition 1946 – Design and Policy Progress Meetings*, 24th Meeting, 9 July 1946.
32. The former also had Sutherland's 'Rose' curtains and the latter 'Summer', a one-colour Helios cotton print.
33. *Mass Observation*, ID 903/1LA, no. 1 and 'Preliminary Report on the BCMI', p. 3. The COID were so concerned about the fact that 'the Victoria & Albert Museum is not a recognised exhibition centre and has probably never been visited for any purpose by a large proportion of the population of London' that it allocated a special budget of £32,000 to promote the venue; *BCMI series 14A: Finance Report*.
34. *Sunday Times* (1957) 24 March, p. 11.
35. Lewis, Frank (1965) *Good Design versus Best Seller*, F. Lewis, p. 7, based on 'the contemplation of a problem that has fascinated me for a number of years'.

6 Moving Forwards But Looking Backwards: The Dynamics of Design Change in the Early Post-war Pottery Industry

Graham M. McLaren

> This day of austerity, in every phase of its rationed life, proves to us that hitherto we were wasteful and improvident – wasteful in every section of our life – and the things of which we have been deprived create no real hardship, and life is not really inwardly or outwardly defrauded or constrained. We have in all spheres time to estimate life's true values ... how are we going to assess the values, and are we going to be *the better* for having passed through a fire that refines?[1]

The first post-war decade was a time of profound change for the British pottery industry, change that extended beyond the particular area of design but which had a pronounced influence upon it. Foreign competition,

Figure 20 Pottery Selection Committee for BCMI

changing relationships with the consumer, and the introduction of new (and sometimes competitive) materials and processes combined to bring a feeling of discontinuity and disruption to what had always been a rather insular industry.

Against this uncertainty it is unsurprising that the pottery industry should see its own design tradition as a key anchor and foundation for future prosperity. The highly equivocal reaction of many industrial potters to the *Britain Can Make It* (BCMI) exhibition was indeed rooted in this belief. The feeling that the exhibition selection committee had chosen 'a limited collection of pottery which will appeal to an even more limited section of the public'[2] was shared by many in Stoke-on-Trent who saw the final display as reflecting the broadly pro-modern and anti-tradition views of the largely London based 'design establishment' (Figures 21 and 22).

Attitudes towards the British ceramic tradition, and the various future roles envisaged for it are the main concerns of this chapter; but to understand the nature of the debate one must first look to the pre-war period.

The ten years before 1939 were something of a roller-coaster ride for the British pottery industry, not least in economic terms; but the greatest impact on design was felt in the area of changing technology. Many significant new methods were introduced during this period, although in some cases it wasn't until after the war that they proliferated. The late 1920s and 1930s saw electricity used as a fuel for the industry for the first time, its cleanliness and controllability allowing a much increased palette of colours. For instance, the use of an electric tunnel kiln operating from 1929 at Royal Doulton made possible the firing of delicate 'on-glaze' colours for the famous 'Doulton Ladies' range of ware. Effectively mouths ever-hungry for both fuel and ware, tunnel kilns were highly significant agents for change. Size, cost, usage of fuel, and that most had to be operated 'around the clock' in order to be economical meant that they benefited the bulk producer with a large and stable market. Their widespread use is one very good reason why the industry became increasingly concentrated into large conglomerates – conglomerates that were able to invest in this scale of equipment.

These kilns profoundly affected design in that they emphasized easily applied surface decoration rather than shape design. They were constantly 'fed' with unfired ware stacked on trolleys trundling through the firing process which meant that it was most economical to stack these with a relatively small range of shapes decorated with a wide range of applied decoration. During the early post-war years concerns like Staffordshire Potteries Ltd developed quickly. Specializing in producing 'once-fired' pieces, they mainly used the

Figure 21 Pottery display arranged by Harry Trethowan of Heals in Shopwindow Street, BCMI.

Figure 22 Pottery display in Shopwindow Street, BCMI.

simple, cylindrical mug shape, with a huge range of applied decoration. By the early 1950s the company boasted that one week's production would stretch end-on the 175 miles from Stoke-on-Trent to London.

The effects of this on design traditions quickly became a real source of concern to critics, and these concerns were most keenly felt in the area of surface decoration. While a technique like screen-printing only had a real impact on the 'look' of ceramics during the 1950s (its first use in commercial production seems to have been by Johnson, Matthey and Co. during 1938) the use of lithographic transfers bought in from specialist firms like Johnson Matthey and Ratauds was already widespread during the 1930s. Pioneer manufacturers such as Susie Cooper demonstrated that the stigma attached to lithographic transfers was unjust. Producing well designed and technically proficient transfers she showed that when used as an innate and internal part of the production process they could cut down on production time and labour costs with little or no sacrifice of quality. Nonetheless, Susie Cooper used lithography as just one of a number of surface decoration processes. Moreover, the designs were her own, produced to harmonize with specific shapes. It was in fact the isolation of the decoration houses from the shape manufacturers, together with the tendency of manufacturers at the lower end of the market to slap lithos on to ill-suited shapes, that made lithography a prime target for the critics of contemporary pottery design.[3]

However, these issues were placed in abeyance by the necessities of war. If the experience of the years immediately before 1939 set the fuse for the debate surrounding 'tradition' in British pottery design, then the profound effect that the Utility scheme had upon the very 'look' of British ceramics most certainly lit it.

While there is an increasing corpus of literature on various aspects of Utility, its influence on the industrial production of ceramics has received very little attention.[4] This can be explained partly by the powerful image of the furniture designer and civil servant Gordon Russell, whose role as the 'creator' of the Utility aesthetic has only been questioned relatively recently. Secondly, and perhaps more tellingly, the application of the Utility scheme to the production of ceramics resulted from about 1943 onwards in the reduction of shapes to a bare, ascetic minimum and the elimination of any coloration, even to produce a backstamp. As a result Utility ceramics offer very few aesthetic or critical footholds by comparison with Utility furniture or fashion. While other areas can still be discussed to an extent in terms of form, decoration and workmanship, Utility ceramics were truly 'utilitarian'.

This is a problem because the legacy of Utility ceramics was an important

element of the reconstruction debate. Indeed, some critics regarded it as one of the most successful aspects of the whole Utility scheme. The *Architectural Review* for example launched a *Design Review* section in 1945 with an advisory panel composed of many of the leading modernist thinkers of the period including Misha Black, Nikolaus Pevsner, and Herbert Read. They were generally positive about the purifying role of Utility as a design aesthetic, but reserved special praise for ceramics:

> the utility designs for tableware have probably reached the highest standard of any utility products; and these have been produced naturally within the industries themselves without any of the 'sweat and toil' which unavailingly has been expended in many other fields.[5]

These critics were of course excited by the plainness of Utility, and by the radical effect it had on the 'look' of British ceramics. Influenced by modernism they saw in it echoes of the functional aesthetic that they hoped would influence British design in the future, breaking down the stultifying influence of tradition. There can be no doubt that Utility did play a part in banishing the huge variety of tableware shapes and services that had been a feature of pre-war production,[6] but the extent to which it helped cause the mid-1950s taste for strong, simple shape and 'modern' surface decoration is less clear.

It was the way in which the scheme forced people to think about the nature of British ceramic traditions that is most significant for this chapter. Even those close to the industry could initially see the advantages that Utility might offer in providing a contemporary feel to design. War-time articles by influential figures in the pottery industry such as Harry Trethowan and Gordon Forsyth use the language of 'chastity', 'virginity', 'cleanliness', 'morality', and 'new growth' to describe the potential of the Utility scheme in this direction. They were particularly impressed by the way in which it forced manufacturers to think about the future. As Forsyth wrote:

> The new enforced contemplation of batch after batch of plain, undecorated ware coming from the kilns may have a salutary effect on the Staffordshire potters. After a period of chaste, virginal shapes, the enormity of some of the pre-war decorations may begin to be realised. A new generation of designers may even be given the opportunity to make a new start.[7]

The extent to which this language changes by the end of the war is startling. An article, again by Forsyth, on 'Planning Prosperity' is one example. He declared:

I believe that there will be an immediate revulsion to white ware, and that the general public will vote solidly for *colour*, and plenty of it. ... The present ghastly phase of extreme standardisation, "utility" this, and "austerity" that, can be carried too far, and will die as quickly as it was imposed on any industry as soon as the barriers are down and we are free from the dead hand of bureaucratic control.[18]

Behind language like this was a desperate concern that the traditional characteristics of British ceramic design ran the risk of being diffused and possibly lost in the post-war world (Figure 23). It was noted with alarm, for instance, that unlike the British experience the concentration of the German industry had been structured so that no factory had been allowed to go out of business. The Germans operated instead on a 'skeleton staff', who would keep alive the prospect of a healthy variety of production for the German industry in comparison with the homogenizing effect of Utility in Britain.

For some the answer was to focus on the role of shape design, seeing the evolution of decoration as something that could be left safely to the whims of fashion. They believed that it was in *shape* that national identity resided, so pre-war, traditionally 'British' shapes shorn of any decoration should be retained in the production of Utility. Gordon Forsyth argued for just such an approach, comparing in illustration the 'excellent' shape of a piece of Pountney hotel ware with the 'Mass Utility' that was 'produced by the

Figure 23 Decorated post-war ceramic designs at BCMI: dinner plate and vegetable dish in cream with pink decorations.

million to Government specification, and likely to damage [the] reputation of British Potters'.[9]

Thus the concern was over the very 'shape' of future pottery design in Britain. Looking back with the benefit of hindsight we can see in the basic cylinder style mug, decried by Forsyth as examples of government-inspired 'Elephantine cups, with clogs on for handles',[10] a shape that was to prosper in the post-war period. Suitably refined, it proved remarkably useful as a vehicle for the new generation of photolithographic and silkscreen-printed decoration and continues to be produced to this day.

These then were the tensions and pressures that already existed, fuelling a fundamental re-evaluation of the significance of the British ceramic tradition by those concerned with the reconstruction of the industry in the post-war period.

To achieve this, however, some form of framework was needed for understanding what this tradition was and how it had started. To this end, many took comfort in being able to see what they believed was a readily delineable and separate tradition for British ceramics extending back to mediaeval times. Such an approach can be traced back to the work of historians like Bernard Rackham (1924) who, together with the young Herbert Read, extolled the virtues of British mediaeval pottery which 'are almost invariably well balanced and effective'[11] and 'show indeed a dignity which is wanting in most of the later wares'.[12]

Of course, the reverence for mediaeval ceramics represented more than simple nostalgia. To Herbert Read there was clearly an interest in the simplicity and functional values demonstrated by these wares, while Gordon Forsyth's daughter Moira, in her *Nuffield College Social Reconstruction Survey* report (1943) for the government, suggested that it was 'not only a fascinating study in itself, but a cautionary tale with a bearing on the present and future of the industry.'[13] To most, however, an interest in mediaeval pottery seems to have been a reaction to a feeling that the spirit that made British ceramics peculiarly 'British' was under attack. On the most obvious level this was due to uncertainty caused by the war, but different sources voiced different concerns. The likely dominance of big business after the war was an active worry for many workers in the industry, while to others a revival of the pre-war 'Jazz-Moderne' style was a looming threat.

Against this problematic future the world of the anonymous pre-industrial potter was idealized in officially sponsored publications designed to give the public a clear understanding of the role of various industries in British life. For instance, the early productions of the potteries were depicted as possessing 'the everyday characteristics of the people them-

selves, commonsense and humour',[14] fourteenth- and fifteenth-century pots 'are robust, generous and hearty and seem to be typical of Chaucer's England',[15] while English slipware and saltglaze of the sixteenth and seventeenth centuries have 'a peculiar wholesomeness, comparable to that of cottage bread'.[16]

A natural extension of this process was to make comparisons between the disruption of the world of the early potter by industrialization, and the wartime situation of Britain. The language used is that of the good, the pure, and the 'British', being challenged and threatened by outsiders. Moira Forsyth's influential survey provides a particularly vivid example of this process in action. She puts the break leading to the eventual loss of the mediaeval tradition as the arrival of the Dutch Elers brothers in the potteries during the 1670s. They were 'foreigners' to the district who 'conducted their work in great secrecy, apart from the general community' and 'thought in terms of metal rather than clay'.[17]

Out of this she developed a framework for understanding the decline of natural 'good taste' in pottery design over the last two centuries by ascribing it to the pernicious effect of foreign influence. Hence Josiah Wedgwood is accused of introducing Neo-classicism into the pottery industry as 'a conception foreign to the natural development of the craft'[18] and an outside artist, John Flaxman, who 'understood nothing of the processes or of the materials in which his work was reproduced',[19] thinking 'not in terms of pottery, but of sculpture'.[20] Similarly, the excessively florid style of the nineteenth century was blamed by Forsyth on the influx of decorators and modellers 'from Sèvres and elsewhere who sought refuge here in the Franco-Prussian war . . . their idea of a design was to apply a spray of highly realistic flowers indiscriminately to any available surface'.[21]

Other authors refined this approach in so far as it could serve both as a propagandist, nationalist view of the past, and as a framework for approaching the problem of pottery design in the post-war world. The most acute of these also managed to link in a direct economic interest. John Gloag, for instance, suggested that a return to an English tradition was essential to the winning of American markets after the war 'for if we can openly say: This idea is *English*, then we shall keep and win many markets by the one quality which precludes competition . . . our way, our national way'.[22]

While the idea of the outsider and the foreign as a direct threat was a particular issue during the war years, in the post-war period the emphasis for the Stoke industry especially shifted rapidly to seeing Whitehall in general and the Council of Industrial Design (COID) in particular as conduits for dangerous foreign ideas, the *Pottery Gazette* in 1949 noting, for

example, 'a very real hostility'[23] to the ideas of the COID. This hostility would have remained on a fairly general level were it not for specific, government-sponsored 'threats' such as the nation-wide touring exhibitions of Picasso's work. Exhibited in Stoke in 1950, Picasso's work caused a local furore. The industrial potters saw it as the antithesis of their heritage of careful workmanship and slow design development. Their attitude towards the 'chaotic mysticism of the Picasso School'[24] meant that the artist's name joined terms like 'Jazz', 'Cinema' and 'Futurist' as terms of general abuse to describe modernist thinking.

This antipathy towards what was seen as government interference might imply that it created an immediate reversion to the dominance of historical form and pattern in pottery after the war ended. The reasons why this was not totally so are varied and complex; but one of the most powerful was a quick realization by the industry that things were not going to be the same in the post-war world as they had been in the 1930s.

Because of this, the debate subtly changed during the late 1940s from a clear divide between traditional design and a more contemporary idiom, to what type of design would provide the most effective and secure future for the industry in a changing world. The central crease of this blurred line became the question of what made British ceramic design peculiarly 'British', in that the preservation of a national design identity in pottery was regarded as the best hope for the future. An echo of this attitude is apparent as late as 1957, by the (unidentified) author of 'Tradition and the Something Different' in *Pottery and Glass* who believed that:

> the industry will receive a challenge when the European Common Market comes into operation. . . . Ultimately, this should encourage countries to stick to making what they have become famous for – in other words, to make the best possible use of their traditional crafts, skills and processes – rather than to imitate popular lines from other countries. We can hope that this will lead to a happy state of affairs, of economic advantage to all.[25]

An emphasis on a national, rather than traditional, design style also offered other advantages. With the possible exception of the Midwinter company after 1950, the most progressive companies for design were 'out-potters' – firms located outside the Stoke-on-Trent area. While the popular perception of traditional design in ceramics focused largely on the products of North Staffordshire, with the post-war expansion of firms such as Poole, Denby, Hornsea and, in Scotland, Govancroft, the focus of interest in terms of contemporary design began to shift away from Stoke-on-Trent.

Perhaps the greatest change however was in the relationship of ceramics

to other industries. Producers were having to face an industrial system that was no longer based on a series of essentially 'island' industries producing design in their own idiom:

> It is, nowadays, becoming increasingly apparent that a link up between pottery, glass and textiles can be a valuable sales aid. Whereas before, or just after the war, the whole idea smacked of being chi-chi, it is clear that the public are growing more and more design conscious. Visible proof can be found in the crowds, purely intent on window shopping and comparing displays, who invade the big towns and cities on Saturdays. As a result, whereas before the war a fashion was prevalent mainly among richer people, today it penetrates to a greater extent down from the West End through every strata and is to be found, though sometimes vulgarised, in every suburban store.[26]

The new 'national' idiom would, therefore, have to be adaptable enough to harmonize with other design conscious industries. In this sense it was crucially different from the idea of the 'Traditional' that emphasized the past of the pottery or the furniture industries in isolation. *Pottery and Glass* ran a series of articles dealing with the possible integration of different materials which pointed out how developments in transfer technology laid open the way for combining and integrating decoration between different media. It also emphasized the extent to which continental firms were already capitalizing on these advances, citing examples such as the links between the German firm Rosenthal and the Swedish glass company Orrefors, offering to put companies in touch with suitable 'opposites' in other materials.[27] From this it seems clear that the requirement for a national rather than Traditional idiom was generated by technological, economic and cultural change, and by the establishment and success of a new class of design conscious 'out-potters'.

A helpful starting point for understanding the form that this new direction took is provided in the introduction to a survey entitled 'The Potteries in Transition' by George Ratcliffe for *Design* (1963). Taking as a baseline the survey of pottery design provided by events such as *Britain Can Make It*, the Festival of Britain, and the souvenirs produced by the industry for the Coronation in 1953, Ratcliffe noted how the 'Brutishness' of British ceramic design had developed into a series of motifs based on a mixing of foreign influences and what he regarded as traditional design. Among these new motifs were:

> An emphasis on body material, with earthenware losing its connotations of cheapness, and generally whiter wares being produced.

A contraction in the number of shapes and patterns available, particularly compared to the pre-war period. This lessened the emphasis on the 'give the customer what he wants' attitude which had been dominant in the industry.

A new concentration on shape that, although moving away from specific examples, continued to use shapes with historical and national meaning. Ratcliffe cited in particular David Queensberry's shapes derived from the old milk churn form for Midwinter.[28]

Ratcliffe's views would be dangerous evidence to take in isolation, but the early 1960s was a period of general reflection on the post-war years, and by this time there was something of a consensus in the trade as well as among outsiders. 'Post-war British designs of new non-traditional character are selling steadily, and in most cases better than traditional designs of prewar and postwar origin'[29] noted the retailer Angus G. Bell in 1962. He suggested that:

continental travel and continental salesmanship brought us both the demand for, and the offer of (at first sight), outlandish designs ranging from almost invisible patterns on the severe white shapes of Scandinavia to the carefree riot of coloured vegetables, etc; from Italy. These things gave our minds a much needed jolt – breached, one might say, our smug, safety first, 'reproduction' defences, and let in the post-war British designers, backed by the COID.[30]

This last quotation hints at a crucial issue behind the development of a 'British Contemporary' style during the late 1950s and early 1960s. This was the transfer of the 'reins' of ceramic design from a sales-led boardroom consensus to a new class of ceramic designer who had far more status and independence. This in turn resulted in a more targeted and professional attitude towards design for foreign markets. A reflection of this can be found in the trade press during 1956. Two articles, 'The Vogue of Today and Perhaps Tomorrow', published during February, and 'The British Touch with Contemporary Patterns', in September, considered the market for British ceramics in Canada. What raises them above the level of the normal review of potential export markets provided by trade magazines is that they saw Canada as particularly useful as an entrepôt for British goods into the far larger United States market. To *Pottery and Glass*, the Canadian market was a unique one, in that it combined an allegiance to Britain with an essentially American outlook towards design.[31] It could, therefore, provide valuable information on foreign tastes, and on the needs of the British market as well. From its Canadian survey *Pottery and Glass* identified 'British Contemporary' as evolving a new relationship between shape and pattern, and singled out the 'Coupe' shape, with the all-over surface pattern allowed by

developments in lithographic techniques. There was also a tendency to spend less on body material (in other words, to buy earthenware and stoneware instead of porcelain) but to buy more frequently.

In terms of pattern design 'British Contemporary' was one that could incorporate the impression of 'fashion' (patterns with a limit to their appeal in terms of time span), with a 'national' identity:

> Stoke and Stourbridge, while making contemporary patterns in a big way, yet succeed in giving them that something extra, something different in their conception that immediately singles them out as being British. It is this something different that gives the Canadian dinner table that extra chic, admired by guests and treasured by the hosts. Like a Paris frock, it has a style about it that is immediately recognisable to the discerning eye.... This individual 'twist' is obvious in feeling and yet it entirely defies attempts to define it. It is undoubtedly in part derived from tradition. Here one of the components can be analysed in those two largely synonymous words, taste and restraint. Even when occasionally a British firm comes out with a first-class gimmick, like that classic 'Man Friday's Footsteps', it is in black on white. But if it had been made in America, it would have probably been in flaming red and emerald....This, then is the field in which Britain can fill a demand that is out of reach to both the American and continental potters ...[32]

The first decade after the Second World War had demonstrated the importance of the 'Brutishness' of British design to the industrial potters, but by the late 1950s it was clear that this alone could not sustain demand in a volatile world market. As manufacturers accepted the necessity of a clear understanding of the latest foreign design and demand, so the emphasis on individual designers with a knowledge of contemporary design trends increased. The designers themselves now visited foreign markets on a regular basis, placing heavier emphasis on the design requirements of particular markets and less on tradition:

> A Canadian agent can come over to Britain and give a detailed report of the latest successful patterns selling in Canada. But he can only report on what he has seen. Not being a designer, it is difficult for him to suggest what can be done. So it is valuable if the designer goes out to Canada himself to sense the public taste. He will find this not only in the pottery and glass, but also in the textiles, the furnishing, wallpapers and even the advertisements, in fact, in the local environment.[33]

The tacit acceptance in this passage is of the training of the designer reaching above the intuition of the sales manager or the company board. Although the role of tradition was still acknowledged and recognized, the impression gained by a study of the last years of the 1950s is of an emphasis on the adaptation of peculiarly 'British' design elements to the particular

requirements of different markets. The 'engine' of all this was a new form of professional ceramic designer.

Notes

1. Trethowan, H. (1943) 'Utility Pottery', *Studio*, February, p. 48.
2. *Pottery and Glass* (1946) 'Exhibition Forum', November, p. 19.
3. The potter, educationist and writer Dora Billington (1937) summed up the problem of re-establishing the link between designer and product, and also holding out the possibility of absorbing the process into tradition when she suggested that: 'no good design in lithographic transfer can possibly arrive until the designer himself draws quickly and freely on the stones', Billington, D.M. (1937), *The Art of the Potter*, Oxford, p. 104.
4. The best sources are Hannah, F. (1986), *Ceramics*, Bell and Hyman; Watkins, C. Harvey, W. & Senft, R. (1980) *Shelley Potteries: The History and Production of a Staffordshire Family of Potters*, Barrie and Jenkins.
5. Its stated intention was to produce 'a discussion of new designs, new materials and new processes, and as a reminder of the specific qualities of our age which war necessities are bringing out in their purest form, and which a more carefree and fanciful post-war world should not forget', *Architectural Review* (1945) 'Design Review – Tableware in Wartime', January, pp. 27–28.
6. There is evidence to suggest that this was however a gradual process. For instance, the Domestic Pottery (Manufacture and Supply) Order 1942 still included differentiated meat and vegetable dishes and sauce boats in its list of essential items; Watkins, C. et al. (1980) p. 135.
7. Gordon Forsyth in Desmond, J. (1942) 'Plain China – A Limitation or a Challenge?', *Pottery Gazette and Glass Trade Review*, February, p. 107.
8. Forsyth, G. (1944) 'Planning Prosperity', *Pottery Gazette and Glass Trade Review*, May, p. 262.
9. Ibid.
10. Ibid.
11. Rackham, B. & Read, H. (1972 reprint of 1924 edition), *English Pottery*, EP, p. 11.
12. Ibid.
13. Forsyth, M. 'Design in the Pottery Industry', *Nuffield College Social Reconstruction Survey*, October 1943.
14. Ibid.
15. Sempill, C. (1946) *English Pottery and China*, Collins, p. 11.
16. Marriott, C. (1943) *British Handicrafts*, British Council, p. 34.
17. Forsyth, M. (1943) op. cit.
18. Ibid.
19. Ibid.
20. Ibid.
21. Ibid.
22. Gloag, J. (1941) 'Planning for the Future', *Art and Industry*, p. 132.
23. *Pottery Gazette and Glass Trade Review* (1949) 'Design Week in the Potteries', April, pp. 375–76.
24. *Pottery Gazette and Glass Trade Review* (1950) April, p. 521.
25. 'Tradition and the Something Different', *Pottery and Glass*, August 1957, pp. 253–54.
26. 'The Link Between Pottery and Furnishings', *Pottery and Glass*, May 1957, pp. 155–61.
27. *Pottery and Glass* (1956) 'Pottery and Glass in Harmony', October, pp. 336–40.
28. Ratcliffe, G. (1963) 'The Potteries in Transition', *Design*, no. 177, p. 48.

29. Bell, A.G. (1962) 'Good Design or Good Seller – Can You Have Both?', *Pottery Gazette and Glass Trade Review*, September, pp. 1089–93.
30. Ibid.
31. *Pottery and Glass* (1956a) 'The Vogue of Today and Perhaps Tomorrow', February, pp. 35–39.
32. *Pottery and Glass* (1956b) 'The British Touch with Contemporary Patterns', September, pp. 286–91.
33. Ibid., p. 288.

7 Good Design by Law: Adapting Utility Furniture to Peacetime Production: Domestic Furniture in the Reconstruction Period 1946–56[1]

Judy Attfield

Introduction

During the Second World War the design of furniture for the civilian population was regulated by laws brought into force as part of the Utility Scheme in 1943 to ensure the best use of scarce material and labour in a time of national emergency.[2] The standard design specifications provided a means of controlling maximum prices in order to prevent profiteering, while also enabling a singular experiment in the use of design as a vehicle to enforce rationalization in the production and fair distribution of essential goods. The

Figure 24 Room designed by Jacques Groag, Furniture and Textiles Section, BCMI, 1946.

interface years between 1945 and 1948 saw a restructured industry adapting itself from war to peacetime conditions fraught with difficulties of shortage and restriction. The first step in the relaxing of the Utility regulations was conceded by the 'freedom of design' allowed in 1948 which lasted until 1952 when the Utility scheme was entirely dissolved. This essay will focus on the politics of design in the post-war years. In particular it will discuss how the various interests of state, producers and retailers were adapted, reflected and played out through the design of domestic furniture in the only period in the history of furniture when its design was governed by law.

The Good Design campaign

A group of idealistic design specialists involved in advising the Board of Trade on the design of Utility furniture, saw the special circumstances which had justified state intervention during the war, as an unprecedented opportunity to improve the general standard of furniture design. Their hopes were expressed in their contribution to *The Working Party Report on Furniture*,[3] published in 1946, in which it stated:

> We do not believe that the public's taste can be properly assessed as long as the choice available is between one poor design and another. . . . In spite of its limitations of choice, we believe that the utility furniture scheme has done much to accustom a wider public to a better standard of design.

Gordon Russell and Jack Pritchard, two individuals particularly active in the initiative to improve the quality of British furniture design, are representative of two quite different strands of the thinking which blended in the formation of the post-war Good Design movement. Russell's respect for English craft traditions and Pritchard's belief in American Fordist mass production techniques were brought together in the public agencies set up to promote the production of well designed furniture. Gordon Russell, steeped in the Arts and Crafts traditions of Ashbee and Gimson, brought those sympathies with him to the chairmanship of the Design Panel which monitored the Board of Trade's Advisory Committee on Utility Furniture from 1942 to 1947 when he left to become Director of the Council of Industrial Design (COID). He was also associated to the Design Sub-Group of the Working Party appointed by the government to produce the report quoted above.[4] Jack Pritchard favoured reforming the process of furniture making from a craft to an engineering practice and treating furniture as an industrial product capable of standardization.[5] During the 1930s he had

been associated with the Venesta Plywood company and the architect Wells Coates with whom he formed Isokon, a firm specializing in the design and production of modern plywood furniture and fittings. In 1945 Pritchard briefly chaired the Design Sub-Group of the Furniture Working Party before becoming the Design Director of Lebus, the largest and most industrialized of the furniture manufacturers in Britain.[6] After three years he left disappointed in his failure to make any impact on their design policy and took up the post of Secretary of the Furniture Development Council set up by the government to steer the rationalization of the industry after the war.

When the Utility specifications set out by the Board of Trade were first established, they encompassed a whole range of goods for civilian use – from ceramics and pencils, to clothing and wedding rings.[7] But it was only the furniture industry which was compelled to conform to specific statutory designs.[8] Initially the policies laid down by the Utility scheme seemed to offer design reformers a chance to coerce manufacturers, retailers and consumers to produce, sell and buy furniture of sound economic construction and modern design – principles derived from an ethics of 'Good Design' rather than based on commercial expediency. It would then seem ironic that the rather blunt styleless appearance of Utility furniture designs should have been accorded heroic status as a triumph of Good Design, when it can clearly be seen to have been the result of an amalgam of pragmatic decisions precipitated by conditions prevailing during a period of scarcity when war production took priority.

Utility designs may have had the morally hygienic effect that the design reformers would have wished – of teaching abstinence from conspicuous consumption; but the wartime Utility designs cannot be said to have been, in any sense, appealing to a majority taste. And nobody knew that better than the small minority of privileged taste leaders who at the end of the war no longer had the justification to dictate design by law. The new task they set themselves was to reconcile their perception of 'Good Design' with the general consensus of popular taste. Typical of the thinking of reformists, were the remarks by the architect Lionel Brett who saw himself as part of that 'new generation of [design] pioneers [preparing] ... to make itself unpopular' working towards the 'steady infiltration of decent standards' in the face of the danger 'of a wild and woolly reaction from Utility which could liquidate the new standards before they have set'. He predicted the role of designers would be:

> to satisfy the demand for rococo pleasures and baroque thrills which is bound to come. It must tackle the subtleties of the monumental and the problem of ornament. In its hands the cactus must learn to flower.[9]

During the war the actual style of Utility furniture was but a small detail in the context of a much larger and longer term project planned for the Reconstruction period, laying the ground for the rationalization of industry after the cessation of hostilities. The aim was to dispense with traditional craft practice except for a small exclusive sector of the trade and adopt an innovative aesthetic, commensurate with machine production and the modern age. But furniture manufacturers and retailers were only prepared to accept the banishment of reproduction antiques, ornament and style variety, together with the control of their profit margins and fixed maximum price, while the war lasted.[10] It was mainly the difficulty in controlling the price of furniture which led to the introduction of the Utility Designs from a recommendation originally made by John Hooper, head of the Ministry of Building and Works to the Central Price Regulation Committee in 1942.[11] The institution of exact specifications and standardization through the Utility designs made it possible to work out precise costings for the fixing of maximum prices.

Post-war responses

Once peace was reinstated it was recognized that a different strategy would be required to persuade the trade to gear its furniture design and production along the lines drawn by would-be reformers. The advisers to the Board of Trade, eager to reform traditional mainstream furniture design, saw the opportunity created by the retention of the Utility scheme in peacetime as a way of ensuring by means of the law, that control over design could be retained until a higher standard was reached. It would thus be able to build on the initiative laid down by the first Utility designs. These were not in themselves considered to be ideal but were the best which could be achieved given the limited materials and the de-skilled small workshop labour force left over once the larger firms had been deployed in essential war work.[12] Characteristic of the reformers' optimism in the virtues of the Utility scheme, was Gordon Russell's observations made in 1947:

> it may well prove that war-time control, accompanied by a positive urge, at a very formative period, has enabled this whole trade to review its position more freely, since the anxiety of what to make for next autumn and next spring has for the moment been removed.[13]

But it was a vain hope, not held for long, that the whole of the furniture industry could be coerced to change from batch production of traditional

types and styles, to modern design suited to mass production processes.[14] Nor were retailers in favour of rationalizing and standardizing designs. They considered their ability to offer a wide variety of models in reproduction styling to be one of the distinctive features on which their business depended. Notwithstanding Jack Pritchard's bias against popular taste, it is evident he understood the retailers' point of view he observed retrospectively:

> Why was there such a difference of opinion between the so-called experts, the critics of design, and the manufacturers who produced for the bulk of the population? It was not just a matter of taste; the manufacturers were also uninterested in evidence about users' tastes and needs. Guided purely by salesmen, the industry celebrated the end of the Utility scheme by piling glamour on glamour – gorgeous cocktail cabinets and amazing dressing tables. It was said that the public liked these designs, but perhaps the reason for making them had more to do with being one up on the next retailer than with trying to find out the needs of the public.[15]

The government's attempt to rationalize the industry through a policy of 'concentration' entailing the amalgamation of several small firms into single large units to maximize productivity and efficiency, remained voluntary and was never realized in the furniture industry. It was only the larger firms like Lebus, who were already familiar with the concept of industrial design based on engineering principles, who didn't need converting to large scale manufacturing. But unlike Marks and Spencer with their own chain of shops, Lebus did not control their retail outlets and, once freedom of design was conceded in 1948, ignored the 'Good Design' practice advised by Jack Pritchard and quickly gave way to retailers' demands for style variety.[16]

While the larger furniture manufacturers like Lebus had been occupied with essential war work, the smaller makers designated to manufacture Utility furniture were kept fully occupied in a sellers' market. But once the war was over and the larger better equipped firms returned to domestic furniture production the small manufacturers were no longer protected from competition. Contrary to the policy of rationalization favoured by the government the trade wanted the option to produce non-Utility goods.

The new peacetime Utility designs were designed with the realities of a diversified industry in mind. The Chiltern range, based on the original Utility range, used a conventional system of manufacture that fitted easily into existing trade practices. The Cotswold range, although ostensibly 'designed for mass production', could also be adapted to handcraft manufacture and was the preferred choice of the post-war Utility design ranges among the promoters of Good Design, figuring prominently in the *Britain*

Can Make It exhibition room settings.[17] It broke away from what modernist design experts considered outdated panel construction, using innovative materials and assembly methods to give a contemporary flush finish. However, the Cotswold range proved too heavy, fussy and expensive to produce and was withdrawn in 1948. A number of prototypes for a more economic range of designs specifically intended for mass production made short appearances under the names of 'Cockaigne' and 'Cheviot' but do not appear to have been adopted for production.

Generally the trade perceived the Utility scheme to have been detrimental to the industry. Representative of this view was L. J. Barnes, furniture designer with Gommes, one of the largest furniture manufacturers in High Wycombe. In a letter to the *Cabinet Maker* in 1948, he expressed his alarm over the 'devastation caused by the control which has given us Utility' and cited it as the reason why 'inventiveness and craftsmanship are dying.'[18] The Board of Trade made a last effort to standardize Utility designs under a single Diversified range but finally gave way to the concerted pressure from the furniture industry and decided not to enforce it. 'Freedom of design' was conceded in 1948, at the same time that rationing also ceased. This allowed manufacturers to design their own Utility furniture provided they kept to a strict specification of dimensions. However, the so-called 'freedom' did not extend to many pre-Utility furniture types such as bridge and tub occasional chairs, because of the dimensional restrictions qualifying Utility tax-free status. Nevertheless a large number of style, structure and quality variations appeared, undermining the principle of standardizing 'Good Design'.

Although growth was considered not only desirable but essential, both for political reasons and for the developing importance of full employment, the government's post-war economic policy was directed at restraining domestic demand.[19] To this end selective fiscal controls were applied to achieve the balance between stimulating demand and exercising restraint without depressing the home demand for consumer goods too much. In 1949 price control of non-Utility domestic furniture was removed and subjected to $33\frac{1}{3}$ per cent purchase tax in contrast to Utility furniture which was tax free, creating a hugh distinction between taxed and tax-free categories. In spite of its low price Utility furniture sales declined as non-Utility furniture became available.[20]

Price control imposed different rates of profit margins on Utility goods for manufacturers and retailers, allegedly favouring the latter and causing much resentment among furniture manufacturers. This also applied to Utility furniture when there was freedom of design. If manufacturers wanted to produce their own Utility designs they had the inconvenience

of still having to comply with strict specifications and a price ceiling, plus having to submit them for approval before they could offer them for sale in the tax-free Utility category. Furniture retailers were not as badly hit as manufacturers of furniture. Demand of consumer goods generally far outstripped supply so there was little selling for the retailer to do. Second-hand furniture was used as a good standby for many furniture retailers while there was shortage of new goods. There was little need for retailers to spend on advertising or any other kind of marketing promotion.

After December 1952 the Utility Scheme came to an end, removing price control and permitting in theory, the return of a competitive 'buyer's market'.[21] This took a long time coming, and according to sale statistics cannot be said to have occurred until supply caught up with demand towards the end of the 1950s.[22] The dissolution of the Utility Scheme also brought an end to its privileged tax-free status, replaced from 1952 by the 'D-scheme', a system of calculating tax on all furniture that enabled a broader spectrum of prices and goods to be made available. The new tax scheme took into account the need to provide goods at a price immediately above top Utility prices by calculating the tax as a deduction (therefore the 'D') of the excess, if any, of the wholesale value of the article over the tax-free limit.[23] Henceforth control on demand of furniture was largely exercised by the government directly through the regulation of hire purchase.[24]

From an ethical aesthetic to 'amazing dressing tables'

The first Utility range had a 'back to the wall' quality making a virtue out of necessity and providing only the most basic of items of household furniture. The designs were hurriedly cobbled together keeping in mind the deskilled sparse labour force and the less well-equipped workshops designated to manufacture it. Though the wartime designs resulted from a realistic appraisal of available resources matched against a well-defined need, their banal appearance cannot be entirely explained away by pragmatic considerations of economic and technological imperatives. It was no accident that the designs avoided all reference to the reproduction 'Jaco' styles which would have been more familiar and attractive to the general public. There is ample evidence that the Utility designs were based on precedents for an ethical aesthetic which agencies like the Design and Industries Association (DIA) were already recommending during the First World War. Percy A. Wells, a furniture designer affiliated to the DIA and head of the cabinet department of the LCC Shoreditch Technical Institute, as early as *c.* 1920 was

maintaining that 'household goods ... can be both cheap and good'. In *Furniture for Small Houses: A Book of Designs for Inexpensive Furniture with New Methods of Construction and Decoration*, illustrating 'an adjustable easy chair' almost identical to the Utility Fireside chair Model No. 1, he wrote:

> we have to get rid of the fallacy that machine-made articles must necessarily be unpleasant in form and repulsive to good taste. ... It is agreed that cheap production can only be obtained by a large output, and that to a certain extent standardisation is inevitable.[25]

The No. 3 Utility ladder-back dining chair, apart from slimmer members, is exactly the same as an unidentified model illustrated among the recommended items in *The Working Class Home* report published in 1937,[26] while the No. 3a Utility dining chair appears to be a slimmed down version of a model illustrated in Anthony Bertram's *Design in Everyday Things* produced to accompany a series of lectures broadcast by the BBC in the same year.[27]

Style and structure were not the only guidelines used in the designing of the first Utility furniture range. The opportunity to grade some types as essential was not lost on the advocates of Good Design. The ethics governing the rationing of furniture appears to have considered the bookcase an indispensable item which figured prominently in the exhibitions held in 1942 and 1943 to introduce the public and the trade to the first Utility designs. But the dressing table, centrepiece of the pre-war bedroom suite, disappeared together with the fully upholstered easy chair and settee. While the sideboard, previously maligned for giving too much space for the display of useless ornaments, under Utility took on a circumscribed form devoted entirely to functional storage.

Although the post-war Utility Furniture Catalogue appeared in a period of great austerity in 1947, it nevertheless introduced a new wider choice of Utility designs,[28] making a few concessions to glamour and comfort by including items such as the previously excluded dressing table, allowing dining chairs to have upholstered backs as well as seats, and adding a fully upholstered version to the choice of easy chairs.

The proliferation of designs that appeared with the revocation of the Utility scheme in 1952 terminated any hopes the design idealists may still have had to rationalize furniture design and production. Agencies like the Council of Industrial Designs now turned their attention to finding new and better means of persuading the furniture industry, the retailers and the public to believe in the cause of Good Design. In the wake of the *Britain Can Make It* exhibition in 1946 and the Festival of Britain in 1951, The Design

Centre opened in 1956 to provide a more permanent venue for the display of well designed goods.[29]

There is a marked contrast between the uncompromising preachy campaigning of the first few years after the war and the more conciliatory tone of Good Design promotion ten years on. For example, the first volume of *The Things We See* series published in 1947 makes analogies between honest furniture and good brown bread and iced cakes alongside an art deco bedroom with a glossy satin bedcover to connote 'vulgarity' and 'bad taste'. A decade later we find Paul Reilly decrying the popularity of the contemporary style as a victim of its own success, warning that 'designers may ignore at their peril' the need to 'face the challenge of capturing a mass following without forsaking its own real values. The temptation to pander has never been greater.'[30] Reilly's recognition of 'repro-contemporary' criticized it for producing 'monstrous pieces of ostentation', for being 'merely fashionable' and a poor imitation of 'the real thing' (Good Design). But what his critique failed to recognize was that it was those very features which incorporated familiar traces of 'repro' styling and differentiated itself from the élite taste of 'Good Design' that contributed to its popularity.

Conclusion

The Utility designs were born out of ethical precedents in a highly charged ideological climate in which even furniture design came to embody sacrifice by dispensing with beauty and comfort as part of the war effort on the home front. But by 1956 the passage of furniture design from an ethical aesthetic to the popular 'repro-contemporary' manifestation of modernity in the shape of 'gorgeous cocktail cabinets and amazing dressing tables' was complete.

Notes

1. This chapter is largely based on the research carried out for a doctoral thesis: Attfield, J. (1992), *The Role of Design in the Relationship Between Furniture Manufacture and its Retailing 1939–1965 with Initial Reference to the Furniture Firm of J. Clarke*, University of Brighton.
2. For the history of the Utility Scheme and its relationship to the history of design see Attfield, J. (ed.) (forthcoming) *Utility Reassessed*, Manchester University Press; Geffrye Museum (1974), *Utility Furniture and Fashion 1941–1951*, Inner London Education Authority; Dover, H. (1991), *Home Front Furniture: British Utility Design 1941–1951*, Scolar Press; Sladen, C. (1995) *The Conscription of Fashion: Utility Cloth, Clothing and Footwear 1941–1952*, Scolar Press.

3. The Board of Trade (1946) *The Working Party Report on Furniture*, HMSO.
4. Russell, G. (1968) *A Designer's Trade: Autobiography of Gordon Russell*, Allen & Unwin. For alternative sources and views on Russell's 'influence' on the Good Design movement see: Woodham, J.M. (1996) 'Managing British Design Reform I: Fresh Perspectives on the Early Years of the Council of Industrial Design' and 'Managing Design Reform II: The Film *Deadly Lampshade* – an Ill-Fated Episode in the Politics of "Good Taste"' in *Journal Of Design History*, vol. 9, no. 1, p. 59ff. and vol. 9, no. 2, p. 101ff.
5. Pritchard, J. (1984) *A View From a Long Chair: The Memoirs of Pritchard*, Routledge & Kegan Paul, p. 146. Also see chapter on 'Aspects of the Good Design Movement' in Attfield, J. (1992).
6. Lebus, L.S. (1960) *A History of Harris Lebus 1840–1947*, [unpublished typescript].
7. Denney, M. (1994) *An Examination of the Introduction of Utility Furniture and the Portrayal of the Utility Furniture Scheme by Subsequent Authors*, MA Dissertation, Winchester School of Art.
8. *Utility Furniture Catalogue* (1943) HMSO. Board of Trade papers on Utility, rationing and price control BT 64 and BT 95. Statutory Instruments and Statutory Rules and Orders Utility Schemes, HMSO, 1941–1952.
9. Brett, L. (1947) *The Things We See No. 2: Houses*, Penguin, p. 62.
10. The Central Price Regulations Committee controlled the price of new and second hand furniture (with the exception of antiques) through statutory regulations first brought in by 'The General Furniture (Maximum Prices, Maximum Charges and Records) Order 1942'. The Utility designs were kept exempt from the Purchase Tax on furniture which took effect from 21 October 1940 and varied between $16\frac{2}{3}$ per cent and $33\frac{1}{3}$ per cent; some upholstery fabrics carried $66\frac{2}{3}$ per cent tax. The tax was intended to slow down consumption by grading all furniture other than Utility as a luxury item.
11. Hooper, J. (1952), *Modern Cabinet Work Furniture and Fitments* (Sixth Edition) Batsford, p. 273.
12. The first Utility designs were worked out by two High Wycombe trade designers – Edwin Clinch of Goodearl Brothers and Herbert Cutler, deputy head of the Wycombe Institute.
13. Russell, G. (1947) *The Things We See No. 3: Furniture*, Penguin, p. 50.
14. See L.J. Mayes (1960) 'Wycombe and the British Furniture Trade' in L.J. Mayes *The History of Chairmaking in High Wycombe*, Routledge & Kegan Paul.
15. Pritchard, J. (1984) p. 146.
16. Attfield, J. (1992) p. 341.
17. Owen, P.J. (1947) *Furnishing to Fit the Family*, The Council of Industrial Design.
18. *Cabinet Maker* (1948) 'Who Killed Cock Robin? Failure of the Utility Scheme', 31 January, p. 236.
19. See Cairncross, A. (1985) *Years of Recovery: British Economic Policy 1914–1952*, Methuen; Morgan, K.O. (1984) *Labour in Power 1945–1951*, Clarendon Press; Barnett, C. (1987) *The Audit of War: The Illusion and Reality of Britain as a Great Nation*, Macmillan.
20. 'Comparison between the FDC and the Board of Trade figures for the output of the industry' in *Furniture Development Council Second Annual Report 1950*, pp. 20–22.
21. Farr, M. (1955) *Design in British Industry: A Mid-Century Survey*, Cambridge University Press, p. 6.
22. Economist Intelligence Unit (1958) 'A Study of the Furniture Industry and Trade in the UK (Special Report), *Retail Business*, vol. 3, pp. 85–89.
23. Sheridan, M. (ed.) (1955), *Furniture Encyclopedia*, (Second Edition), The National Trade Press, p. 465.
24. Economist Intelligence Unit (1962) 'Quarterly Review of Retailing' *Retail Business*, no. 53, July; Oliver, F.R. (1962) *The Control of Hire Purchase*, Allen & Unwin.
25. Wells, P.A. (1920) *Furniture for Small Houses: A Book of Designs for Inexpensive Furniture*, Batsford.

26. Council for Art and Industry (1937) *The Working Class Home*, HMSO
27. Bertram, A. (1938) *Design in Everyday Things*, Penguin.
28. Such as the Chiltern and Cotswold ranges.
29. Reilly, P. (1957a) 'The Design Centre', *Ideal Home Book 1957*, Daily Mail, p. 109.
30. Reilly, P. (1957b) 'Glamour, Glitter and Gloss', *Ideal Home Book* 1957, Daily Mail, p. 88–89.

Figure 25 Display of kitchen equipment by J. Bainbridge, the Australian designer, showing developments from the laborious Victorian kitchen to 1946.

8 Industrial Design: Aesthetic Idealism and Economic Reality

Patrick J. Maguire

In October 1948, reflecting on the *Design At Work* exhibition at Burlington House, London, Gordon Russell concluded that:

> at all costs we must re-establish the reputation we enjoyed in the eighteenth century as first-rate designers: but we shall not do so by copying old designs made for hand production or new designs made abroad. In fact we shall not do so by copying at all. We shall do it along our own lines by patient research into design as we have learnt to apply research into techniques using our wonderful design tradition as an inspiration. It will have to be done mostly in the factory by fruitful collaboration between the designer and the other skilled technicians; and it will take time.[1]

In the same article, Russell defined the designer's task as interpreting 'the consumer's real needs in terms of efficient techniques, suitable materials, [and] good design'. As defender of the design faith through his role as Director of the Council of Industrial Design (COID), Russell's somewhat Henrecian outlook may have been predicated upon an approach akin to an aesthetic equivalent of Lukács' conception of 'false consciousness'. Nonetheless, his stance typified that of many of the advocates of aesthetic self-improvement attached to the Council of Industrial Design and similar bodies. As such it often bore little relationship to the prevailing location of the design process within British industry; still less to the role and function of those charged within industry with responsibility for design. It was more closely identified with particular notions of craft production married to a slightly odd (mis)understanding of the role of design consultants in those sectors of American industry which were dominated by a largely oligopolistic corporate capitalism in the process of forcible reconstruction in response to the collapse in demand after 1931. In the British context, it also bore a particularly strong relationship to the kind of aspiring white collar trade unionism which was often self-represented as 'professionalization', and which wished to enhance the bargaining power of particular sections of the labour market while

appearing to distance them from crudely commercial considerations by bestowing the epithet 'professional'.[2]

A constant complaint from both the COID and its somewhat more limited 1930s predecessor, the Council for Art and Industry (CAI), was that the designer was neither sufficiently recognized nor remunerated. As the CAI complained in its 1937 report, *Design and the Designer in Industry*,

> the rates of pay [for designers in industry] are low ... and are insufficient to attract the ablest artist or craftsmen. It must be remembered that the conditions of life and employment are more attractive in London than in other large industrial centres and that there is a much greater demand for original work in the free-lance world, in commercial art and, of course, in fine art than the world of industry ... most artists of originality and freshness of outlook, and even trained industrial designers, prefer to take their chance as free-lance designers or "commercial artists" in London. ... Industry must be prepared to pay adequately for design and to give the designer a position of standing and responsibility, so that his aims and efforts may receive due weight and recognition.[3]

The assumptions upon which such testimony rested, the distinctly metropolitan location, the dismissal of existing industrial practices, the equation of design with the individual designer (assumed overwhelmingly to be male rather than any wider interpretation which might be afforded by the ambiguity of conventional contemporary linguistic construction) and the belief that consumption could be design-led would equally characterize the early activities of the COID. The latter, for example, complained in its evidence to the Board of Trade's Pottery Working Party of 1946 that 'until the status of the designer is improved design can never be satisfactory'. Such a theme was constantly repeated in the COID's evidence to the various other working parties which had been established by the Labour administration in an effort to obtain some leverage on the development of industrial policy in the still vast private sector. Thus the Hosiery Working Party was informed that 'the present training, status and remuneration of the designer are unsatisfactory' while the Carpet Working Party was advised that 'the creative designer should not be burdened with administrative work'; the Wool Working Party could rest assured that the technical abilities of designers was excellent but that it should be worried by the 'neglect of the necessary training and development of his artistic and creative talents'.[4]

It might be expected that bodies heavily influenced by professional, or self-styled, designers, as well as by the kind of representatives of the cultured élite who habitually staffed quangos, not least in Labour's post-war administrations, should press the claims of their would-be constituents to special recognition. Less predictable was the extent to which organizations like the

COID adopted what might best be termed an environmental theory of creativity, with the environment of the provinces depressing designers. At the opposite end of the spectrum the allegedly peculiar beauty of Paris was held as sufficient explanation for the supremacy of French design in fashionable areas of production. As an internal memorandum on the unpublished CAI report, *Design and the Designer in the Dress Trade*, viewed the position in 1944: 'Manchester, Leeds, Northern Ireland and the distressed areas cannot develop style sense, the designing will be done in London ... the bulk production will take place in the provinces.'[5] Even more crudely, the Hosiery Working Party was informed that 'The designer's chief handicap is his "provincial" environment. His sense of style and fashion is conditioned by what he sees in his native town.' The tensions which such views could give rise to in the context of the overwhelmingly 'provincial' location of industry is well illustrated by the views of a member of the Midlands Industrial Design Association who told that association's annual dinner that:

> our provincial cities have designers, who, having been engaged in the local industries all their lives, know a lot more about their business than these 'Chelsea and Pimlico arty specialists'. Midland manufacturers will not suffer these so-called designers, who have been polluted by the foetid atmosphere of London.[6]

Although couched in the language of cultural élitism and informed by the overt disdain of commerce so characteristic of sections of Britain's ruling élite, the argument was less about the culture of industry than its structure.

To a considerable extent the argument also rested upon a misconception of the functioning of the industry to which design was to be so liberally applied. In the article quoted at the opening of this chapter, Gordon Russell went on to write of the industrial designer that 'mass production ... gives him staggering opportunities'. The equation of machine with mass production would be endemic, and not just in narrowly conceived design circles. As is argued elsewhere in this volume, much of the discourse on British industry in the 1940s was predicated upon what was taken to be the American exemplar. Nowhere was this more true than in debates about the function of industrial design (and, by extension, the industrial designer). However, while mass production was indeed a prominent characteristic of much American industry, particularly in the consumer goods sector, which had a rapidly growing, heavily protected, continental-size market within which to peddle its wares, British industry attempted to relate to a volatile and highly segmented world market which required intense product specialization. As the Chairman of Barclays Bank informed his shareholders'

annual meeting in 1929, British markets remained highly resistant to mass production strategies since:

> this country has not yet, save only with a very few exceptions, proved itself to be entirely suited for mass production on a great scale, chiefly because of the comparatively limited home market....In the case of world markets, the variety of needs and tastes of customers has also proved a limiting factor.[7]

The diversity of markets necessarily dictated the production strategy pursued by manufacturers. As the Cotton and Rayon Manufacturers' Association made clear in 1947 this had a significant impact on the design strategies pursued, or not pursued. Commenting on efforts to standardize production, which all the numerous enquiries into the industry had highlighted as a significant area of potential savings, the Association's *Bulletin* noted that there was a considerable disparity between the goods required for the still strongly-controlled home market and export markets to the extent that, far from being a homogeneous market, 'Lancashire's trade consists in reality of many thousands of commercially different sub-types.' It was also reported that:

> Even for 'home trade' markets such as Sweden, Denmark and Norway, about half the cloths exported differ from cloths made for the home market in some respect – weave, width or design, and the markets differ considerably from each other. For 'export' markets such as West Africa, India and Argentina, home market cloths are a very small proportion ...[merchant] convertors of different home market sub-types must establish different export affiliations. They find by trial and error which markets are attractive and are able to include in or add to their ranges designs and colourings likely to be saleable....[Expanding production] depends less on bulk and long runs and increasingly on variety....We are able to offer what the Japanese and the domestic industry cannot – exclusive styles to distributors.[8]

Moreover, knowledge of particular market requirements and developments rested not with the manufacturers but was mediated through a complex merchanting structure in which the role of merchant convertors was dominant. It was the convertors who commissioned orders and here, too, a multiplicity of competitors characterized the industry.[9] This was scarcely the kind of capital-intensive production which was taken to be the American norm. Nor was such an approach confined to the textile industry.

In the pottery industry, before the outbreak of the Second World War, some 170 different companies constituted the export group, no less than 90 of which produced domestic wares.[10] In the motor vehicle industry, despite the apparent dominance of a clutch of large-scale producers, it was

feared that any attempt to reduce the number of models so inefficiently produced before 1939 would be doomed to failure as 'the public demand for variety is so strong'.[11] In similar fashion the *Wool Working Party Report* observed that criticism of the manufacturers for being 'too prolific in their designs' was unjustified as a 'wide choice and high standard of materials and designs are necessary' to satisfy British export markets.[12] In the furniture industry more than 4,000 firms competed for business in the 1930s: 3,000 of them employed fewer than ten workers, less than 40 more than 300, and just two employed more than 750.[13] In the pottery industry, of 375 firms in operation in 1939, 150 employed fewer than 100 workers. The plethora of producers competing for business was nowhere more evident than at the British Industries Fair (BIF), a product of wartime nationalism subsequently much despised by the would-be design improvers. By 1929 the BIF could boast of almost 1,000 exhibitors at Birmingham, where it occupied around 11 acres, with another 300,000 sq ft of exhibition space occupied at White City, London, and could be expected to attract 100,000 buyers.[14] Moreover, each sector was marked by considerable uneven internal development. Some 50 per cent of the cotton textile export trade was handled by 49 merchant convertors, while 50 per cent of pottery exports were generated by ten individual companies. Such diversity scarcely facilitated any homogeneous or, frequently, coherent design policy. Far from stimulating the growth of a design profession in Britain it encouraged the pre-existing pattern of in-house training and promoting 'off the tools'. Outside the small number of large-scale producers it placed a premium on skilled technicians, who were intimately familiar with the possibilities and limitations of an *individual* company's machinery and workforce. Even within large companies, custo-mized production was often the norm. The dependence upon customer specifications hardly encouraged investment in centralized design func-tions, still less in design innovation. Moreover, in the British context, depression intensified product conservatism as manufacturers initially sought to maintain market share by trading on stock and, particularly in the 1930s, resorted increasingly to market-sharing and price-fixing strate-gies. As early as 1928, for example, Armstrong Engineering, part of the Armstrong-Whitworth conglomerate and one of the largest engineering companies in the United Kingdom, was agreeing to sell ten locomotives (of two different types) at cost to Brazil in order to break into the market, a strategy it followed with equal success in securing government orders. By the following year it was taking a leading role in facilitating amalgamations within industry and, under the auspices of the Locomotive Manufacturers Association, had devised a strategy 'to avoid wasteful competition ... to

compete with foreign companies'. By 1935 the Association had established a monopoly within the industry.[15]

Short runs of design encouraged flexibility of approach within the production process, itself often reliant upon machinery which predated mass production techniques. As the cutlery manufacturers told the Board of Trade Committee considering their application for protection, in 1925, under the Safeguarding of Industry Act, 'machinery was justified only if it could be kept constantly employed; if the output was small, experience showed that manual processes were more economical'.[16]

Time after time, the complaint would be that the design process was in the hands of the aesthetically uneducated. As the Pottery Working Party was informed, 'few designers receive adequate art or industrial training'; their counterparts on the Carpet Working Party were warned that 'the post of chief designer in a firm of carpet manufacturers is too often only reached after a prolonged apprenticeship in the design room'. The Hosiery Working Party was presumably intended to find it reprehensible that 'designers are generally recruited from those factory cutters or machinists who show an aptitude for the work', while the Lace Working Party was warned that 'it is difficult for the staff designer ... to avoid the narrowing influence of the specialised and expert nature of his work on his judgment of questions of design' and that, therefore, consultant designers should be employed to supervise their work and 'to maintain high artistic standards'.[17] In the clothing industry, the COID's Industrial Committee was warned in 1949 that 'the designers are craftsmen rather than designers. They generally graduate through the workshop and not through Art School.'[18] That structure of formal and informal apprenticeship – necessarily the latter in the case of females – was not an abstract choice made by manufacturers, still less a necessarily perverse one. It was historically constructed to meet their perceived requirements and to allow for the constant negotiation and marginal adjustment of design (and other factors of production) necessitated by the largely customer-led markets upon which they were reliant. It was a structure which necessarily also rested upon relatively poor remuneration for most designers. Short runs did not facilitate large design fees. A survey of design markets conducted by the Council for Art and Industry in 1937 found that the average price for designs in cotton dress materials was £4, for linoleum £3 10s, for small designs for the silk industry from £1–£2, for wallpaper designs £9 and for furnishing fabrics between £12 and £15.[19] To put those sums in context, the major survey of earnings conducted by the Ministry of Labour in 1938 gave average male weekly earnings as £3 9s, with males working in the printing industry (the highest earning group) earning

more than £4 per week.[20] Any substantial increase in the remuneration of designers within the existing industrial structure could hardly be expected to be well-received by industrialists. As one Birmingham manufacturer complained in 1937, upon receipt of the *Design and the Designer in Industry* report:

> They talk glibly of design rooms, internal and external designers, men costing three to five hundred pounds a year. These conditions simply don't exist in a town like Birmingham, except in perhaps the thirty largest factories.[21]

If anything the trajectory of British industry in the inter-war period reinforced the reliance on marginal differentiation and short runs as international competition forced manufacturers to move out of high volume, low quality production and to move, or appear to move, towards shorter runs of higher quality. The Committee on Trade and Industry enquiry into the textile industry, for example, found in a survey of 53 export markets between 1922 and 1924 that where exports of goods with a value below £14 per thousand yards had declined by 50 per cent in comparison with 1913, those goods valued at over £17 per thousand yards had increased their exports by some 14 per cent, with the result that the industry 'has been stimulated to produce a large variety of novel effects and design'. Standardization was virtually non-existent, to the extent that there had not even been a reduction in the vast variety of sizes in which blankets were produced, 'owing to the different tastes of export markets'.[22] As a Board of Education Report of 1929, *Design and the Cotton Industry*, saw it, 'compelled by intensified foreign competition and the consequent loss of markets for plain goods, manufacturers are turning their attention to the production of fancy goods in which design is all important'.[23] In the same year, woollen manufacturers seeking protection informed the Board of Trade inquiry that 'people wanted smaller quantities and more frequent changes'.[24] As early as 1917 the Federation of British Industries was expressing concern about Japanese competition at the lower end of the market, particularly where designs were easily pirated and reproduced illegitimately.[25] Even in an area open to standardization and volume production, and one which might have been expected to be price sensitive, bicycle production, it was noted that there remained a 'very large range of designs, qualities and prices' as it was felt 'popular taste would not favour a very cheap bicycle ... the home sales of such a product [would] not justify production on a large scale.'[26]

This, however, was not a version of the function of design which was readily accepted by the various organizations devoting themselves to its

improvement. It often seemed the last thing that would-be design reformers welcomed was any conception of popular influences on manufacturers' design strategies. As the Pottery Working Party was informed, 'consumer taste in many markets is undeveloped, so that poor designs are actually preferred'.[27] Some ten years earlier, the CAI had complained that it was virtually impossible to alter design standards in the wallpaper industry because of 'the conservatism of public taste' as well as the opposition of decorators and the tendency of manufacturers to 'stick to conventional designs which have an assured sale'.[28] The apparent contradiction between 'good' and 'popular' design would embitter relationships between manufacturers and their would-be advisers. As the Wholesale Textile Association noted in 1936, 'manufacturers primarily produce for profit and cannot be expected to trouble about design unless they believe it is profit-making'.[29]

Tensions between profit-making and proselytizing were evident from an early stage as the Design and Industries Association (DIA) rapidly discovered, in 1917, when representatives of the pottery industry complained of one of the DIA's early ventures in the field of design promotion. They said that the DIA: 'should have approached the potters. . . . However much they wished to improve design they must reckon with the capital already invested in the industry'.[30]

The industry's distrust of design organizations would be evident in the lead up to the *Britain Can Make It* exhibition not least because of the overt stance of the COID that it was not intended to be 'an exhibition of "best sellers". . . [but] to give a lead to manufacturers'.[31] To representatives of the British Pottery Manufacturers Federation the possible priorities which would inform selection policy for *Britain Can Make It* caused considerable anxiety as early as December 1945:

> There was a very strong feeling expressed by the meeting [of the Federation with a representative of the COID] that the selection for exhibitions in the past had not been representative of the best products of the industry. There is undoubtedly a very strong hangover from the Burlington House Exhibition [of British Art in Industry of 1935] and also from the Paris Exhibition [of 1937], and it was recommended by the Federation that whatever Selection Committee were appointed their tastes would not be those of a small too advanced minority, but would be more broadly based on the accepted standards of good taste.[32]

The reasons for the public conflicts between design organizations and industrial bodies can too easily be ascribed to the vagaries of personal relationships. While the British cultural context often ensured that personal antipathies could easily assume class or regional connotations, where even

the debate could be conducted in different accents, the problems were much more structural. What appeared to be cultural conflicts often reflected, and all too often masked, very different priorities.

Nowhere were those tensions more evident than in the sphere of exhibitions, the public face of manufacturers, where industrial and design organizations had very different priorities. As the Pottery Manufacturers made clear to the COID in the early stages of planning for *Britain Can Make It*, design strategies varied considerably from one market to another, as did strategies for product or company branding and not only could not be treated in a homogeneous fashion but often had to be viewed as mutually antagonistic. At the meeting between representatives of the COID and the Pottery Manufacturers referred to earlier, potentially divisive expectations were immediately apparent:

> The Federation asked for a ruling whether the Exhibition was intended to cater mainly for the home market, or mainly for the export buyer.... Our biggest export markets are the Dominions and America, and the designs which are bought by these markets are traditional designs, some good, some not so good. Broadly speaking the spirit of the designs is not that in which the Exhibition is conceived. However, if the export buyer is to be encouraged he will only be interested in those designs which he knows from the past he can sell ...[33]

The concern was a long-running one. The rival ambitions of promoting ideas on the one hand and goods for sale on the other had long dogged relationships. This was particularly the case where public funding was involved and civil servants, if no one else, needed to be sensitive to accusations of favouritism through the inclusion or exclusion of particular wares from individual manufacturers. As a senior civil servant warned in 1935:

> doubts occur as to whether a *State Department* can advertise specially the goods of certain manufacturers and exclude the rest, especially when there is a question of sale of the goods, and also whether there is really so much difference, when we come to ordinary cheap goods, as to justify the state imprimatur, and whether the State could ensure fairness.[34]

Such discrimination was best left to intermediaries, 'expert' bodies whose advice could be utilized, if necessary, to defend actions and deflect criticisms. If the twentieth-century British state showed a marked preference for utilizing such strategies, nowhere was this more true than in the field of culture and cultural production where quangos blossomed from the 1920s, if not earlier. However, that strategy itself could lead to serious conflicts where the 'experts' and the producers differed substantially and nowhere was this

more true than in the field of industrial design. State endorsement, however circumscribed, of particular products, or styles, was guaranteed to antagonize producers who did not fall within the chosen categories. For bodies charged with promoting standards of design within industry this proved a particularly intractable, and often acrimonious problem, as their existence was necessarily predicated upon the failings of most designs and, therefore, their attempts to alter standards necessarily involved conflict with the majority of manufacturers. Where this structural antagonism was heightened by a stylistic one, with would-be design reformers embracing varieties of modernism, sometimes heavily influenced by the influx of Central and East European refugees whose own formative experiences had been within areas scarcely touched by British commerce, at least outside the capital goods sectors it tended to become particularly vitriolic. Having to adopt a didactic approach and to select exemplars from outside the mainstream areas of production again guaranteed conflict at best, and impotence at worst. As an internal Board of Trade note on the 1935 Burlington House exhibition of British Art in Industry rather tartly observed:

> If the exhibition can be made up of articles in production, it is obviously more representative of industry and more likely to be satisfactory from the sales point of view. It should also be a general principle that as many firms as is practicable should be represented, provided that their products are up to standard, and the exhibition should be selected to illustrate the different types of articles sold in the trade.... In future exhibitions, greater attention should be given to showing a considerable volume of articles bought for the homes of the middle and working classes.... In many sections this point was well covered, but in others it was felt that exhibits were too much confined to the high priced end of the trade, and too many freakish and unpracticable objects admitted.[35]

While disagreements about exhibiting or selection policy might cause civil servants considerable embarrassment, they created more pecuniary problems for manufacturers. Divergent priorities and interests often ensured that exhibitions were major causes of conflict. As the Federation of British Industries (FBI) noted in 1934, when advising against participation at the Brussels International Exposition of 1935, British manufacturers preferred to support purely British exhibitions in foreign countries rather than engage in the kind of showpiece occasions favoured by many of the self-consciously cultured doyens of Whitehall and its associated outposts.[36] That was not merely an argument about location but also about function: British manufacturers preferred to exhibit their wares where there was a possibility of selling them. The real objection of the FBI to Brussels was that recently increased import quotas made sales in Belgium virtually non-existent for

most British manufacturers, a problem which would be repeated with far more visible public repercussions in Paris three years later, when so rare were sales that many manufacturers could not even supply price details for the French market. Unsurprisingly, that often meant orientation towards imperial markets, or high cost products in affluent markets, which ruled out most of continental Europe and with it much of the emergent style favoured by government advisers. The embittered experience of the inter-war years would soon resurface in debates about the organization, structure and function of the *Britain Can Make It* exhibition.

Notes

1. *The Times*, 27 October 1948.
2. Perkin, H. (1989) *The Rise of Professional Society*, Routledge.
3. Council for Art and Industry (1937) *Design and the Designer in Industry*, HMSO, p. 26.
4. ID 360/17, Evidence to Working Parties. Note that all numbers of documents quoted here commencing with ID are located in the Design Council Archive at the Design History Research Centre, the University of Brighton.
5. BT 64/3579. Note that all documents quoted here commencing with BT relate to Board of Trade papers, Cab to Cabinet Papers and T to Treasury Papers, all held at the Public Record Office, Kew.
6. Midlands Industrial Design Association (1951), *Bulletin*, no. 9, Birmingham Central Reference Library.
7. *The Economist*, 19 January 1929.
8. Cotton and Rayon Manufacturers Association, *Members Bulletin*, vol. 3, no. 2, September 1947.
9. Cab 124/336, *Whither the Cotton Industry?*
10. T 229/158.
11. *The Economist*, 28 August 1943.
12. Wool Working Party (1947) *Report*, HMSO.
13. E. Hargreaves & M. Gowing (1952) *Civil Industry and Trade*, Longman.
14. *The Times*, 13 February 1929.
15. Armstrong (Engineering), *Minute Books*, Tyne & Wear Archive, Newcastle upon Tyne.
16. Committee on Trade and Industry (1928) *Survey of Metal Industries*, HMSO.
17. ID/360/17.
18. ID/850/1, Industrial Committee, 25 May 1949.
19. BT 37/15/259.
20. Ministry of Labour (1941) *Gazette*, March.
21. BT 57/16/286/37, Letter from Morris Ltd, 26 May 1937.
22. Committee on Trade and Industry (1928), *Survey of Textile Industries*, HMSO.
23. Board Of Education (1929), *Design and the Cotton Industry*, HMSO.
24. *The Times*, 14 March 1929.
25. Federation of British Industries (1917) Overseas Trade Committee, 21 November, Modern Records Centre, University of Warwick.
26. Committee on Trade and Industry (1928) *Survey of Metal Industries*, HMSO.
27. ID/360/17.
28. BT 57/15/259.

29. BT 57/13/213/36.
30. Design and Industries Association (1917) *Journal*, October.
31. ID/352/14A, *Notes for Guidance to Selectors*.
32. ID/516/14A, 20 December 1945.
33. ID 516/14A, Minutes of Meeting 20 December 1945.
34. BT/57/12/144/35, letter from O.E. Stocks, Office of the Commissioner of Crown Lands, to W.C. Eaton, Board of Education, 18 November 1935.
35. BT 57/7/A112.
36. Federation of British Industries, Overseas Trade Committee, 22 February 1934.

9 Putting the Industrial into Design: Early Problems Facing the Council of Industrial Design

Jonathan M. Woodham

'Art' and 'Industry': an ideological and geographical divide

In a number of the previous chapters attention has been drawn to the tensions that existed between those concerned with 'improving' the supposedly poor standards of taste among manufacturers, retailers and the public and those involved in manufacturing industry itself. On both sides of this cultural-

Figure 26 'Design Man', designed by James Gardner, a motif introduced throughout BCMI to illustrate the seeing eye of the designer.

commercial divide there was a widespread conviction that a considerable credibility gulf lay between the aesthetic idealism of a metropolitan cultural élite (articulated both by official and independent organizations, usually centred in London) and the economic priorities of industrialists in the regions. Furthermore, in Britain there had been a long-standing historical legacy of the separation of the 'fine' and 'industrial' arts. This looked as far back as the last 30 years of the eighteenth century when Sir Joshua Reynolds, through his presidential Royal Academy *Discourses* and commitment to the 'elevated' genre of History Painting, sought to legitimate the intellectual status of fine artists in Britain, distancing them from those who were involved in more 'manual' and less 'elevated' decorative commercial trades. Histories of British design customarily chart a number of subsequent efforts to bridge these two worlds of 'art' and 'manufactures', whether through such enterprises as Henry Cole's establishment of Felix Summerly's Art Manufactures in 1847, the apparent reconciliation with machine production (though not necessarily mass-production) of a number of later Arts and Crafts practitioners or even the establishment of the Design and Industries Association (DIA) in 1915. Nonetheless, in Britain in the 1920s and 1930s there still remained a clear division between 'art' and 'industry' which a number of well-publicized initiatives, such as the setting up of the Gorell Committee on Art and Industry[1] in 1931, the mounting of industrial design exhibitions at Dorland Hall, London, in 1933 and 1934 and the British Art in Industry show of 1935,[2] did little to heal. Nor was it overcome by the establishment, or subsequent activities, of the Board of Trade's Council for Art and Industry (CAI) in late 1933.

Often, particularly in the fields of pottery and textile design, fine artists were invited into manufacturing companies to produce designs which could be applied to predetermined shapes and surfaces. For example, in the early 1930s Thomas A. Fennemore,[3] the Managing Director of Foley China in Fenton (Stoke-on-Trent), forged links with the pottery firm of A. J. Wilkinson Ltd, bringing in to design tableware 26 well-known artists such as Vanessa Bell, Frank Brangwyn, Milner Gray, Barbara Hepworth, Dame Laura Knight, Ben Nicholson, Albert Rutherston and Graham Sutherland. The artists' understanding of manufacturing processes was generally limited, mostly resulting in the necessary adaptation of their designs for industrial production by experienced ceramic designers such as Clarice Cliff, Wilkinson's Art Director from 1930 onwards, and Freda Beardmore. Interestingly, in the light of later debates about the supposed qualities inherent in 'good' industrial design (as well as more specific industrial responses to the *Britain Can Make It* exhibition and organization)

this aesthetically-charged experiment proved a critical success but a commercial failure.[4] As a result, it did little in the eyes of pottery manufacturers to sustain arguments for greater recognition and remuneration of designers in industry as subsequently proposed in the 1937 CAI Report on *Design and the Designer in Industry*.[5] Similar, though often more successful, schemes took place in the field of textiles: Edinburgh Weavers and Allan Walton Textiles were among those companies which successfully commissioned artists to design screen-printed textiles, while larger enterprises such as Warner & Sons embraced more fully the design process through their employment of trained designers with a knowledge of woven textiles. A key figure in this respect was Theo Moorman who worked for the company from 1935, establishing a handweaving department for modern design.

The design profession had sought to establish itself more securely in the eyes of the manufacturing sector through the establishment in 1930 of the Society of Industrial Artists (SIA), intending to provide a framework for promoting and protecting the interests of all who were active in 'the production of Design for Industry, Publishing and Advertising' as well as organizing 'the resources of Design as a vital factor in British Industry and so to assist the advancement of British Trade, both at home and abroad'.[6] Despite the presentation of evidence on behalf of the profession to various enquiries into design in Britain in the 1930s, the SIA wielded limited influence before the war and exhibited a far greater leaning towards graphic rather than industrial design, notwithstanding the establishment of regional branches in the manufacturing centres of Birmingham, Liverpool, Manchester and Stoke-on-Trent.[7] Indeed it was not until after the Second World War that the SIA was rigorously re-organized: its existing membership was entirely disbanded and applicants had to submit their work to the scrutiny of a selection committee as well as demonstrate that they were actively involved in design for mass-production. Clearly the more *laissez-faire* approach of the early years had done little of substance to convince manufacturers of the claims of designers in the industrial process.

In fact, in inter-war Britain there had been little by way of an industrial design profession modelled along the commercial lines of first generation design consultancies such as those established in the United States by Raymond Loewy, Henry Dreyfuss, Norman Bel Geddes or Walter Dorwin Teague. With the possible exception of the Basset-Gray Group of Writers and Artists, which became the Industrial Design Partnership[8] in 1935, industrial design output in 1930s Britain generally remained the work of anonymous draughtsmen and engineers or, occasionally, of well-known individual artists, designers or architects such as Wells Coates and Keith

Murray. Much more in line with the American model, unsurprisingly, was Raymond Loewy's London design studio which was set up as Raymond Loewy Associates in the mid-1930s under Carl Otto who had a background in American practice. He was joined by the English designers John Beresford Evans and Douglas Scott and generated a number of important manufacturing clients before the office was closed following the outbreak of war in 1939.

Resistance to American models of industrial design practice

Concern about post-war competition from the United States, together with anxiety about US penetration in the field of industrial design (as discussed in earlier chapters), did not entirely centre upon purely economic considerations on the part of design reform circles in post-war Britain. Indeed, despite the award to the American Raymond Loewy of an Honorary Membership of the Faculty of Royal Designers for Industry in 1939, a lecture by him to the Royal Society of Arts in 1941 and a letter of 19 November 1945 to *The Times*[9] commending commercially-oriented corporate practice in the United States, there were few (if any) in COID circles who subscribed to Loewy's conviction that 'aesthetics consists of a beautiful sales curve shooting upwards'. Furthermore, three years after the end of the war Edgar Kaufmann Jr (Director of the Department of Industrial Design at the Museum of Modern Art, New York, and an ardent American propagandist for notions of Good Design) warned his British design-reforming counterparts about the 'dangers' of commercially-driven styling of many American products. A 1948 article in the *Architectural Review* entitled 'Borax – or the Chromium-Plated Calf',[10] condemned the 'superfluous' streamlining and superficial styling of many American products, portraying such 'undesirable' characteristics as encouraging obsolescence and stimulating the cycle of production. Such moralizing notions[11] (seen in isolation from the realities of business economics) fell on sympathetic ears in Britain as there were many who resisted notions of the American consumerist way of life, fearing the loss of individuality in the face of the everyday social imprint of oligopolistic, homogenizing corporations. For example, as the 1950s unfolded *Design* magazine, the public voice of the COID since its inception in 1949, warned with increasing frequency of the perils of American marketing practices, culminating in 1960 with an editorial on the theme of 'Consumers in Danger'. This dramatically warned of the ways in which consumer psychology was being systematically exploited by American industry, likening it to 'a form of economic totalitarianism not greatly dissimilar from Orwell's terrifying

prophecy'.[12] Michael Farr, a key figure at the COID at the time, also echoed similar concerns to those expressed earlier by Kaufmann. Assuming something of the moralizing tone of his mentor, Nikolaus Pevsner, he wrote of styling for obsolescence in his study on *Design in British Industry: A Mid-Century Survey*[13] as 'the wrong and self-assertive element in the American character'.

'What Industrial Design Means' at the *Britain Can Make It* exhibition

As has been considered in a number of the preceding chapters and will be seen later in Part 4, an important dimension of the COID's early ideas for the *Britain Can Make It* exhibition was always concerned with an explanation of the supposedly beneficial role that industrial design might be seen to play in the manufacturing sector. A number of the difficulties inherent in such a strategy have already been signalled in earlier chapters (especially Chapters 3, 4 and 7). The general position was not seen as encouraging either by educationists or by those involved in the industrial design business. In early January 1945 Noel Rooke, of the Central School of Arts and Crafts in London, contributed to an ongoing debate about design in British industry in the correspondence columns of *The Times*. Commenting on the difficulties facing students entering the design profession he wrote that:

> Conditions are said to be better in London than in the industrial North. But even in London I have heard a manager in a well known firm speak to his salaried artist before me, a visitor, in a manner no civilised man would use to an animal, and no prudent man to a member of a powerful trade union ... [Those] in charge of designers are in too many cases unacquainted with the nature of their work; a Gilbertian situation, as if a publisher's business were to be conducted by people who had not taken the trouble to learn to read.[14]

Herbert Read, of the Design Research Unit (DRU), was even more specific in his critique of industrial design in Britain. He drew attention to the fact that although British design education recognized the importance of handcraftsmanship in the curriculum it failed to gear itself to an industrial context. He declared that:

> There is practically no training of designers in the terms of machine-tools and mass-production, nor is there, at present, the staff and equipment to make a beginning with such training. After two years' experience directing an organisation [the DRU]

whose main function is to provide consultant designers for British industry I would venture to say that in this country there are not more than a dozen artists of the required competence.[15]

Against such a backcloth, the importance of the potential role that the COID might play at the 1946 exhibition was made clear in Sir Charles Tennyson's preliminary schema for *The Scope of the Exhibition*. He suggested that, as one of the possible displays:

We might have another 'side-show' which would illustrate the work of British Industrial Designers, as a counter-blast which will come from American Designers directed against this country.[16]

Early discussions of the COID's Exhibitions Committee, chaired by Tennyson, were fairly wide-ranging. When considering two proposed sections on The Process of Design and British Industrial Designers, Tennyson suggested that a Brains Trust be included, Leigh Ashton (the Director of the Victoria & Albert Museum) proposed the inclusion of a synchrophone or of making a potter's wheel available for use by the general public, while Jack Beddington felt that 'such stunts, or gentleman's fun fair, would be desirable features of the Exhibition'.[17] However, it fell to the DRU to put together the important propagandist display of 'What Industrial Design Means', a central plank of the COID's propagandist mission directed at both manufacturers and the general public. It was decided that the exhibit be devoted to the problems of designing an egg cup for mass-production (Figure 27), examining the related work of the industrial designer and the ways in which different materials and production processes might influence design solutions (Figure 28). Misha Black had overall responsibility for the exhibit, with assistance from Bronek Katz, R. Vaughan and Austin Frazer.

As indicated in Chapter 4, the Mass Observation Reports revealed that the public were generally unresponsive to the didacticism of the DRU display (Figure 29). Most were more absorbed in the plastic moulding machine which stamped out 3,000 egg cups a day than in explanations about the involvement of managers, engineers and buyers in the design process. Their focused interest in (or mesmerism influenced by) the mechanics of production technology was simply explained by the fact that the machine was the only moving part of the exhibit. Nor was the actual choice of an egg cup on which to centre lessons of the importance of industrial design in everyday life perhaps the most likely object on which to concentrate widespread public attention.

Figure 27 One of displays relating to the design of an egg cup in the 'What Industrial Design Means' display at BCMI by Misha Black, Bronek Katz and R. Vaughan of the Design Research Unit.

It may well be that the pace with which things were moving at the COID, which had in little more than 18 months evolved from a projected existence on paper to a full-blooded organization charged with mounting a major post-war exhibition, led to an unrealistic mood of optimism about its ability to change prevailing attitudes to design. Despite problems with the selection of goods for BCMI encountered by the COID in different sectors of manufacturing industry, the Mass Observation Reports caused few serious doubts about strategy within the organization. Indeed a few months later, at the British Industries Fair of 1947, a highly significant venue for putting across its message to the manufacturing and retail sectors, the Council's display was somewhat esoteric in respect of the nature of its message. The exhibit consisted of an imaginary Design Centre fashioned from scaffolding where manufacturers and designers met, respectively symbolized in surrealist fashion by their T-square and cogwheel heads. The fact that the explanation of the Council's purpose was framed in small type and

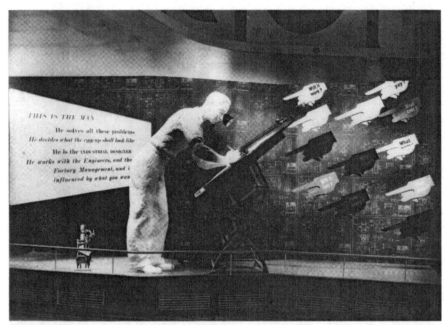

Figure 28 'What Industrial Design Means' display at BCMI by Misha Black, Bronek Katz and R. Vaughan of the Design Research Unit.

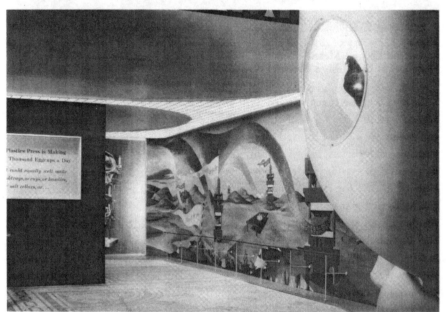

Figure 29 'What Industrial Design Means' display at BCMI by Misha Black Bronek Katz and R. Vaughan of the Design Research Unit.

demanded more time than many were prepared to give did little to convince many manufacturers of the relevance of Good Design. As will be seen below, exemplified by the drawn-out plans to produce a COID booklet about the meaning of industrial design, there was considerable uncertainty about what precisely was the nature of the message that the Council wished to convey.

A proposed 'Bible of industrial design'

It seems that Misha Black's outline script for the 'Section Dealing with the Principles and Fundamentals of Industrial Design' to be displayed at the BCMI was only considered in detail at the COID at a comparatively late stage, less than two months before the exhibition actually opened. Leslie first commented on it on 3 August 1946, suggesting that Black's script for the exhibit might be worked up into a booklet which could be sold at the exit to the exhibition.[18] This was clearly something about which Black was keen as it was reported less than a week later that: 'M. B. looks on this as a potential Bible for industrial designers. And a Bible cannot be tossed off by the day after tomorrow. Further, he would want to oversee closely the re-cooking of his egg.'[19]

Within a few days Dorothy Goslett, the DRU's business manager, made it clear to the COID that it would be impossible to produce a book 'which would in any way be worthy of the importance of the subject' by the time of the BCMI opening. More significantly, she stated that:

> There has been no adequate simple primer on this subject addressed to the completely 'lay' public and the increasing need for it seems to make it all the more important that it should be done properly if it is to be done at all.[20]

Discussions between Black, the DRU and the Council in relation to the production of the booklet became increasingly complex as time passed by, with the commissioning of photography, the employment of a writer and an artist and the commencement of negotiations with the printers Lund Humphries and the publishers, HMSO. However, by late October 1946, Stella Carlisle of the COID was warning that if the proposed booklet was costed at 6d on a print run of 25,000 there would be insufficient income even to pay the DRU's bill.[21] It was also reported later that the project was turned down 'partly because it [the DRU's work] was poor in itself, and partly because production delays meant that we [the COID] had missed the

post-B.C.M.I.-sales bus'. [22] Nonetheless, the COID showed a continued faith in the DRU, recommissioning from it the whole project in a re-designed 16-page booklet. It was intended that it would accompany a touring version of 'The Birth of an Egg Cup' exhibit in 1947 in conjunction with the propagandist Design Weeks which were to be mounted by the Council in major cities in England and Wales. Despite the fact that the fee proposed by the DRU for its work on the new project was 150 guineas (which was in addition to the £119 14s 0d incurred for the abandoned scheme), the 'go ahead' was given by the COID on 19 December 1946. However, by the end of March 1947 it was clear that 'The Birth of an Egg Cup' exhibit would never travel, again raising doubts about the proposed booklet as a valuable free-standing publication. Undaunted by this knowledge, by the middle of the following month fresh discussions were initiated between Alan Jarvis, Misha Black and Dorothy Goslett for the DRU to design and produce a miniature version in six flat cases which would tour schools, women's institutes and other venues as had other similar COID-initiated packages. [23] However, this time the proposed DRU fee of 175 guineas proved too much for the COID.

By the late summer of 1947 there was considerable unease at the COID about continuation of the production of the re-formulated DRU booklet. Indicating a serious level of in-house concern, on 31 October Jean Stewart forwarded a set of 'comments [about it] from senior staff' to the COID's new Director, Gordon Russell. By early January 1948 the dummy and layout of the booklet had also been seen by a number of Council members and the project was finally axed.

Such uncertainties about how to communicate the message of Good Design also permeated other spheres of the COID's activities, including film. As a result of discussions between Leslie, the COID's director, and John Grierson, the celebrated documentary film maker, in early 1947 the Council commissioned a feature film from International Realist. Eventually entitled *Deadly Lampshade*, it was finally axed two-and-a-half years later after constant rewrites, retakes and growing rumblings among COID members and staff. [24] The whole exercise had cost perhaps a hundred times as much as the projected DRU booklet but, unlike the latter, was fully completed, including music. In many ways this scrapping of a project which had spanned a considerable period of the Council's formative years reflected a positive move away from the somewhat naive idealism which characterized many of its early propagandist effort towards an outlook which had been considerably tempered by the growing consciousness of the incontrovertible fact that industry was actively resistant to its aesthetic overtures.

Conclusion

Although there were some positive signs of the emergence of industrial design consultancies in Britain in the late 1940s, this was at least partially hampered by the lack of available training and education in the field. A plethora of Working Parties were set up to report to the Board of Trade on numerous areas of manufacturing industry but these voluminous texts did not engender any fundamental change of industrial attitudes to design in Britain. Although, in a memorandum to the Board of Trade 1944, the Federation of British Industries had itself proposed that various industries should establish design centres in conjunction with the projected Design Council, an idea which the FBI also endorsed at the time, industry itself did little to further such ideas in the tricky economic waters of the aftermath of war. Inspiration came from the Cotton Board Fashion Design & Style Centre which had opened in Manchester in 1940. However, although the COID had confidently suggested in its *First Annual Report of 1945–46* that it would open a succession of similar centres supported by industry, only two, both short-lived, actually came to fruition: the Design and Research Centre for the Gold, Silver and Jewellery Industries (1946–52) and the Rayon Design Centre (1949–52). Against such a background the Council's Information Division became more prominent than the Industrial Division, propaganda and publicity proving to be less problematic areas for visible activity than the constant friction and rebuffs engendered by attempts at liaison with manufacturing industry. Many of the problems of definition, selection policy and lack of co-operation encountered at *Britain Can Make It* of 1946 were to resurface in relation to industrial design at the Festival of Britain in 1951. Although a number of lessons had been learned through bitter experience, it was clear that the evangelical message of Good Design was easier to preach than to radically influence either industrial or social attitudes.

Notes

1. HMSO (1932) *Report of the Committee appointed by the Board of Trade under the Chairmanship of Lord Gorell on the Production and Exhibition of Articles of Good Design and Everyday Use.*
2. For an introduction to some of these exhibitions see Woodham, J. (1980), 'British Art in Industry 1935', Design Council, pp. 39–44.
3. Late Secretary to the Council for Art and Industry (CAI), registrar of the National Register of Industrial Art Designers. Foley China was made by E. Brain and Co., Stoke-on-Trent.
4. The scheme is discussed by Noel Carrington (1934), a DIA lobbyist, in 'Artists and Industry at Harrods', *Design for Today*, pp. 461–64.

5. CAI (1937) *Design and the Designer in Industry*, HMSO.
6. Quoted in Gray, M. (1970) 'SIAD: The First Forty Years', *Designer*, October, p. 4.
7. For a rather more partisan account, see Holland, J. (1980), *Minerva at Fifty*, Weidenfeld and Nicolson.
8. Two of its partners were Milner Gray and Misha Black, both of whom were also heavily involved with the Design Research Unit which was responsible for the 'What Industrial Design Means' display at the BCMI.
9. *The Times*, 19 November 1945.
10. Kaufmann Jr, E. (1948) 'Borax or the Chromium-Plated Calf', *Architectural Review*, August, pp. 88–93. This is one of a number of such tirades penned by Kaufmann.
11. These are extremely usefully discussed in Riley, T. & Eigen, E. (1995) 'Between the Museum and the Marketplace: Selling Good Design' in Museum of Modern Art, *The Museum of Modern Art at Mid-Century at Home and Abroad*, MOMA/Harry N. Abrams, New York.
12. Blake, J.E. (1960) 'Consumers in Danger', *Design* 134, p. 25.
13. Farr, M. (1955) *Design in British Industry: A Mid-Century Survey*, Cambridge University Press.
14. *The Times*, 3 January 1945.
15. *The Times*, 11 January 1945.
16. ID 312/14A, Appendix CM (45) 9.
17. ID E/1, Exhibitions Committee (Director's File), Minutes of Meeting, 13 September 1945.
18. ID 385/8, 'Birth of an Egg Cup' booklet by Misha Black. (Fundamentals of Design Section, Britain Can Make It, note by SCL to Alan Jarvis.)
19. Ibid., internal COID note from Stella Carlisle to Alan Jarvis, 9 August 1946.
20. Ibid., letter from Dorothy Goslett to Allen [*sic*] Jarvis, 13 August 1946. Her knowledge of existing texts on industrial design was clearly limited. John Gloag's *The Missing Technician in Industrial Production* of 1944 was one of a small number of British texts already in existence.
21. Ibid., internal COID note from Stella Carlisle to Alan Jarvis, 24 October 1946.
22. Ibid., internal COID report on *The Birth of an Egg Cup*, initialled by Stella Carlisle, 27 October 1947.
23. A number of these initiatives are discussed in essays contained in Pavitt, J. (1996) *The Camberwell Collection: The Object Lesson*, Camberwell College of Arts, London Institute.
24. This is discussed fully in Woodham, J. (1996), 'Managing British Design Reform II: The Film *Deadly Nightshade* – An Ill-fated Episode in the Politics of "Good Design"', *Journal of Design History*, vol. 9, no. 2, pp. 101–15.

Part 4

DOCUMENTATION AND COMMENTARY

10 Introduction to the Documents

Patrick J. Maguire and Jonathan M. Woodham

The function of this section is to provide an indication of the range of original documentation relating to the *Britain Can Make It* exhibition. A variety of types of document have, therefore, been chosen and it cannot be emphasized too strongly that this represents a very small, and not necessarily representative, selection. The types of document chosen range from private, confidential letters, official public pronouncements to the minutes of various committees, the deliberations of state officials and the formal instructions issued to officers of the COID. In all cases the existing reference number of the document is supplied along with a brief note as to the origin and nature of the document.

Historians rely on such documents in constructing their histories but they do not speak for themselves and much of the historian's art lies in properly interrogating the available sources. That means that the internal structure, the purpose, implicit as well as explicit, and the conventions within which the document is formulated need to be established. No document can be taken solely at face value and all have their particular constraints as well as their particular historical virtues. While private correspondence, for example, may be considerably more candid than official letters it may also be inaccurate to the extent that it embodies individual prejudices, half-truths, innuendo and plain gossip (although gossip has its historical uses too). On the other hand the measured tone of official minutes may appear to have all the hallmarks of dispassionate veracity but may well have been constructed, particularly in relationship to sensitive issues, to minimize tensions and disagreements within a given committee or organization. Most good chairs and secretaries of committees have largely constructed a meeting before it happens and official minutes can often bear more relationship to script writing than to precise documentation. Official letters (as opposed to private internal minutes and memoranda) are usually constructed according to conventions as precise as any literary genre, and not merely in terms of formal address, while internal minutes may have has much to do with the positioning and politicking of

the author (or department) concerned as with the apparent substance of the minute or note. That is not to say that documents are overtly misleading, although on occasions they may be so, still less to imply that they can be avoided by the assiduous scholar. It is to suggest that the historian cannot afford to be seduced by the apparent verisimilitude of paper, however dusty and authentic it may appear. There are no short cuts in the construction of history and documents, like any other body of evidence, carry with them their own problems. It is for the historian to establish the provenance of the documentation and to properly penetrate the layers of historical meanings buried within.

Almost all of the documents contained within this section are drawn from the Design Council Archive which is located in the Design History Research Centre at the University of Brighton. The reference numbers derive from those originally used by the COID. Few of them have been used in any previous studies on the *Britain Can Make It* exhibition.

11 Documents and Commentary

DOCUMENT 1: NOTES FOR THE PRESS: COID MEMBERSHIP

The brief biographical notes issued by the Press Office provide a useful guide to the COID's initial membership. It should be noted, however, that these refer solely to public members and not to civil servants, nor indeed to the paid staff like the COID's Director, S.C. Leslie. The membership is dominated by individuals, overwhelmingly male, who were associated both with pre-war design groups and with the wartime state in a variety of capacities.

Ref: ID/1945

COUNCIL OF INDUSTRIAL DESIGN
Notes for the Press

Sir Thomas Barlow: Director-General of Civilian Clothing; Past President, Manchester Chamber of Commerce; Member, Council of the Royal College of Art; former Member, Council for Art and Industry; Member, Industrial and Export Council, Board of Trade; chairman, Barlow & Jones Ltd; Director, District Bank Ltd.

Mrs Margaret Allen: Member of the Women's Cooperative Guild, Management Committee of Watford Cooperative Society Ltd, and Central Board of the Cooperative Union.

Sir Steven Bilsland: Vice-Chairman, Scottish Council on Industry; former Vice-Chairman, Council for Art and Industry and Chairman of Scottish Committee; Chairman, Bilsland Bros. Ltd, and of Union Bank of Scotland Ltd.

Sir Kenneth Clark: Director of the National Gallery; Vice-Chairman, CEMA.

Dr. R.S. Edwards: Member, Industrial and Export Council of Board of Trade; Director, Cooperative Wholesale Society Ltd, Member, Export Guarantees Advisory Council.

Mr. Leslie Gamage: Vice-Chairman and Joint Managing Director, General Electric Co. Ltd; also on the Board of several exporting companies and electricity supply companies; President, Institute of Export.

Mr. E.W. Goodale: Chairman, Silk and Rayon Users' Association Inc.; Vice-President, British Rayon Federation, and Chairman of the Federation's Industrial

Art Committee; Chairman, Furnishing Fabric Federation; President, Furnishing Fabric Manufacturers' Association; Vice-President, Royal Society of Arts; Former Member, Council for Art and Industry; Director, Warner & Sons Ltd.

Mr. William Haigh: Member, Council of the National Wool Textile Export Corporation; Member, Wool Industries Reconstruction Committee; Managing Director, Dobroyd Mills Co. Ltd, and of Eastwood Bros. Ltd.

Mrs Mary Harris: Principal, Mary Harris Gowns, Clothing Manufacturers, Team Valley Trading Estate.

Mr. Francis Meynell: Adviser to the Board of Trade on Consumer Needs; Founder, Nonesuch Press; Director, Mather & Crowther Ltd; Writer and Broadcaster.

Mr. Gordon Russell: Member, Utility Furniture Advisory Committee; Chairman, Design Panel Advisory Committee on Utility Furniture; Member, Furniture Production Committee; Chairman, Gordon Russell Ltd.

Mr. Charles Tennyson: Chairman, National Register of Industrial Art Designers, FBI Industrial Art Committee, Central Institute of Art and Design, Advisory Committee on Utility Furniture, Furniture Production Committee; Member, Council of Royal College of Art; Former Member, Council for Art and Industry; Secretary, Dunlop Rubber Co. Ltd.

Mr. A.G. Tomkins: General Secretary, National Amalgamated Furnishing Trades Association; skilled craftsman.

Mr. J.H. Tresfon: Managing Director, Boulton and Paul Ltd.; Chairman, H. Widdup & Co. Ltd; Director of several other engineering companies.

Mr. Allan Walton: Director of Glasgow School of Art; Director, Allan Walton Fabrics; Member, Special Committee on Technical Education of the Advisory Council on Education in Scotland.

The Hon. Josiah Wedgwood: Member, Council of Royal College of Art; Managing Director, Josiah Wedgwood & Sons Ltd; Director, Bank of England.

DOCUMENT 2: 1946 EXHIBITION PROPOSAL

The initial outline proposal framed by the COID demonstrates the extent to which the export drive was already considered of central importance, even if, as indicated in paragraph 10, the Council was aware that many of the items on display would be, at best, prototypes only. At this stage it clearly did not envisage the difficulties which would occur the following autumn. The other rationale for a major exhibition, already outlined before the inception of the COID, was a concern for 'national prestige', also clearly at the forefront of the organization's thinking.

Ref: ID 312/14A

The British Exhibition of 1946

A Proposal to the President of the Board of Trade

1. The Council of Industrial Design wishes to propose, for your consideration, that an exhibition of British Industrial design be held as early as possible in the summer of 1946.
2. The purpose of the exhibition will be to inaugurate, and to symbolise, the new era of creative achievement that lies before British industry. It will show to Britain herself – her manufacturers, traders and people – and to the world the capabilities of our national industry, and the way in which it is preparing for the great export drive. The project, suitably announced by yourself, with an intimation of your full support, will spur industry to new efforts in the development of design.
3. Moreover, the project will secure to the Council an initiative in promoting and maintaining high standards, which it might well lose if industry's plans were allowed to take shape independently of the influence which will be conferred upon the Council by its power of selection for a notable national Exhibition. The Council's general programme for industry is a long term one. The plan for forming design centres must come into being slowly, and its practical effects on production will be slower still. But the present is the vital time. During the next few years, any goods that can be produced will be saleable. This offers an opportunity to which industry may rise – or a temptation to which it may succumb. We submit that national interest requires the Council to do everything possible to ensure that the temptation of turning our poor or old fashioned design in the knowledge that it will sell at home and abroad is resisted, and the opportunity to attain new and progressive standards, without commercial risk is grasped. The suggested Exhibition will set the current of industrial activity moving in the right direction from the outset.
4. The practical difficulties in the way are considerable, but if the argument of the foregoing paragraphs is accepted it follows that the effort to overcome them is well worth making. The can, in our view, be overcome provided – and only provided – that two conditions are fulfilled.
5. The Government must be prepared to announce the Exhibition as a major project of great importance in the public interest, and to issue a clear call to industry to co-operate.
6. Secondly, the Government will need to clear away whatever administrative obstacles may stand in the way of the full participation of manufacturers in such an exhibition, by releasing designers from the Forces and industry, and by making available all reasonable facilities to would-be participants.

SCOPE AND NATURE

7. The exhibition should cover all the main consumer goods in wood, textiles, plastics, ceramics and metals but not light or heavy productive machinery (a first provisional list of commodity groups is attached, with a note). It should include a section of moderate size aimed at educating the consumer in the fundamentals of design, and one dealing with the work of British industrial designers individually.

8. It should include a survey of the wartime achievements of the relevant industries – both those which had opportunities of production for war purposes, and those which, while restricted during the war, produced articles for export which have never seen the light of day at home. These wartime achievements should, where possible, be shown as the precursors or foundations of the new post-war productions which will, in many industries, owe so much to wartime developments of material, technique or design.

9. One purpose of the exhibition must be to show the significance of post-war design for an increase of beauty and amenity in the home. At the same time, the balance must be fairly held between these decorative industries (textiles, pottery, glass, etc.) in which British leadership is traditional and which loomed large in the export trade of the past, and those other minor industries with which the future so largely lies, both in the national economy at home and in the export trade. On the one hand, the intense interest of the ordinary citizen in his or her future home must be served; on the other hand, it is essential to avoid any suggestion arising from this, the first post-war gesture of our industry, that Britain as a producer is becoming a lightweight. The criticism levelled at the British stand in the Paris Exhibition of 1937 may or may not have been fair; it is in any case essential that no such criticism should be levelled at the Exhibition now proposed, which must contrive to show that many of the industries producing the consumer goods of the future are, or are integrally related to, those which helped to win the war, and that they have their roots in a powerful industrial economy belonging to a first-class Power.

10. In so far as the goods to be shown are available in quantity for export or home sale, well and good; but many of the exhibits will clearly not have gone beyond the prototype stage. The Council believes, however, that a show of goods of this kind, even if many of them are not available to the public for months to come, will be perfectly acceptable, if its significance and its limitations are clearly explained. The Council is, moreover, satisfied that a considerable volume of developmental work has in fact gone on, and that under the stimulus of a project such as this, ore still will go on during the next six or nine months, so that the range of new design from which selection can be made will be sufficient. Industrialists will, however, need some reassurance that their normal fear of the copying of exhibition designs will not on this occasion have special grounds, since a number of them will be showing goods not yet in production, and copyists will have exceptional opportunities to catch up with the originators.

11. It is intended that the commodities on show should in general be displayed spaciously, so as to throw emphasis upon their individual qualities as objects of design, and should not be crowded together in the manner of a Trade Fair.

12. While the Exhibition should not be arranged as a commercial fair, it will be possible to operate a system referring inquirers to the manufacturers of any goods which may have aroused their interest.

13. The main target at which the propaganda message of the Exhibition is aimed is at home – the British manufacturer and public. A good deal of foreign interest – particularly on the part of Continental countries – will express itself automatically. It is, however, a matter for consideration whether special efforts should be made to attract overseas visitors, including buyers. In this connection it will be remembered that the first postwar British Industries Fair is timed to open in the Spring of 1947, perhaps about six months after the close of the Exhibition now proposed. The undoubted advantages of attracting overseas commercial visitors to a propaganda exhibition of this kind must be weighed against the possibility that certain of them, having come to see goods for which only forwards orders can be accepted, may be deterred from re-visiting Britain a little later for the national trade fair. The Council does not wish to make or to imply any recommendation on this issue, but merely to point out that it requires careful consideration.

14. In order to achieve the purposes of this Exhibition, it is essential for the Government or the Council to retain full and unfettered power of selection. The co-operation of industry will be necessary for many purposes, including the assembly of the necessary ranges of goods from which the Council's selection committees will make their choice. It might be possible, in theory, to induce organised industries to share the cost of the Exhibition by renting the space allotted to them, and dividing it among their constituent firms in proportion to the space occupied by the goods selected. One successful exhibition on these lines was held, some years before the war. It was, however, on a smaller scale and involved considerable tasks of salesmanship and persuasion. To adopt this policy in present circumstances would introduce serious elements of uncertainty, and of delay, which it would not be wise to envisage when time is so short and there is so much to be done. The Council, therefore, recommend that the Exhibition be financed wholly by the government, apart from attendance receipts, the sale of catalogues and possibly the rent of catering space, if that should be decided upon.

PRACTICAL DETAILS

15. Date: The Exhibition should open in May, if this is found practicable. So early an opening, however, is unlikely, and if it were not found possible to be ready until July we do not think this would be too late. It would leave at least three months of suitable weather and temperature conditions.

16. Size: It is impossible to offer definitive estimates at this stage, but after a careful discussion of the purpose and scope of the Exhibition with the authorities of the Department of Overseas Trade – whose help and co-operation we wish to acknowledge – we have come to the conclusion that

the floor area should be not less than 75,000 sq. ft. and not more than 100,000 sq. ft. These areas are not large in relation to the considerable range of commodities to be shown, and the need for spacious and individual display. (For purposes of comparison it may be mentioned that the area of the British Government Pavilion at the Glasgow Exhibition was 60,000 sq. ft. and the area of the largest single hall at Olympia is 100,000 sq. ft. The total gross floor area of Olympia is about 500,000 sq. ft.)

17. Site: We have considered various possibilities. Olympia is in use for the army demobilization clothing scheme and is ruled out. Earls Court might be de-requisitioned in time, partly at least, but many wartime structures would need to be removed and at best this building is not ideal in site or character for the present purpose. It is, however, an important possibility. Stafford House has claims to consideration, on account of its position, its prestige, and the beauty of the building and the rooms; whether it offers enough practical space, and can house some of the larger exhibits, is not certain. The Victoria and Albert would not be able to offer the necessary space, and its site leaves much to be desired – unfortunately, since such an exhibition falls entirely within the special purposes for one, a waterborne Exhibition on barges or boats on the Thames, the other the erection of temporary structures in Hyde Park. The novelty and publicity value of each is obvious, and so is the advantage of their central positions. The former, however, may not be practicable while against the latter must be mentioned the traditional objections – deeply felt in some quarters – to the use of space in the Royal Parks, the special difficulty just now of diverting materials and labour from the housing programme and the cost of special buildings. (It may be worth considering whether tubular steel and asbestos sheeting would be available; how much the use of the special forms of labour needed for their erection would affect the housing programme; and whether the Royal Engineers could be used for the constructional work, in which some of their Companies are expert).

18. The Council is unable, at present, to make any positive recommendation from among these suggestions but would welcome some guidance on the issues of policy involved, and thinks that it may be desirable to explore these and other possibilities with the Ministry of Works, whose advice on questions of site and types of building construction has been offered and would be most valuable.

19. Cost: The cost of internal constructions (stands, fittings, etc.), of lighting, murals, designs and fees, can be very roughly put at £1 per square foot of gross floor space at the present time. In addition must be reckoned £20,000 for publicity at home, £5,000 for staffing and guardianage, £5,000 for administration other than as provided by the Council's staff, and a contingencies figure of ten per cent. This totals roughly £115,000 for the smaller area mentioned, and some £145,000 for the larger. Rent cannot be estimated until the sight is determined. Temporary construction on the lines indicated would cost about £80,000 for 75,000 square feet and about £90,000 for 100,000 square feet. Again an addition of ten per cent for contingencies would be prudent.

20. The Ideal Home Exhibition at Olympia drew some three quarters of a million people in less than a month. In a much smaller area, but on a central site, the first postwar National Exhibition might, with full Government backing,

draw in three months anything from three quarters of a million to a million and a half – conceivably more; admission at 1/- per head (this figure might be higher) would then yield from £37,500 to £75,000.

21. The cost of the Government stand at the Glasgow exhibition was £165,000; the cost of the British Pavilion at the New York World's Fair was £350,000.

22. After its conclusion in London the Exhibition might well be sent on a world tour, either to a succession of fixed sites in or near capital cities, or in a large merchant or naval vessel.

DOCUMENT 3: LIST OF SUGGESTED TITLES FOR THE 1946 EXHIBITION

From an early stage the specific identity of the putative exhibition would present problems. The list of proposed titles does not actually include the final one, which Leslie credited to the Council's Librarian, but does show a strong concern for national projection (including possibly impolitic suggestions such as 'The Lion's Share') and industrial performance, important subtexts which would run through the exhibition.

Ref: ID 312/45

To: Mr. Leslie

From: C.A. Mesling

<u>Suggested Names for the Exhibition</u>

Power for Peace*	Design for Peace
Good British Goods	Designed for Peace
The Best in Britain	The Design for Trade
Plan for Production	Peace Effort
Made in Britain	Arms for Peace
British Made*	Industry for Action
Britain's Shop Window	Industry on Parade
Britain's Victory Show	Hallmark – British
The Lion's Share	Trademark – British
Britain's Production Plan	British – Trademark
The Lion on the Label	Design for Reconstruction
Passport to Peace	Design for the Future
Victory in Industry	Designs of Industry
Good British Goods	Designs of British Industry
Design for Efficiency	Britain Creates
Design for Production	

C.A. Mesling
17th October 1945

* Are the only 2 I really like

DOCUMENT 4: BRIEF NOTES ON ORGANIZATION

Given the politically problematical performance of the Council's predecessor, the Council For Art and Industry, in mounting major exhibitions, particularly the 1937 Paris Exhibition, considerable effort was made to ensure that the new organization was more sensitive to the political and industrial interests it would necessarily have to embrace. Ryder's memorandum to Leslie in September 1945 shows the extent to which Council operations were structured.

Red: ID 312/45

To: Mr. Leslie

Summer Exhibition 1946

Brief Notes on Organization

General
1. It is most important at the outset to define clearly the purpose of the proposed Exhibition so that a proper theme can run through it.
2. The next thing is to decide on the scope and size of the Exhibition.
3. Duration.
4. Location.

Organisation
Having settled the above points, it is necessary to consider:

 (a) The design and layout of the Exhibition.
 (b) Its organisation and management.

(a) An Architect should be appointed to make a survey of the site or building in which the Exhibition will be held. He will be responsible to the Exhibition Manager or Organiser, and the Display Designers. Artists appointed at various stages for different sections will work under the direction of the Architect, who will co-ordinate all their plans so that he may pass (through the Manager) the constructional and wiring drawings to various standfitting and electrical firms, who will be asked by the Manager to submit tenders.

 The Architect will be responsible for the general supervision of the construction of the Exhibition as a whole, while the Display Designers will only be responsible for their particular sections. It is obvious that the Architect and the Display Designers will have to work in very close touch with one another.

 Until the exact scope and size of the Exhibition is known, it is not possible to say how many or what kind of Display Designers we shall need to employ.

One type of mind may be good for a section such as clothing or textiles, while quite another mind would be required for work in connection with a section dealing with domestic appliances.

(b) The practical work of organising the Exhibition should be handled by a small Management Committee. The Chairman of this Committee should be, to my mind, a Member of the Council. The Committee itself should in theory consist of:

(1) Chairman (Member of the Council)
(2) A finance expert
(3) The Architect
(4) The Exhibition Manager

Co-opted Members:
(1) Publicity Expert
(2) Display Designers

Sir Charles Tennyson would, I think, make an admirable Chairman, and he could also incorporate the duties of the finance expert. The Exhibition Manager would act as Secretary to the Committee. It is important that the publicity expert should attend all meetings of this Committee from the earliest possible date. On second thoughts, perhaps the finance expert should be a member of the Finance and General Purposes Committee.

Publicity
Perhaps we should consider the appointment of a small Publicity Committee. It is often found desirable to form a general 'Snob' Committee when organising an Exhibition. Such a Committee does help in many ways to make the Exhibition more widely known, and to get people to go to it when it is finally opened to the public. Perhaps, however, in this case we might dispense with such a Committee.

Organisation of Exhibits
From time to time we shall need to call upon a number of different people for advice, and I cannot help feeling that it would be a good idea to have an Advisory Committee, to which we could add names as and when required. The Committee, however, would not meet as a body, but the Management Committee, or Manager, should be in a position to seek the advice of members at any time. Finally, when the Exhibition is opened to the public, the names of such members could be mentioned in all publicity material as being members of the Exhibition Advisory Committee. They might all be asked to meet together on some occasion towards the date of the opening of the Exhibition, and in any case they and their wives should be invited to the official opening or private view.

When the exact size and scope of the Exhibition is known, and when we have decided on which Industries should be invited to take part, we should consider the following points:

(a) Finding the most suitable progressive individual in each Industry who could be made a member of the Advisory Committee.

(b) The formation of a small Committee by an Industry itself with its own Secretary, to work in close touch with the Exhibition Manager.

(c) The formation of a Committee of not more than three people to act as Selectors of exhibits. This Committee should consist of:

1. A Member of the Council?
2. A person within the Industry with good taste.
3. Some person not connected with the Council or with the Industry, but who is known to have some knowledge and interest in the Industry covered by the particular Committee. In the case of the Pottery Industry, this person might be Mr. Honey of the Victoria & Albert Museum.

I think in our discussions we have covered the internal organisation and Staff required. I agree with you that we must make every effort to delegate to outside individuals and organisations as much work as possible, and remain ourselves as the producers of the main ideas and the co-ordinators of all activities which will contribute to the building up of the Exhibition as a whole.

I would, however, like to stress that I think it is essential that all orders to firms involving expenditure of the Council's money, should be passed through the Manager, so that he may be in a position to keep a tight hold on the financial side of the work. At the earliest opportunity he should draw up rough estimates of costs and running expenses, and he should be able at short notice to submit, if called upon to do so, the exact financial position. From time at time considerable variations and adjustments in the original estimates will be found necessary. Ten per cent of the total original estimate should be allowed for contingencies.

DOCUMENT 5: SCOPE OF THE EXHIBITION

Tennyson, as Chair of the Federation of British Industry's Industrial Art Sub-Committee, had played an influential role in the formation of the COID. An experienced and astute lobbyist, he had been a prominent figure in the various debates concerning the function of design in industry prior to 1939. His own industrial experience and concern at the assumed imminent impact of reinvigorated American competition are well illustrated in this briefing paper presented to a meeting of the COID's members, as are his concerns that the exhibition should exert a considerable populist presence.

Ref: ID 312/14A

Scope of the Exhibition

Report by Sir Charles Tennyson:
The general lines of the Exhibition suggested were these. It was of course its primary purpose to demonstrate to the British people and the rest of the world what Britain was going to do after the War, and also to act as an incentive to manufacturers, arousing their interest in the importance of Design.

It was felt that the main display must be one of selected products, and that we should probably not be able entirely to fill this with new products designed specifically for the postwar period. We do not altogether want to cut out the best of what was done before the War. We have to rely on both sources.

A very good way of giving the Exhibition a topical note and a special interest would be to link up with the display of products something to show how the needs of War production have influenced Design for civilian production, and to link those two ideas together. For example, the use of light metals and laminated veneers and plywood, and the new forms of plastics and so on, could be shown in their war and peacetime uses.

These would be the main sections and would have a certain number of 'side shows' attached to them. One of those might show the importance of Design in the export field; another might show what Industrial Design means and how it is arrived at – the purpose of Design and the way in which Industrial Design is evolved, not by one person, but by team work.

Another section which we thought might possibly be of value in regard to the needs of the future would be devoted to the tourist traffic in some way – travel and an inducement to people to visit this country.

We might have another 'side-show' which would illustrate the work of British Industrial Designers, as a counter-blast to the blast which will come from American Designers directed against this country.

Yet another might be an exhibit dealing with the fundamentals of Design as a means of educating the public in its real significance.

Broadly speaking, that is the kind of idea which we contemplate.

We had a Meeting on Wednesday of a number of individuals, who we thought might be able to contribute ideas, and from them we got some very interesting suggestions. One, from Mr. Gloag was that as we were likely to be rather short in new products, the Council should commission designs and have these specially made up. If they cannot be made up by the full industrial process, then they could be shown as models, such as could be manufactured by the process contemplated.

There were two alternative ways of introducing these. One was that we might have them included in each section, so as to strengthen the section and bring out the idea of the future, or they might be a separate section which should probably come at the end, so that the visitor would then come to this section showing the future, which might appeal to the imagination.

Our exhibits in the main portion of the Exhibition will probably fall into three groups:

1. Interior furnishing
2. Dress
3. Functional objects, such as domestic machines, radio, etc.

Interior Furnishings. We would show these in rooms to some extent as well as in commodity groups. This would also apply partly to No. 3. We may also have a small street of shop windows.

Dress. There has been a good deal of discussion about this. Some people were against an attempt to show feminine costume, on the ground that we are not so good at it as other people and that it is difficult to display. The majority opinion is that certainly we must have a strong fashion display because so much hangs on it. We have decided to recommend a strong fashion element.

It has been decided to eliminate the mannequin and to deal with this in a special way. Our thoughts at present are moving in the direction of picking our own Designers and getting them put forward ideas for display in co-operation with the principal Fashion Houses. This will extend to both male and female fashions, and no doubt the dress fabrics will be linked up with this.

We also decided that we would not entirely eliminate the historic past. Where there are historical British products in line with the British styles of today and tomorrow, we would probably include examples of those, e.g. furniture. The line between the old furniture of the 18th Century and the high grade furniture of today is not so remote in methods of construction.

We have not yet found a title to our satisfaction.

One of the visitors to the Conference thought that the note of the Exhibition must be something to appeal to the imagination and make the visitor think to himself 'Something has happened to England' I would like this introduced into the title – something new and unexpected – something of the future.

Now a word about the organisation and the preparation of the Exhibition. The view of the Committee is that we want so far as possible to encourage youth in the display – and new ideas. We will probably engage a number of display men as far as we can – young men of imagination – to take charge of different sections. Probably there will also be a Consulting Architect and also a Chief Designer. These matters are not yet quite fully worked out.

There is a great deal of difficulty about the place. There is very little suitable space available in London. The President of the Board of Trade has come down very strongly in favour of Earls Court, which is a disagreeable building, but has a great deal of space, and is associated in the public mind with entertainments. If we do go there, the public will go there in the right spirit, and it will probably attract them. We must try to deal with the ugly building by internal adaptation.

We have given a great deal of thought of interesting Industry and getting what we want from it. It is a matter of great difficulty because so few industries will have their plans well enough forward, and those with new ideas may feel that they will not be able to put them on the market until 12 months after the Exhibition. They might be unwilling to exhibit them and give their competitors the advantage of copying them. Perhaps the President will help us personally in that respect.

After some discussion the Council gave general approval to the plans outlined by Sir Charles Tennyson.

DOCUMENT 6: EXHIBITION DRAFT PLAN

Still undecided as to the title of the exhibition, the Council's outline proposal has already shifted the focus somewhat to identifying a distinctive British industrial design aesthetic (and ethic) with previous 'achievements' relegated to a supporting role. The reiteration of the industrial design focus frequently obscures thematic and organizational confusions.

Ref: ID 361/14A

PAX/P.1.

THE COUNCIL OF INDUSTRIAL DESIGN
Proposed Exhibition – Summer 1946

Draft Plan (2)

Suggested Title:

Swords into Ploughshares: British Goods for the New Age

Purpose
The primary purpose of the Exhibition is to demonstrate to the British people and the rest of the world the quality of postwar British industrial design, (to be unmistakably distinguished from arts and crafts) and to stake a claim to British leadership in the new age.

British design and industrial achievement in war can be used as a supporting theme to underline the significance of the postwar display. Apart from this the reference to historical achievements should be limited. Logical though it is to argue 'Britain has always led – she will still lead', in practice too much backward looking would confirm the critics and doubters of Britain's continued leadership.

As incidentals, there should be some exposition of the significance of design to the consumer and some account of the work of British industrial designers. It will be legitimate to take the opportunity quietly to convey some account of the work and purpose of the Council.

Main Display
The heart of the Exhibition must be a display of a series of articles representing the best new design in all the commodity ranges decided upon.

These articles will be grouped <u>by industries</u>: but as a large proportion (by no means all) of them will be household commodities of use and ornament, there should be a complementary display of fully furnished and equipped <u>rooms</u>. If shop and office equipment looms large enough among the commodity exhibits,

this too might be displayed in use as well. A small street of well-designed shop windows would provide an attractive background for displaying exhibits. Other exhibits might perhaps include a civil aircraft interior, a railway coach interior, a ship's cabin, and one or more postwar motor bodies.

As an introduction and context of this postwar display, the work of the contributing industries in war should be shown in such a way as to indicate the relationship between war and peace. This relationship will of course be different according to whether the industry was engaged in important war production, or was concentrated and its development work confined to export. In the former case, war production will lead on to peace – the Mosquito to the new plywood furniture, the Lancaster fuselage to the aluminium house, tropical packaging to the new type of display carton, the transparent bomber-nose to the delicately figured plastic light-fitting and so on. In the case of the wartime civilian industries there can be some reference to their achievements in Utility production and their progress in design for export (in some instances this will be an interesting surprise to the public). For the rest, these industries' postwar designs will appear as a triumph over the handicap of the war years, instead of an adaptation of the opportunities the war created.

It is not certain whether the relation of war to peace can best be shown industry by industry, in one big spatial unit subdivided according to commodity ranges: or whether war production can be grouped by commodities in one hall or section, leading on to the main section with postwar designs arranged on a similar ground-plan so as to suggest the link, industry by industry, with the war display. This issue can only be settled in relation to the space available and to the ideas and suggestions of the exhibition display experts.

The war-into-peace theme will be the big 'talking point' of the Exhibition and it should be easy to stock the main section or sections with numerous 'features' of real news value and of great interest to the public.

Supplementary Sections
We now set out briefly a possible list of special sections, with some slight indication of content and method as a basis for discussion and a way of stimulating the main displays, occupying very much smaller spaces, and not pretending to comparable interest. At the same time the opportunity of developing a series of themes, in the service of propaganda for design, should not be missed; and the ideas underlying the main displays should be brought out explicitly in these supporting sections.

Approach
The note of Industrial Design must be struck at once. A pair of symbolic objects, or large industrial products on plinths with half a dozen suitable words might achieve this.

Entrance Hall
The idea here would be to set industrial design in its widest context. To live, Britain must import food and materials for manufacture into goods, many of which must be exported to pay for the food and materials. The exhibits would be

placed, like pieces of sculpture, in flood-lit recesses, and should represent (in a logical series, the meaning of which will be apparent) Food, Raw Materials, Labour, Fuel, Power, Industrial Design, Production, and Marketing – and so back to the beginning.

Section 1. The Task of Export
The representational exhibits in the Entrance Hall started with Food and Raw Materials and finished with Marketing. In Section 1 there should be a map of the world showing from where this country obtains much of its food and raw materials in normal times, and to which countries exports are sent. All this information could be collated, and cubes of various sizes signifying so many £s value could be placed in the pans of a large model of a pair of scales, showing how the exports must balance the imports.

There might also be marked on the map of the world the export markets previously held by Germany and Japan with some details of the opportunity they now offer to British industry.

Section 2. The Fundamentals of Design
The main part of this Section should deal with the fundamentals of Design where visitors would be invited to touch abstract objects in order to appreciate the meaning of shape, feel materials to understand texture, and look at various colour combinations and contrasts. It might be feasible to include in this Section, or to attach to it as a subsection a Design 'Quiz' or Puzzle, which might be composed of two rooms, the first one containing so many articles or features which are incorrect from a Design point of view, visitors being asked to fill in a numbered form stating what they think are the incorrect features or articles. The answers to the questions might be printed on the back. The second room should approach the subject from the opposite point of view, namely, so many features or articles should be correct, the visitors again being asked to fill in a similar form.

Note: the position of this whole section in the series should be further considered. It might possibly come better after the main Exhibition.

Section 3. The Process of Design
An attempt should be made to explain what is meant by Industrial Design. It should be emphasised that a final design is not necessarily the product of any one man's mind, but may be the result of team work. The team would consist of such people as the ideas man, e.g., the designer, the scientific or raw materials expert, the production engineer, a representative of the management and the sales manager, etc. It might also be suitable to show the various stages through which a design passes after it leaves the drawing board until it becomes the finished article.

Section 4. British Industrial Designers
This Section should be devoted to the work of present day British Industrial Designers, with examples of the work for which they have been responsible, mention of course being made of the names of their designers and of the Manufacturers, and possibly even of the different members of the manufacturers'

staffs who have collaborated with the Designers. Murals or other devices might recall the historical triumphs of British design.

Section 5. Leisure Section
This should be devoted to Leisure. The exhibits include Hotel and Cafe Furniture, Garden Furniture, Tools and Equipment, Hand Tools, Sports Clothing and Goods, Bicycles, Travel Goods, Camping Equipment and Picnic Baskets, etc.

Section 6. Fashion
This should be a strong feature of the Exhibition, and would include dress fabrics and both male and female fashions. Specially picked Designers would cooperate with the principal Fashion Houses, but it is not proposed to make use of mannequins.

Section 7. Final Section
In this Section might be shown some entirely new designs by Designers specially commissioned. They would be produced, either in final or in model form, in close collaboration with Industry, and should serve to stimulate the imagination of the visitor, and send him away from the Exhibition feeling that 'Something has happened to England'.

NOTE: The sequence of the above Sections has not yet been finally settled.

DOCUMENT 7: FIRST MEETING OF THE COID EXHIBITION POLICY COMMITTEE

By October 1945 the Council had finally agreed on a title for the 1946 exhibition but the focus of the exhibition continued to shift towards a more didactic undertaking promoting 'Good Design', as is evident from the interchange between John Gloag and S.C. Leslie. Equally, as was commented upon later, some of the emphasis on 'futuristic' designs, that is to say an imaginative exercise scarcely related to present or even imminent industrial production, was beginning to enter the Council's deliberations.

Ref: ID 361/14A

THE COUNCIL OF INDUSTRIAL DESIGN

The First Meeting of the Exhibition Policy Committee was held at Tilbury House, Petty France, S.W.1. on Thursday, 25th October, 1945, at 3 p.m.
 The following were present:

Sir Thomas D. Barlow, K.B.E.
 (Chairman)
Mr. Leigh Ashton
Mr. J.L. Beddington
Dr. R.S. Edwards, Ph.d., A.R.C.S.
Mr. T.A. Fennemore
Mr. R.E.J. Moore
Sir Charles B.L. Tennyson, C.M.G.
Mr. Allan Walton, R.D.I.
Sir Cecil M. Weir, K.B.E., M.C.,D.L.

Lord Woolton, P.C., C.H., D.L.
Mr. S.C. Leslie (Director)
Mr. Hollowood
Mr. Jarvis
Mr. Macaulay
Mr. Mesling
Mrs. Murdoch
Mr. Ryder
Mrs. Tomrley

The <u>Chairman</u> referred to the formation of the Policy, Executive, and Finance Committees for the Exhibition, and to the appointment to the Policy Committee of Lord Woolton and Sir Cecil Weir, whose advice would be of the greatest value. He said it would be necessary to provide them with adequate assistance and secretarial help.

1. SCOPE OF EXHIBITION

The <u>Chairman</u> referred to the Memorandum of the plan of the exhibition (PAX/p.1) which had already received the approval of the Council.

(a) <u>Mr. Gloag's suggestion</u> that the Council should commission a few Designers to produce some entirely new designs of an advanced nature, but worked out in close collaboration with Industry, was discussed in some detail, and it was decided this idea should be worked out. It was proposed that Mr. Gloag should become Chairman of a small Committee to handle this Section, and that he should be consulted as to who should be appointed by the Policy Committee to this small Committee.

Mr. Leslie was asked to draw Mr. Gloag's notice to the following points which arose during the discussion, namely:

 (i) The importance of good design as opposed to new design.
 (ii) Policy as regards ownership of designs.
 (iii) Cost of production
 (iv) Designer fees.

It was felt that possibly a lump sum should be set aside to enable this Section to be adequately treated.

<u>Dr. Edwards</u> felt that this Section might prove a great attraction, but only if the designs shown were so far ahead of the rest of the postwar designs in the Exhibition as to form a most striking contrast.

It was fully agreed that after Mr. Leslie's meeting with Mr. Gloag, a more detailed scheme, with, if possible, estimate of costs, should be laid before the Policy Committee for its consideration.

(b) Section 2. The Fundamentals of Design
Dr. Edwards drew attention to the proposals for this section. It was agreed that they required considerable thought, and that a more detailed scheme should be laid before a future meeting of the Policy Committee. Dr. Edwards thought that some form of Design Competition, with an entrance fee and prizes, might be organised in connection with this Section.

(c) Section 5. Leisure
Sir Charles Tennyson felt that it had been decided at a Meeting of the Council that this should be replaced by a Tourist Section. The Chairman replied that he thought that what had been questioned was the position of the Leisure Section at the end of the Exhibition. It was decided that further consideration should be given to the matter.

(d) Section 6. Fashion
Dr. Edwards said that it had previously been decided to include mass-produced clothes in this Section. This was agreed.

2. APPOINTMENTS
The Chairman mentioned that the Council had appointed, as Chief Display Designer, Mr. James Gardner, and that it was proposed to appoint an Architect to assist him.

Mr. Ryder explained that, in accordance with the wishes of the Exhibitions Committee, he had approached the Royal Institute of British Architects for their views on the suitability of the following Architects:

Mr. Joseph Emberton
Mr. Basil Spence
Mr. Herbert Rowse
Mr. Howard Robertson
Mr. Brian O'Rorke
Mr. Maxwell Ayrton

It had been suggested to Mr. Ryder that Mr. Howard Robertson or Mr. Basil Spence should be considered, but it was thought that the former would probably be too busy to undertake the work. After some discussion the Policy Committee agreed to appoint Mr. Basil Spence.

It was also agreed that both Mr. Gardner and Mr. Basil Spence should receive a personal fee of 1,000 guineas each, plus a sum for working expenses, for which they would have to provide estimates and accounts. In addition they would, subject to the approval of the Inland Revenue authorities, receive travelling expenses, and personal expenses based on the appropriate Government scale, e.g. a subsistence allowance of 23/6d a day.

Mr. Gardner was then introduced to the Policy Committee and remained in attendance at the Meeting.

It was mentioned that <u>additional Designers</u> would be appointed as required to deal with individual Sections within the Exhibition.

<u>Press Officer</u> Mr. Leslie reported that it has been suggested that Mr. Andrew Reid should be appointed, but on enquiry he had found that Mr. Reid was unwilling to become a candidate for the post. He said that he was now in touch with Press Secretaries Limited, and intended to approach Mr. Colin Wintle, and he asked the Committee for further suggestions. Among the names put forward were the following:

Mr. J.L. Henderson
Mr. Donald McCullough
Mr. Robert Williamson
Mr. G.C. Lawrence.

<u>Sir Cecil Weir</u> undertook to ask Mr. Lawrence to get in touch with Mr. Leslie.

3. LIAISON WITH INDUSTRY
<u>Mr. Leslie</u> reported that the 'Preliminary Notice' of the Exhibition, now before the Meeting, had been circulated to about a hundred Trade associations, with a covering letter asking them if they would be willing to co-operate and to circulate the memorandum to their membership. They were also asked to assist the Council by setting up an Organising Committee in each industry to collect the best designs for submission to the Selection Committee.

4. SELECTION COMMITTEES
The <u>Chairman</u> stated that Lord Woolton had agreed to act as Chairman of a Panel of Selection Committees.

<u>Dr. Edwards</u> put forward the view that each Selection Committee should consist of one member with an intimate knowledge of the industry; one member from the staff of the Council; and one member representing the public view point (who might possibly be a member of the Council).

<u>Mr. Leslie</u> was in favour of including certain buyers of taste and judgment.

The Committee agreed with the view expressed by the council at its last meeting, that members of the Council such as Mr. Russell, Mr. Meynell and Mr. Walton should be considered from the point of view of their technical qualifications as possible members of Selection Committees. After some discussion it was agreed that a paper on the scope of the Selection Committees, and the range of commodities to be dealt with by each, should be prepared and placed before the Policy Committee for consideration.

5. TITLE OF THE EXHIBITION
<u>Mr. Leslie</u> said that it was desirable that the title of the Exhibition should be decided upon before the Luncheon on 2nd November, and he put forward the suggestion that it should be 'Britain Can Make It'. It was agreed that this be an admirable title and it was formally approved. <u>Mr. Leslie</u> pointed out the credit for this suggestion should be given to Miss Goodwin, the Council's Librarian.

6. SITE

Dr. Edwards asked whether a site had been obtained for the Exhibition, and Mr. Leslie explained that the Committee would be justified in assuming that the Exhibition would be held at Earls Court though official decisions had not yet been made.

7. FINANCE

Dr. Edwards in his capacity as Chairman of the Finance Committee emphasised the importance of preparing a budget for the Exhibition. Mr. Ryder mentioned that he had been in touch with the Board of Trade, and hoped to be in a position in the near future to arrange for the Finance Committee to visit Earls Court to open negotiations with the Receiver with regard to rental, and afterwards to prepare a provisional estimate of expenses in connection with the whole Exhibition.

T.D. Barlow

DOCUMENT 8: LETTER FROM ALIX KILROY TO THOMAS BARLOW

Tensions between the Council and its sponsoring department, the Board of Trade, are already evident in Kilroy's note to Barlow. Tightly policed by the Treasury, particularly given the financial constraints of the post-war period, career civil servants like Kilroy were always sensitive to potential financial embarrassments. In Kilroy's case, she was well acquainted with the vagaries of design lobbyists and their penchant for extravagance, both through her pre-war experience and her marital relationships.

ID 312/14A

D.I.M.(G)904/45

Board of Trade
Millbank
SW1

25th September 1945

I.M.(G)904/905

Dear Sir Thomas

I think you will like to have for record the attached note of a talk which Mr. Carruthers and I had with Mr. Ryder last week about next year's exhibition and a

suggestion on which had been made that there should also be an International Congress of Designers and Artists next year. While the Board do not wish to interfere with the Council in the running of the exhibition, they are anxious to be of any assistance they can and must, of course, keep in close touch from the point of view of expenditure of public money. As regards the policy of the exhibition, the President will no doubt wish to consider the broad lines and to approve them before any announcements are made, and all I think we should wish to do at this stage is to emphasise the importance of the general policy being in the hands of the Council. You will, I am sure, agree about the importance of this since it is the first big venture of the Council and may well make or mar its future.

Yours sincerely
A. Kilroy

Sir Thos. Barlow, K.B.E.
Council of Industrial Design
Tilbury House
Petty France SW1

DOCUMENT 9: NOTES OF AN INTERNAL BOARD OF TRADE MEETING

Civil service direction of quangos tended to be discreet and tangential but, as this note of an internal Board of Trade meeting shows, career civil servants were anxious on the one hand to guide the Council's activities while, on the other, preferring that public responsibility should be ascribed to the Council in order to distance themselves, and the Minister/Department, from potential embarrassments.

Ref: ID 312/14A

Miss Kilroy had a talk this morning with Mr. Ryder about the 1946 Exhibition. Mr. Carruthers and Miss Griffiths were also present.

After a preliminary discussion of conditions at Earls Court between Mr. Ryder and Mr. Carruthers, Miss Kilroy raised the question of the President's letter on the proposed Congress of Designers, a copy of which had been considered by the Council of Industrial Design, who were not in favour of the proposal. She said that it was essential to know whether it would be confined to a Congress or would extend to an exhibition. If the latter, would it adversely affect the Council's exhibition? Further, if the Central Institute ran the affair, would it cast a reflection on the prestige of the Council? It was felt that the appropriate time for such a Congress to be held was as part of the International Exhibition of 1951. It was decided that the letter should be referred to the Council who would let the Board have observations.

The constitution of the various committees required to deal with the work of

the exhibition was then discussed. Mr. Ryder was in favour of an Advisory Committee which would settle the theme and title of the exhibition in time for the luncheon and, thereafter, would only meet at irregular intervals when its advice was required. Miss Kilroy pointed out the necessity of the general policy remaining in the hands of the Council, but that there were obvious advantages in having a committee to prepare schemes for the consideration of the Council and that it was desirable that this committee should be appointed.

DOCUMENT 10: NOTES FOR THE GUIDANCE OF INDUSTRIAL LIAISON OFFICERS

The relationship between organizations like the COID and manufacturers was frequently a fraught one. Inclusion, or otherwise, in a major exhibition could have serious implications for individual manufacturers. Given also their experience of the inter-war years, many manufacturers and, often more importantly, their politically powerful trade associations were wary of metropolitan policing of their industrial practices. As many of those concerned with the COID had experienced directly such tensions it is scarcely surprising that their officials were initially instructed to tread warily.

Ref: ID 361/14A

Notes for the Guidance of Industrial Liaison Officers
Note: Two of the principal objects of liaison officers' calls on or correspondence with manufacturers are:

1. To find out a given firm's plans and intentions and to report clearly and fully upon them, and
2. To give manufacturers whatever practical information they need about the organisation of the Exhibition, the method of submitting their goods, etc.

The third object is to discuss design and, where appropriate, to give advice and guidance on it.

The manner in which this point is dealt with is of such great importance for future relations between the Council and industry that I am circulating some general observations for guidance.

The Council's staff should convey to manufacturers with whom they are in contact, that their attitude and the long-term attitude of the Council is primarily helpful and constructive. It is essential that industrialists should learn to think of us as a body whose object is to help them get more business by the maintenance of enlightened and skilful design policy. We must avoid the suggestion that we are a doctrinaire body with a preconceived idea that particular types of design are good and other types bad. We must avoid too any appearance of approaching industry in a critical spirit, to prove them wrong or to tell them what to do. Our

long-term objective is to enable them to give the very best that is in them for their own and the national benefit.

At the same time it must be clear that in the Council's belief there is such a thing as good design and that it is by no means necessarily synonymous with short-term commercial success. It may not always be easy – though it is always essential – to keep strictly to the line between a superior or doctrinaire approach on the one hand and mere appeasement of some manufacturer's narrowly commercial instincts on the other.

Some manufacturers sincerely want and will respond to guidance, and these should be given it according to the liaison officer's best judgment and discretion – this being one of the objects of the whole scouting process.

Others think they want advice more than in fact they do.

Some few others start and finish with the idea that they know better than anyone else.

If a manufacturer clearly would like to submit a certain article, he should not be discouraged from doing so. The industrial officer is in no sense the representative of a Selection Committee and his taste should not be set against that of the manufacturer. If the latter clearly and unmistakably wants guidance it should be possible to give it to him on a friendly and personal basis without appearing to speak for the Council or the Selection Committee. If, as may sometimes happen, he dislikes the advice he has asked for, it should be emphasised that his is the decision whether he will submit or not, and that the Selection Committee's view may well be different from the liaison officer's.

If, however, a manufacturer uses the argument that whatever the liaison officer or the Selection Committee may think, a certain design has proved itself a very good seller, or that in his judgment it is likely to become so, and that this should be decisive, the liaison officer has no alternative but to point out what is meant by a selective exhibition of design organised with the purpose of giving a lead to industry, retailers and the public. This is not at all inconsistent with the view that the liaison officer must not press his view of any particular design to the point of discouraging its submission if the manufacturer clearly believes in it.

It may often be useful to tell a friendly and reasonably receptive manufacturer that what we want him to do is to exercise his own best taste and judgment and to submit those articles in which he would be interested and would make if he knew that he could sell them. One of the objects of the Exhibition and the Council's whole programme is to make it easier to sell well-designed articles by clearing away inertia and prejudice among retailers and the public.

In nine cases out of ten it will probably be true that any interview which concludes in a warm and friendly spirit, with the manufacturer feeling that he understands the Council's objective, and will be glad of further contact with it, is a good interview whatever its immediate effect on submissions for the Exhibition. Any interview which falls short of this is to that extent unsuccessful whatever its immediate outcome. There should nearly always be an opportunity to find some common ground between a manufacturer with some belief in his work, and a Council set up primarily to help industry establish itself in a basis of greater efficiency and success.

DOCUMENT 11: NOTES FOR THE GUIDANCE OF SELECTION COMMITTEES

From an early stage the Council's sense of directing design initiatives as well as reflecting design practice would cause problems. The constitution, remit and representativeness of selection committees would be a sensitive issue as it was they who would both be charged with <u>not</u> selecting goods and, if the need arose, with defending selection policy. The declared aim of 'giving a lead to manufacturers' was always going to be pregnant with the possibilities of discord and the eschewing of 'traditional' designs was equally laden with potential conflicts.

Ref: ID 361/14A

PAX/P.10

Note of Guidance for Selection Committee

1. If this is a selective exhibition it is essential that high standards should be maintained. The Selection Committee will be advised in due course of the approximate area of floor and wall available for each Commodity, but this should not be taken as indicating that that space must in any circumstance be filled. Maintenance of high standards is the over-riding consideration, and the Selection Committee should not feel bound to choose enough goods to fill the given space if that means lowering of standards.

2. One or two assessors from each industry will be appointed to advise the Selection Committee on questions arising in connection with the commodities produced by that industry. These assessors will be able to deal with both production and marketing questions.

3. In an exhibition of new designs, some of them submitted in prototype and in advance of quantity production, special questions may arise about practicability of manufacture on which the assessors will be able to give advice, as well as on those general questions affecting production which arise whenever design is under consideration.

4. On marketing, more difficult issues may emerge. The industrial assessors may hold the view that a certain design, however attractive in itself, would not sell. In the last resort this must be a matter for the discretion of the Selection Committee. The council has no intention of organising an exhibition of 'best sellers'; the purpose of the Exhibition is to give a lead to manufacturers, retailers, and the public alike, and the judgment of the market is itself something which is capable of education and development. At the same time no practical purpose is served by showing objects completely divorced from the tastes and requirements of the particular section of the market which would be reached by an article at a given price.

5. Manufacturers have been advised that while no sections of the Exhibition will be specially set apart for export designs, such designs will not be excluded even if they do not meet the current tastes of the home market. If

they reach the standards of design appropriate for their own kind, they should be regarded as qualifying. Manufacturers have been asked in submitting such designs to indicate that they are for export and (if this information would be helpful to the Selection Committee) that they are intended for some particular market. On points of this sort the advice of the industrial assessors may be especially valuable.

6. The Exhibition is primarily intended as a display of new designs but the best designs from the immediate pre-war period should be included, if the number of good news designs leaves room for them, and provided that they do not occupy a very large fraction of the total exhibit of the commodity in question.

7. Designs which are more reproductions or minor variations of traditional ideas should not be accepted; but designs based upon traditional ideas and themes and showing fresh creative inspiration should be sympathetically considered.

8. If articles submitted are not already in quantity production it is essential that they must in good faith be intended for such production at a reasonably early date and as soon as conditions permit. It is important to exclude mere 'stunts' or special designs produced simply with the idea of qualifying for the Exhibition.

9. Every article shown will be marked in such a way as to indicate whether it belongs to the upper, middle or lower price range for that class of commodity. Actual prices will not be shown. The Selection Committees will be informed of the approximate price of each article and of the limits considered appropriate for each of the three price levels. Selection Committees should ensure that, so far as the character of the submissions allows, each of the three price groups is well represented and that there is not undue emphasis on the higher priced articles.

POINTS FOR THE GUIDANCE OF SELECTION COMMITTEES

1. One or more trade assessors will be appointed to each Selection Committee. They will give the Committee guidance on matters affecting production.

2. The standard of design must in all cases be maintained on a high level but the Committees should see that they are not carried away by their enthusiasm so that they may not be accused of making a selection of exhibits divorced from the requirements of normal people.

3. Exhibits will fall into 3 main price groups, and care should be taken that emphasis is not laid on the higher price range.

4. As many good new designs as possible should be included, although the best pre-war designs will not be excluded, if it is intended to put them into production once more.

 Fresh designs of a traditional character will not be excluded but mere reproductions will not be accepted.

 Stunt exhibits must be avoided but prototypes will be included if they are the forerunners of intended production ranges.

5. Wherever possible, manufacturers' and designers' names will be mentioned in the exhibition catalogue and adjoining the exhibits.

DOCUMENT 12: REPORT FROM SELECTION SUBCOMMITTEE TO EXHIBITIONS POLICY COMMITTEE

The internal workings of organizations like the COID are well illustrated by attempts to conciliate industrial interests while at the same time vetting membership of key committees. The separation of technical assessors from the selection franchise reflects many of the assumptions which would inform the Council's definition of design and the very particular definition of the designer as creative rather than technical, a definition which ran counter to the common industrial practice of promoting design staff 'off the tools'.

Ref: ID 352/14A

COUNCIL OF INDUSTRIAL DESIGN

Report from Selection Sub Committee
to Exhibitions Policy Committee

The Selection Sub Committee, consisting of the Chairman, Sir Charles Tennyson, Sir Cecil Weir and the Director met on the 9th January with members of the staff in attendance.

The following recommendations were agreed upon:

1. A list of names considered suitable for membership of the panel of selectors was provisionally built up and the staff was asked to consider the addition of further possible names and to make suggestions for the division of the list, according to commodity groups for submission to the Policy Committee. It was agreed that the Sub Committee itself could not carry matters further at the meeting since the list must be built up largely in relation to the final arrangements made about the commodity ranges and groups at the Exhibition itself, and these arrangements were not then completed.
2. The industry or industries concerned should be asked to appoint one or more technical assessors to each Selection Committee. These assessors would not take part in the choice and would have no responsibility for selection, but would advise the Selection Committees on questions of production technique, and home and export marketing, that might be involved. (Note. This recommendation was tentatively mentioned at the Council Meeting on the 11th January and members of the Council warmly supported it.)
3. There should be a staff member in attendance at the meetings of each Selection Committee: he would normally be the officer who had been in contact with individual firms in the industry concerned in order to keep in touch with their preparations for the Exhibition and answer their requests for information and advice.

4. As soon as the composition of Selection Committees has been decided upon the industries concerned should be notified.

DOCUMENT 13: JOINT MEETING OF THE COID AND THE BRITISH POTTERY MANUFACTURERS FEDERATION ABOUT THE 1946 EXHIBITION

The potential tensions between the COID and the manufacturers' organizations are apparent in this meeting between the BPMF and the Council's representative. Concern about the nature of the exhibition, the representativeness of selected items, the process of selection and the commercial structure of the exhibition were informed by previous difficulties. While the BPMF were circumspect in voicing these concerns they were clearly wary of the COID's stance.

Ref: ID 516/14A

ID 434

MINUTES OF A MEETING HELD AT FEDERATION HOUSE, STOKE-on-TRENT at 2.30pm on WEDNESDAY 20th DECEMBER 1945

Present:

From the Council
Mr. F. J. Muller

From the British Pottery Manufacturers Federation

Mr. C.E. Bullock (Chairman)	Mr. A. Steele
Mr. George Campbell	Mr. W. Moorcroft
Mr. N. Bishell	Miss Susie Cooper
Mr. L. Irving	Mr. F.T. Sudlow
Mr. F. Shepard Johnson	Mr. J.F. Gimson
Mr. H. Francis Wood	Mr. R.W. Baker
Mr. A.E. Gray	Mr. H. Bowen (Secretary)
Mr. C. Wiltshaw	

Apologies for non-attendance were received from Mr. John Wedgwood and Mr. P. Cooper. Apologies were tendered on behalf of the Council for the unavoidable absence of Brigadier Gurney and Major Haggas. Mr. Muller then outlined the plan of the Exhibition.

1. The Federation are willing to support the Exhibition and have been awaiting further details from the Council before circularising their members with the information which they will require. Mr. Muller asked that a small executive

committee be set up in order to act as an administrative link between the industry and the Council, but Mr. Bullock stated that they had already set up an Exhibition Committee prior to this meeting. This committee comprises all the members from the Federation who were present and also Mr. John Wedgwood.

2. The question was raised whether electrical porcelain would have any part to play in this Exhibition, and Mr. Muller stated that as the Exhibition was primarily one of consumer goods, and porcelain manufacturers' products did not exist except as part of a component made by some other industry, that their goods would not be suitable for the purposes of the present Exhibition.

3. The display of sanitary ware, tiled fireplaces and tiles was discussed. Mr. Muller expressed the opinion that these would probably not be shown by product groups in the Hall of To-day, but would take their place where required in the furnished rooms that were being designed. This was in a complete accord with the manufacturers, and they agreed to set up a small sanitary ware and tiles fireplaces sub-committee. The designers for the furnished rooms when appointed would then be put in touch with this sub-committee, who would be in a position to give these designers full advice as to the most representative products being manufactured at the present time.

4. The meeting asked for detailed information regarding
 (a) The object of the Exhibition, and a definition of the phrase 'good modern design' which had been used to indicate the type of goods that it was hoped would be sent forward to the Selection Committee.
 (b) The extent to which the Exhibition was intended to cater for export buyers.
 (c) The amount of each article of pottery which would be required for the Exhibition (after approval by the Selection Committee).
 (d) Early information regarding the composition of Lord Woolton's final selection committee.

(a) Scope of the Exhibition

There was a very strong feeling expressed by the meeting that the selection for exhibitions held in the past had not been representative of the best products of the industry. There is undoubtedly a very strong hangover from the Burlington House Exhibition and also from the Paris Exhibition, and it was recommended by the Federation that whatever Selection Committee were appointed their tastes would not be those of a small too advanced minority, but would be more broadly based on the accepted standards of good taste. Mr. Muller was asked to define 'good modern design'. This he refused to do, on the grounds that any definition given by him would most certainly not be interpreted in the same way by all members of the meeting. (There was much laughter at this point of the meeting, and it was obvious that opinions on the question of modern design vary considerably.)

The Federation was extremely anxious to know the amount of space that would be allotted to the pottery industry, and also the way in which pottery would be shown. The reason for this anxiety was that they felt if they could be given some concrete backgrounds, against which to design their exhibits, they would be able to create articles which were both good in design and

yet have been fundamentally designed to show off in a certain given set of circumstances. Mr. Muller explained that pottery would be shown broadly in two ways; firstly, in its normal state in the furnished rooms and, secondly, as pottery in the Hall of To-day. It would be very difficult, even were the Federation's request agreed, to tie the designer of the Exhibition down to certain backgrounds and certain areas. This was appreciated by a section of the meeting, but did not seem to convince the remainder. Mr. Gray suggested as a compromise measure that perhaps the Council would appoint some person with the necessary qualifications who would be able to visit manufacturers who required guidance as to the intention of the Exhibition, so that the standard of design submitted to the primary Selection Committee could be higher than it otherwise would be. Mr. Muller said that this idea seemed to be sound, and asked for the meeting's opinion as to whether this was generally desirable. The Chairman of the Federation, however, would not ask for a vote and this suggestion, therefore, had to lapse. (It was, however, said afterwards by Mr. Gray, Mr. Baker and Mr. Bowen that, when their members had been circularised, requests for guidance would undoubtedly come in from many of them. If these requests were sufficient the Federation Committee would no doubt pass a resolution asking the Council for Assistance in this direction.)

(b) The extent to which the Exhibition was intended to cater for export buyers
The Federation asked for a ruling whether the Exhibition was intended to cater mainly for the home market, or mainly for the export buyer. The reason for this request was as follows. Our biggest export markets are the Dominions and America, and the designs which are bought by these markets are traditional designs, some good, some not so good. Broadly speaking the spirit of the designers is not that in which the Exhibition is conceived. However, if the export buyer is to be encouraged he will only be interested in those designs which he knows from the past he can sell, and as only buyers from foreign countries will be coming, and not members of the general public from foreign countries, it is obviously impossible to try and foist on the foreign buyer shapes which he feels unacceptable to his market. On the other hand, the Exhibition, if in advance of public taste at home, will be able to mould public taste to its idea by the very fact that the public are being admitted. Mr. Muller said that the difficulty was obviously a real one and as it posed a fundamental dilemma it would have to be referred to the Exhibition Policy Committee for clarification.

(c) The amount of each article of pottery which would be required for the Exhibition
This question relates to the number of pieces that will be required in any selected dinner or tea set. The manufacturers, when submitting their designs to the primary Selection Committee, would submit one of each shape in the dinner or tea service. If this design were selected they might find considerable difficulty in making the required number in time for the Exhibition. For this reason it would be as well to define to the industry approximately how many complete dinner, breakfast or tea services will be required as it is very prob-

able that any manufacturer wishing to submit a design would have to make a complete service beforehand.

(d) Early information regarding the composition of Lord Woolton's final Selection Committee

The industry asked that the names of the proposed final Selection Committee should be forwarded to it as soon as possible. This request was based on two reasons; firstly, that they would be able to make exhibits which they knew were satisfactory to the Selection Committee and, secondly, that they would be in a position to request a broadening of the Selection Committee, in order that a representative exhibit from the industry as a whole could be obtained. This prejudice and fear is again a hangover from Selection Committees of pottery exhibits held over the last few years, and is one which is expressed very strongly in the Potteries.

5. In the circular letter forwarded to the Federation on behalf of Sir Cecil Weir it is stated that the executive committee nominated by the Federation would act in close collaboration with the primary Selection Committee. The Federation interpreted this to mean that the executive committee would have an equal voice in the choice of rejection of the exhibits it was asked to see. Mr. Muller was not certain that this was really intended. It is suggested, therefore, that amplification of this paragraph of Sir Cecil Weir's letter be sent to the Federation.

DOCUMENT 14: LETTER FROM THE BRITISH POTTERY MANUFACTURERS FEDERATION TO THE COID

Relationships between the COID and the BPMF appear to have deteriorated rapidly. Concerns about the organizational competence of the Council are clearly evident in the correspondence and the apparent inability of the Council to liaise with individual manufacturers was a fruitful area for friction to develop.

Ref: ID 516/14A

12th August 1946

British Pottery Manufacturers' Federation

Dear Mr. Muller,

You will no doubt recall that on 16 July last we had a telephone conversation about the collection of pre-selected pottery ware for despatch to London for the final selection for the Exhibition in September.

You spoke at that time of your idea of collection by road with the object of assembling all the samples and despatching them to London in one lot. Personally, I think that this would involve a number of difficulties, and that it would be

simpler and more expeditious if each manufacturer were asked to arrange for the despatch of his own wares to an address to be notified by the Council.

I am writing to you because I feel disturbed at the lack of arrangements and the relatively short time before the Exhibition is due to open.

I have had several enquiries from manufacturers, stating that they have received no directions about the despatch of their wares to London; and I, therefore, ask particularly that we may be informed as soon as possible of the plans afoot. Particularly, I should like to know whether the Council will notify each manufacturer of his requirements, and send a copy of such directions to the Federation in order that we may be kept posted. Without wishing to interfere in any sense with the arrangement of your Council, I hope that you will interpret this letter as an attempt to help you, and at the same time to give you clear information that difficulties will arise if manufacturers are not given immediate notification of what the Council wishes them to do. I do not wish the Federation or individual manufacturers to be criticised for failing to carry out their obligations; and I am sure that you will agree that it is only reasonable for manufacturers to be given as much as notice as possible.

> Yours sincerely,
> W. Wentworth Shields
> Deputy Director

F. J. Muller Esq.,
Council of Industrial Design,
London, S.W.1

DOCUMENT 15: LETTER FROM THE COID TO THE BPMF

The Council's sensitivity to manufacturers' complaints is evident in their attitude to the BPMF which had a longstanding history of involvement and conflict with wouldbe design improvement groupings.

Ref: ID 516/14A

EF
ID/616

20th November 1946

Dear Mr. Wentworth Shields,

Confirming my telephone conversation with you today, our Director, Mr. S.C. Leslie, is making a speech at the Export Conference which is being held in London shortly, and he has asked me to find out from the principal British Industries whether you consider that:

(i) Special designs are needed for export on long-term policy as distinct from those for the home market.
(ii) If goods made for export can be regarded as covering the necessary field for the home market so that separate designs are not required.
(iii) Whether goods already produced for the home market meet the bill for export so that separate designs for export are not required.

We should be most interested to have your views on this subject, thinking in terms not of today but of the future.

<div style="text-align:right">Yours sincerely,
S.D. Cooke.</div>

W.F. Wentworth Shields, Esq.,
Deputy Director,
British Pottery Manufacturers Federation,
Federation House,
Stoke-on-Trent.

DOCUMENT 16: LETTER FROM A.E. HEWITT (COPELAND & SONS LTD) TO SIR THOMAS BARLOW

Hewitt's, originally hand-written, note to Barlow exemplified some of the distrust of metropolitan intellectuals often voiced by provincial manufacturers. With his social and political standing unquestionable it is clear that Barlow was judged to be a suitable conduit for the expression of such concerns.

Red: ID 516/14A

<div style="text-align:right">W.T. COPELAND & SONS LTD.
Manufacturers of fine china & earthenware
Stoke-upon-Trent

7th September 1946</div>

Sir Thomas Barlow, K.B.E.,
Dene House,
Lancaster Road,
Didsbury,
Manchester.

Dear Sir Thomas,
Please forgive me for sending you on this correspondence, particularly at a time when, I am sure, you are very fully occupied with the arrangements for the 'BRITAIN CAN MAKE IT' Exhibition.
 I am not quite sure what position Mr. Muller and his associates have, and how far they are responsible for the control of the Council of Industrial Design,

neither am I sure whether they are there to carry out the instructions of the Council, or whether they are acting on their own initiative. If my latter supposition is correct, I and several of my friends here are frankly worried and appalled if their attitude of mind is as set out in Mr. Black's exposition of the fundamentals of design.

As industrialists, our ideas and the ideas of the theorists in London, who seem to be dominating the Government, are apparently poles apart, and I really do not see how the Board of Trade can make a success of the Council unless a different attitude is adopted.

I should very much like to have an opportunity of discussing this with you personally some time at your convenience either before, during, or after the Exhibition.

I am sending this correspondence to your private address as I do not want to criticise the wrong people, but I have been very tempted indeed to send the whole of it to our local and technical Press!

> Yours sincerely,
> (A.E. HEWITT)

AEH/BHD

DOCUMENT 17: LETTER FROM SIR THOMAS BARLOW TO S.C. LESLIE

As a seasoned political figure, his brother having been one-time Prime Minister's Secretary, Barlow was well aware of the dangers of adverse publicity. His letter to Leslie, and the immediate arrangement of a visit by Leslie, shows the extent to which Barlow was prepared to go to conciliate perceived industrial interests. As an industrial grouping the Potteries enjoyed considerable political leverage with their position as a major export industry and the concentration of parliamentary seats consequent upon geographical location giving them relatively easy access to government.

Ref: ID 516/14A

[Stamped as received at the COID on 9th September 1946]

Dene House, Lancaster Road
Didsbury, Manchester
Telephone Didsbury 2323

7 Sept., 1946

Dear Leslie

I enclose correspondence with Mr. Hewitt. I replied as follows:-

'I am much obliged to you for writing to me. There are as you can readily understand a huge number of industries to attend to and this job is split up amongst

members of the staff as indeed it must be. You do not have to tell me of our difficulties with our customers. I should think that mine are more difficult even than yours i.e. retail drapers. In fact with a microscopical number of exceptions one never gets any help at all in regard to design. The raising of design standards must of necessity be a slow process.

So far as Mischa Black's document is concerned, I do not know him well but should tell you that he is not at all a long-haired highbrow, but I should say very intelligent and hard boiled. Keare read the document. I think the choice of an egg-cup as an example is not happy, but in principle I do not think what he says is unsound. Perhaps there should have been a reference to the initial necessity of considering (in many commodities at any rate) consumer requirements and pre-ferences.

I should tell you that I am aware of the fact that we have got out of step in regard to pottery. I had a long talk with the director last week and we decided that he should come to Stoke. He is coming on Sept. 11 and I am sending on your letter to him. I hope he may find it possible to see you.'

TDB

I made no further comment except to be thankful that he did not write to the Press. When you get to Stoke if you find you can't get through without staying over ring me up anytime i.e. up to 4.30 – Manchester Central 7181 after Didsbury 2323, and say if you would like to come here and stay the night. If you can say when you will arrive it would be a great help and it would be best to get out at Stockport. I would then arrange to meet you or have you met.

Ever Yours
T.D. Barlow

DOCUMENT 18: NOTE ON THE METHODS USED BY MASS OBSERVATION AT *BRITAIN CAN MAKE IT*

Founded in 1937, Mass Observation mounted a number of projects, the most famous of which is probably the study of Bolton 'Worktown', detailing and recording social conditions and attitudes. Its highly distinctive psephological approach was commissioned by government on a number of occasions, as with the report below. Although it utilized a number of methods its prime tool, and in many ways the reason for its accessibility, was participant observation, the participants being largely self-selected. While this gives its reports an almost literary flavour and a sense of nuance denied to many other, more statistically rigorous forms of analysis, it also gives them a very particular slant (Figure 30). The Mass Observation Archive at the University of Sussex holds a vast collection of material of interest to any student of the period.

TIME CHART
Percentage of total time in exhibition spent in each section

Represents minimum time necessary to look at all exhibits in section

+ INDICATES POSITIVE INTEREST ABOVE MINIMUM PERIOD

SECTION		SECTION	
1 From war to peace +		12 Things for children +	
2 What the goods are made of +		13 Men's clothes	
3 Shopwindow Street +		14 Dress fabrics II	
4 Dressing the goods		15 Great British designers	
5 Heat, light and power		16 What industrial design means =	
6 Furniture and furnishing fabrics		17 The Council of Industrial Design =	
7 Living and dining rooms +		18 Travel goods	
8 Radio, etc.		19 Utility and other furniture, carpets	
9 Dress fabrics I		20 Garden tools and sport	
10 Rest lounge		21 Books and printing	
11 Women's dress		22 Designs of the future	
Miscellaneous resting, etc.			

Figure 30 Mass Observation Survey.

Ref: ID/903

A NOTE ON THE METHODS EMPLOYED BY MASS OBSERVATION DURING THEIR SURVEY OF 'BRITAIN CAN MAKE IT'

1. In this survey, 15 field investigators were employed for an approximate time of 244 man days; the Exhibition was visited and studied at all times of day and for all days of the week. Analysis, correlation, report writing, typing, etc., is additional to the above.
2. 2,523 valid interviews were obtained during the course of the survey. These were divided into two types:-
 a) The direct interview in which the investigator asks exactly the same question to everybody in exactly the same words.
 b) The informal interview in which the investigator is given the general line upon which to work and may use his own words to obtain the answer.
3. In the direct interviews, 32 different major questions were asked. Direct interviews were made on samples as follows:
 a) a random sample of London, divided equally into men and women, people over 40 and under 40, and by proportionate class breakdown. The purpose of this questionnaire was to discover the extent to which people knew about the Exhibition.
 b) A sample similar to (a) in Portsmouth, Birmingham, Manchester and Nottingham to discover the extent of knowledge of the Exhibition outside London.
 c) A sample in Dagenham and South Kensington, artisan class only, to discover the effect of distance inside London on knowledge of, and attendance at, the Exhibition.
 d) A sample of people joining the queue, with a breakdown as in (a) to discover the type of people going, occupation, standard of living, etc.
 e) A sample of people leaving the Exhibition, with a breakdown according to the number and type of people attending. Main purpose of this questionnaire was to discover immediate reactions to the Exhibition as a whole, and also individual likes and dislikes.
4. Informal interviews were made as follows:
 a) On people approaching the Exhibition. If they were actually going, investigators asked them what they were expecting to see, why they thought of coming, etc.
 b) On people inside the Exhibition at given sections (see Section C of the report). These visitors were escorted round the sections concerned by investigators who discussed their likes and dislikes on individual items.
 c) On people in rest rooms and when leaving who were asked to go through the Council of Industrial Design's booklet 'Design Quiz' discussing their personal likes and dislikes.
 d) On furniture dealers in the neighbourhood, who were asked if they had noted any effects of the Exhibition.
 e) On visitors to the Exhibition in their own homes. These were interviewed some time after they had been to Britain Can Make It and investigators discussed the possible effects of the Exhibition on people's homes.

5. Throughout the period of the survey, all investigators noted all comments (on the Exhibition) made by people with whom they were in casual conversation. In all such cases people did not know that they were being interviewed.
6. About 1,000 <u>overhead</u> comments in the Exhibition were noted and analysed.
7. Observers made <u>straight factual reports</u> of the queue both by joining it and also watching it from outside. Inside the Exhibition investigators in some cases moved through noting all reactions as they passed and in others stayed in one particular section noting all that happened there.
8. <u>Counts</u> were made of people leaving the Exhibition divided by age, sex and class and also by group composition. These counts were made every two hours throughout the day for a week.
9. At fixed times the number of people in various sections were counted.
10. People were <u>followed</u> from the time they entered the Exhibition until they left it. The exact time they spent in each section was noted together with comments and reactions where possible.
11. <u>Comparative</u> material was obtained throughout by doing similar work on other exhibitions, counting other types of group composition, etc.
12. In a number of cases many of the above methods were used simultaneously; e.g. people would be followed through the Exhibition, and their comments would be noted; they would then be interviewed on leaving, and, later, with their permission, would again be interviewed at their own home.

DOCUMENT 19: LETTER FROM TOM HARRISSON OF MASS OBSERVATION TO S.C. LESLIE AT THE COID

Tom Harrisson was one of the two founders of Mass Observation, the other being Charles Madge. As well as detailing responses to the exhibition, the letter demonstrates Harrisson's concern with the approach to projects, one much influenced by his own anthropological experience and concerns.

Ref: ID 903/14A

MASS-OBSERVATION
Director: Tom Harrisson

21 Bloomsbury Street
London WC1
MUSeum 6811
30/xii/46.

S.C. Leslie, Esq.,
Council of Industrial Design,
Tilbury House,
Petty France, S.W.1.

Dear Leslie,
Here is the last part of the report.

I am very sorry that it has taken such a long time, and I think I owe it both to you and to ourselves to record the reasons for this, briefly:

(1) As I think you will appreciate, a very great deal of work has gone into preparing this report. In fact we have done much more than we 'need' have done, and have done our best to get everything possible out of the information, instead of falling back on simplifications of tabulation, etc. etc.

(2) You set us a vast problem and, because we wished to be helpful in a subject that seems of wide interest, we agreed to take on everything you suggested, and considerably more than we had originally accepted. This is by no means a complaint, merely an explanation.

(3) We accepted a fee which was low for work of this magnitude and considerably less than the fee we asked for, which was based on a proper costing. We accepted this fee because we were anxious to show our goodwill and educational body, and not a commercial one. The fee you gave us was barely enough to cover the fieldwork alone. And we have had to finance the analysis and editing out of our own pockets. I hope that under these circumstances you will appreciate that while we have done everything we can to give you the material as quickly as possible, it has simply not been possible to do it any more quickly under these conditions. We could have let you have, for the money, a report much more quickly, but I venture to hope that the delay is justified by a more thoughtful and thorough document, which I only hope will be of use to you. And the only Section which involved immediate action, relevant to the actual course of this particular Exhibition, was sent to you immediately. I trust the remaining Sections will be of value.

Hoping to hear from you presently,

Yours sincerely,
Tom Harrisson

DOCUMENT 20: SUMMARY OF FINDINGS OF MASS OBSERVATION SURVEY AT *BRITAIN CAN MAKE IT*

Mass Observation's report demonstrates the conceptual complexity of 'reading' the exhibition and its audience. It also demonstrates, despite its attempted statistical analysis, the difficulty of attaching singular meanings to components of the exhibition and the extent to which they could be viewed differently by differing audiences.

Ref: ID/ 903

THOSE WHO CAME
From enquiries made among a cross section of the 1,432,369 visitors to Britain

Can Make It, it is revealed that 40 per cent of the visitors were Londoners, 25 per cent lived within 25 miles of the Capital and 35 per cent came from the Provinces, Scotland, Wales and Ireland. Three-fifths of the visitors appeared to be under 40 years old and children numbered 161,000. There were 15 per cent more women than men coming to the Exhibition.

One-half of the people attending live in four or five rooms and one in ten have seven or more rooms; only one in ten had three or less. Three-quarters of the people had a house or flat of their own.

Nearly three-quarters of all the visitors were married and of those who were still single, one in seven were engaged.

More than nine persons out of ten spent between one and four hours in the Exhibition.

The most widely represented class was very definitely artisan working class.

THE QUEUE

The survey gave little indication that the queue was a deterrent, rather it tended to be treated as a part of the entertainment, especially in the days when the buskers were in full swing. Indeed, observation on queue behaviour shows that for many the queue was something of a social occasion whose bustle and anticipation is enjoyable. On the 20th October, at 3.30 pm when the police told people in the queue they would not get in, the following remark, typical of many was over-heard: 'I think we'll stop a bit . . . it's a bit of excitement isn't it.' The queue's length and rate of progress were continual subjects of discussion, pleasurable to those in front and hopeful to those further back.

Ninety-two per cent of those who had been to the Exhibition said they would recommend their friends to go.

SPECIAL INTEREST

Thirteen per cent more women than men had a special exhibit in mind when they went to the exhibition, just as substantially more women than men went with the intention of making selections for future purchases.

Women wanted to see kitchens and kitchen equipment, fashion fabrics, house-hold goods, labour-saving devices – the men wanted to see mechanical items and electrical goods. Furniture is the only item which men and women equally want and nearly one in five spontaneously mentioned the furniture as the special exhibit inside the Britain Can Make It exhibition that they wanted to see.

GENERAL REACTION

Four out of five people leaving the Exhibition said that they had enjoyed the Exhibition and only two in one hundred said that it was bad. Many were specific about what interested them most and a middle class housewife remarked: 'I liked the way they were spaced out. It gave you a pretty good idea what things looked like and how a lot of things could fit into a small space'. A builder's wife com-mented 'The curtains have taken our eye every time – they are really lovely – lovely design and good material'. A dock worker's wife expressed approval of the plastic kitchen cabinets because she thought 'They do keep the mice out'.

REACTIONS TO SPECIAL EXHIBITS

Interest was very high indeed at Shopwindow Street and in the Children's Section and in the Furnished Rooms in which latter section the Miner's kitchen proved to be the highest centre of interest in the whole exhibition.

It would doubtless be of great interest to Exhibition Organisers that visitors to Britain Can Make It spend on average, 16 per cent of their time in the rest rooms, toilets and in the Tea Bar and Restaurant specially set aside by the Exhibition Organisers for their comfort.

It is interesting to note that there were two men for every woman who mentioned furniture as their special interest in the Exhibition.

The most unpopular items in the Exhibition were the pictures which adorned the walls of the Furnished Rooms. This dislike might be partly attributable to the fact that the paintings displayed were rather ahead of and less related to public taste than any other item on show. Again, utility is a vital factor in the general approval of the exhibits and even those assessed mainly by aesthetic considerations are assumed first to be satisfactory to their purpose. A picture has no direct utility at all in this sense. A designer of a tea-pot, whatever shape he makes it, must consider how it will pour, whether the handle will get hot and how much tea it will hold; a painter need worry about none of these matters. He need relate himself less to the general public and in consequence the general public understands him less.

Many people showed an occupational interest in what they were seeing. Said a regular soldier: 'I am interested to see the electrical gadgets mainly ... as I fiddle about with cars.' A shopkeeper: 'I have a haberdashery shop-cum-ironmongers crockery, cutlery, etc. Naturally I want to see what new lines there's soon going to be.' 'I want to see electrical apparatus really', said a clerk in the electrical trade – 'It is my profession'. Women also showed a strong occupational interest and a typical observation by the wife of a tube-train driver was 'I just wanted to see the kitchens and to see if there are any new gadgets'. A cotton worker's wife who had come down from Lancashire especially to see the Exhibition said: 'We are on our honeymoon, so we thought we would come along and see how to furnish our house when we get it'.

BUYING INTEREST

A quarter of the men and nearly a third of the women said that they were interested in the prospect of buying. Rather more mentioned 'occupational interest' or 'housewives interest', both of which could be linked with buying.

Those hundreds of thousand of people who went to Britain Can Make It have received guidance for their future buying from the goods they saw on show. This effect upon the taste of potential buyers is reflected in the following remark by a woman: 'The Exhibition has made up our minds for us, because we know now exactly what we want when the things become available, whereas before, we knew what we wanted in a vague sort of way.' Eighty-five per cent of those stating what they most wished to buy regardless of the Exhibition mention items that were actually displayed and only 5 per cent say that what they had seen was unsuitable. There is, in other words, a strong desire among everybody, to have in their ideal home what they had seen in the course of their visit.

CHANGE OF TASTE

On leaving the Exhibition a large number of people were asked if they felt that their tastes had been altered by what they had seen, or if they felt that their ideas of the home they wanted or the things they wanted for their home had been changed at all. About half of those asked, felt that their tastes had not been altered and one-third say that they definitely have. The remainder are not sure of the extent to which they have been influenced. Unskilled workers were far more definite in their answers and the majority of them volunteered the information that their ideas or tastes definitely had been altered.

That the people who came to Britain Can Make It were actually design conscious is revealed by the following table:

Percentage of sample naming this reason

	Reason for LIKING items	for DISLIKING items
Design	63	55
Material	13	15
Colour	9	11
Originality	7	6
Compactness	6	—
Labour saving	5	—

(Remaining answers cover many miscellaneous subjects: some people named more than one reason.)

DESIGN QUIZ

Nearly 500 copies a day were sold in the Exhibition of a Council of Industrial Design publication 'Design Quiz', in which sets of three comparative photographs of such things as armchairs, lamp shades, gas fires, tea-pots, etc. were displayed. At the end of the book, design experts gave their opinion as to which was the best design. The reader was asked to assess the merits of the item of domestic equipment illustrated by asking himself or herself 'Will the item do what it is meant to do?' 'Does it look what it is?' 'Will it look pleasant and fit in with other furniture?' Of those visitors to the Exhibition who were asked to make their own selection, in only one case out of twelve was there an extreme variance from the public and the experts. This confirms the opinion of many people who are in a position to know that the general public is much more critical and analytical of the goods that are displayed in shop-windows than is generally supposed. Typical remarks were:

Housewife	'I should like (B) best – the shape is better than the other two. It would go with any furniture. I don't like the front design of (C).'
Man of 35	'I like the design and shape of (A). (B) is too gaudy and (C) is too much like a box.'
Woman of 35	'Personally, I prefer a chair where the seat isn't so low. I like the shape of the arms better. There are no corners and the cleaning is easier as there is a space underneath.'

Observations showed that the Functionalist conception seems to have been ignored by the general public as completely as the utilitarian and aesthetic ones have been accepted. Those who say that their tastes have been altered for the most part, give the impression that it is not so much that old tastes have been changed but that new ideas have been planted. Thus, the builder's wife says: 'It has given us a lot of new ideas on things we want', and a nurse remarks 'What I want now is different from what I wanted when I came into the Exhibition because there are things that I have never seen before'.

With many the new ideas were coupled with the intention of carrying out general improvements in their homes – one housewife said 'A pleasant sort of room. Bert will be rigging up shelves over the bed when he sees this.' Another housewife said: 'My husband is very good at carpentry and is going to copy one of the armchairs, you know, the one which has no arms – then a woman can knit or sew without bumping her elbows every time she starts a line.' An electrician remarked: 'Some of the development made in the kitchens I hadn't visualised – all modern and spotless and everything fitting so neatly – that definitely altered my ideas'.

Comments from the men were generally more aesthetic and less utilitarian than women's. Said a builder: 'I think it has altered my tastes in the use of colour', and a draughtsman remarked: 'My taste towards glassware has changed – I like the modern designs'.

There is plenty of indication that people have related the items they have seen to practical use and have mentally placed them in their own homes. To those people starved of household goods throughout the war, the Exhibition was especially appealing in its display of new things that they had not been able to see, much less buy, for so long. To these people, the conditioning of tastes by the Exhibition may be a deciding factor. This may be epitomised by the following remark typical of many: 'I have had my house for over 21 years and feel that I would like to improve the house with more modern things. Take the kitchen – I have made do with that for so long – now I want to start afresh'.

On the whole, labour saving devices did not seem to play the same big part in altering people's tastes as design, material and colour. There is naturally a trend away from pure utility and a desire to get back to some degree of ornamentation. People who have been starved of anything but plain white pottery for six years are naturally delighted to see once again colours and patterns on their plates and dishes. The same attitude was almost equally apparent in every section of the Exhibition. It is the simple delight of being able to get again '2d. coloured' as well as the '1d. plain'.

Many of those who said that their tastes had not been affected by the Exhibition, expressed the opinion that they were already in agreement with what they had seen displayed.

There is evidence from retailers in London that the impact of the change in public taste is already being felt. Said the owner of a furniture and drapery business: 'It is altering that attitude in their buying and made them dissatisfied with their buying. It has made them grumble at the things they can get.' Said another retailer: 'There is no falling off in the demand for general utility but an increased demand for the newer design.

DOCUMENT 21: SAMPLE TABLES EXTRACTED FROM THE MASS OBSERVATION SURVEY OF THE *BRITAIN CAN MAKE IT* EXHIBITION, REVEALING PROFILES OR VISITOR INTEREST IN DIFFERENT FIELDS OF DESIGN

The extracts illustrate the range of material in the exhibition and the comprehensive approach adopted by Mass Observation.

Table 14: Percentage of each group mentioning this item

Item mentioned	Total	Men	Women	Over 40	Under 40	Middle Class	Artisan Class	Unskilled Working Class
Furnished Rooms	24	26	24	28	21	29	24	26
Women's Dress	12	1	20	13	12	8	13	9
Furniture	11	16	8	13	10	13	11	15
Furnishings and Fabrics	11	8	13	12	10	18	10	2
Future Design	9	16	4	7	17	13	9	9

It will be noted from the above table:

1. The unskilled are little interested in furnishings and fabrics; they show, however, an interest in children's toys that is greater than among middle class or artisans.
2. Middle class and younger people are the most interested in future design.
3. Two men mention furniture for every woman that does so.

Table 15: Percentage of each group giving this reason

Reason	Men	Women
Interest in progress	10	11
Occupational interest	41	11
Hobby – special interest	14	13
Housewife's interest	–	31
Prospect of buying	25	30
Being told about	2	1
General interest	8	3

Table 16: Percentage naming this item in each group

Main items mentioned	Total	Men	Women	Over 40	Under 40	Middle Class	Artisan Class	Unskilled Working Class
Furnishings and Fabrics	13	7	19	20	9	15	12	8
Furniture	11	12	9	6	16	9	10	14
Dresses	8	2	13	4	12	7	8	8
Car	7	14	–	4	8	8	6	–

From this table it can be seen:

1. The main buying interest <u>outside</u> the Exhibition (i.e. cars) is purely a masculine one, and confined to middle class and artisans.
2. Older people are interested in furnishings, younger people in the furniture itself. Similarly middle class people are interested in the furnishings and unskilled workers in furniture.

DOCUMENT 22: SAMPLE TABLES EXTRACTED FROM THE MASS OBSERVATION SURVEY OF THE *BRITAIN CAN MAKE IT* EXHIBITION, REVEALING PROFILES OF VISITOR PATTERNS OF TASTE

Some preliminary efforts were made to assess the impact of the exhibition by Mass Observation. The need to justify the expenditure of public funds, and some of the adverse publicity which had accompanied the opening stages, clearly inclined both the COID and the Board of Trade to emphasize any findings which could be construed as indicating an immediate impact.

CHANGE OF TASTE
On leaving the Exhibition, people were asked if they felt that their tastes had been altered by what they had seen, or if they felt that their ideas of the home that they wanted, or the things they wanted for their home, had been changed at all.

Table 17: Percentage saying they have altered to this extent among:

	Men	Women	Under 40	Over 40
Extent of alteration				
Tastes altered	29	30	27	31
Perhaps a bit	15	12	12	15
Irrelevant	2	4	3	3
Very little	2	5	4	4
Not at all	51	49	54	47
Don't know	1	–	–	–

Table 18: Percentage saying they have altered to this extent among:

	Middle	Artisan	Unskilled
Extent of alteration			
Tastes altered	21	30	47
Perhaps a bit	11	15	2
Irrelevant	5	2	10
Very little	5	4	–
Not at all	58	49	39
Don't know	–	–	2

Only one person in five from the middle class says that their taste has changed, but very nearly in two among unskilled workers does so. Unskilled workers are far more definite in their answers, only 12 per cent give qualified answers compared to 21 per cent of both middle and artisan classes.

Reasons for like and dislike
When people were asked what most interested them in the Exhibition and what they most disliked, they were also asked the reason. The causes of like and dislike were very similar.

Table 19: Percentage of sample naming this reason

	Reason for LIKING items	for DISLIKING items
Design	63	55
Material	13	15
Colour	9	11
Originality	7	6
Compactness	6	–
Labour Saving	5	–

(Remaining answers cover many miscellaneous subjects: some people named more than one reason.)

DOCUMENT 23: EXTRACT FROM MAY CONSTANCE CLARK'S DIARY, ENTRY OF 3 NOVEMBER 1946, RELATING TO HER VISIT TO *BRITAIN CAN MAKE IT*

This entry shows a warm response typical of many visitors to the show. Mrs. Clark had been born in Johannesburg in 1885, marrying G.M. Clark, a civil engineer in 1909. After living in South Africa, India and Egypt, the Clarks moved to Whitstable, Kent in 1931. Here she became involved in Red Cross work and, during the war ran the Whitstable Branch.

Ref: Personal Diary Mrs. Clark

Went up to London by 9.18, met Mrs. Davies at Victoria St. We decided to dash to South Kensington to see if we could get into 'Britain Can Make It' Exhibition. There was the same tremendous queue, but it was moving in, so we were inside in half an hour. We spent rather over 1 hour getting an impression of it and will hope to go again before the close in December. The whole thing is splendidly presented and the settings are quite remarkable and original. There must be miles of fabric used – both for display and to line the long corridors as one goes in – the latter have the walls completely covered with pale olive-green material pleated stiffly.

DOCUMENT 24: CONGRATULATORY LETTER TO THE COID ABOUT THE *BRITAIN CAN MAKE IT* EXHIBITION FROM S.E. SKAWONIUS, MANAGING DIRECTOR OF SVENSKA SLÖDFÖRENINGEN

This letter reveals the strength of relationships between various organizations concerned with the promotion of 'improved' standards of design in everyday life. Although the Svenska Slödföreningen was founded in 1845 to strengthen the relationship between art and industry in Sweden, its campaigning efforts were not widely recognized outside Scandinavia until the twentieth century. It is interesting to note, particularly in the light of discussions about the nature of industrial design in the preceding essays, how Skawonius refers to the *Britain Can Make It* exhibition as doing a great deal 'to promote the British arts and crafts'.

Ref: ID 910/14A

Svenska Slödföreningen
SWEDISH SOCIETY OF ARTS AND CRAFTS . SCHWEDISCHER WERKBUND . SOCIÉTÉ
SUÉDOISE DES ARTS ET MÉTIERS
STOCKHOLM 7

Stockholm, 1st of November 1946

To The
Council of Industrial Design
Tilbury House
Petty France
London S.W.1.
England

Dear Sirs,
Back in Stockholm again after a memorable week in London, I here-with beg to express my own, as well as all the Swedish party's warm thanks for the great and friendly hospitality proved by the Council of Industrial Design.

I have already expressed my great admiration for the exhibition 'Britain Can Make It', but I want to say once more to which extent it will always remain in my memory as the most generous, the most brilliant and stimulating achievement in the line in which we are working ourselves. In the long run I am sure that it will make a lot not only to promote the British arts and crafts, but also to act as a well of inspiration for everybody having had the opportunity of studying it closely.

We beg you to convey our specially warm thanks to Mr. Kearley who was kind enough to take us round in the exhibition.

We also want to say how much we appreciated the generosity and friendliness that met us at the luncheon at the Rembrandt Hotel which occasion gave us the opportunity of meeting many old friends and to make new and interesting acquaintances.

With best regards and thanks from all the Swedish party, I remain,

Yours very sincerely,
(S.E. Skawonius)
Man. director.

DOCUMENT 25: LETTER OF 1 OCTOBER 1946, FROM H.R. HUNGERFORD OF THE FOREIGN SERVICE AT THE AMERICAN EMBASSY, LONDON, TO MR KEARLEY AT THE COID

Given the strategic importance of America to Britain's post-war recovery, favourable reports from the United States or its representatives were particularly valued.

Ref: ID 910/14A

<div align="center">

THE FOREIGN SERVICE
OF THE
UNITED STATES OF AMERICA

</div>

HRH/sas

<div align="right">

AMERICAN EMBASSY,
1 Grosvenor Square,
London, W.1.
October 1, 1946.

</div>

Dear Mr. Kearley

I wish to express the appreciation of Ambassador Harriman, as well as that of Mr. Jule Smith and myself, for your courtesy yesterday in showing us around the 'Britain Can Make It' Exhibition.

The Ambassador was very pleased that he had an opportunity to make even a quick tour of the exhibits and he told me upon return to the Embassy that he was impressed with the presentation and had spent a very interesting three quarters of an hour with you. He mentioned his particular interest in exhibits of products for which the American market is receptive, such as china, glassware, cutlery, high class textiles and leather goods. He also commented favorably on the packing exhibits and the showing of advance designs.

Please be assured that your kindness in arranging the tour is very much appreciated.

<div align="center">

Sincerely yours,
H.R. Hungerford

</div>

M.E. Kearley, Esquire,
Deputy Director,
'Britain Can Make It' Exhibition
Victoria & Albert Museum, S.W.7

DOCUMENT 26: EXTRACT FROM A LETTER TO THE COID ABOUT *BRITAIN CAN MAKE IT* FROM MRS. DARCY BRADDELL, 26 SEPTEMBER 1946

This letter shows something of the confusion about exactly at whom the show was aimed since special viewing arrangements for buyers were not actually put into place until after the exhibition had opened. It should be remembered that there had been considerable efforts among the organizers to distance it from 'trade fairs' such as the British Industries Fair. The references to the Paris Exhibition of 1937, at which Dorothy Darcy Bradell was a prominent exhibitor in the British Pavilion, reflected a similar confusion of intent since the official British display there (selected under the auspices of the Council for Art and Industry) was perhaps more a display of cultural ideology than one with heavily commercial ends. Mrs. Braddell, a keen member of the Design and Industries Association, was a well-known interior designer and domestic planner. She advocated higher standards of industrial design, collaborating closely with manufacturers in the design of kitchen equipment, and exhibited at all the major shows of British design in the 1930s, as well as at *Britain Can Make It*.

Ref: ID 911/14A

... I hope you won't mind if I make a suggestion that may not, in fact be needed. I heard Mr. Frank Phillips make his remarks over and over again about the Hall of the Future, and it struck me, or rather my son, how much more apt it would have been had he said it once in English, and several other times in various foreign tongues. I heard French, German, Swedish, Czech and doubtless many other languages spoken yesterday and I feel it would be both useful and a good gesture to cater more obviously for all these people. Is the catalogue being printed in various languages, and are there interpreters about?

Forgive me if this is already being seen to, but I remember how much our pavilion at the Paris Exhibition suffered from lack of interpreters, and it seems such a glorious opportunity at this exhibition, which is obviously going to have an enormous public, to show that we are very much up to date in our approach to foreign buyers.

DOCUMENT 27: LETTER FROM CHRISTIAN BARMAN TO S.C. LESLIE ABOUT THE *BRITAIN CAN MAKE IT* EXHIBITION, 23 SEPTEMBER 1946

This letter shows how many of those connected with design reform were closely entwined personally and professionally. Christian Barman had a background as a trained architect and editor of the modernizing periodicals *Architects Journal* and *Architectural Review*. He also ran his own architectural and design practice before becoming Publicity Officer for London Transport in 1935, where he formed a close association with Frank Pick, the first Chairman of the Council for Art and Industry, in many ways the predecessor to the Council of Industrial Design. He was also Pick's biographer, publishing *The Man Who Made Public Transport* in 1979. During the war, from 1941–45, he was concerned with ideas for a future post-war world as Assistant Director of Post-war Building at the Ministry of Works, before becoming Publicity Officer to the Great Western Railway from 1945–47 and then to the British Transport Commission where he was employed until 1962.

Ref: ID 911/14A

<div align="right">

Great Western Railway
Paddington Station
London W2
23 September 1946

</div>

Manager, Paddington Station
Paddington 7000 ext

My dear Clem
There can be no question about it. It's terrific. There are certain things I disagree with and there are even a few things I dislike. In many cases the decor is so good that it puts the goods to shame, like the wonderfully staged queue in which everything is right except that the tenor chap can't sing. But no doubt it is right and salutary that these products <u>should</u> be put to shame. I bow down in praise. I admire the grandeur of it, the vitality – <u>your vitality</u>, for let there be no mistake, this thing could never have happened without you.

Two things you must put right. The complete lack of ventilation in the smaller rooms and passages is very unpleasant. And the bus conductress still called 'Brompton station'! You must talk to Lord Ashfield about that. Clem, you're a great fellow.

Yours ever,
Christian

DOCUMENT 28: LETTER OF 24 SEPTEMBER 1946 FROM W.J. BASSETT-LOWKE TO DUDLEY RYDER ABOUT *BRITAIN CAN MAKE IT*

It is unsurprising to see W. J. Bassett-Lowke praising the work of the COID at *Britain Can Make It* since he had been intimately involved in the modernist cause for more than 20 years. Of the specialist model-making company bearing his name, he was an ardent member of the Design and Industries Association (DIA) from its early years, becoming a forceful advocate of modernist architecture and design. He had commissioned the prominent German architect-designer Peter Behrens to design his house, *New Ways*, in Northampton in 1925, also visiting and writing about the famous Stuttgart Weissenhof exhibition of modernist housing in 1927. This sense of a reforming 'coterie' of like-minded individuals was reflected in the continuity between pre- and post-war design propagandists seen in many other such letters about BCMI.

Ref: ID 911/14A

W. J. Bassett-Lowke, M.I. Loco. E.
20 St. Andrew's Street
Northampton
24th September 1946

Dear Mr. Dudley Ryder
I feel I must drop you a line to congratulate you on the excellent way in which the exhibits of the BRITAIN CAN MAKE IT Exhibition have been displayed and the general arrangement and imagination shown in the whole lay-out.

I had to catch the 4.30 p.m. train back to Northampton from London yesterday so I was prevented from seeing more than half of the Exhibition. However, I am looking forward to many future visits.

Might I make <u>one or two suggestions</u> to you which I think would be helpful? A small scale plan of the Exhibition should be given out so that people know where they are at any point in the Exhibition -- it is rather like Hampton Court Maze, although the whole lay-out is good. Also there should be some method whereby a person who is visiting a certain section of the exhibition should be able to get out quickly without either working his way back to the entrance or going through the whole routine of the Exhibition.

With these few remarks and my regret that several English manufacturers did not support you in displaying some of their best goods, may I again congratulate you on a most excellent show?

Yours sincerely,
(signed) W. J. BASSETT-LOWKE.

DOCUMENT 29: LETTER OF 31 OCTOBER 1946 ABOUT BCMI TO J.W. GOLSBY, EXPORT PROMOTION DEPARTMENT, LONDON

By the time that this critical letter had been circulated around the Export Promotion Department at the Board of Trade and then forwarded by Captain C.R. McCrum to the COID its authorship was unclear. McCrum, when forwarding a copy on to the COID on 5 December, commented that 'so much of the criticism is either ill-informed or out of date that it's not worth bothering about'. None the less there was, as has been seen in a number of earlier essays and documents, a considerable anxiety at the COID about American competition in the field of industrial design.

Ref: ID 911/14A

Pers. 54 (1.176)

31st October, 1946

Dear Golsby,

1. A few days ago I was invited to a reception for Sir Patrick Ashley-Cooper, the Governor of the Hudson's Bay Company, at present visiting Winnipeg, and on introduction, he immediately buttonholed me to let me have some criticisms regarding the 'Britain Can Make It' Exhibition. He evidently felt quite strongly on the various points he mentioned and I think it best that you should be aware of them for transmission at your discretion to the Exhibition authorities.

2. The chief criticism seemed to be that inadequate provision was made for the reception and transition into the Exhibition of genuine buyers and commercial visitors from U.K. exporting firms, U.K. Buying Houses of Overseas firms and Overseas visitors themselves.

3. I understand that he and other business acquaintances experienced these same difficulties and he thought it would have been far preferable to reserve certain times (probably the bulk of each day) for bona fide buyers and business representatives, restricting the ordinary public to visits outside such hours. According to him, the interest displayed by the general public was great and resulted in the Exhibition space being crowded by them to the exclusion of the people for whom the Exhibition was principally intended.

4. Another criticism was that there was a lack of informed assistants, and he himself had considerable difficulty in finding people on duty there who could talk intelligently and helpfully about the various products, their availability, etc. I gather from Sir Patrick from some U.K. press references that the Information Service within the Exhibition was not outstandingly brilliant. I was told of one official of the Exhibition, conducting a party, who explained to them that he had formerly been a Bank Clerk and was no longer banking because the Bank did not consider him good enough. This in itself could have

been true, and the ex-Banker could still have been a first-class Exhibition assistant, but from the way it was told to me, it would not make good advertising for the Exhibition.

5. The final criticism Sir Patrick offered was that he and many others felt it would have been preferable to be able to place orders on the spot, though I gather that no such provision was made.

6. I have no doubt that many of the above criticisms are capable of satisfactory explanation, but they are forwarded for what they are worth, and I thanked him accordingly.

7. Finally he mentioned that it had come to his knowledge that the A.M.C. (Amalgamated Merchandising Corporation of New York) had issued a circular to all their members which was severely critical of the Exhibition on many grounds and was indeed something of a 'smear'. I gather that he had not actually seen the circular, but he suggested that if a copy could be obtained it might usefully be forwarded to the Exhibition authorities or the Department. I am sending a copy of the letter to Howell in New York in the hope that he may have some further knowledge of the circular, or may even be able to obtain a copy of it for transmission to you.

With kind regards.

Yours sincerely,

J.W. Golsby, Esq., C.B.E.,
Export Promotion Department
London, S.W.1.

DB/KL

DOCUMENT 30: RESPONSE TO CAPTAIN McCRUM BY N.E. KEARLEY, OF THE COID ADMINISTRATIVE STAFF, TO THE POINTS RAISED IN DOCUMENT 29

As can be seen from Kearley's comments the notion of trade fairs, such as the British Industries Fair which was shortly to recommence after the war, was something of an anathema to design reforming organizations such as the COID and, preceding it, the Board of Trade-controlled Council for Art and Industry (CAI). There was a clear division in the minds of many design reformers between notions of 'good design' and the prevalence of historic encyclopaedism or 'streamlined' styling among best selling lines. It was felt by such propagandists that trade fairs were organized on highly commercial lines and did little to promote notions of 'improved standards' of design in British industry. This was also an important reason why such store was set by

the fact that exhibitors could not buy space (and thus promote what <u>they</u> wanted) but were subject to the approved selection process put in place by accredited selectors appointed through the COID. This had first been instituted by the CAI for the official British display at the Paris International Exhibition of 1937.

Ref: ID 911/14A

6th December, 1946
911/MF

Dear McCrum,

Miss Fox has shown me the enclosure to your note of the 5th December. I cannot tell from the copy who wrote this screed to Golsby, and as it is dated 31st October it is rather late in the day to be advising on a reply to the points other than that raised in paragraph 7. As, however, you are writing in reply to the last paragraph I think it would be as well to make our position perfectly clear with regard to the treatment of buyers, and other trade visitors to the Exhibition. I would like you to emphasise that the Exhibition was never intended to be a Trade Fair, that no space was sold to exhibitors, and therefore there were no stand attendants or other 'informed assistants' who could shoot a line about the products of individual firms, and that the display was of selected goods only.

On the matter of trade information we have had throughout a trade inquiries office, staffed by our Industrial Liaison Officers, who as they were the Secretaries of the various Selection Committees knew as much about the exhibits as anyone, and we have had evidence that their efforts in this direction have been much appreciated by those who have found their way to the Trade Information section.

With regard to the special facilities for buyers to see the Show, you will doubtless be able to answer that without any assistance from me, but it is of interest that very soon after our announcement about arrangements to exclude the public on one morning a week for the benefit of business men we were faced with a Parliamentary question enquiring why it was necessary to close the Exhibition to the public.

I hope that all these points have been made clear to Sir Patrick Ashley Cooper by now, but just in case they have not you may wish to include them in your reply,

> Yours sincerely,
> N.E. Kearley,
> Deputy Director

DOCUMENTS 31, 32 AND 33: CORRESPONDENCE BETWEEN LESLIE GAMAGE OF GEC, AND MEMBER OF THE COUNCIL OF INDUSTRIAL DESIGN, AND S.C. LESLIE, THE COID'S DIRECTOR

Leslie Gamage, who was a prominent member of the COID as well as being active in the Federation of British Industry, was one of a clutch of industrialists who patronized design reform organizations. As a public figure with an industrial background his opinion carried some weight with civil servants and their political masters.

DOCUMENT 31: LETTER FROM LESLIE GAMAGE TO S.C. LESLIE

Ref: ID 911/14A

<div align="right">

The General Electric Co., Ltd.
Magnet House
Kingsway
London WC2
30th September 1946

</div>

S.C. Leslie Esq.,
Council of Industrial Design
Tilbury House
Petty France
SW1

My dear Leslie
Attached is a comment by my Sales Manager on the Exhibition, which I thought you might like to have.

<div align="center">

Yours sincerely
Leslie Gamage

</div>

Encl. [See below]

DOCUMENT 32: GEC SALES MANAGER'S COMMENTS ON *BRITAIN CAN MAKE IT*

'BRITAIN CAN MAKE IT' EXHIBITION
I am fairly sure it will be a success from the point of view of the number of people attending, subject only to one consideration in connection with amenities. The

public are ready for such an Exhibition where display and layout of goods is more prominent than an attempt to sell them. In fact, of course, there is no positive selling angle.

The general arrangement is reasonably good although the approach, though possibly symbolically accurate, through a comparatively dark entrance to lighter displays is somewhat gloomy and may have a bad psychological effect.

The amenities do not appear to be very complete as it would seem that there is not enough restaurant space, nor on Monday was there apparently sufficient chairs and other rest arrangements available. It took me two hours to walk round without sitting down at all and the average person will want at least one rest in this time.

The display of goods is very uneven, by which I mean in some cases it is excellent, I thought the Sports Room for example was well laid out, whereas in other cases it is crowded, as for example the section showing electric cookers, washing machines, etc. While some are quite nicely and individually arranged, as in the case of clocks and radios, others are rather absurdly set out as with the electrical household appliances where the majority of them are hanging from strings from the ceiling so that they neither look natural, nor can they be said to be at all functional. Forgetting the question of irons, the fact that warming plates which are essentially intended to be laid out horizontally should be hung vertically is surely wrong.

It does not appear as if there are any technical veto imposed on the electrical material exhibited since there were at least two irons where there was apparently no automatic rest of any sort and therefore the provision of an asbestos pad or some other stand would be necessary and one would have thought that this by now would have been a technical necessity. Worse than this, there was shown a combined bed-warmer and bed-light, which unless there was some automatically controlled device, which was not at all visible, was literally a danger for use as a bed-warmer. Such a device should never have passed any technical adviser.

DOCUMENT 33: REPLY FROM S.C. LESLIE TO LESLIE GAMAGE RELATING TO HIS SALES MANAGER'S COMMENTS

2nd October 1946

My dear Gamage,

Thank you for the copy of your Sales Manager's comments on the Exhibition. The following comments in reply may interest him.

Paragraph 2. The comparative darkness of the opening sections has been part of the plan from the very beginning, and personally I think the object we deliberately aimed at has been achieved. The brightness of the peacetime displays comes with extra effect after the dim opening with its wartime settings.

Paragraph 3. We could not, as you know, do anything about increasing restaurant space, indeed are lucky to have what we have got. There are a considerable number of rest spaces, and we have put in fifty extra chairs since the opening day.

Paragraph 4. The criticism of the display of electrical and other goods hung on strings is one which occurred to us as soon as we saw the completed section, and it is being altered as quickly as possible. I am sure that your Sales Manager is right in thinking that objects intended to be used flat should be shown flat and on a proper base.

Paragraph 5. The technical assessors who worked with the Selection Committee were appointed by BEAMA and if they did not place a technical veto on any articles which were unsound I can only say they did not do the job they were there to do. As you know, the Council was very anxious not to show technical excellence for its own sake but to ensure that anything selected on the ground of design in our sense, was beyond technical criticism. This was the whole purpose of the idea of technical assessors.

Yours sincerely
S.C. Leslie

Leslie Gamage Esq.,
The General Electric Co. Ltd.,
Magnet House
Kingsway
London WC2

DOCUMENT 34: DRAFT LETTER FROM THE PRESIDENT OF THE BOARD OF TRADE TO THE KING

The politics and parliamentary proprieties of a state-funded exhibition ensured that the Board of Trade handled official communications extremely sensitively. Technically the letter is from the Minister responsible (technically a servant of the Crown) though drafted by career civil servants. It necessarily stresses the success of the exhibition, as indeed later does the COID's *Annual Report*. The Board of Trade was responsible for the COID's activities as its sponsoring department and the records of the Board of Trade (together with those of some other government departments), housed at the Public Record Office, are an invaluable resource for historians of this and other design organizations.

Ref: BT/60/23/4

Since you and H.M. the Queen paid your visit to London to open the 'Britain Can Make It' exhibition, I have envisaged the tendering to you of my most grateful thanks for your gracious action in interrupting your holiday and making the long journey south. I have, however, delayed a little in the belief that you would

find interest in some general account of the reception with which the Exhibition has met and the extent to which it has lived up to the hopes we entertained of its effect in furthering the national welfare.

Let me say at once that it has proved a success beyond our expectations. From the very outset it has caught the public imagination more than any exhibition since Wembley, which was, of course, far larger and more widely publicised. This impact upon the public mind at home was greatly assisted by the way in which your own action in breaking your holiday and coming to London dramatised, in a way most likely to appeal to all classes of our people, the importance attached to the Exhibition. Nor has the home public alone been affected. Press reports and other evidence make it clear that 'Britain Can Make It' has caught the eye of the world and has registered, in a way that all countries can recognise, the remarkable extent of the national reconversion and the powerful claims Great Britain has to remain (as the leading American business magazine has said) the world's pre-eminent supplier of first grade goods.

I will give you a few details.

The Public
The attendance has averaged something like twenty thousand a day from the outset. The total will certainly exceed a quarter of a million by the time the Exhibition has been open a fortnight: Visitors include many from the provinces. Enterprising coach proprietors are organising trips from long distances. The holding capacity of the Museum has been tested to the utmost. The Exhibition guides and attendants report a general feeling of satisfaction and pleasure among all visitors, and warm praise for the great majority of the sections, the furnished rooms being first favourite. There has been singularly little evidence of discontent with the fact that so many articles are not at present available in adequate quantities, or at all, and I take this as evidence that the significance of the export drive and the necessity for giving high priority to its claims is very generally understood.

From **manufacture** there have been many compliments and expression of satisfaction, together with quite a volume of evidence (I think there will be more) that, despite the non-commercial character of the Exhibition's immediate aim, a considerable amount of enquiry from overseas and home buyers has reached exhibitors. The Council of Industrial Design is hearing regularly from firms whose goods were rejected or who did not submit, indicating their wish to profit from the lesson which the Exhibition teaches. Exhibitors and non-exhibitors alike have remarked that the demonstration of how to display goods was something from which they would profit. Several forms have made the interesting point that the success of the Exhibition, coupled with the knowledge among their work people that their goods were on display, has led to a marked increase in output.

Home Buyers, Shopkeepers, etc.
Here the response has been broadly similar to that of manufacturers. There seems to be a large number of small traders visiting the Exhibition among the body of the public, and in conversation with the guides they frequently say that they have

come to look ahead and gain an impression of the type of goods and of designs likely to be in favour later on.

Overseas Buyers are visiting the Exhibition in numbers which vary from one hundred to three hundred a day. They come from all over the world.

On one day, taken at random in the second week, they included visitors from Bratislava, Stollwerk in Czechoslovakia, from Zurich, Cophenhagen, Rotterdam, Amsterdam, Gothenberg, Greece, Brussels, Finland, Bilbao, the United States (Indiana, Washington, New York, Chicago and Cleveland), Latin America (Buenos Aires, Bogota and Montevideo), India, Nepal, the Dutch East Indies, Nova Scotia, Kenya Colony, Johannesburg, Cape Town, Cairo, Burma, Rhodesia, Singapore, Christchurch and Auckland, as well as Eire and Channel Islands. Their praise for the display of goods is enthusiastic and practically unanimous. To the goods themselves there are two types of reaction: those overseas buyers who are eager for supplies tend to be enthusiastic about the design and quality of the goods shown, but a number of the larger and more experienced traders from various parts of the world, including the Empire show some reserve in their comments and it seems evident that they think there is room for improvement – a view which I myself and the Council of Industrial Design share.

The Press
At home the newspapers have given great space to descriptions of and comment on the Exhibition – the vast majority favourable. The trade press, the bulk of whose advertisers are forms not represented in the Exhibition, might have expected to be more critical, but among hundreds of these papers only two have so far sounded a jarring note. There has been great interest in many home publications in the possibility of putting the Exhibition on tour, a matter which is now being considered.

The Overseas Press has shown great interest, which is still growing if measured by the number of callers and telephone enquiries. In the first week eight hundred correspondents representing overseas papers came to the Museum. It is too early yet to have seen press cuttings or to have had the reports which the Council has asked for from our Press Attaches in the Empire and overseas, but first accounts show that the interest shown by foreign correspondents here is duly reflected in the reports appearing in print abroad. The opening of the Exhibition was front page news in several of the leading American papers, not only in New York but in the Middle West and on the Pacific Coast.

I trust that this outline of the response to the Exhibition may be of interest to you, and in renewing my own expression of grateful thanks for the support and help which you and the Queen gave by your visit I would add that Sir Thomas Barlow, the Chairman of the Council of Industrial Design, has especially asked that the Council's heartfelt and loyal thanks be joined with my own.

12 Outline Biographies

Thomas **Barlow** (Figure 31): Born in 1883, the younger son of Queen Victoria's physician, and educated at Marlborough and Trinity College, Cambridge. Barlow was not only director of the high class textiles company Barlow & Jones, and later chairman of the District Bank, but also a prominent public figure in the semi-official apparatus of the British state. President of Manchester Chamber of Commerce from 1931 to 1934, he was knighted in 1934 and served as chairman of the Lancashire Industrial Development Council. During these years he was also closely involved with debates about the role of the designer, serving on the Council for Art and Industry's committee for the report on *Design and the Designer in Industry* of 1937. His involvement with high quality design was underlined by his establishment of a small subsidiary, Helios, inside Barlow & Jones, with the aim of producing fine weaving. From 1941 to 1945 he was Director

Figure 31 Sir Thomas Barlow, Chairman COID, 1946.

General of Civilian Clothing, working at the Board of Trade when Sir Cecil Weir and Alix Kilroy were setting up the Control of Factory and Storage Premises. He would also have come into contact with Francis Meynell who was wartime Adviser on Consumer Needs to the Board of Trade. A member of the Council for the Encouragement of Music and the Arts (CEMA) he was appointed as the first Chairman of the Council of Industrial Design in 1944, a post which he held until 1947.

Misha **Black**: Born in Russia in 1910, his family moved to England in the same year. Educated at the Dame Alice Owen School and at the Central School of Arts and Crafts (now part of the London Institute), his long and distinguished career in design began in 1928 when he worked, mainly in exhibition design, for J. Arundell Clark. In 1933 he joined the Bassett-Gray Group of Artists and Writers which evolved in 1935 into the more multidisciplinary Industrial Design Partnership of which he was a partner until 1939. During the war he was appointed Principal Exhibition Architect to the Ministry of Information and, in 1943, became a partner and co-founder of the Design Research Unit (DRU), an important consultancy with which he retained ties until his death in 1977. The DRU commenced work in 1945 and was commissioned for the 'What Industrial Design Means' exhibit at the 1946 *Britain Can Make It* exhibition. Organized by Black, this was one of a number of commissions which the COID sought from the DRU in its early years. Black was also a member of the Presentation Panel and Design Group for the Festival of Britain of 1951, an important vehicle for the COID's promotion of modern design in Britain. Through the DRU over the next 30 years he gained many major consultancies from leading companies. He also played a distinguished role in industrial design education, most notably at the Royal College of Art where he was Professor from 1959 to 1975. He was highly sought after to serve on national and international design juries and played an important role in a number of professional organizations, including a term as President of the International Council of Societies of Industrial Design from 1959 to 1961.

Kenneth **Clark** (Figure 32): Born in 1903, he was educated at Winchester and Trinity College, Oxford. His family had private wealth and he worked in Florence with the celebrated scholar Bernard Berenson, becoming an authority on Italian Renaissance art. He held the post of Keeper of Fine Art at the Ashmolean, Oxford, from 1931 to 1933, following which he was appointed Director of the National Gallery, London, a post which he held from 1934 to 1945. He was appointed as an original member of the Council of Industrial Design in 1944. He was also well-known in Whitehall circles,

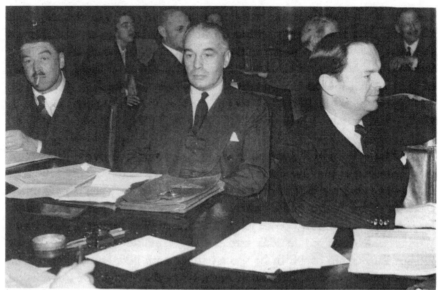

Figure 32 Kenneth Clark (right) at the first meeting of the COID, January 1945, with E.L. Mercier (Board of Trade) and Mr. Tresfon.

particularly through the highly influential Alix Kilroy (see below) one of whose close friends from Malvern Girls' College and Somerville College, Oxford, he married. He subsequently held a number of important posts on national bodies, including the Chairmanship of the Arts Council from 1953 to 1960 and of the Independent Television Authority from 1954 to 1957. He is widely considered to have been a popularizer of cultural matters, broadcasting widely-viewed programmes on taste on commercial television in the 1950s and his more famous series *Civilisation* in 1969.

Stafford **Cripps**: Born in 1899 and a nephew of Beatrice Webb, Cripps was a prominent member of one of Britain's political dynasties and a leading barrister in the inter-war years. He joined the Labour Party in 1929 and served as an MP for Bristol from 1931 until his death in 1952. His stormy career embraced leadership of the Socialist League and expulsion from the Labour Party in 1939. He rejoined it in 1945, serving as Attlee's President of the Board of Trade until 1947 and then as Chancellor until ill health forced his retirement in 1950. During the war he had served successively as Churchill's special emissary to Moscow and then India before becoming briefly Lord Privy Seal and Leader of the House in 1942, and then Minister of Aircraft Production from 1942 to 1945.

Hugh **Dalton**: Born in 1887 and educated at Eton and King's College, Cambridge, Dalton was one of the Labour Party's leading power-brokers and another member of the bar. He served in the armed forces during the First World War and was successively a lecturer at the London School of Economics and at the University of London before devoting himself entirely to his political career. Having joined the Labour Party in 1907 he served as MP for Camberwell from 1924 to 1929, for Bishop Auckland from 1929 to 1931 and from 1935 to 1959. He also held the junior office of Under Secretary at the Foreign Office in MacDonald's second administration; he was Churchill's Minister of Economic Warfare from 1940 to 1942; and served as President of the Board of Trade from 1942 to 1945. He was also Attlee's Chancellor until 1947; a political indiscretion forced his resignation from that office, and he was subsequently Chancellor of the Duchy of Lancaster from 1948 to 1950 and Minister of Planning from 1950 to 1951.

James **Gardner** (Figure 33): Born in 1907, he attended evening classes at Westminster where his tutors included the graphic designer McKnight Kauffer. In 1923 he was apprenticed to the Bond Street, London, branch of Cartier the jewellers. In the late 1920s he travelled around Europe and Africa after which he was employed at Carlton Studios, London, a very large commercial art organization. During the 1930s he came into contact with Jack Beddington of Shell, who commissioned from him both poster and exhibition work (and later, according to Gardner, secured his position as Chief Designer at *Britain Can Make It*). In the war he was involved with

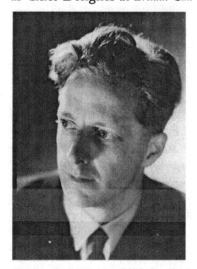

Figure 33 James Gardner, 1946.

camouflage work, working with the couturier Victor Stiebel and the set designer Oliver Messel. He was appointed as Chief Designer for the *Britain Can Make It* exhibition, the first of a series of commissions for the Council of Industrial Design which included the Enterprise Scotland exhibition of 1947 and the Festival of Britain of 1951, for which he served as a Design Panel member and design co-ordinator of the whimsical Battersea Pleasure Gardens. A number of other official commissions followed, including the British Government Pavilion at the Brussels World Fair of 1958 and the British contribution to the Montreal World Fair of 1967. However, it was in the field of museum and exhibition design upon which his reputation most firmly rested; notable projects included the Evoluon Museum at Eindhoven and the Museum of Natural Science at Brunei.

Milner **Gray**: Born in 1889 and educated at Goldsmiths College School of Art, London, he was a founder member of the Bassett-Gray Group of Artists and Writers, a multidisciplinary design practice which in 1935 became the Industrial Design Partnership. He also sought for recognition of the professional status of designers, becoming a founder member of the Society of Industrial Artists in 1930 and was also a Council Member of the Design and Industries Association from 1935 to 1939. Together with Misha Black he worked on exhibition design at the Ministry of Information during the war. With Black and the critic Herbert Read he was also, in 1943, a co-founder of the Design Research Unit (which was active from 1945 onwards). Like Black, his association with the DRU lasted for several decades. He also participated in a number of exhibitions in which the Council of Industrial Design played a significant role, including *Britain Can Make It* and the Festival of Britain of 1951. Well-known in the fields of corporate and packaging design he was an important propagandist for the design profession in Britain for many years.

Alan **Jarvis**: Born in 1915, he was educated at the University of Toronto and the Graduate School of Fine Art, New York University. Like Leslie (see below) under whom he worked at the Council of Industrial Design, he was a Rhodes Scholar at Oxford where he studied at University College from 1938 to 1939 when he was repatriated on the outbreak of war. He returned to England in 1941 when he worked in the Ministry of Aircraft Production. In 1945 he was appointed as Special Assistant, then Private Secretary, to Stafford Cripps, then Minister of Aircraft Production. He also edited a collection of Cripps' speeches entitled *Democracy Alive*. In the same year, following Cripps' appointment as President of the Board of Trade, he became Director of Public

Relations at the COID. During his time at the COID he was involved in film production, including the infamous (aborted) full-length feature film *Deadly Lampshade* and, in 1947, was invited to become Executive Director of the newly-established company, Pilgrim Pictures. He was succeeded at the COID by Paul Reilly but he maintained his connections with the organization, working as a co-author with Gordon Russell (then the COID's Director, see below) on *How to Buy Furniture* in 1953. He was head of Oxford House, Bethnal Green from 1950 to 1955 when he was appointed to the post of Director of the National Gallery of Canada where he remained for four years.

Alix **Kilroy** (Figure 34): Born in 1903, the daughter of a Royal Navy Surgeon Commander, Alix Kilroy was educated at Malvern Girls College and Somerville College, Oxford. On joining the Board of Trade in 1925 she was placed in the Department of Industry and Manufacture and rose rapidly up the Civil Service hierarchy to become one of the two leading female civil servants of her generation. Closely associated with a number of prominent figures in the Bloomsbury Set, Civil Service rules ensured that her liaison with Francis Meynell (see below) was kept secret until their marriage in 1946. Created Dame in 1949, she was seconded as Secretary to the Monopolies and Restrictive Practices Commission from 1949 to 1952 prior to retiring from the Service in 1955. Called to the Bar in 1956, she also

Figure 34 Alix Kilroy (left) with Mr Caruthers and Mr Newman, all of the Board of Trade at the first meeting of the COID, January 1945.

Figure 35 S.C. ('Clem') Leslie, Director of the COID, 1946.

served as a member of the Harlow New Town Corporation, the Performing Rights Tribunal and as a member, and subsequently Chair, of the South East Gas Board Consultative Committee.

S.C. ('Clem') **Leslie** (Figure 35): Born in Perth in 1898, Leslie was educated at Melbourne Grammar School and Melbourne University before arriving at Balliol as a Rhodes Scholar and completing a doctorate. A brief period as a lecturer at University College North Wales and the University of Melbourne was brought to a close by his appointment as assistant to the Australian Prime Minister at the 1926 Imperial Conference. In 1936 he became publicity manager for the Metropolitan Gas, Light and Coke Company where he remained until his appointment in 1940 as Director of Public Relations at the Ministry of Supply. From 1943 he was Principal Assistant Secretary at the Home Office and then Director of the COID from early 1945 to 1947 when he was succeeded by Gordon Russell. From 1947 to 1959 he was head of the Treasury's Information Division, after which he became an information consultant, also serving as a member of the Northern Ireland Development Council between 1955 and 1965.

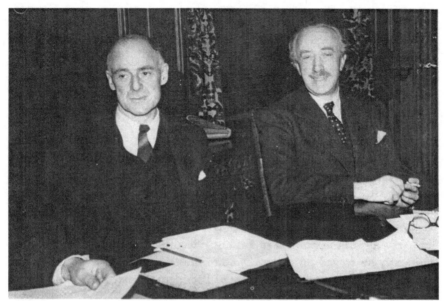

Figure 36 Sir Francis Meynell (left) and William Haigh, COID members at the first meeting of the COID, January 1945.

Francis **Meynell** (Figure 36): Born in 1891, he was educated at Downside and Trinity College, Dublin. He worked at the Catholic publishing house Burnes and Oates from 1911 to 1916, the year in which he founded the Pelican Press. After serving as a director of the *Daily Herald* from 1918 to 1920, in 1923 he founded the Nonesuch Press which carried on many of the traditions of the private press movement while reconciling high standards of design with machine production. In 1935, the company was taken over and Meynell became a columnist with the *News Chronicle*, working also with the Gaumont-British Picture Company. After joining Mather and Crowther, the advertising agency, during the war he was seconded as an Adviser on Consumer Needs to the Board of Trade. As indicated above he married Alix Kilroy (a leading civil servant and key figure in the formation of the COID), in 1946 when she became his third wife. Invited to serve as an original member of the COID in 1944, he became Typographical Adviser to HMSO in 1946. In 1945 he was elected as a Royal Designer for Industry.

Gordon **Russell**: Born in 1892 and educated at Campden Grammar School, Russell served with the Worcestershire Regiment throughout the First World War and was awarded the Military Cross. At the end of the war he became a partner in Russell & Sons prior to establishing his own

furniture manufacturing firm of Gordon Russell in 1926, in which year he also became a member of the Art Workers Guild. His firm's work was shown at many of the major international exhibitions of the period, including the British Empire Exhibition at Wembley in 1924 and the 1925 Exposition des Arts Décoratifs et Industriels in Paris where it won gold and silver medals. His long-standing commitment to design reform was reflected in his initiation in 1938 of a retailing consortium, the Good Furnishing Group, for selling well-designed, mass-produced furniture. During the Second World War he was a member of the Board of Trade's Advisory Committee on Furniture Production in 1942 and served as chairman of the Board of Trade Design Panel from 1943–47. An original member of the COID in 1944, he succeeded Leslie as Director in 1947, as well as becoming a member of the Arts Council Arts Panel from 1948–53 and serving on the Festival of Britain Executive Committee in 1951. Subsequently he served on many key committees connected with design and design education, including a term as President of the Design and Industries Association from 1959 to 1962.

Basil **Spence** (Figure 37): Born in India in 1907, he was educated at George Watson's College, Edinburgh, Heriot-Watt University, and the Bartlett School of Architecture in University College, London. He early career was heavily influenced by his time as an assistant in the architectural office of Sir Edwin Lutyens where he worked on a number of government buildings in India. After serving in the army from 1939–45, he was involved in a number

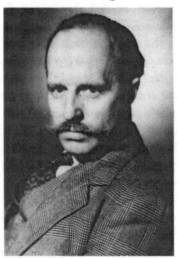

Figure 37 Basil Spence, Chief Architect, BCMI, 1946.

of important commissions. He was appointed Chief Architect for the Council of Industrial Design's *Britain Can Make It* exhibition of 1946 and for Enterprise Scotland of 1947. At this time he was acting as an adviser to the Board of Trade in relation to the British Industries Fairs of 1947, 1948 and 1949. He also played a significant role in the Festival of Britain exhibition of 1951, designing the Sea and Ships Pavilion on the South Bank, London. Perhaps his best known commission was Coventry Cathedral, for which he won the competition in 1951, although his highly successful career also included a number of university buildings, among them the architectural layout for the University of Sussex.

Charles **Tennyson** (Figure 38): Grandson of the famous Victorian poet, he was born in 1879 and was educated at Eton and King's College, Cambridge, before being called to the Bar in 1905. He served as an assistant legal adviser at the Colonial Office from 1911–19 prior to entering the world of commerce. In 1928 he became Secretary of the Dunlop Rubber Company, a post he held until 1948. Chairman of the Federation of British Industry's Industrial Art Subcommittee and a Fellow and Governor of the British Institute of Industrial Art, he was subsequently Chairman of the National Register of Designers and of the Board of Trade's Utility Furniture and Utility Furniture Production Committees and was knighted in 1945. Like Thomas Barlow he

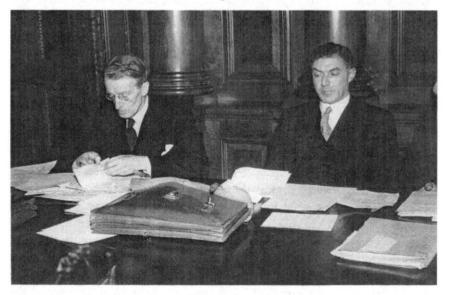

Figure 38 Charles Tennyson (left), Chair of the Industrial Art Designers National Register, and S.C. Leslie at first meeting of the COID, January 1945.

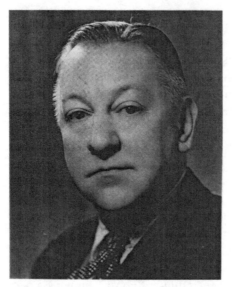

Figure 39 Allan Walton, COID member, 1946.

also served on the committee for the Council for Art and Industry's report on *Design and the Designer in Industry* of 1937.

Allan **Walton** (Figure 39): Born in 1891, he trained as an architect and painter in London and Paris. Coming from a family background in the textile trade he established in Manchester his own innovative company, Allan Walton Textiles, which became a leader in the commissioning of screen-printed textiles from both designers and fine artists, including Vanessa Bell, Duncan Grant and Kenneth Martin. A designer himself of interiors, printed textiles, carpets and embroidery he became, Director of Glasgow School of Art from 1943–45 and served on the Council of Industrial Design from the outset.

Josiah **Wedgwood**: Born in 1899, he was educated at Bedales School, University College, London, and the London School of Economics. From 1922–26 he worked at the Rural Industries Bureau, firstly as Secretary and then as Director, after which he was involved in economic research. In 1928 he joined the family firm as Secretary, before becoming Managing Director, a post which he held from 1930–61. He was also the Chairman of the company between 1947–67, from when until the following year in which he died, he was also President. Appointed as an original member of the Council of Industrial Design in 1944, he played the difficult role of mediating

Figure 40 Cecil Weir at the Board of Trade offices, Portland House, 1946.

between the conservative outlook of the Stoke-on-Trent pottery industry and the more progressive metropolitan aesthetic endorsed by the COID.

Cecil **Weir** (Figure 40): Born in 1890, Weir was one of Scotland's leading industrialists, a partner in the firm of Schrader, Mitchell and Weir. He was President of the Glasgow Chamber of Commerce and chairman of the administration committee of the 1938 Glasgow Empire Exhibition. On the outbreak of war he became Civil Defence Commissioner for the Western District of Scotland. A member of the Board of Trade's Industrial and Export Council from 1940–45 he also served as Controller General of Factory and Storage Premises from 1941–42 before becoming Director General of Equipment and Stores at the Ministry of Supply from 1942–46. After the war he served successively as Economic Adviser to the Control Commission in Germany from 1946–49 and then as Chairman of the Dollar Exports Board from 1949–51 and was subsequently made Chairman of International Computers and Tabulators prior to his death in 1960.

13 BCMI 1946: Photographs

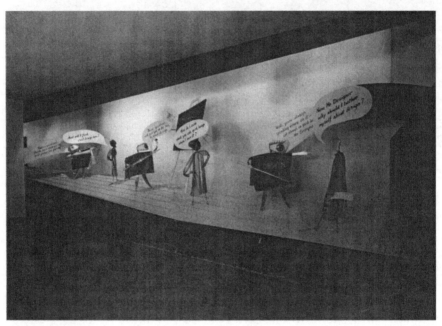

Figure 41 Introduction to *Britain Can Make It,* designed by James Gardner and Basil Spence.

Figure 42 Inflatable rubber chair, R.F.D. Co. Ltd, Guildford, from the War to Peace Section BCMI.

Figure 43 Display of glass in Shopwindow Street, BCMI, 1946.

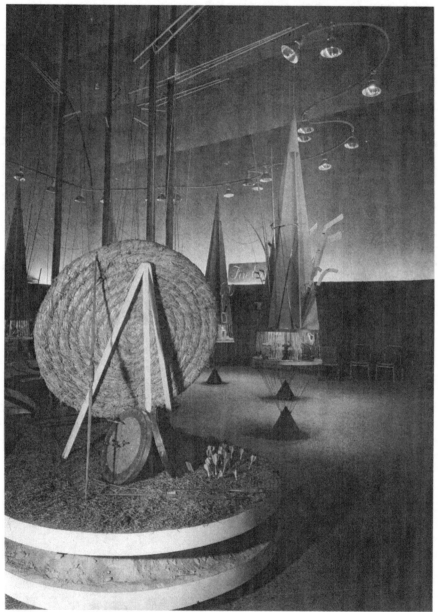

Figure 44 Sport and Leisure Section, BCMI, displays by R.Y. Godden.

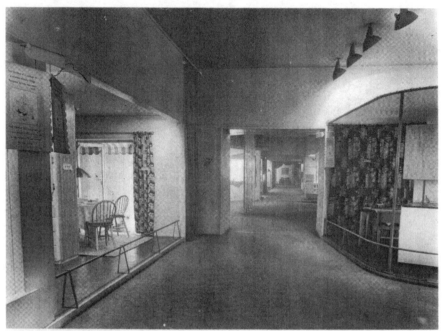

Figure 45 General display of Furnished Rooms Section, BCMI.

Figure 46 Living Room with Kitchen Recess in Small House, designed by Mrs. Darcy Braddell, BCMI.

Figure 47 Kitchen with Dining Recess for an architect and his family, designed by F. MacManus, BCMI.

Figure 48 One of the imaginary families envisaged by John Betjeman for Furnished Rooms designs at BCMI. The drawing by Nicolas Bentley shows a young artisan, who enjoys a bit of carpentry, his mother-in-law, his wife who is clever at needlework and embroidery, and their baby. Their projected living room was designed by Elizabeth Denby.

Figure 49 One of the imaginary families envisaged by John Betjeman for
Furnished Rooms designs at BCMI. The drawing by Nicolas Bentley shows a
family consisting of a Managing Director of an engineering works, with a
university education; his wife lived in America for some years. Their daughter,
now at boarding school. Their staff, two maids and a manservant. Their projected
kitchen design was by Maxwell Fry and Jane Drew.

Figure 50 A corner of the Toys Section at BCMI.

Figure 51 Nursery School, designed by Ralph Tubbs at the BCMI.

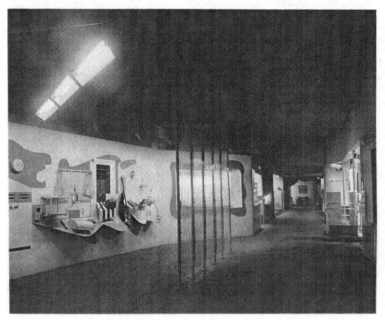

Figure 52 Bathroom and Kitchen Equipment at BCMI.

Figure 53 'Goldwyn Girls' in the Fashion Hall, BCMI.

Figure 54 Fashion Section, BCMI, Hyde Park Set, designed by James Bailey.

Figure 55 Menswear Section, BCMI, designed by Ashley Havinden.

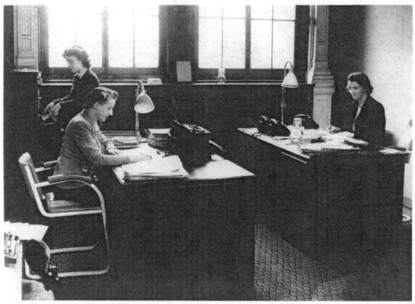

Figure 56 Staff Office for the BCMI exhibition.

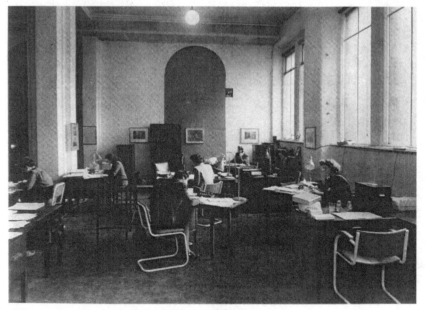

Figure 57 Trade Enquiry Office at BCMI.

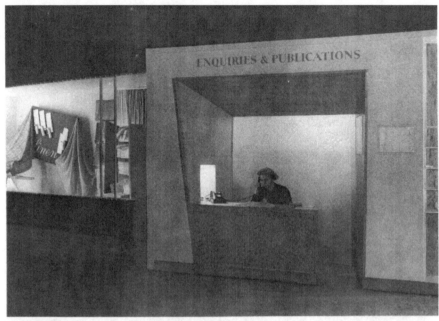

Figure 58 Enquiries and Publications Stall at BCMI.

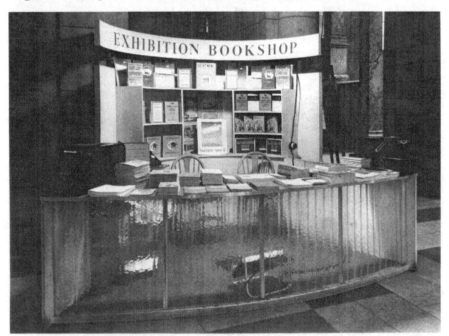

Figure 59 Exhibition Bookshop at BCMI.

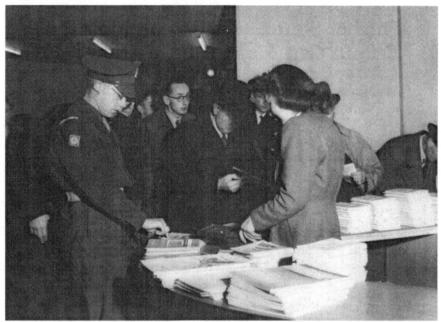

Figure 60 Books and Publications Stall at BCMI.

14 Further Sources for Researching the *Britain Can Make It* Exhibition 1946

A. Notes on the Material Contained in the Victoria & Albert Museum Archives

Doreen Leach

Before considering material directly relating to the exhibition it is useful to be aware of the relationship between the Victoria & Albert Museum (V&A) and the Council of Industrial Design (COID) which predates plans for the exhibition. The information set out below has been obtained from the Victoria & Albert's official files.

There is correspondence in one file entitled *Ministry of Education* (ref: 44/1368) which expresses the Museum's concern at the fact that it was not officially represented in terms of membership on the new Council of Industrial Design (COID). The Museum seems to have become aware of the setting up of the Council and its membership from an article in *The Times*. Not only did the Museum feel that its own remit should have entitled it to a place on the Council but there was concern that Sir Kenneth Clark (then the Director of the National Gallery) had been made a member (although it was subsequently suggested that he was serving in a personal capacity). After some correspondence on this subject the Director of the V&A, Sir Leigh Ashton, was eventually invited to become an assessor for the Council, although he was intimately involved in early COID discussions about the planning of the *Britain Can Make It* exhibition of 1946.

The Victoria & Albert Museum Archive also holds a file entitled *Council for Industrial Design* (ref: 45/498) which contains a memorandum (12 May 1945) from Sir Leigh Ashton to the Museum Secretary declaring that he was 'staggered' to find that the COID intended to purchase objects out of its Treasury grant. This was felt to put the Council in direct competition with the V&A's Department of Circulation. (This had been established in 1854 to purchase items to be 'circulated among Schools of Art and publicly exhibited' with the aim of aiding the instruction given in Schools, extending their funding, and encouraging the formation of local museums as well as generally improving the 'public knowledge of taste'.)

The Chairman of the Designs Committee who wished to make the purchases was Sir Kenneth Clark and Sir Leigh Ashton was clearly unhappy about Sir Kenneth Clark's role. As Leigh Ashton wrote:

> the part of it that I dislike is the Director of the National Gallery being in a position to cut across this Museum without any reference being made to it. What in effect you then get is a dictatorship on modern design controlled by Sir Kenneth Clark and two Government Departments competing with each other.[1]

Sir Leigh Ashton informed the COID that under their charter they were not in fact entitled to purchase works of competition with the Department of Circulation. The V&A had apparently already experienced problems when the COID's spiritual predecessor, the Council for Art and Industry, had purchased 'extensively' and, according to Leigh Ashton, 'had landed this Museum with an enormous mass of practically useless material'.[2] Sir Leigh Ashton recommended that objects should be borrowed rather than purchased from the trade sector and this was apparently accepted.

A further memorandum from Sir Leigh Aston also stated that the COID had proposed a series of small circulating exhibitions to schools and other educational institutions and organizations and again this came into conflict with the role of the Museum's Department of Circulation.

The relationship between the Museum and the COID was obviously a difficult one from the start and helps to explain any initial reluctance by the V&A to host the *Britain Can Make It* exhibition.

As far as *Britain Can Make It* exhibition material contained in the V&A Archive is concerned, much of it concerns the planning and detailed arrangements for the exhibition from a Museum perspective. Important issues were: whether to hold it at the V&A at all; whether the Museum would be compensated for the disruption and deferment of its own priorities; whether sufficient building labour would be supplied; and whether there should be a charge for entry to the exhibition.

The following extracts from some of the correspondence may be of interest to historians. These extracts are from Special File 209 46/175: *Council of Industrial Design, Accommodation in the Museum* which covers the whole of 1946. This file also contains an A4 size map of the museum with the location of the *Britain Can Make It* exhibition marked in red, together with a large plan dated 30 January 1946. Unfortunately, the file does not appear to be complete as there are letters which are clearly in response to others which are not present. However, the following extracts give a flavour of the museum's position:

1. Sir Leigh Ashton wrote (in January 1946) a confidential letter to Sir Thomas Barlow asking if it would be possible for one or two V&A staff to be involved in the Selection Committees 'in view of the fact that they would have to give up space for the exhibition'.

2. A minute from Sir Leigh Ashton to the Museum Secretary (2 January 1946) emphasized the importance of allowing the normal activities of the Museum to continue during the exhibition and the fact that it must be made clear publicly that the exhibition was being held at the V&A at the express wishes of His Majesty's Government. This was in view of the disruption that it would cause to the return of objects following their removal from the V&A during the war and the criticisms which had already been made by the public about this. Sir Leigh felt that this could partly be offset by explaining 'publicly that the exhibition has wider importance than our normal activities'.

3. A letter of 2 January 1946, from Mr. de Normann, of the Ministry of Works, in response to a letter (not on file) from Sir Leigh Ashton, said that 'I note that you are anxious to assist the Council of Industrial Design by lending them space in the Museum for their Exhibition.' This is a different emphasis to the letter referred to in 2 above. Mr. de Normann expressed reservations about how much help the Ministry of Works could give and how they would be open to criticism if they took men away from housing projects to help with an exhibition.

 Sir Leigh Ashton responded to Mr. de Normann's letter on 4 January, saying that he was in complete agreement with Mr. de Normann's views and that at first sight the proposals seemed to be 'alarmingly large'. He went on to say that

 > my Minister has expressed herself in favour of the project and I believe the real motivating power is Sir Stafford Cripps, who has indicated that the exhibition, wherever it is held, must have top priority.
 >
 > If we are pushed into this Exhibition, I have made it a condition that the announcement that it is to be held here, must be made as a Government Statement.

 Sir Leigh wanted it made 'absolutely clear' that the exhibition was part of the campaign for 'our vital overseas trade' and that the decision to hold it at the V&A had been made by the Cabinet.

4. A minute of 3 January 1946, from Sir Leigh Ashton to the Museum Secretary emphasized the poor physical state of the buildings, with rain streaming through the roof of nearly every gallery. It went on to suggest that pressure might be brought to bear on the Ministry of Works on the

grounds of tourist attraction. (There was a government scheme to attract tourists to England.)

There was apprehension of a bad press if visitors to the *Britain Can Make It* exhibition were unable to visit other parts of the Museum and see at the same time some of the National Collections which had not been available during the war. Sir Leigh used the example of Italian museums and galleries which were 'having money poured out like water on them, in order to satisfy the tourist traffic'.

5. S.C. Leslie, Director of the COID, wrote on 3 January 1946, to Mr. J.P.R. Maud at the Ministry of Education, asking for his consent to the exhibition being held at the V&A. He said that The National Exhibition of Industrial Design was to have been held at Earls Court but 'in view of serious practical difficulties ... the Council welcome Sir Leigh Ashton's suggestion that the Exhibition might be transferred to the V&A'.

 Mr. Leslie pointed out that the intention had been to charge an entry fee for the exhibition but, if it was to be held at the V&A, there would probably be periods when it was open free of charge.

 Mr. Maud replied to S.C. Leslie on 8 January 1946, conveying his Minister's consent to the exhibition being held at the V&A 'on the understanding that the Ministry of Works can provide enough labour to make the building suitable for this purpose.' Mr. Maud asked that it may be made clear that the V&A had agreed to the exhibition 'because it is regarded by the Government as most important'.

6. S.C. Leslie wrote to Sir Leigh Ashton on 7 January 1946, offering to do anything necessary to satisfy the 'friends of the Museum about our exhibition.' He also felt that it was 'a great chance to put the Museum still more firmly on the map for its own specific purpose'.

7. It is clear from Sir Leigh Ashton's letter to S.C. Leslie of 9 January 1946, that the Museum expected something in return for hosting the exhibition i.e. getting glass roofs repaired and painting done.

8. S.C. Leslie wrote to Sir Leigh Ashton on 26 January 1946, reporting that he was preparing plans for the advertising of the exhibition and asking whether Sir Leigh would object to the site being referred to as the V&A. This simpler description rather than 'Victoria & Albert Museum' was felt to be more appealing to 'masses of inhabitants of the Eastern half of London'. Sir Leigh replied two days later that the Museum was always known as the V&A in the art world anyway and that he had no objection.

9. S.C. Leslie wrote to Sir Leigh Ashton on 21 February 1946, on behalf of

the COID to express thanks to the V&A for the exhibition. He said that 'The Council also takes pleasure in the thought that the Exhibition, and the extensive publicity which will attend it, may widen and intensify public interest in the long-term activities of the Museum'.

10. S.C. Leslie wrote to Sir Leigh Ashton on 13 March 1946, asking whether he would be prepared to act as a member of the Exhibition Selection Committee for Furnishing Textiles.

11. S.C. Leslie wrote to Sir Leigh Ashton on 21 May 1946, asking whether it would be possible to extend the exhibition if there was a great deal of demand for it.

12. On 12 June 1946, James Gardner, the Chief Designer for the exhibition, sent Sir Leigh Ashton a scale model of the suggested design for the Information Kiosk to be placed in the centre of the entrance hall. The letter is annotated to say that the model was approved by the Director but he did not wish it to be kept after the exhibition.

13. Sir Leigh Ashton wrote to S.C. Leslie on 24 October 1946, saying that 'The Advisory Council agreed to extending the Exhibition until 31 December on condition that the building could be cleared by 1 February'.

14. On 26 November 1946, R. Dudley Ryder of the COID wrote to T.R. Parkin of the V&A asking that the warders be reminded that no sketching or photography is allowed in the exhibition. Apparently members of the public had been found sketching or photographing exhibits and there was 'a danger of designers' and manufacturers' copyrights being infringed'.

15. Special File 209 46/2645 contains a complaint (apparently made by people on the stand of the exhibition) which had been forwarded to Tom Driburg MP that the premises were in 'a verminous condition'. There was a suggestion from the Museum side of a history of 'bad feeling' behind this complaint.

16. Special File 209 46/1750 includes a list of artists working on the mural decorations. This included, for instance, Duncan Grant, Vanessa Bell and Graham Sutherland.

17. Special File 209 46/1534 contains some temporary passes which had been issued to COID staff to enable them to enter the Museum.

There are 23 official museum files relating directly to the exhibition. However, a number contain material of a trivial nature, for example:

• correspondence about missing parts from a vacuum cleaner loaned to the Museum by the Ministry of Works (Special File 209 47/297);

- a request from the West London Road Safety Committee asking if it would be possible to display a panel near the Museum exit reminding the public to be careful on their way home (Special File 47/270);
- disposal of lost property (Special File 47/270).

There is also a report of a more serious matter (Special File 46/2848): one of the visitors to the exhibition, a man in his twenties, apparently collapsed and died.

The Archive of Art and Design (AAD) at the V&A holds some material (AAD/1977/4) on the *Britain Can Make It* exhibition which probably belonged to R. Dudley Ryder (Organizing Secretary for the Exhibition and an employee of the COID). Most of this consists of carbon copies of letters, minutes of meetings, records of attendance figures, etc. There is also an example of the exhibition leaflet (the exhibition guide is held in the National Art Library), a guide's badge and disc, and examples of admission tickets.

The key points which stand out from this material are:

- the clear brief to design room settings on a class basis;
- the number of lenders to the exhibition who appear to have complained about the way their items were displayed;
- the problems which had to be tackled to keep items looking fresh during the exhibition;
- an article in the *Daily Express* (25 September 1946) written by William Barclay who had attended the exhibition with his wife and who complained that the majority of items were not then obtainable, but would be available 'later' or 'soon';
- an article in the *Evening Standard* (28 September 1946) which said that 'Britain Can Make It is the most frustrating show on earth' because much of the new items were being made for export and were not available in British shops. Even items described as 'available now' often could not be bought in shops.

The Archive of Art and Design at the Victoria & Albert Museum was set up in 1978 to collect, conserve and make available to researchers the archives of designers, design associations, and companies involved in the manufacture and promotion of design objects, with a particular emphasis on the twentieth century.

B. Notes on the Mass Observation Archive at the University of Sussex

Dorothy Sheridan

Scholars engaged in research in the history of design in the period surrounding the *Britain Can Make It* exhibition of 1946 will find it useful to visit the Mass Observation Archive at the University of Sussex.

Mass Observation (MO) was an independent social research organization set up in 1937 by a group of young people who intended to create what they described as 'an anthropology of ourselves'. From 1937 until the years of the Second World War, they used a variety of methods to document in great detail the everyday lives of ordinary people in Britain. These not only included traditional surveys, but observations of events and behaviour, ethnographic accounts, and the soliciting of people's own writing in the form of diaries and detailed personal reports. In 1949, Mass Observation registered as a market research company, and continues today as a subsidiary of British Market Research Bureaux.

The papers generated by the research from 1937 until the early 1950s were transferred to the University of Sussex in 1970, and the material was quickly made available for public consultation. The Archive is a unique documentary of British social life for the period, and attracts researchers from all over the world. Since 1981 it has also been the base for a new writing project which complements the original papers with accounts by hundreds of ordinary people of their lives in the 1980s and 1990s.

The Archive can be mined for information about people's homes – both what people have and what they would like to have – for accounts of their furniture and the domestic equipment within their homes; for descriptions of buildings, especially public places such as cinemas, dance halls and pubs; for reports on clothing and personal appearance, on Utility designs during wartime, rationing, the 'make do and mend' campaigns; and for fashion trends after the war (e.g. the New Look).

The design of printed materials, especially those used for Government propaganda (posters, films, advertisements, leaflets) were also part of MO's studies. Mass Observation undertook a number of commissions for the Council of Industrial Design (later, Design Council). For example, there are several reports and five boxes of papers relating to the *Britain Can Make*

It exhibition. Mass Observation carried out an investigation into reactions to this design exhibition held at the Victoria & Albert Museum in September 1946, as seen in earlier documents included in this anthology. Material comprises questionnaires, observations and ephemera detailing the exhibition itself. Mass Observation was always concerned to understand the more subjective level of public opinion and, through its in-depth diaries and reports, it is possible to gain insights into the way people interacted with each other and their material worlds.

Selected Published Material

Original Mass Observation Books

1941 *Clothes Rationing*, Advertising Service Guild Bulletin, Change No. 1.
1941 *Home Propaganda*, Advertising Service Guild Bulletin, Change No. 2.
1943 *People's Homes*, Advertising Service Guild Bulletin, Change No. 4.
1949 *People and Paint*, ICI Publications.

Published research based on Mass Observation

Bloome, D., Sheridan, D., & Street, B. (1994) 'Reading Mass Observation Writing: Theoretical and Methodological Issues in Researching the Mass Observation Archive' in *Auto/Biography* (Bulletin of the BSA Auto/Biography group), Spring issue. Also available as Occasional Paper No. 1 from the Archive, price £2.50.
Calder, Angus & Sheridan, Dorothy (1984 and 1985) *Speak for Yourself: A Mass Observation Anthology 1937–49*, Cape and Oxford University Press.
Calder, Angus (1985): 'Mass Observation 1937–49' in Bulmer, M. (ed.), *Essays on the History of British Sociological Research*, Cambridge University Press.
Chaney, D. & Pickering, M. (1986) 'Sociology as an Art Form in Mass Observation' in Corner, J. (ed.), *Documentary and the Mass Media*, Arnold.
Richards, Jeffrey & Sheridan, Dorothy (1987), *Mass Observation at the Movies*, Routledge.
Spender, Humphrey (1982) in Mulford, J. (ed.), *Worktown People: Photographs from Northern England 1937–38*, Falling Wall Press.
Swales, V. (1990) 'Making Yourself at Home: A Study in Discourse' in Putnam, T. & Newton, C., *Household Choices*, Futures Publications.

For more information, please write to the Archivist, Mass Observation Archive, University of Sussex Library, Brighton BN1 9QL (telephone 01273-678157, e-mail d.e.sheridan@sussex.ac.uk). Visits are by appointment only.

More detailed information may also be obtained from the Mass Observation's Web site at http://www.susx.ac.uk/Units/library/massobs/home-arch.html. The Archive is in the process of mounting its catalogues and indexes on the Internet so that researchers will be able to explore the Archive's holdings in advance of making a visit.

C. Public Record Office, Kew

The documentary material lodged at the Public Record Office is essential for any study into the relationship between the state, manufacturing industry and the public in Britain in the 1940s. As well as containing an invaluable repository of material relating to the Council of Industrial Design and its often problematic relationship with a variety of state departments, many insights are provided into related contemporary political and economic debates.

15 1940s British Design:
A Select Bibliography

This bibliography should be used in conjunction with the footnote references in the various chapters contained in the book, and especially with their political and economic counterparts which are to be found at the end of the Introduction. It is not intended to be definitive but rather to indicate the range and type of writings on design to be found in relation to the *Britain Can Make It* exhibition in particular, and to 1940s British design in general. The generally positive flavour of most of the writings of the time, many of them written from an unashamedly partisan standpoint, have perhaps unduly coloured many early accounts of design in Britain in the immediate post-war period. It is to be hoped that the preceding chapters and documents will provide an appropriate counterweight.

A *Britain Can Make It* 1946

Apollo (1946) 'Design and Purpose: Britain Can Make It Exhibition at South Kensington', November, pp. 109–10.

Architectural Review (1946) 'Industrial Design – Special Issue', October, pp. 91–117.

Art & Industry (1945) 'A National Design Exhibition' (editorial), December, p. 161.

Art & Industry (1946) 'Britain Has Made It' (editorial and other articles), November, pp. 129, 151.

Art & Industry (1947) 'Under the Spotlight: Selected Exhibits from "Britain Can Make It"', February, pp. 34–41.

Arts, Beaux Arts, Littérature, Spectacles (1946) ' "Britain Can Make It" au Victoria and Albert Museum', 25 October, p. 3.

Austen, P. (1946) 'Britain Can Make It: The Council of Industrial Design', *Graphis*, March/April, pp. 258, 260.

Board of Trade, Journal of (1946) 'Britain Can Make It: The Exhibition of British Post-war Products', Supplement, 28 September.

Bourne, S. (1947) 'Britain Can Make It', *Display*, April.

Cabinet Maker, The (1945) 'Britain Can Make It: A Magnificent If Premature Exhibition', December.

Carrington, N. (1946) 'Britain Can Make It', *Journal of the Royal Society of Arts*, 27 September, pp. 663–64.

Clark, P. (1990) 'Case Study: Ben Bowden's "Bicycle of the Future", 1946', *Journal of Design History*, vol. 5, no. 3, pp. 227–35.

COID (1946) *Britain Can Make It*, Exhibition Catalogue, HMSO.

COID (1946) *Britain Can Make It*, Exhibition Catalogue Supplement, HMSO.

COID (1946) *Britain Can Make It*, Exhibition Catalogue Amendments, HMSO.

COID (1946) *Britain Can Make It*, 1d pamphlet, COID.

COID (1946) '*Britain Can Make It*: The First Post-War National Exhibition. 'Good Design and Good Business', pamphlet (including material by Sir Stafford Cripps, Sir Thomas Barlow, Sir Clive Baillieu, Lord Woolton *et al*), COID.

COID (1946) *Design Quiz*, COID.

COID (1946) *First Annual Report 1945–46*, HMSO.

COID (1946) *New Home*, COID.

COID (1946) 'The Council of Industrial Design Announces A National Exhibition', HMSO.

COID (1947) *Second Annual Report 1946–47*, HMSO.

COID/Federation of British Industries (1946) *Report of the Conference on Industrial Design*, COID.

Economist, The (1946) 'Britain Can Make It', 28 September, p. 490.

Economist, The (1946) 'Industrial Design', 21 September, pp. 455–46.

Form (Sweden) (1946) 'Milsten' (Britain Can Make It), no. 9, pp. 183–99.

Gaunt, W. (1946) 'Design Makes Good', *Evening Standard*, 25 September.

GEC (1946) GEC Products and Britain Can Make It Exhibition, GEC.

Hansard (1946) Vol. 427, 21 October, cols. 289–90.

Hansard (1946) Vol. 428, 28 October, col. 262ff.

Hansard (1947) Vol. 432, 27 January, cols. 8, 138.

Hardern, L. (1946) 'Design of Gas and Coke Appliances: Britain Can Make It', *Art & Industry*, November, pp. 140–48.

JBB (1946) 'Britain Can Make It: A Late Look Round', *Punch*, 30 October, pp. 374–75.

Leslie, S.C. (1946) 'Britain Can Make It: Overseas Buyers' Interest in Exhibition', *The Times*, 4 October.

Mortimer, R. (1946) 'Britain Can Make It!', *New Statesman & Nation*, 28 September, p. 220.

Museums Journal (1946) 'Victoria & Albert Museum: Britain Can Make It', December, pp. 177–78.

Newman, W.H. (ed.) (1946) *Design '46: Survey of British Industrial Design as Displayed at 'Britain Can Make It' Exhibition*, COID.

Picture Post (1946) 'Britain Can Make It', 19 October, pp. 21–23.

Punch (1946) 'The Great Exhibition', 16 October, p. 305.

Read, H. (1946) 'Britain Can Make It', *The Listener*, 3 October, pp. 429–30.

RIBA, Journal of (1947) 'The Success of "Britain Can Make It"', February, p. 206.

Royal Society of Arts, Journal of (1945) 'Exhibition of British Industrial Design', 7 December, pp. 41–43.

Royal Society of Arts, Journal of (1947) 'Britain Can Make It', 17 January, pp. 148–49.

Russell, G. (1947) 'Furnished Rooms: Britain Can Make It', *Art & Industry*, January, pp. 8–13.

Shaw, M. (1946) *Buying for Your Home No. 1: Furnishing Fabrics*, HMSO.

Sparke, P. (ed.) (1986) *Did Britain Make It? British Design in Context, 1946–86*, Design Council.

Sunday Times, The (1946) 'Britain Can Make It – Some Criticisms', 29 September.

Trethowan, H. (1946) 'Pottery: Britain Can Make It', *Art & Industry*, November, pp. 130–35.

Times, The (1946) 'Britain Can Make It' (leading article), 24 September, p. 5.

Times Educational Supplement (1946) ' "Britain Can Make It": A Notable Achievement', 28 September.

B Design in 1940s Britain

Architectural Review (1945) 'The Barlow Council', February, 1945, p. liii.

Architectural Review (1945) 'Design at Home: Exhibition at the National Gallery', June, pp. liii–iv.

Architectural Review (1946) 'Industry and Education', Special Issue. January.

Architectural Review (1951) 'COID: Progress Report', December, pp. 349–59.

Architectural Review (1952) 'COID: Progress Report: the Director Replies', February, pp. 73–75.

Art & Industry (1945b) 'Design and Exports', November, p. 156.

Attfield, J. (1992) *The Role of Design in the Relationship between Furniture Manufacture and its Retailing 1939–1965 with Initial Reference to the Furniture Firm of J. Clarke*, Phd thesis, University of Brighton.

Attfield, J. (forthcoming) *Utility Reassessed: Utopia or Strategy?*, Manchester University Press.

Barlow, T. (1945) 'Associations Connected with the Promotion of Industrial Design', *Journal of the Royal Society of Arts*, 30 March, pp. 201–02.

Barman, C. (1949) *The Things We See: Public Transport*, Penguin.

Bertram, A. (1946) *The Enemies of Design*, DIA booklet.

Black, M. (1944) 'Propaganda Exhibitions and their Relation to Museums', *Museums Journal*, July, pp. 18–23.

Black, M. (1946) 'Design for Ceremony and Exhibitions' in Read, H. *The Practice of Design*, Lund Humphries, pp. 182–202.

Black, M. (ed.) (1950) *Exhibition Design*, Architectural Press.

Blake, A. (1984) *Misha Black*, Design Council.

Board of Trade (1946) *Boots and Shoes: Working Party Report*, HMSO.

Board of Trade (1946) *Cotton: Working Party Report*, HMSO.

Board of Trade (1946) *Furniture: Working Party Report*, HMSO.

Board of Trade (1946) *Furniture: An Enquiry Made for the Board of Trade by the Social Survey*, HMSO.

Board of Trade (1946) *Hosiery: Working Party Report*, HMSO.

Board of Trade (1946) *Jewellery and Silverware: Working Party Report*, HMSO.

Board of Trade (1947) *Carpets: Working Party Report*, HMSO.

Board of Trade (1947) *Cutlery: Working Party Report*, HMSO.

Board of Trade (1947) *Handblown Domestic Glassware: Working Party Report*, HMSO.

Board of Trade (1947) *Heavy Clothing: Working Party Report*, HMSO.

Board of Trade (1947) *Jute: Working Party Report*, HMSO.

Board of Trade (1947) *Lace: Working Party Report*, HMSO.

Board of Trade (1947) *Light Clothing: Working Party Report*, HMSO.

Board of Trade (1947) *Linoleum and Felt Base: Working Party Report*, HMSO.

Board of Trade (1946) *Pottery: Working Party Report*, HMSO.

Board of Trade (1947) *Rubber Proofed Clothing: Working Party Report*, HMSO.

Board of Trade (1947) *Wool: Working Party Report*, HMSO.

Board of Trade (1948) *China Clay: Working Party Report*, HMSO.

Boards of Trade & Education (1944) *Report on Art Training* (Meynell-Hoskins Report, unpublished).

Brett, L. (1947) *The Things We See: Houses*, Penguin.

Britain Today (1948) 'Industrial Design' series: 'Pottery', June, pp. 24–28.

Britain Today (1948) 'Exhibition Display', July, pp. 34–38.

Britain Today (1948) 'Domestic Equipment', August, pp. 37–34.

Britain Today (1948) 'Table Glass', September, pp. 34–36.

Britain Today (1948) 'Radio', October, pp. 14–18.

Britain Today (1948) 'Motor Cars', November, pp. 25–30.

Britain Today (1948) 'Books', December, pp. 25–29.

Cabinet Maker, The (1946) *The Cabinet Maker and Complete Home Furnisher Guide to Utility Furniture*, Benn.

Cabinet Maker, The (1948) 'Who Killed Cock Robin? Failure of the Utility Scheme, 31 January, p. 236.

Carrington, N. (1947) 'State and Industrial Design', vol. 3, no. 18, pp. 108–17.

Central Institute of Art & Design (1948) *Report on the Work of the Central Institute of Art and Design, September 1948*, CIAD.

Clark, K. (1977) *The Other Half*, John Murray.

Council for Art & Industry (1944) *Design and the Designer in the Light Metal Trades*, HMSO.

Council for Art & Industry (1945) Design and the Designer in the Dress Trade, HMSO.

Council for Encouragement of Music & the Arts (1945) *Design at Home*, catalogue for exhibition at the National Gallery, London, CEMA.

COID (1946) *Conference on Packaging*, COID.

COID (1946) *New Home No. 2*, COID.

COID (1946) *Report on the Training of the Industrial Designer*, COID.

COID (1946–47) *Design Digest*, September 1946–January 1947.

COID (1947) *Design Folios*, (A–Q), COID.

COID (1947) *Digest Report of Conferences Held in Connection with the Design Week at Newcastle upon Tyne*, COID.

COID (1948) *Design Report: Ideas for Industry from Design Week Wales*, COID.

COID (1948) *How to Buy Things for the Kitchen*, COID.

COID (1949) *Furniture Design: Report on Conference at RIBA*, COID.

COID (1949) *Report on Design Course for Retailers*, COID.

COID (1949) *Report on Design Course for Retail Staff Trainees*, COID.

COID (1947) *What Is a Design Centre?*, COID.

Cripps, S. (1946) 'Industrial Art: The Betterment of Design Standards', *Cabinet Maker*, 28 September.

Darwin, R. (1949) 'The Training of the Industrial Designer', *Journal of the Royal Society of Arts*, 6 May, pp. 421–36.

Department of Overseas Trade (Post-war Export Trade Committee) (1943) *Report of the Sub-Committee Appointed by Mr. Harcourt Johnston on Industrial Design and Art in Industry* (Weir Report, unpublished).

Design Research Unit (*c.* 1945) *Industrial Design*, DRU.

Dover, H. (1991) *Home Front Furniture, British Utility Design 1941–1951*, Scolar Press.

Dutton, N. (*c.* 1943) *A Concise Approach to Industrial Design*, published privately.

Dutton, N. (1946) 'Britain Can Lead the World in Design', *Art & Industry*, January, pp. 2–6.

Edwards, R.S. (1948) 'Social and Economic Aspects of Industrial Design', *Journal of the Royal Society of Arts*, December, pp. 25–38.

Gamage, L. (1945) 'Exports & Home Trade are One Market', *Art & Industry*, October, pp. 120–22.

Gardner, J. (1983) *Elephants in the Attic: The Autobiography of James Gardner*, Orbis.

Gardner, J. (1993) *James Gardner: The ARTful Designer*, Centurion Press.

Geffrye Museum (1974) *Utility Furniture and Fashion 1941–1951*, ILEA.

Gloag, J. (1944) *The Missing Technician in Industrial Production*, Allen & Unwin.

Gloag, J. (1947) *Self Training for Industrial Designers*, Allen & Unwin.

Goodale, E. (1941) 'Design and the Manufacturer', *Journal of the Royal Society of Arts*, 25 October, pp. 690–703.

Goodale, E. (1945) 'Post War Design: How It Will Effect Furnishing Fabrics', *The Cabinet Maker*, 27 January, pp. 3–6.

Grey, J. (1946) *Fitness – For What Purpose?*, DIA booklet.

(Hansard: early COID references)

Hansard (1944) Vol. 406, 19 December, cols. 1612–15.

Hansard (1945) Vol. 407, 30 January, cols. 1337–81.

Harrison, T. (1943) 'Public Taste and Public Design', *Art & Industry*, pp. 83–85.

Hollowood, B. (1947) *The Things We See: Pottery and Glass*, Penguin.

Holmes, A.H. (1946) 'Design and the Retailer', *Journal of the Royal Society of Arts*, 25 October.

Jarvis, A. (1946) *The Things We See: Indoors and Out*, Penguin.

Leslie, S.C. (1945) 'Design for Home and Export', *Board of Trade Journal*, 24 March, p. 117.

Logan, M. (1948) 'Design at Work (Royal Designers for Industry Exhibition)', *Art & Industry*, December, pp. 203–08.

MacCarthy, F. (1979) *A History of British Design, 1830–1970*, Allen & Unwin.

Maguire, P. (1991) 'Designs on Reconstruction: British Business, Market Structures and the Role of Design in Post-War Recovery', *Journal of Design History*, vol. 4, no. 1, pp. 15–30.

Mansfield, F. (1949) *4 Ways of Living*, pamphlet for 1949 Ideal Homes Exhibition, COID.

McNeil, P. (1993) '"Put Your Best Face Forward": The Impact of the Second World War on British Dress', *Journal of Design History*, vol. 6, no. 4, pp. 283–299.

Mercer, F. (1947) *The Industrial Consultant: Who He Is and What He Does*, Studio.

Meynell, F. (1971) *My Lives*, Bodley Head.

Owen, P.J. (1947) *Furnishing to Fit the Family*, COID.

PEP (1946) *The Visual Arts: A Report Sponsored by the Dartington Hall Trustees*, Oxford University Press for PEP.

Pevsner, N. (1946) *Visual Pleasures from Everyday Things*, Council for Visual Education/Batsford.

Pleydell-Bouverie, M. (1944) *Daily Mail Book of Post-War Homes*, Associated Newspapers.

Read, H. (1944) 'Design Review: Education of the Designer', *Architectural Review*, December, pp. 183–4.

Read, H. (1946) *The Future of Industrial Design*, DIA booklet.

Read, H. (ed.) (1946) *The Practice of Design*, Lund Humphries.

Reilly, P. (1987) *An Eye on Design: An Autobiography*, Max Reinhart.

Robertson, H. (1947) *Reconstruction and the Home*, Studio.

Royal Society of Arts/COID (1948) *Design at Work*, RSA/COID.

Royal Society of Arts, Journal of (1946) 'Conference on Industrial Design in Connection with the Britain Can Make It Exhibition', 25 October, p. 690.

Royal Society of Arts, Journal of (1946) 'The Council of Industrial Design', 30 March, pp. 201–02.

Royal Society of Arts/COID (1948) *Design at Work: An Introduction to the Industrial Designer with a Study of His Methods of Working and the Position He Holds in British Industry: Exhibition Handbook*, RSA/COID.

Russell, G. (1944) 'Taste in Design', *Art & Industry*, August, pp. 49–53.

Russell, G. (1947) 'The New Director of CID', *Architectural Review*, 1947, p. 147.

Russell, G. (1947) *Things We See: Furniture*, Penguin.

Russell, G. (1947) *How to Buy Furniture*, COID.

Russell, G. (1948) 'National Furniture Production', *Architectural Review*, December, pp. 182–85.

Russell, G. (1949) 'What is Good Design?', *Design*, January.

Russell, G. (1950) 'The Development of Cooperation between Museums and Industry', *Museums Journal*, November, pp. 172–76.

Russell, G. (1968) *Designer's Trade: Autobiography of Gordon Russell*, Allen & Unwin.

Sladen, C. (1995) *The Conscription of Fashion: Utility Cloth, Clothing and Footwear 1941–1952*, Scolar Press.

Studio (1947) *Designers in Britain*, Vol. 1.

Studio (1949) *Designers in Britain*, Vol. 2.

Symes, A. (1948) *Selling Through Display: Ideas for the Smaller Shop*, COID.

Tennyson, C. (1957) *Stars and Markets*, Chatto & Windus.

Trethowan, H. (1943) 'Utility Ware', *Studio*, no. 125, pp. 48–50.

Waterer, J.W. (1947) *This Design Business*, COID.

White, J. Noel (1989) 'The First Crafts Centre of Great Britain: Bargaining for a Time Bomb', *Journal of Design History*, vol. 2., nos. 2 & 3, pp. 207–14.

Woodham, J.M. (1983) *The Industrial Designer and the Public*, Pembridge.

Woodham, J.M. (1996) 'The Consumers of the Future: The Council of Industrial Design and Educational Strategies for Schools, 1944 to the Late 1950s', in Pavitt, J. (ed.) (1996), *The Camberwell Collection: The Object Lesson*, London Institute, pp. 16–25.

Woodham, J.M. (1996) 'Managing British Design Reform I: Fresh Perspectives on the Early Years of the Council of Industrial Design', *Journal of Design History*, vol. 9, no. 1, pp. 55–65.

Woodham, J.M. (1996) 'Managing British Design Reform II: The Film *Deadly Lampshade* – An Ill-fated Episode in the Politics of "Good Taste"', *Journal of Design History*, vol. 9, no. 2, pp. 101–15.

Index

Numbers in italics refer to illustrations.
'BCMI' indicates the *Britain Can Make It* Exhibition.

Addison, Paul 7
Adorno, Theodor 12
A. J. Wilkinson Ltd 124
*All Things Bright and Beautiful: Design in Britain
 1830 to Today* (MacCarthy) 17
Allan Walton Textiles 125, 208
Allen, Margaret 139
Amalgamated Merchandising
 Corporation 191
Amies, Hardy 71
Anderson, M.L. 79
Anglo-American Council on
 Productivity 34, 35
Annan, Noel 13
apprenticeship 116
Architectural Journal 188
Architectural Review 18, 56, 89, 126, 188
Archive of Art & Design, Olympia 23
Arends, Andrew 5
Argentina 38, 114
Armstrong Engineering 115–16
Armstrong-Whitworth conglomerate 115
'art' and 'industry' 123–6
Art and Industry periodical 18
Art Manufactures 124
Art Workers Guild 206
Arts Council 200
 Arts Panel 206
Arts and Crafts Movement 17, 47, 100, 124
Ascher (London) Ltd 74, 75, 76, 79
Ashbee, Charles 100
Ashford, Douglas 7
Ashford, F. 12
Ashley 75
Ashley-Cooper, Sir Patrick 190, 191, 192
Ashton, Sir Leigh 49, 128, 155, 224, 225,
 226, 227, 228

Ashton Bros 77
Ashworth, William 5
Atlantic Charter 9
Attlee (Harris) 6
Attlee, Clement Richard, 1st Earl 5, 6, 10,
 40, 45, 200, 201
The Attlee Years (Tiratsoo) 6
The Audit of War (Barnett) 9, 30
Australia, British exports to 38
Ayrton, Maxwell 156

The Backbench Diaries of Richard Crossman
 (Morgan) 6
Bailey, James *220*
Bainbridge, J. *110*
Barclay, William 229
Barclays Bank 113
Barlow, Sir Thomas 46, 47, 52, 54, 75–6, 77,
 79, 139, 155, 170, 171–2, 197, 198–9, *198*,
 226
Barlow & Jones 75, 76, 77, 81, 198
Barman, Christian 188
Barnes, L.J. 104
Barnett, Correlli 9, 30
Basset-Gray Group of Writers and
 Artists 125, 199, 202
Bassett-Lowke, W.J. 189
Battersea Pleasure Gardens, London 202
Bauhaus 78
Bawden, Edward 74
BCMI *see Britain Can Make It* Exhibition
Beardmore, Freda 124
Beddington, Jack 49, 128, 155, 201
Behrens, Peter 189
Bel Geddes, Norman 125
Belgian Chamber of Commerce 39
Belgian Embassy (London) 55

Belgium, British sales 120–1
Bell, Angus G. 95
Bell, Vanessa 74, 124, 208, 228
Bentley, Nicholas *216, 217*
Berenson, Bernard 199
Bertram, Anthony 106
Betjeman, John *216*
Bevan, Nye 41
Bevan, R.A. 56
Bevanism 6
Bibliography of Design in Britain 1851–1970
 (Coulson) 18
bicycle production 117
Bilsland, Sir Steven 139
Birmingham 115, 117, 125
Birmingham Chamber of Commerce 33
Black, Misha 59, 89, 128, *129, 130,* 131, 132,
 171, 172, 199, 202
The Bleak Midwinter (Robertson) 3
Board of Education 117
Board of Trade xiv, 5, 17, 19, 35, 38, 51–2,
 54, 55, 59, 70, 117, 120, 124, 158, 171, 182,
 203, *209*
 Advisory Committee on Furniture
 Production 206, 207
 Advisory Committee on Utility
 Furniture 100, 207
 Design Panel 46, 100, 206
 Export Promotion Department 190
 furniture industry 101, 102, 104
 notes of an internal meeting 159–60
 responsible for the COID's
 activities 195
 Working Parties 133
Bolton 'Worktown' 172
'Borax – or the Chromium-Plated Calf'
 (Kaufmann) 126
Bourne, Stafford 57
BPMF *see* British Pottery Manufacturers'
 Federation
Braddell, Dorothy Darcy 187, *214*
Brangwyn, Frank 124
Brazil 115

Brecht, Bertolt 41
Brett, Lionel 101
Bretton Woods Agreement 33
Britain
 anti-Americanism 33–4
 balance of payments 33, 42
 commercial rivalry with America 9,
 30, 48–9, 190
 Coronation (1953) 94
 exports 30, 31, 33, 34, 35, 37–40
 factory closures 40
 fuel shortages 40
 imperial preference 33
 imperialism 9, 10, 33, 34, 121
 imports 31, 34, 35, 38
 industry *see* British industry
 loan from the US 3, 30, 33, 36, 38, 41
 patriotism 40
 protectionism 32–3, 36
 rationing 34, 38, 39, 68, 104, 230
 Second World War 7, 30, 31, 32, 35–6
 sterling 5, 36, 38, 40
Britain Can Make It Exhibition (BCMI,
 Victoria and Albert Museum, 1946)
 14, 39, 106
 aims 9, 29, 69, 142–3, 151, 161
 attendance 19, 196
 availability codes 68, 69
 'Birth of An Egg Cup' exhibit 128, *129,*
 132
 buyers 196–7, 229
 catalogue *2,* 19–20, 69, 81, 187
 Children's Section 178
 cost 144, 158
 debates about 121
 'The Designer Looks Ahead'
 Section 11, *11, 12*
 documentation 137–97
 Draft Plan 49, 151–4
 Dress Accessories Section 71
 Dress Fabrics Section *72,* 74–6
 evaluations 55–9, 124, 177–8, 184–97
 exports 167

Fashion Hall *219, 220*
Furnished Rooms Section 53, 58, 76,
 78, 79, *80*, 81, *82*, 83, 103–4, 178,
 214, 215, 216, 217
Furnishings and Textiles Section 58,
 99
Furniture Section 58, 76, 77
Furniture Selection Committee 52–3,
 53
Future Design display 58, 154, 187
historiography 19–24
importance of fashion 50
keynote 68
Leslie's *Draft Proposal* 46
maps *45*, 225
Mass Observation 57–9, 128, 129,
 172–83, 230–1
Menswear Section *220*
metropolitan–regional tensions 52, 54,
 59
Opening Ceremony *ii*
organization 146–8
origins and early plans 46–8
photographs *210–23*
Pottery Selection Committee *85*, 86
the press 197
proposed 46, 47, 140–5
'The Public' stand 20
putting the 'Britain' into BCMI 48–50
Quiz Banks 58
scope 148–51, 155–6, 166–7
selection process 50, 52–5, 58,
 59–60, 75–6, 118, 129, 143, 157,
 161–8, 192, 195, 226
settings 57
Shopwindow Street 21, *22*, 58, *87*, 150,
 178, *212*
site 51, 144, 158
Sport and Leisure Section 194, *213*
title 51, 145, 151, 154, 157
Toys Section 181, *218*
trade buyers 19–20
Utility and other Furniture Section *68*

visitors 58, 181–3
War to Peace Section 194, *211*
'What Industrial Design Means'
 Section 59, 127–31, 199
Women's dress display 58
see also under individual industries
British Art in Industry Exhibition
 (Burlington House, London,
 1935) 118, 120, 124
British Broadcasting Company (later
 Corporation) (BBC) 106
British Commonwealth 47
The British Council, The First Fifty Years
 (Donaldson) 13
British Culture and Economic Decline (ed. Collins
 and Robbins) 13
British Electrotechnical and Allied
 Manufacturers' Associations
 (BEAMA) (Federation of) 195
British Empire 33, 36, 40
British Empire Exhibition (Wembley,
 1924) 10, 196, 206
British Industries Fair (BIF) 47, 115, 129,
 143, 187, 191, 207
British industry
 American rivals 9, 30
 attempts to sell against the fashion
 39–40
 attitude towards new or difficult
 markets 39
 Economist 37
 Labour's failure to link production and
 patriotism 43
 perceived key to regeneration 31
 re-stocking boom 31
 tariffs 30
 weaknesses 30, 31–2
British Institute of Industrial Art 207
British Market Research Bureaux 230
British Pottery Manufacturers' Federation
 (BPMF) 40, 118, 119, 165–9
The British War Economy (Hancock and
 Gowing) 8

Bromley School of Art 71
Brussels Chamber of Commerce 55
Brussels International Exposition
 (1935) 120
Brussels World Fair (1958) 202
Bullock, C.E. 165, 166

Cabinet Maker 104
CAI *see* Council for Art and Industry
Cairncross, Alex 3, 5
Calder, Angus 7
Campbell, John 6
Canada 38, 95, 96
Capitalism, Culture, and Decline in Britain
 (Rubenstein) 13
Carew, Anthony 9
Carlisle, Stella 131
Carlton Studios, London 201
carpet manufacture 116
Carpet Working Party 112, 116
Carrington, Noel 17, 19, 49
Carruthers, Mr 158, 159, *203*
Cartier 201
Castle, Barbara 7
Cavendish Textiles 77, 78
Central Institute of Art and Design
 (CIAD) 48–9
Central Price Regulation Committee 102
ceramics *see* pottery industry
Chamberlain, Joseph 33
Chambers of Commerce xiv
Change and Fortune (Jay) 6
Charmley, John 9
Chester, D.N. 5
Churchill, Sir Winston Leonard
 Spencer 4, 29, 201
Churchill's Grand Alliance: The Anglo-American
 Special Relationship 1940–1957
 (Charmley) 9
CIAD *see* Central Institute of Art and
 Design
Civil Industry and Trade (Gowing and
 Hargreaves) 8

The Civil Servants: An Inquiry Into Britain's
 Ruling Class (Kellner and Crowther-
 Hunt) 5
Clark, J. Arundell 199
Clark, Sir Kenneth 46, 47, 49, 139, 199–200,
 200, 224, 225
Clark, May Constance 184
Cleveland Belle, Jimmy 49, 50, *50*, 75–6
Cliff, Clarice 124
clocks 55
coal mining 5, 7
Coates, Wells 101, 125
COID *see* Council of Industrial Design
Cold War 3, 38
Cole, Henry 124
Collins, Bruce 13
Colour, Design and Style Centre,
 Manchester 52, 74, 75, 76
Committee on Trade and Industry
 Survey of Metal Industries 116
 textile industry 117
Common Market 93
Communism 12
Cooke, S.D. 169–70
Cooper, Susie 88, 165
Copeland & Sons Ltd 170
cotton 35, 67–70, 73–6, 79, 81, 83, 115, 116
Cotton and Rayon Manufacturers'
 Association 114
 Members Bulletin 114
Cotton Board 74
 Fashion Design & Style Centre,
 Manchester 133
Coulson, Anthony 18
Council for Art and Industry (CAI) 17, 56,
 76, 79, 188, 191
 designer's pay and professional
 standing 112
 established (1933) 124
 major exhibitions 146
 Paris Exhibition 52, 146, 187, 192
 survey of design markets 116
 V & A 225

wallpaper industry 118
Council of Industrial Design (V & A Museum
 Archive file) 224
Council of Industrial Design (COID) xiv,
 10, 13, 23, 76, 81, 111, 170–1, 182, 188,
 191
 aims 60, 161
 Annual Report 1946/47 19
 'Bible of industrial design' 131–2
 Board of Trade 195
 conference on industrial design 56
 Design 126
 Design Council 17, 230
 designer's lack of status 112
 Executive (Management)
 Committee 51
 Exhibition Policy Committee 51,
 154–8, 164
 Exhibitions Committee 61n, 128
 Festival of Britain 199
 film 132, 203
 Finance Committee 51, 155, 158
 First Annual Report 1945–46 133, 195
 first meeting (January 1945) *205, 207*
 founding charter 59
 furniture industry 106
 'Good Design' ethos 18, 49, 51, 58, 60
 governing body 5
 Industrial Committee 116, 133
 industrial liaison officers 160–1, 192
 Information Division . 133
 major debut with BCMI 45, 129
 Notes for the Press 139–40
 optimism and idealism 45
 Post War Export Trade Committee
 29
 pottery industry 92–3, 118, 119, 165–70,
 208–9
 preparations for BCMI 46, 47, 49,
 224
 proposal for 1946 exhibition 46, 47,
 140–5
 Public Record Office 195, 233

 reassessment (1986) 23
 Scottish Committee 49
 stand at BCMI 20, *20, 21*
 V & A 224
*Council of Industrial Design, Accommodation in the
 Museum* (V & A Museum Archive
 Special File) 225–8
'Coupe' shape 95
Coventry Cathedral 207
Creed, Charles 70
crepe 71, 75
Cresta Silks 74, 75
Cripps, Sir Stafford 60, 200, 202
 balance of payments 42
 BCMI 21, 45, 46, 47, 48, 49
Crossman, Richard 12
Crowther-Hunt, Lord 5
culture, debasement by commerce 12–13
cutlery manufacture 116
Cycle and Motor Cycle Manufacturers 40

Daily Express 229
Dalton, Hugh 4, 33, 201
Day, Lucienne 79
'The Days of the New Look'
 (Partington) 8
de Normann, Mr (Ministry of Works) 226
Deadly Lampshade (film project) 132, 203
The Decline of Industrial Britain 1870–1980
 (Dintenfass) 3
Delanghe, Angele 71
Denby, Elizabeth *216*
Denby pottery 93
Denmark 114
Department of Overseas Trade 143
Design (periodical) 18, 94, 126–7
Design '46 71
Design and British Industry (Stewart) 18
Design and Industries Association
 (DIA) 17, 54, 56, 79, 81, 105, 118, 124,
 187, 189, 202, 206
Design and Research Centre for the Gold,
 Silver and Jewellery Industries 133

Design and the Cotton Industry (Board of
 Education report) 117
Design and the Designer in Industry (CAI
 report) 56, 112, 117, 125, 198
Design and the Designer In The Dress Trade (CAI
 report) 113
Design at Work exhibition (Burlington
 House, London, 1948) 111
Design Centre 106–7
design consultancies 125
Design Council xiv, 17, 133, 225, 230
Design Council Archive, University of
 Brighton 23, 138
Design for Today (periodical) 18
Design History Research Centre, University
 of Brighton xiv, 138
Design in British Industry a Mid-Century Survey
 (Farr) 127
Design in Everyday Things (Bertram) 106
'Design Man' *123*
Design Panel 46, 100, 206
Design Quiz (COID) 58, 174, 179–80
Design Research Unit (DRU) 58, 127, 128,
 129, 130, 131, 132, 199, 202
Design Weeks 132
designers
 remuneration 112, 117, 125
 status 112, 125, 127
 training 112, 116, 127–8
A Designer's Trade (Russell) 23
Deutsche Werkbund 17
DIA *see* Design and Industries Association
DIA Quarterly magazine 17
The Dialectics of Enlightenment (Adorno and
 Horkheimer) 12
The Diary of Hugh Gaitskell 1945–1956
 (Williams) 5
Did Britain Make It? British Design in Context
 (ed. Sparke) 23
Dimbleby, David 9
Dintenfass, Michael 3
Display (magazine) 57
Dobroyd 71

Donald Brothers 77, 78
Donaldson, Frances 13
Donoughue, Bernard 4
Dorland Hall, London 124
Dorset Federation of Divisional Labour
 Parties 42
Drew, Jane *217*
Dreyfuss, Henry 125
Driburg, Tom, MP 228
DRU *see* Design Research Unit
Drucker, Peter 11–12
Duke, J.A. 74, 75
Dupree, Marguerite 4

Earls Court, London 51–2, 144, 150, 158,
 159, 227
Early British Computers (Lavington) 10
The Economic Problem in Peace and War
 (Robbins) 5
The Economic Section 1939–1961 (Cairncross and
 Watts) 5
Economist 35, 37, 60
Edgar, Jane 78
Edinburgh Weavers 67, 76, 81, 83, 125
Edwards, Dr R.S. 139, 155, 156, 157, 158
Egerton, David 10
Elephants in the Attic (Gardner) 21
Elers brothers 92
Eliot, T.S. 12
Elizabeth, Queen (later the Queen
 Mother) *ii*, 195
Emberton, Joseph 156
The Emergence of the Welfare State (Ashford) 7
employment, full 37
England and the Aeroplane (Egerton) 10
*England Arise: The Labour Party and Popular
 Politics in 1940s Britain* (Fielding,
 Thompson and Tiratsoo) 6
*English Culture And The Decline of the Industrial
 Spirit, 1850–1980* (Wiener) 13
Enterprise Scotland exhibition
 (1947) 202, 207
Evans, John Beresford 126

Evening Standard 229
Evoluon Museum, Eindhoven 202
Ewart, William 77
Export Conference (London) 169
Export Promotions Department 5
Exposition des Arts Décoratifs et
 Industriels (Paris, 1925) 206

Faculty of Royal Designers for
 Industry 126
Farleigh, John 78
Farr, Michael 19, 127
fashion 50, 57, 70–1, 74, 83, 150, 154, 230
 Utility 70, 71, 88
The Fateful Years (Dalton) 4
Federation of British Industry (FBI) 56,
 117, 120, 133, 193
 Industrial Art Sub-Committee 148,
 207
Fennemore, Thomas A. 48–9, 124, 155
Festival of Britain (1951) 4, 94, 106, 199,
 202, 206, 207
Fielding, Steven 6
Fighting All the Way (Castle) 7
First World War 10, 30, 32, 39, 42, 105
 imperial forces 34
 motor industry 32
The Five Giants (Timmins) 7
Flaxman, John 92
Fleetwood, Kathleen 78
Foley China 124
Forbat, Olga 78
Forsyth, Gordon 89–91, 92
Forsyth, Moira 91, 92
France
 British sales 121
 cooperation between textile
 manufacturers and fashion
 designers 70
 design supremacy 113
 Second World War 30
Fraser, Eric 20, *20, 21*
Frazer, Austin 128

Fry, Maxwell *217*
Furniture Development Council 101
furniture industry
 BCMI 52–3
 'Cheviot' prototype 104
 Chiltern range 103
 'Cockaigne' prototype 104
 Cotswold range 103, 104
 'D-scheme' 105
 ethical aesthetic 105
 'freedom of design' (1948–52) 100, 104
 Good Design campaign 100–2, 103
 hire purchase regulation 105
 price control 104–5
 rationalization 101, 103
 'repro-contemporary' style 107
 reproduction 'Jaco' styles 105
 size of firms 115
 standardization 100, 102, 103, 104
 Utility 81, 88, 99–107
 weaving companies 76–7
*Furniture for Small Houses: A Book of Designs
 for Inexpensive Furniture with New
 Methods of Construction and Decoration*
 (Wells) 106
Furniture Working Party 100
 Design Sub-Group 100, 101
*The Future of Industrial Man: A Conservative
 Approach* (Drucker) 11–12
Fyrth, Jim 3

Gamage, Leslie 47, 139, 193
Gardner, James 21, *22,* 23, 51, 56, *123,* 156,
 201–2, *201, 210,* 228
General Agreement on Tariffs and
 Trade 33
General Electric Company, Ltd (GEC) 47,
 57, 193
George VI, King *ii,* 195
Germany
 key competitor 31, 39, 153
 pottery industry 90
 Second World War 7, 9, 36

Gimson, Ernest 100
Glasgow Empire Exhibition (1938) 144,
 145, 209
Glasgow School of Art 208
Gloag, John 49, 50, 55, 91, 149, 154, 155
The God that Failed (Crossman) 12
Godden, R.Y. *213*
Goebbels, Joseph 43
Golsby, J.W. 190, 192
Gommes 104
Good Design 131, 132, 191
 campaigners' commonality of
 purpose 56
 change in method of promotion 107
 COID 18, 51, 58, 60, 154
 debates about 124
 furniture industry 100–2, 103
 ineffective message of 131, 132, 133
 Olins 74
 pre-war design 49
 Read 54
 standardization 104
 textiles 76, 83
Good Furnishing Group 206
Goodale, Sir Ernest 76, 77, 79, 139–40
Goodwin, Miss (COID Librarian)
 157
Gordon Russell (furniture manufacturing
 firm) 206
Gorell Committee on Art and
 Industry 124
Gosforth Co-operative Party 34
Goslett, Dorothy 131, 132
Govancroft pottery 93
Gowing, Margaret 8
Grafton [F. W.] Fabrics 68, 71, 75, 77, 78
Grant, Duncan 208, 228
Gray, Milner 20, *20*, *21*, 49, 124, 202
Greg & Co., R. 77, 78
Grierson, John 132
Griffiths, Miss 159
Groag, Jacqueline 78
Groag, Jacques *77, 99*

Haigh, William 140, *205*
Hancock, W.K. 8
Hargreaves, E.L. 8
Harriman, Ambassador 186
Harris, Kenneth 6
Harris, Mary 140
Harrisson, Tom 57, 175–6
Hartnell, Norman 71, 74
Havinden, Ashley *220*
Heal Fabrics Ltd 77, 78
*Health, Happiness And Security: The Creation of
 the National Health Service*
 (Honigsbaum) 7
Heathcote's 75
Helios 76, 77, 78, 81, 198
Henderson, J.L. 157
Hennessy, Peter 5, 6
Hepworth, Barbara 124
Herbert Morrison: Portrait of a Politician
 (Donoughue and Jones) 4
Hewison, Robert 12
Hewitt, A.E. 54, 170–1
Hill, John 81
History Painting 124
HMSO 131, 205
Holliday & Brown 68
Hollins, William 70, 75
Hollowood, Mr 155
Holtom, Gerald 74, 75, 76, 79
Holywell Mills 77, 78, 81
Home Office 40
Honey, Mr (V&A) 148
Honigsbaum, Frank 7
Hooper, John 102
Horkheimer, Max 12
Hornsea pottery 93
Horrockses mill, Preston 7
Hosiery Working Party 112, 113, 116
How to Buy Furniture (Jarvis and
 Russell) 203
Hoyle's 75
Huddersfield Chamber of Commerce
 38–9

Hugh Gaitskell (Williams) 5
Hungerford, H.R. 186
Hunter, Alec 76, 78, 79
Hyde Park (London) 51, 144

Ideal Home Exhibition, Olympia,
 London 144
In Anger: British Culture in the Cold War
 1945–60 (Hewison) 12
Incorporated Society of London Fashion
 Designers 70
India 9, 10, 79, 114
Industrial Design in Britain (Carrington) 17
Industrial Design Partnership 125, 199, 202
The Industrial Designer and the Public
 (Woodham) 18
Industrial Efficiency and State Intervention
 (Tiratsoo and Tomlinson) 8
Industrial Revolution 46
An Industrialist at the Treasury (Plowden) 4
International Council of Societies of
 Industrial Design 199
International Monetary Fund 33
International Realist 132
iron and steel industry 35
Isaacs, George 38
Isokon 101

Jaeger 71
Japan
 key compctitior 31, 38–9, 117, 153
 Second World War 7, 9, 29, 36
 textiles 79
Jarvis, Alan 132, 155, 202–3
Jay, Douglas 6
'Jazz-Moderne' style 61n, 91
jewellery 55
Johnson, Matthey and Co. 88
Johnstone, Harcourt 29
Jones, G.W. 4

Katz, Bronek *20*, 128, *129*, *130*
Kauffer, McKnight 201

Kaufmann, Edgar, Jr 126, 127
Kearley, M.E. 185, 186, 191–2
Kellner, Peter 5
Kilroy, Dame Alix 52, 158–9, 160, 199, 200
 203–4, *203*, 205
Knight, Dame Laura 124
Knox, John 71

Labour government
 committed to domestic reform 36
 economic performance 5, 8
 failure to link production and
 patriotism 43
 industrial policies 3–4
 nationalization 4, 5, 8, 37
 patriotism 40
 political tensions within the party 6
 politicizes economic performance
 36–7
 working parties 112
Labour Governments and Private Industry: The
 Experience of 1945–1951 (ed. Mercer,
 Rollings and Tomlinson) 8
Labour In Power (Morgan) 6
labour market 111–12
 absenteeism 41–2
 disputes 3
 responsibility 41
Labour Party
 Conference (1949) 41
 Executive Committee 42
 in government *see* Labour government
Labour Under The Marshall Plan (Carew) 9
Labour's High Noon (Fyrth) 3
Labour's Promised Land? (Fyrth) 8
Lace Working Party 116
Lachasse 70
Lancashire 114
Lancashire And Whitehall: The Diary of Sir
 Raymond Streat (ed. Dupree) 4
Lancashire cotton industry 79
Latin America 29
Lavington, Stephen 10

Lawrence, G.C. 157
Lebus 101, 103
Leeds 113
Leichner, Margaret 78, 79
Leslie, S.C. ('Clem') 19–20, 46, 47, 48, 51–5, 131, 132, 139, 145, 154, 155, 157, 158, 169, 171, 194–5, 202, 204, *204*, 206, *207*, 227–8
linen 71, 75, 76
Lipski, T. *20, 21*
Listener 54
lithography 88, 94–5
Liverpool 125
Locomotive Manufacturers Association 115, 116
Loewy, Raymond 125, 126
Logan Muckelt & Co. Ltd 68, *68*, 75
London 112, 113, 124, 127, 150
London County Council 4
London Passenger Transport Authority 4
The Lost Victory (Barnett) 9, 30
Lukacs, György 111
Lund Humphries 131
Lutyens, Sir Edwin 206

Macaulay, Mr 155
MacCarthy, Fiona 17, 19
McCrum, Captain C.R. 190, 191
McCullough, Donal 157
MacDonald, James Ramsay 4, 201
Macgregor, Lady 49
Machine Tool Advisory Committee 40
MacKinnon, Lana 75, 79
MacManus, F. *215*
Madge, Charles 57, 175
The Man Who Made Public Transport (Barman) 188
Manchester 73, 113, 125
Marks and Spencer 103
Marshall Aid programme 38
Martin, Kenneth 208
Mass Observation Archive, University of Sussex 23, 172–3, 230–2

Mass Observation Reports 57–9, 128, 129, 172–83
Maud, J.P.R. 227
Medd, D.L. 81
Memoirs: The Making of a Prime Minister 1916–1964 (Wilson) 10
Mercer, F.A. 49
Mercer, H. 8
Mercier, E.L. *200*
Mesling, C.A. 145, 155
Messel, Oliver 202
Meynell, Alex 4
Meynell, Sir Francis 47–8, 140, 157, 199, 203, 205, *205*
Midlands Industrial Design Association 113
Midwinter 93, 95
Milward, Alan 9
Ministry of Education 5
Ministry of Food 38
Ministry of Health 5
Ministry of Information 202
Ministry of Labour 40, 42, 116
Ministry of Production 70
Ministry of Supply 5, 209
Ministry of Works 144, 226–7, 228
modernism 17, 18, 104, 120, 189
Molyneux 71
Montreal World Fair (1967) 202
Moore, Henry 76
Moore, R.E.J. 155
Moorman, Theo 125
Morgan, Janet 6
Morgan, Kenneth 6
Morris, William 17, 83
Morrison, Herbert 4, 7, 8, 40–1, 42
Mortimer, Raymond 54–5, 57
Morton, Alistair 78, 79
Morton, Digby 70
Morton Sundour Fabrics Ltd 67, 76, 77, 78, 81
Mosca, Bianca 70
Moseley, Edna *82*

motor industry 31, 32–3, 35, 114–15
*Mr Attlee's Engine Room: Cabinet Committee
 Structure And The Labour Government
 1945–1951* (Hennessy and Arends) 5
Muller, F. J. 165–6, 167, 168, 170
Murdoch, Mrs 155
Murray, Keith 125–6
Museum of Modern Art, New York 56
Museum of Natural Science (Brunei) 202

National Art Library 229
National Register of Designers 207
The Nationalisation of British Industry (Chester) 5
nationalization 4, 5, 8, 37
Neo-classicism 92
Never Again (Hennessy) 6
New Statesman and Nation 54–5
New York World's Fair 145
New Zealand, British exports to 38
Newman, Mr *203*
Nicholas, Kate 7
Nicholson, Ben 124
Nicholson, E.M. 4
Northern Ireland 113
Norway 114
Notes Toward a Definition of Culture (Eliot) 12
Nuffield College Social Reconstruction Survey
 report (Forsyth) 91, 92
Nye Bevan and the Mirage of British Socialism
 (Campbell) 6
nylon 71, 79

*Oceans Apart: The Relationship between Britain
 and America in the Twentieth Century*
 (Dimbleby and Reynolds) 9
Olins, Wally 74
Olympia, London 144
O'Rorke, Brian 156
Orrefors 94
Otto, Carl 126

Paris Exhibition (1937) 52, 118, 142, 146,
 166, 187, 192

Partington, Angela 8
The People's War (Calder) 7
Pevsner, Nikolaus 17, 46, 49, 50, 89, 127
Picasso, Pablo 93
Pick, Frank 188
Picture Post 37, 41, 55
Pile, Barbara 78
Pilgrim Pictures 203
Pimlott, Ben 4
Pioneers of the Modern Movement (Pevsner) 17,
 46
Piper, John 74
'Planning Prosperity' (Forsyth) 89–90
Plowden, Edwin 4
Poole pottery 93
poplins 73, 76
Post War Export Trade Committee 29
'The Potteries in Transition'
 (Ratcliffe) 94–5
Pottery Gazette and Glass Trade Review
 92–3
Pottery and Glass 93, 94, 95
pottery industry 53–4
 BCMI 50, 53, 86, *87*, 90, 148
 'British Contemporary' style 95, 96
 British Empire 40
 COID 92–3, 118, 119, 165–70, 208–9
 DIA 118
 exports 114, 115, 170
 fine artists 124–5
 foreign design 92, 93, 95, 96
 industrialization 31
 lithography 88
 pre-industrial potters 91–2
 productivity 35
 relationship to other industries 93–4
 shape design 86, 88, 89, 90–1, 95
 surface decoration 86, 88, 89, 95–6
 Utility ceramics 88–9, 90–1, 180
Pottery Working Party 112, 116, 118
Pountney hotel ware 90
Press Secretaries Limited 157
Pritchard, Jack 100–1, 103

Public Record Office, Kew 23, 195, 233
Public Servant, Private Woman (Meynell) 4
Pugin, A.W.N. 17
Punch (magazine) 59

Queensberry, David 95

Rackham, Bernard 91
Ratauds 88
Ratcliffe, George 94–5
Ravillious, Eric 74
Raymond Loewy Associates 126
rayon 71, 74, 75, 76, 79
Rayon Design Centre 133
Read, Sir Herbert 49, 54, 89, 91, 127–8, 202
The Reconstruction of Western Europe 1845–1951
 (Milward) 9
Reed, Louis 71
Reid, Andrew 157
Reilly, Paul 23, 107, 203
Reynolds, David 9
Reynolds, Sir Joshua 124
R.F.D. Co., Ltd (Guildford) *211*
The Road to 1945 (Addison) 7
Robbins, Keith 13
Robbins, Lionel 5
Robertson, Alex 3
Robertson, Howard 156
Rollings, N. 8
Rolls Royce 47
Rooke, Noel 127
Rosenthal 94
Rover 47
Rowse, Herbert 156
Royal Academy 124
Royal College of Art 199
Royal Doulton 86
Royal Institute of British Architects
 (RIBA) 156
Royal Society of Arts 126
Rubenstein, W.D. 13
Ruskin, John 17
Russell, Gordon 14, 23, 46–7, 48, 76, 77,

79, 88, 100, 102, 111, 113, 132, 140, 157,
 203–6
Russell, Peter 70–1
Russell, R.D. *80*
Russell & Sons 205
Rutherston, Albert 124
Ryder, R. Dudley 51, 52, 146–8, 155, 156,
 158, 159, 160, 228, 229

Safeguarding of Industry Act 116
Salvation Army 20
Sanderson Fabrics 68
satin 70
Schorr, Ralph 71, *72*
Schrader, Mitchell and Weir 209
Schreiber, Gaby 68, 69
The Scope of the Exhibition (Tennyson) 51, 128
Scott, Douglas 126
screen-printing 88, 125, 208
Second World War
 British productive efforts 35–6
 imperial forces 34
 as an imperial war 10
 Utility programme 17–18, 99, 101
 wartime collectivism 7, 8
 see also under Britain; France;
 Germany; Japan; United States of
 America
The Second World War Diary of Hugh Dalton
 (ed. Pimlott) 4
*The Secret Constitution: An Analysis of the Political
 Establishment* (Sedgemore) 5
Sedgemore, Brian 5
Settle, Alison 49–50, 70
Sèvres 92
Shils, Edward 13
SIA *see* Society of Industrial Artists
silk 68, 71, 74, 75, 76, 116
Silkellal 71
silversmithing 55
Simeon, Margaret 78
Skawonius, Sven 55, 184–5
Smith, H.L. 8

The Social Effects of Unemployment in Teesside
 (Nicholas) 7
Society of Industrial Artists (SIA) 125, 202
South Africa 38
Soviet Union 7, 9, 29, 36
Sparke, Penny 23
Spence, Sir Basil 51, 71, *72*, 156, 206–7,
 206, *210*
Stafford House, St James's (London) 144
Staffordshire Potteries Ltd 86
The State In Business (Ashworth) 5
Stavenow, Professor Ake 56
Stewart, Jean 132
Stewart, Richard 18, 19
Stiebel, Victor 70, 202
Stoke-on-Trent 86, 92, 93, 96, 125, 209
Storey's 81
Stourbridge 96
Straub, Marianne 77, 78, 79
Streat, Sir Raymond 42–3, 52
Studio (periodical) 18
Stuttgart Weissenhof exhibition of
 modernist housing (1927) 189
Summerly, Felix 124
Sunday Times 83
Sutherland, Graham 74, 75, 76, 124, 228
Svenska Slödföreningen 55, 56, 184
Sweden 55–6, 114, 184
Swindells, Albert 78

Tanner, Betty 75
Taylor, Robert 3
Teague, Walter Dorwin 125
Team Valley Weavers 78
Tennyson, Sir Charles 49, 51, 128, 140, 147,
 148–51, 155, 156, 164, 207–8, *207*
textile industry
 BCMI 67–83
 Committee on Trade and Industry
 enquiry 117
 complacency of suppliers to the home
 trade 68–9
 complexities of production 69

exports 38, 67–8, 73, 114, 115, 117
fine artists 124
industrialization 31
lack of cooperation between clothing
 manufacturers and fabric
 suppliers 70–1
lack of standardization 117
national importance 7, 42
productivity 35
Thatcher, Margaret (Baroness
 Thatcher) 23
The Things We See series 107
Thompson, Peter 6
Thoms, David 8
Tilbury House, Petty France
 (London) 154
The Times 43, 55, 126, 127, 224
Timmins, Nicholas 7
Tiratsoo, Nick 6, 8
Tisdall, Hans 78, 81
Tomkins, A.G. 140
Tomlinson, George 38
Tomlinson, J. 8
Tomrley, Mrs 155
Tootal Broadhurst Lee 75, 79
trade union movement 37, 41, 42, 111
The Trade Union Question in British Politics
 (Taylor) 3
Treasury xiv, 19, 38, 158, 204, 224
Tresfon, J.H. 140, *200*
Trethowan, Harry 49, 55, *87*, 89
Tubbs, Ralph *218*
Turnbull & Stockdale 77, 81
tweeds 71, 76, 77, 78, 81

unemployment 7
United States of America (USA)
 British anti-Americanism 33–4
 British ceramics 95
 British exports 167
 cessation of lend-lease 33, 36
 commercial rivalry with Britain 9, 30,
 48–9, 126, 190

design consultancies 125
dollar shortage 5, 33, 36
exports 29, 70
industrial system 34–5
loan to Britain 3, 30, 33, 36, 38, 41
manufacturing 9–10, 31
production 34, 100, 113, 114
productivity 34, 35
Second World War 29, 30
'styling revolution' 70
United States Embassy (London) 55
University of Sussex 207
Utility programme 17–18, 76, 88, 99, 100,
 101, 106, 230
 ceramics 88–9, 90–1, 180
 fashion 70, 71, 88
 furniture 81, 88, 99–107
 Utility weave 81

V & A *see* Victoria & Albert Museum
 (London)
Vaughan, R. 128, *129, 130*
Venesta Plywood company 101
Victoria & Albert Museum (London)
 (V & A) 51, 144, 224–9, 231
Vienne, Jacqueline 70
'Viyella' 70, 75
Vogue 71
Vogue Book of British Exports 71

wallpaper industry 118
Walton, Allan 140, 155, 157, 208, *208*
War, Industry and Society (Thoms) 8
*War and Social Change: British Society in the Second
 World War* (Smith) 8
Ward, A. Neville 81
Wardle's 81
Wareite 79
Warner & Sons 76, 77, 78, 81, 125
Watts, Nita 5

weaving 50, 67, 76–7, 78, 125
Wedgwood, John 166
Wedgwood, Josiah 46, 92
Wedgwood, Hon. Josiah 55, 56, 140,
 208–9
Weeks, Hugh 56
Weir, Sir Cecil 49, 51, 155, 157, 164, 168, 199,
 209, *209*
welfare state 7
Wells, Percy A. 105–6
Wentworth Shields, W. 168–9
West Africa 114
Whalley, Philip 46, 47, *48*
White City (London) 115
Whitehall (Hennessy) 5
Wholesale Textile Association 118
Wiener, Martin 13
Williams, Philip 5
Williamson, A.H. 78
Williamson, Robert 157
Wilson, Sir Harold (Baron Wilson) 8, 10,
 38
Wilson, Woodrow 10
Wintle, Colin 157
Withers, Audrey 71–3, 75, 79
Woodham, J. 18, 19
Woodman, Herbert 78
wool 35, 71–3, 75, 76, 79, 81, 117
Wool Working Party 112
 Report 115
Woolton, Lord 51, 155, 157, 166, 168
The Working Class Home (Council for Art and
 Industry) 106
The Working Party Report on Furniture (Board of
 Trade) 100
World Bank 33
worsted fabrics 71, 79
Worth 70

Years of Recovery (Cairncross) 3

Lightning Source UK Ltd.
Milton Keynes UK
UKOW04f1012110914

238353UK00007B/266/P